War Photographs

Taken on the

BATTLEFIELDS

of the

Civil War

All Rights Reserved. No part of this book may be reproduced in any manner without the express written consent of the publisher, except in the case of brief excerpts in critical reviews or articles. All inquiries should be addressed to Skyhorse Publishing, 307 West 36th Street, 11th Floor, New York, NY 10018.

Skyhorse Publishing books may be purchased in bulk at special discounts for sales promotion, corporate gifts, fund-raising, or educational purposes. Special editions can also be created to specifications. For details, contact the Special Sales Department, Skyhorse Publishing, 307 West 36th Street, 11th Floor, New York, NY 10018 or info@skyhorsepublishing.com.

Skyhorse® and Skyhorse Publishing® are registered trademarks of Skyhorse Publishing, Inc.®, a Delaware corporation.

Visit our website at www.skyhorsepublishing.com.

10 9 8 7 6 5 4 3 2

Library of Congress Cataloging-in-Publication Data is available on file.

ISBN: 978-1-62087-644-2

Printed in China

War Photographs

Taken on the

BATTLEFIELDS

of the

Civil War

By Mathew B. Brady and Alexander Gardner

Who operated under the Authority of the War Department and the Protection of the Secret Service

Rare Reproductions from Photographs Selected from Seven Thousand Original Negatives Taken under Most Hazardous
Conditions in the Midst of One of the Most Terrific Conflicts of Men that the World Has Ever
Known, and in the Earliest Days of Photography—These Negatives Have Been in
Storage Vaults for More than Forty Years and are now the

Private Collection of Edward Bailey Eaton

Valued at $150,000

FIRST PRESENTATION FROM THIS HISTORIC COLLECTION
MADE OFFICIALLY AND EXCLUSIVELY
BY THE OWNER

Skyhorse Publishing

Martyrs on Altar of Civilization

BY

FRANCIS TREVELYAN MILLER

EDITOR OF THE JOURNAL OF AMERICAN HISTORY

THIS is undoubtedly the most valuable collection of historic photographs in America. It is believed to be the first time that the camera was used so extensively and practically on the battle-field. It is the first known collection of its size on the Western Continent and it is the only witness of the scenes enacted during the greatest crisis in the annals of the American nation. As a contribution to history it occupies a position that the higher art of painting, or scholarly research and literal description, can never usurp. It records a tragedy that neither the imagination of the painter nor the skill of the historian can so dramatically relate.

The existence of this collection is unknown by the public at large. Even while this book has been in preparation eminent photographers have pronounced it impossible, declaring that photography was not sufficiently advanced at that period to prove of such practical use in War. Distinguished veterans of the Civil War have informed me that they knew positively that there were no cameras in the wake of the army. This incredulity of men in a position to know the truth enhances the value of the collection inasmuch that its genuineness is officially proven by the testimony of those who saw the pictures taken, by the personal statement of the man who took them, and by the Government Records. For forty-two years the original negatives have been in storage, secreted from public view, except as an occasional proof is drawn for some special use. How these negatives came to be taken under most hazardous conditions in the storm and stress of a War that threatened to change the entire history of the world is itself an interesting historical incident. Moreover, it is one of the tragedies of genius.

While the clouds were gathering, which finally broke

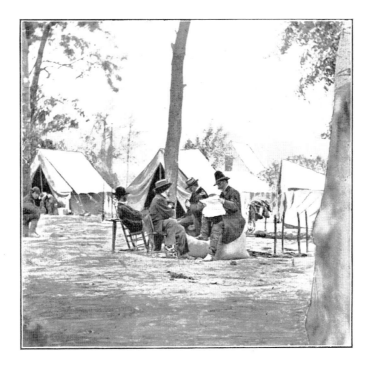

MATHEW BRADY, FIRST WAR PHOTOGRAPHER IN AMERICA
He followed the Armies during the Civil War and secured these remarkable Negatives—In conference with Major-General Burnside at the Headquarters of the Army of the Potomac near Richmond, Virginia—Brady occupies the chair directly in front of the tree while General Burnside is reading a newspaper—This picture was found among his negatives

into the Civil War in the United States, there died in London one named Scott-Archer, a man who had found one of the great factors in civilization, but died poor and before his time because he had overstrained his powers in the cause of science. It was necessary to raise a subscription for his widow, and the government settled upon the children a pension of fifty pounds per annum on the ground that their father was "the discoverer of a scientific process of great value to the nation, from which the inventor had reaped little or no benefit"

This was in 1857, and four years later, when the American Republic became rent by a conflict of brother against brother, Mathew B. Brady of Washington and New York, asked the permission of the Government and the protection of the Secret Service to demonstrate the practicability of Scott-Archer's discovery in the severest test that the invention had ever been given. Brady was an artist by temperament and gained his technical knowledge of portraiture in the rendezvous of Paris. He had been interested in the discoveries of Niepce and Daguerre and Fox-Talbot along the crude lines of photography but with the introduction of the collodion process of Scott-Archer he accepted the science as a profession and, during twenty-five years of labor as a pioneer photographer, took the likenesses of the political celebrities of the epoch and of eminent men and women throughout the country.

Brady's request was granted and he invested heavily in cameras which were made specially for the hard usage of warfare. These cameras were cumbersome and were operated by what is known as the old wet-plate process, requiring a dark room which was carried with them onto the battle-fields. The experimental operations under Brady proved so successful that they attracted the immediate attention of President Lincoln, General Grant and Allan Pinkerton, known as Major Allen and chief of the Secret Service. Equipments were hurried to all divisions of the great army and some of them found their way into the Confederate ranks.

"THE black art," by which Brady secured these photographs, was as mystifying as the work of a magician. It required a knowledge of chemistry and, considering the difficulties, one wonders how Brady had courage to undertake it on the battle-field. He first immersed eighty grains of cotton-wool in a mixture of one ounce each of nitric and sulphuric acids for fifteen seconds, washing them in running water. The pyroxylin was dissolved in a mixture of equal parts of sulphuric ether and absolute alcohol. This solution gave him the ordinary collodion to which he added iodide of potassium and a little potassium bromide. He then poured the iodized collodion on a clean piece of sheet glass and allowed two or three minutes for the film to set. The coated plate was taken into a "dark room," which Brady carried with him, and immersed for about a minute in a bath of thirty grains of silver nitrate to every ounce of water. The plate was now sensitive to white light and must be placed immediately in the camera and exposed and developed within five minutes to get good results, especially in the South during the summer months. It was returned to the dark room at once and developed by pouring over it a mixture of water, one ounce; acetic acid, one dram; pyrogallic acid, three grains, and "fixed" by soaking in a strong solution of hyposulphite of soda or cyanide of potassium. This photograph shows Brady's "dark room" in the Confederate lines southeast of Atlanta, Georgia, shortly before the battle of July 22, 1864. It is a fine example of wet-plate photography.

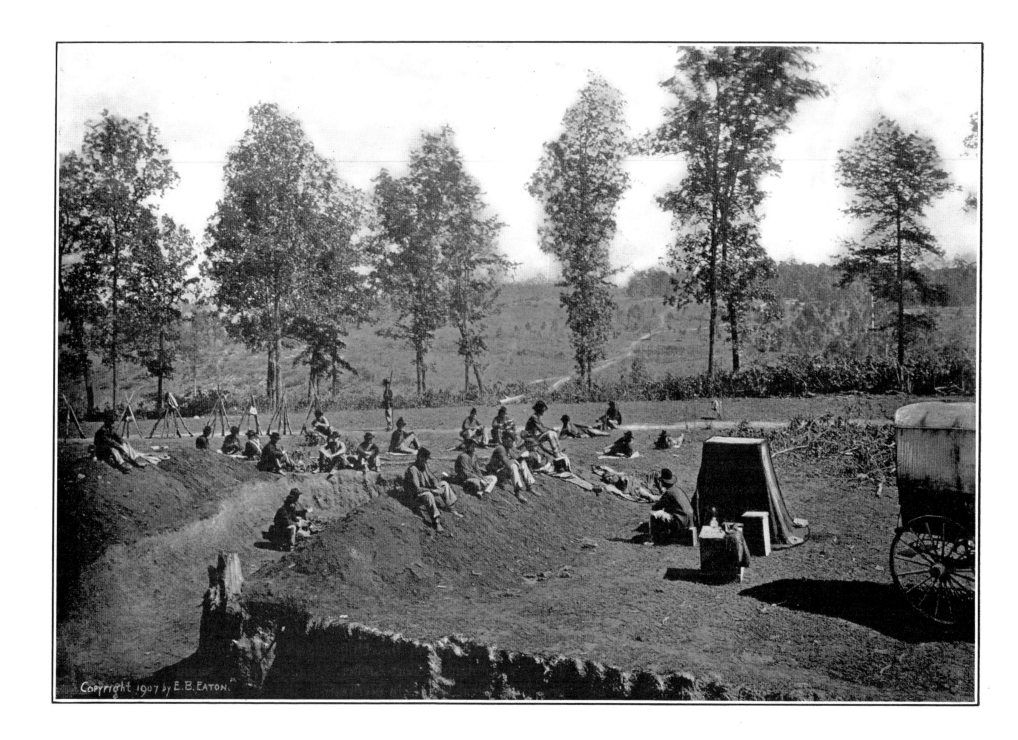

Copyright 1907 by E. B. Eaton.

THE secret never has been divulged. How Mr. Brady gained the confidence of such men as Jefferson Davis and General Robert E. Lee, and was passed through the Confederate lines, may never be known. It is certain that he never betrayed the confidence reposed in him and that the negatives were not used for secret service information, and this despite the fact, that Allan Pinkerton and the Artist Brady were intimate. Neither of these men had any idea of the years which the conflict was to rage and Mr. Brady expended all his available funds upon paraphernalia. The government was strained to its utmost resources in keeping its defenders in food and ammunition. It was not concerned in the development of a new science nor the preservation of historical record. It faced a mighty foe of its own blood. It must either fall or rise in a decisive blow.

It was indeed a sorry time for an aesthete. Mr. Brady was unable to secure money. His only recourse was credit. This he secured from Anthony, who was importing photographic materials into America and was a founder of the trade on this continent. The next obstacle was the securing of men competent to operate a camera. Nearly every able-bodied man was engaged in warfare. The science was new and required a knowledge of chemistry. Brady was a man of speculative disposition and plunged into the apparently impossible undertaking of preserving on glass the scenes of action during one of the most tremendous conflicts that the world has known. Pressing toward the firing-line, planting his camera on the field almost before the smoke of artillery and musket had cleared, he came out of the War with his thousands of negatives, perpetuating scenes that human eyes never expected to look upon again. There can be but very few important movements that failed to become imprinted on these glass records.

With the close of the War, Brady was in the direst financial straits. He had spent every dollar of the money accumulated in early portraiture and was heavily in debt. Seven thousand of his negatives were sent to New York as security for Anthony, his largest creditor. The remaining six thousand negatives were placed in a warehouse in Washington. Brady then began negotiations for replenishing his funds by disposing of the property. He exhibited proofs of his negatives in galleries

FIRST CAMERAS EVER USED ON THE BATTLEFIELD
One of Brady's Photograph Wagons in the wake of the Army at Manassas on the Fourth of July, in 1862—These mysterious canvas-covered wagons, traveling under the protection of the Secret Service, aroused the curiosity of the soldiers whose frequent queries "What is it?" soon earned for them the epithet of the "What is it?" wagon—Found among Brady's negatives

of the New York Historical Society the year following the cessation of the conflict. On the twenty-ninth of January of that same year, 1866, the Council of the National Academy of Design adopted a resolution in which it acknowledged the value of the Brady collection as a reliable authority for art and an important contribution to American history. It indorsed the proposal to place the collection permanently with the New York Historical Society. General Ulysses S. Grant had been much interested in the work of Brady on the battlefield, and in a letter written on February third, 1866, spoke of it as "a collection of photographic views of battlefields taken on the spot, while the occurrences represented were taking place." General Grant added: "I knew when many of these representations were being taken and I can say that the scenes are not only spirited and correct, but also well-chosen. The collection will be valuable to the student and artist of the present generation, but *how much more valuable it will be to future generations?*"

These were days of reconstruction. It was almost impossible to interest men in matters not pertaining to the re-establishment of Commerce and Trade. Brady had spent twenty-five years in collecting the portraits of distinguished personages and endeavored to dispose of these to the Government. The joint committee on libraries, on March third, 1871, recommended the purchase of some two thousand portraits which they called: "A National Collection of Portraits of Eminent Americans." The congressmen, however, faced problems too great to allow them to give attention to pictorial art and took no final action on the subject. In the meantime Brady was unable to meet the bill for storage and the negatives in Washington were offered at auction. William W. Belknap, the Secretary of War, was advised of the conditions and in July, 1874, he paid the storage bill and the negatives fell into possession of the Government. The purchase was made at a public auction and the Government bid was $2840 from money accumulated by Provost Marshals and turned in to the Adjutant-General at the close of the Civil War. The Government Records fail to give a list of the negatives made either at the time of the purchase or for many subsequent years. The original voucher dated July 31st, 1874, is silent as to the number of negatives received by the Government.

THIS photograph is selected from the seven thousand negatives left by Mathew B. Brady, the celebrated government photographer, as one of the most valuable in existence. It seems to be the first instance on the Western Continent, and possibly in the world, in which a camera successfully imprinted on glass the actual vision of a great army in camp. While scenes such as this are engraved on the memories of the venerable warriors who participated in the terrific struggle this remarkable negative preserves for all ages the magnificent pageant of men, who have offered their lives in defense of their country, waiting for the call to the battle-line. The photograph was taken on a day in the middle of May in 1862 when the Army of the Potomac was encamped at Cumberland Landing on the Pamunky River. A hundred thousand men rested in this city of tents, in the seclusion of the hills, eager to strike a blow for the flag they loved, yet such was the tragic stillness that one who recalls it says that absolute quiet reigned throughout the vast concourse like the peace of the Sabbath-day. On every side were immense fields of wheat, promising an abundant harvest, but trammeled under the feet of the encroaching armies. Occasionally the silence was broken by the strains of a national song that swept from tent to tent as the men smoked and drowsed, fearless of the morrow. The encampment covered many square miles and this picture represents but one brigade on the old Custis place, near White House, which became the estate of General Fitzhugh Lee, the indomitable cavalry leader of the Confederacy and an American patriot during the later war with Spain. The original negative, although now forty-five years old, has required but slight retouching in the background.

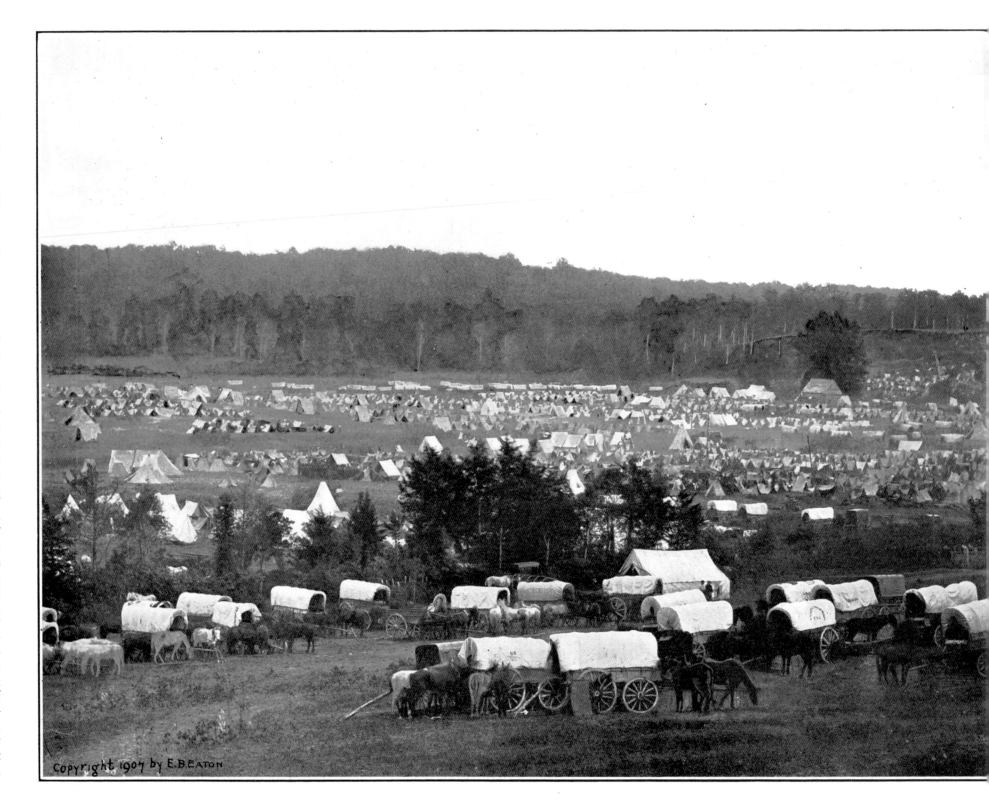

Copyright 1907 by E. B. Eaton

GENERAL JAMES A. GARFIELD was fully acquainted with the conditions under which the negatives were taken and the subsequent impoverishment of Mathew Brady. He insisted that something should be done for the man who risked all he had in the world and through misfortune lost the results of his labors. General Benjamin Butler, Congressman from Massachusetts, also felt the injustice, and on his motion a paragraph was inserted in the Sundry Civil Appropriation Bill for $25,000 "to enable the Secretary of War to acquire a full and perfect title to the Brady collection of photographs of the War." The business element in Congress was inclined to question the material value of the negatives. They were but little concerned with the art value and the discussion became a matter of business inventory. Generals Garfield and Butler in reply to the economists declared: "*The commercial value of the entire collection is at least $150,000.*" Ten years after the War, but too late to save him a vistage of business credit, the Government came to Brady's relief and on April 15, 1875, the sum of $25,000 was paid to him. During these years of waiting, Brady had been unable to satisfy the demands of his creditors and an attachment was placed on the negatives in storage in New York. Judgment was rendered to his creditor, Anthony, and the negatives became his property.

Army officers who knew of the existence of the negatives urged the Government to publish them as a part of the Official Records of the War. The Government stated in reply: "The photographic views of the War showing the battlefields, military divisions, fortifications, etc., are among the most authentic and valuable records of the Rebellion. The preservation of these interesting records of the War is too important to be intrusted in glass plates so easily destroyed by accident or design and no more effective means than printing can be devised to save them from destruction." While a few proofs were

taken for the purpose of official records, the public still remained unacquainted with the scenes so graphically preserved. One who is acquainted with the conditions says: "From different sources verbal and unofficial, it was learned that quite a number of the negatives were broken through careless handling by the employees of the War Department." The negatives were transferred to

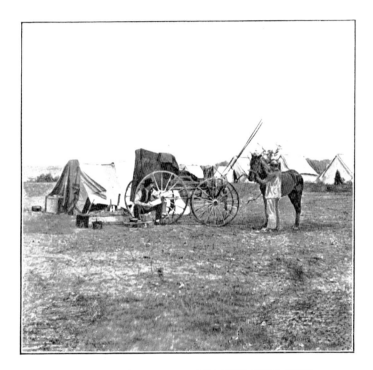

BRADY'S "WHAT IS IT?" IN THE CIVIL WAR
The Photographer's Headquarters at Cold Harbor, Virginia, in 1862, where he had taken refuge to prepare his paraphernalia for a long and hazardous journey—It was with much difficulty that the delicate glass negatives were protected from breakage on these daring rides through forests and fields and proofs were taken at the first opportunity that offered

the War Records Office and placed under the careful supervision of Colonel R. N. Scott.

Twenty-five years ago, in 1882, Bierstadt, a chemist, informed the Government: "The breakableness of the glass and the fugitive character of photograph chemicals will in short time obliterate all traces of the scenes these represent. Unless they are reproduced in some permanent

form they will soon be lost." Fifty-two negatives were sent to him and he reproduced six of these by a photographic mechanical process. The Government, however, decided that the cost was prohibitive, the expense of making the prints was seventy-five dollars a thousand and would not allow any general circulation.

Honorable John C. Taylor, of Hartford, Connecticut, a veteran of the Civil War, believed that the heroes of the conflict should be allowed to look upon the scenes in which they participated, and made a thorough investigation. Mr. Taylor is now Secretary of the Connecticut Prison Association and Past Commander of Post No. 50, Grand Army of the Republic. In relating his experiences to me a few days ago he said: "I found the seven thousand negatives in New York stored in an old garret. Anthony, the creditor, had drawn prints from some of them and I purchased all that were in his possession. I also made a deal with him to allow me to use the prints exclusively. General Albert Ordway of the Loyal Legion became acquainted with the conditions and, with Colonel Rand of Boston, he purchased the negatives from Anthony who had a clear title through court procedure. I met these gentlemen and contracted to continue my arrangement with them for the exclusive use of the prints. I finally purchased the Brady negatives from General Ordway and Colonel Rand with the intention of bringing them before the eyes of all the old soldiers so that they might see that the lens had forever perpetuated their struggle for the Union. The Government collection had for nine years remained comparatively neglected but through ordinary breakage, lax supervision, and disregard of orders, nearly three hundred of their negatives were broken or lost. To assist them in securing the prints for Government Records I loaned my seven thousand negatives to the Navy Department and shipped them to Washington where they were placed in a fireproof warehouse at 920 E Street, North West. I did all that was possible to facilitate the important work."

THE lens here perpetuates the interesting spectacle of an army wagon train being "parked" and guarded from a raid by the enemy's cavalry. With a million of the nation's strongest men abandoning production to wage devastation and destruction the problem of providing them with food barely sufficient to sustain life was an almost incalculable enigma. The able-bodied men of the North and the South had turned from the fields and factories to maintain what both conscientiously believed to be their rights. Harvests were left to the elements and the wheels of industry fell into silence. The good women and children at home, aided by men willing but unable to meet the hardships and exposures of warfare, worked heroically to hold their families together and to send to their dear ones at the battle-front whatever comforts came within their humble power. The supply trains of the great armies numbered thousands of six-mule teams and when on the march they would stretch out for many miles. It was in May, in 1863, that one of these wagon trains safely reached Brandy Station, Virginia. Its journey had been one of imminent danger as both armies were in dire need of provisions and the capture of a wagon train was as good fortune as victory in a skirmish. To protect this train from a desperate dash of the Confederate cavalry it was "parked" on the outskirts of a forest that protected it from envious eyes and guarded by the Union lines. One of Mr. Brady's cameras took this photograph during this critical moment. It shows but one division of one corps. As there were three divisions in each corps, and there were many corps in the army, some idea of the immense size of the trains may be gained by this view. The train succeeded in reaching its destination at a time of much need.

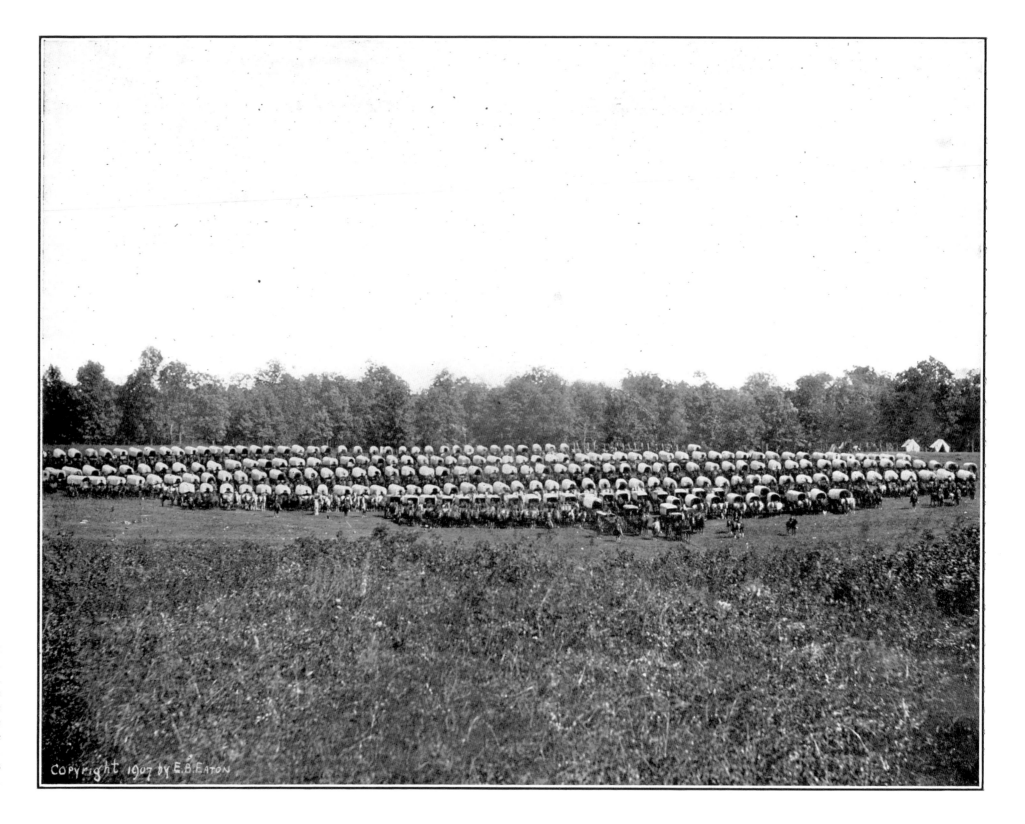

ENDEAVORS to reveal these negatives have been futile as far as rank and file of the army and the public at large are concerned. The Government, as the years passed, became impressed with the value of this wonderful record, but has now officially stated with positive finality: "It is evident that these invaluable negatives are rapidly disappearing and in order to insure their preservation it is ordered that hereafter negatives shall not be loaned to private parties for exploitation or to subserve private interest in any manner."

The genius Brady, in possession of $25,-000, which, came from the Government too late to save his property, entirely lost track of his collection. Misfortune seemed to follow him and his Government money was soon exhausted. In speaking of him a few days ago, John N. Stewart, Past Vice Commander of the Department of Illinois, Grand Army of the Republic, told me: "I was with the Army of the Potomac as telegraph operator. I knew that views of battlefields were taken by men with a cumbersome outfit as compared with the modern field photographer. I have often wondered what became of their product. I saw Mr. Brady in Washington, shortly before his death, and I made inquiry of him as to the whereabouts of his war scenes. I asked him if the negatives were still in existence and where proofs could be procured. He replied: 'I do not know!' The vast collection must possess great value and be of remarkable historical interest at this late date."

In talking with Mr. Taylor, in his office at the State Capitol at Hartford, Connecticut, recently he recalled his acquaintance with Brady, and said: "I met him frequently. He was a man of artistic appearance and of very slight physique. I should judge that he was about five feet, six inches tall. He generally wore a broad-brimmed hat similar to those worn by the art students in Paris. His hair was long and bushy. The last time I met him was about twenty-five years after the War and he appeared to be a man of about sixty-five years of age. Despite his financial reverses he was still true to his love for art. I told him that I owned seven thousand of his negatives and he seemed to be pleased. He became reminiscent and among the things that he told me I especially remember these words: 'No one will ever know what I went through in securing those negatives. The world can never appreciate it. It changed the whole course of my life. By persistence and all the political influence that I could control I finally secured permission from Stanton, the Secretary of War, to go onto the battlefields with my cameras. Some of those negatives nearly cost me my life.'" Mr. Brady told Mr. Taylor of his difficulty in finding men to operate his cameras.

BRADY ON THE BATTLEFIELD OF GETTYSBURG IN JULY 1863—The smoke of the terrific conflict had hardly cleared away when Brady's "What is it" wagon rolled onto the bloody "wheat field"—This picture shows Brady looking toward McPherson's woods on the left of the Chambersburg Pike at the point near which the Battle of Gettysburg began

"PINKERTON" is a name associated with the discovery of crime the world over. It is a word shrouded in mystery and through it works one of the most subtle forces on the face of the earth to-day. Sixty-five years ago an unassuming man fled from Scotland to America. It was charged against him that he was a chartist. Eight years later he was in Chicago established in the detection of crime. While the distant rumbles of a Civil War were warning the nation, he went to Washington and became closely attached to President Lincoln. When a plot was organized to assassinate Lincoln in his first days of the presidency, this strange man discovered the murderous compact. It was he who, in 1861, hurriedly organized the Secret Service of the National Army and forestalled conspiracies that threatened to overthrow the Republic. In speaking of himself he once said: "Now that it is all over I am tempted to reveal the secret. I have had many intimate friends in the army and in the government. They all know Major E. J. Allen, but many of them will never know that their friend, Major Allen and Allan Pinkerton, are one and the same person." To those who knew Major Allen this picture is dedicated. It reveals Allan Pinkerton divested of all mystery, father of the great system that has literally drawn a net around the world into which all fugitive wrongdoers must eventually fall. Under the guise of Major Allen, chief of the Secret Service in the Civil War, he was passing through the camp at Antietam one September day in 1862. He was riding his favorite horse and carelessly smoking a cigar when one of Mr. Brady's men called to him to halt a moment while he took this picture.

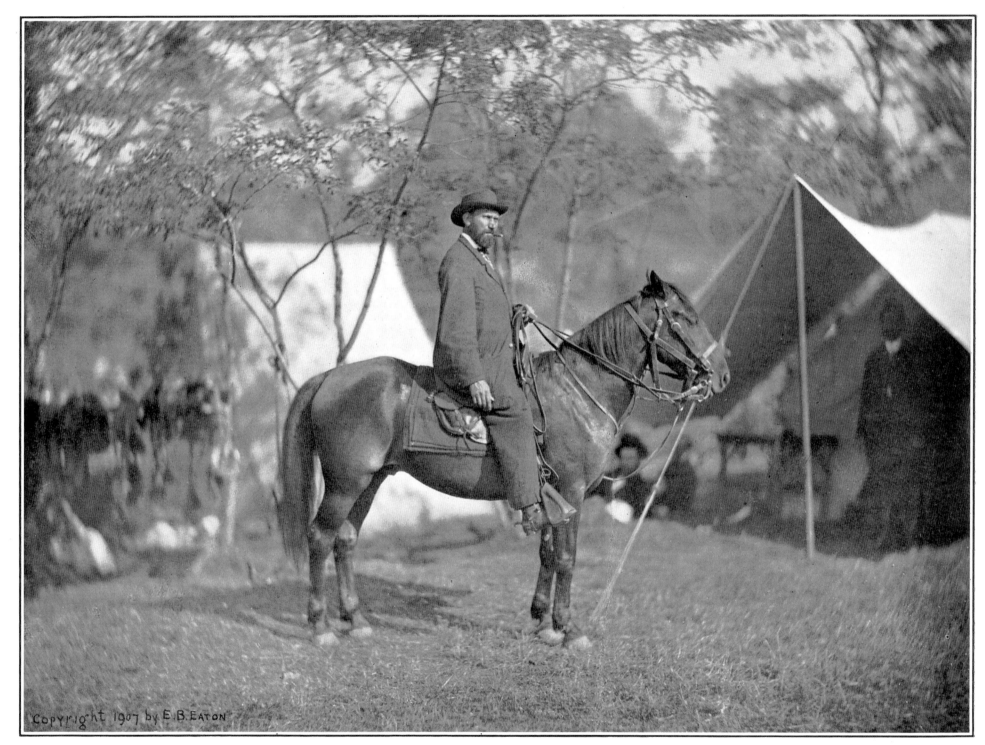

BRADY said he always made two exposures of the same scene, sometimes with a shift of the camera which gave a slight change in the same general view. He related several interesting incidents of his early experiences in photography in America. It is generally conceded that Mr. Brady should be recognized as one of the great figures of the epoch in which he worked.

It is here my duty to record an unfortunate incident that is not unusual in the annals of art and literature. Brady's life, which seems to have been burdened with more ill luck than the ordinary lot of man, found little relief in its venerable years. Misfortune followed him to the very threshold of his last hour. He died about eight years ago in New York, with a few staunch friends, but without money, and without public recognition for his services to mankind. Since Brady's death some of those who knew and esteemed him have been interested in making a last endeavor to bring his work before the world. Mr. Taylor has worked unceasingly to accomplish this result. The late Daniel S. Lamont, Secretary of War in President Cleveland's Cabinet, was much interested. Brigadier-General A. W. Greeley, in supervisory charge of the Government collection, said: "This collection cost the United States originally the sum of $27,840, and it is a matter of general regret that these invaluable reproductions of scenes and faces connected with the late civil conflict should remain inaccessible to the general public. The features of most of the permanent actors connected with the War for the Union have been preserved in these negatives, where also are portrayed certain physical aspects of the War that

are of interest and of historic value . . . graphic representations of the greatest of American, if not of all, wars."

The Government, however, has stated positively that their negatives must not be exploited for commercial purposes. They are the historic treasures of the whole people and the Government has justly refused to establish a dangerous system of "special privilege" by granting

SECRET SERVICE GUIDE DIRECTING BRADY TO SCENE OF ACTION—Pointing toward the edge of the woods where General Reynolds was killed at Gettysburg in July, 1863—Brady carried his cameras onto this field

permission for publication to individuals. As the property of the people the Government negatives are held in sacred trust.

Mr. Edward B. Eaton, the first president of the Connecticut Magazine, one of the leading historical publications in this country, became interested in the historical significance of the Brady collection and conferred with the War Department at Washington about the Brady negatives. He found that the only possible way to bring the scenes before the public was through the private collection which not only includes practically all of the six thousand Government negatives but is supplemented by a thousand negatives not in the Government collection.

Mr. Johann Olsen of Hartford, who was one of the first operators of the old wet-plate process used by Brady, personally examined many of the negatives in storage in Washington and stated that some action should be taken immediately. He says: "Many of the negatives are undergoing chemical action which will soon destroy them. Others are in a remarkable state of preservation. I have found among them some of the finest specimens of photography that this country has ever seen. The modern development of the art is placed at a disadvantage when compared with some of these wonderful negatives. I do not believe that General Garfield overestimated their value when he said they were worth $150,000. I do not believe that their value to American History can be estimated in dollars. I was personally acquainted with one of Brady's men at the time these pictures were taken and I know something of the tremendous difficulties in securing them." A few months ago Mr. Eaton secured a clear title to the seven thousand Brady negatives owned by Mr. Taylor with a full understanding that he would immediately place the scenes before the public. The delicate glass plates were fully protected and removed from Washington to Hartford, where they are today in storage in a fire-proof vault.

THIS is conceded to be the most characteristic photograph of Lincoln ever taken. It shows him on the battle-field, towering head and shoulders above his army officers. It is said that Lincoln once sent for this photograph and after looking at it for several minutes he remarked that it was the best fulllength picture that the camera had ever "perpetrated." The original negative is in a good state of preservation. The greater significance of this picture, however, is the incident which it perpetuates. There had been unfortunate differences between the government and the Army of the Potomac. The future of the Union cause looked dark. A critical state of the disorder had been reached; collapse seemed imminent. On the first day of October, in 1862, President Lincoln went to the headquarters of the Army of the Potomac and traversed the scenes of action, walking over the battle-fields of South Mountain, Crampton's Gap, and Antietam with General McClellan. As Lincoln was bidding good-bye to McClellan and a group of officers at Antietam on October 4, 1862, this photograph was taken. Two days later Lincoln ordered McClellan to cross the Potomac and give battle to the enemy. Misunderstandings followed, and on the fifth of November, President Lincoln, with his own hand, wrote the historic order that deposed the beloved commander of the Potomac, and started controversies which are still renewed and vigorously argued by army officers and historians. It is one of the sad incidents of the passing of a hero, who had endeared himself to his men as have few generals in the annals of war.

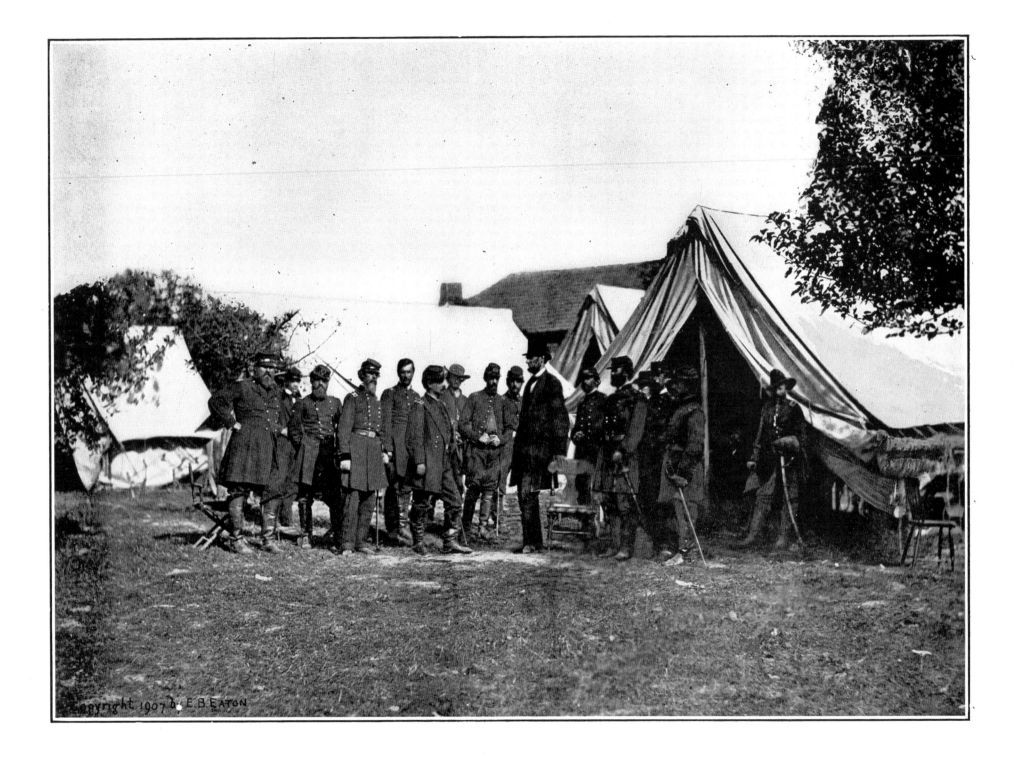

MODERN photographers have experienced some difficulty in securing proofs from the collodion negatives, due both to the years that the negatives have been neglected and their inexperience with the peculiar wet-plate process. Mr. Olsen is still working over them and has succeeded in stopping the chemical action that threatened to destroy many of them. Six thousand of the negatives are pronounced to be in as good condition today as on the day they were taken, nearly a half-century ago. Accompanying the collection is found an occasional negative that seems to have been made by Alexander Gardner or Samuel Cooley. Gardner was one of the photographers employed by Brady, but he later left him and entered into competition. Cooley was an early photographer who conceived a plan similar to Brady's, but operated on a very limited scale. Most of his negatives were taken in South Carolina.

From this remarkable collection, witnessing the darkest days on the American continent and the first days of modern American photography, the prints are selected for these pages and are here dedicated to the American People. Until recent years there has been no mechanical process by which these negatives could be reproduced for general observation. The negatives are here accurately presented from the originals, by the modern half-tone process with only the slightest retouching where chemical action has made it absolutely necessary.

In selecting these prints it has been the desire of the editor to present, as nearly as possible, a chronological pictorial record of the Civil War in the United States. At strategic points where the large cameras could not be drawn into the conflict, Brady used a smaller and lighter camera that allowed him to get very close to the field of action. Many of the most critical moments in the long

siege are embodied in these small negatives. They link the larger pictures into one strong chain of indisputable evidence. It would require forty volumes to present the entire collection. This book can be but a kaleidoscopic vision of the great conflict. Thousands of remarkable scenes must for the present, at least remain unveiled. That the public may know just what these negatives conceal, a partial record has been compiled in the closing pages of this volume.

The drama here revealed by the lens is one of intense

It has been estimated that since the beginning of authentic history war has destroyed fifteen billions of human lives. I have seen the estimate put at twice that number. The estimated loss of life by war in the past century is fourteen millions. Napoleon's campaigns of twenty years cost Europe six millions of lives.

The Crimean War	1854	750,000
The Italian War	1859	63,000
Our Civil War, North and South	(killed and died in other ways)	1,000,000
The Prussian-Austrian War	1866	45,000
The expeditions to Mexico, China, Morocco, etc.		65,000
The Franco-German War	1870	250,000
The Russo-Turkish War	1877	225,000
The Zulu and Afghan Wars	1879	40,000
The Chinese-Japanese War	1894	10,000
The Spanish-American War		5,000
The Philippine War	1899	Americans 5,000 / Filipinos.. 1,000,000
The Boer War	(killed and wounded)	Boers.... 25,000 / British.... 100,000
The Russo-Japanese War		450,500

These are probably all under the actual facts.

BENJAMIN F. TRUEBLOOD,
Secretary American Peace Society.

realism. In it one can almost hear the beat of the drum and the call of the bugle. It throbs with all the passions known to humanity. It brings one face to face with the madness of battle, the thrill of victory, the broken heart of defeat. There is in it the loyalty of comradeship, the tenderness of brotherhood, the pathos of the soldier's last hour; the willingness to sacrifice, the fidelity to principle, the love of country.

Far be it from the power of these old negatives to bring back the memory of forgotten dissensions or long-

gone contentions. Whatever may have been the differences that threw a million of America's strongest manhood into bloody combat, each one offered his life for what he believed to be *the right*. The American People today are more strongly united then ever before—North, South, East and West, all are working for the moral, the intellectual, the industrial and political upbuilding of Our Beloved Land.

The path of Progress has been blazed by fire. Strong men with strong purposes have thrown their lives on the altar of civilization that their children and their children's children might live and work in the light of a new epoch that found its birth in the agonizing throes of human sacrifice. From the beginning of all ages the soldier has been, and always must be, a *mighty man*.

He who will step deliberately into the demon's jaws to defend a principle or to save his country must be among the greatest of men. His is the heroic heart to whom the world must look for the dawn of the Age of Universal Peace. It is his courageous arm that must force the world to halt. The citizenship of the future must be moulded and dominated by the men with the willingness to sacrifice for the sake of Justice and such men are soldiers, whether it be in War or Peace.

There is a longing in the hearts of men, and especially those who have felt the ravages of battle, for the day when there shall be no more War; when Force will be dethroned and Reason will rule triumphant. The Great Washington, who led the conflict for our National Independence, longed for the epoch of Peace. "My first wish," he exclaimed, "is to see this plague to mankind banished from the earth."

The mission of these pages is one of Peace—that all may look upon the horrors of War and pledge their manhood to "Peace on Earth, Good Will toward Men!"

"WAR is hell!" The daring Sherman's familiar truth is here witnessed with all its horrors. War *is hell,* and *this is war!* If it were not for the service that this negative should do for the great cause of the world's Peace, this picture, which has lain in a vault in Washington for an epoch, would never be exposed to public view. Its very gruesomeness is a plea to men to lay down arms. Its ghastliness is an admonition to the coming generations. It is a silent prayer for universal brotherhood. The negative was taken after the third day's battle at Gettysburg. The din of the batteries had died away. The clash of arms had ceased. The tumult of men was hushed. The clouds of smoke had lifted and the morning sun engraved on the glass plate this mute witness of the tragedy that had made history. It was the nation's holiday—the Fourth of July in 1863. The camera was taken into the wheat-field near the extreme left of the Union line. The heroes had been dead about nineteen hours. It will be observed that their bodies are already much bloated by exposure to the sun. These men were killed on July 3, 1863, by one discharge of "canister" from a Confederate cannon which they were attempting to capture. Tin cans were filled with small balls about the size of marbles and when the cannon was fired the force of the discharge burst open the can, and the shower of canister balls swept everything before it. When this photograph was taken a detail had already passed over the field, and gathered the guns and accoutrements of the dead and wounded. Shoes, cartridge belts and canteens have been removed from these dead heroes as it was frequently necessary to appropriate them to relieve the needs of the living soldiers. From diamond at extreme right of picture these men are identified as belonging to the second division of third army corps.

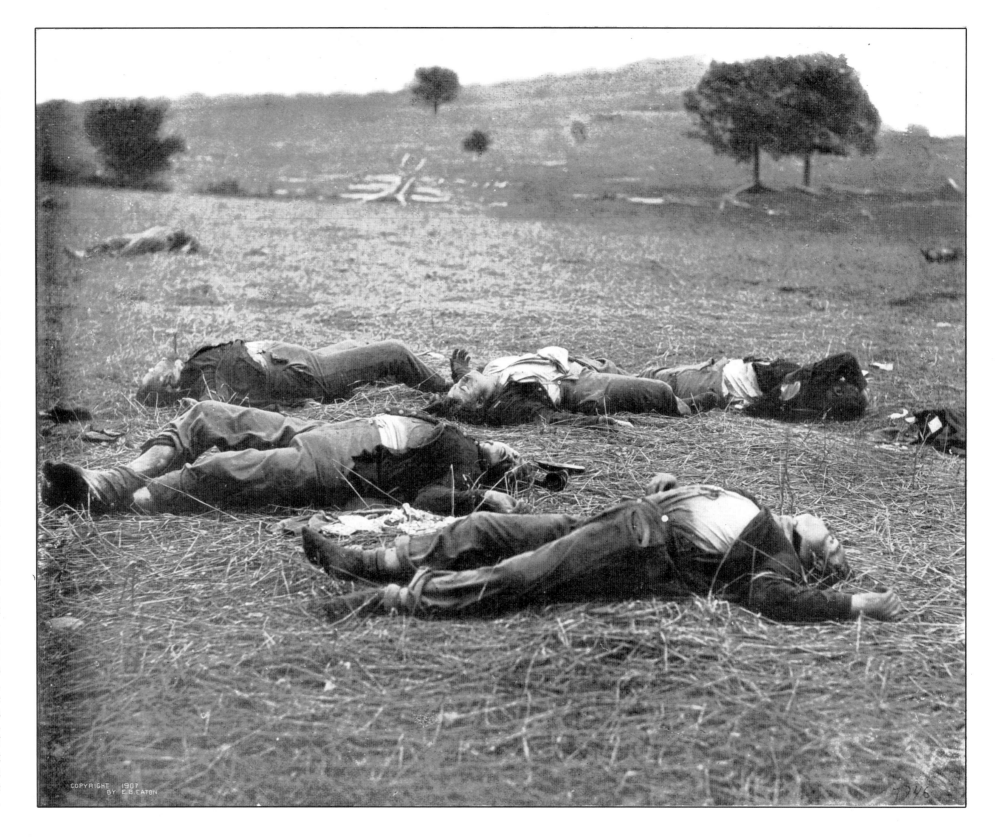

IN the conflicts within the lifetime of men now living, more than three billions of dollars sterling have been thrown into the cannon's mouth, and nearly five millions of human lives have fallen martyrs to the battlefield. In the United States of America, a government founded on the Brotherhood of Man, the greatest expenditure since the beginning of the Republic has been for bloodshed, over six billions for War, nearly two billions for navy, and about three and one-half billions for pensions—more than eleven billions out of a total of something over nineteen billions of dollars. In the last half century the population of the world has doubled; its indebtedness, chiefly for war purposes, has quadrupled. It was but eight billions fifty years ago; it is thirty-two billions today.

America has never been a war-seeking nation. Its one desire has been to "live and let live." When once aroused, however, it is the greatest fighting force on the face of the globe. It is in this peace-loving land that civilization witnessed the most terrible and heart-rending struggle that ever befell men of the same blood. "Men speaking the same language, living for eighty-four years under the same flag, stood as enemies in deadly combat. Brother fighting against brother; father against son; mothers praying for their boys—one in the uniform of blue, and the other wearing the gray; and churches of the same faith appealing to God, each for the other's overthrow."

There were 2,841,906 men and boys sworn into the defence of their country during the Civil War in the United States. The extreme youth of these patriots is one of the most remarkable records in the annals of the world's warfare. The average age of the soldier in the army and navy was about nineteen years. Some of them followed the marching armies on the impulse of the moment; most of them were enlisted with the consent of their parents or guardians. Thousands of them never returned home; thousands more came back to the pur-

suits of Peace and have contributed for nearly a half century to the Good Citizenship of the Republic. To-day they are gray-haired patriarchs. One by one they are stepping from the ranks to answer the call to the Greater Army from which no soldier has ever returned. This record has been compiled for this volume from an authoritative source. The men who re-enlisted are counted twice as there is no practical way to estimate the number of individual persons:

682,117 were over 21 years of age;
1,159,789 were 21 years old and under;
1,151,438 were 18 years old and under;
844,891 were 17 years old and under;
231,051 were 16 years old and under;
104,987 were 15 years old and under;
1,523 were 14 years old and under;
300 were 13 years old and under;
278 were 12 years old and under.

When the Great Struggle began, the United States was the home of less than thirty-two millions of people. Today it has passed eighty millions and the peoples from all the nations of the earth are flooding into our open gates to the extent of more than a million a year. A new community of more than three thousand inhabitants could be founded every day from the men, women and children who disembark from the sea of ships charted to the American shores. There are among us today more than forty-eight millions who have been born here or immigrated into this country since the beginning of the Civil War. These people have no personal knowledge of it and their information is gathered from the narrations of others. These Brady negatives will come as a revelation to them and give a truer understanding of the meaning of it all. The good service they may do for the nation in this one respect cannot be over-estimated.

With thirty-two millions of people aroused by an over-powering impulse that dared them to follow the dictates of conscience by pledging their loyalty to the states

they loved—whether it be under Southern suns or Northern snows—it is almost beyond comprehension that Brady came out of the chaos with even one photographic record. While his extensive operations could not begin until system and organization were accomplished, he did secure many negatives in 1861.

Hardly had the news of the first gun passed around the globe when a half million men were offering their services to their country. Loyal Massachusetts was the first to march her strong and willing sons to the protection of the Government. The shrill notes of the fife sounded throughout the land and battle-scarred old Europe beheld in amazement the marshalling of great armies from a nation of volunteer patriots wholly inexperienced in military discipline—a miracle in the eyes of older civilization that had been drenched in the blood of centuries.

It was the simultaneous uprising of a Great People. The first shot from South Carolina transformed Virginia, the beloved mother of presidents, into a battleground. The streets of Baltimore became a scene of riot. The guns of the navy boomed on the North Carolina coast. The men of the West moved on through Missouri, blazing their way with shot and shell. Through Kentucky and Tennessee the reign of fire swept on until it re-echoed from Florida on the gulf to the wilderness of New Mexico and the borderline of Texas.

The American Republic was in the clutches of terrific conflict and in the first twelve months nearly a million and a quarter of its manhood was fighting for the National Flag. There was no turning from the struggle. It must be waged to its deadliest end. From this moment, for four dreadful years, fighting was taking place somewhere along the line every day and more than seven thousand battles and skirmishes were fought on land and sea.

Nearly three-fourths of the men who stood in the Union ranks in the Civil War were native-born Americans. The others were the best and bravest blood of fellow-nations.

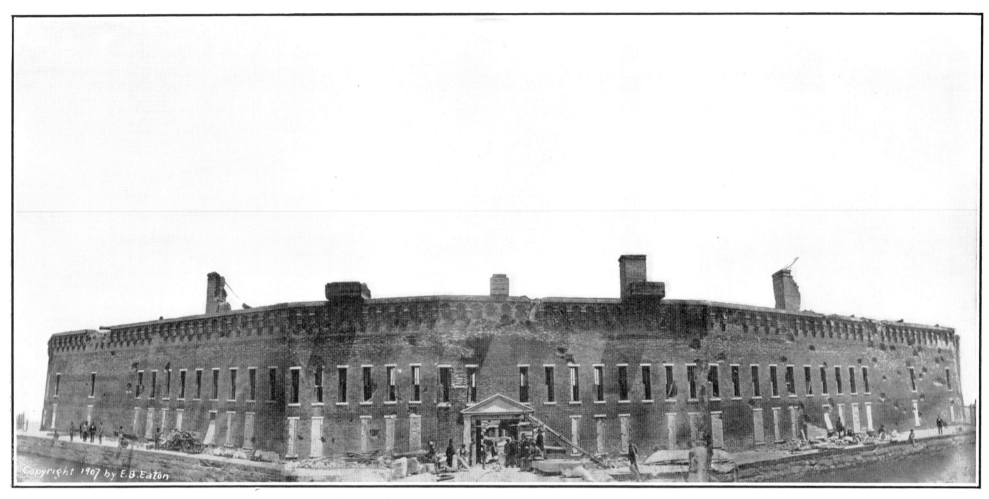

PHOTOGRAPH TAKEN AT FORT SUMTER IN 1861

"THEY have fired on Fort Sumter!" These are the words that rang across the continent on the morning of the twelfth of April, in 1861, and the echo was heard around the world. The shot that began one of the fiercest conflicts that civilization has ever seen was fired just before sunrise at four in the morning. Special editions of newspapers heralded the tidings through the land. Thousands of excited men crowded the streets. Trade was suspended. Night and day the people thronged the thoroughfares, eager to hear the latest word from the scene of action. Friday and Saturday were the most anxious days that the American people have ever experienced. When the news came on Sunday morning that Major Robert Anderson had evacuated the fort with flags flying and drums beating "Yankee Doodle," the North was electrified with patriotism. The stars and stripes were thrown to the breeze from spires of churches, windows of residences, railway stations and public buildings. The fife and drum were heard in the streets. Recruiting offices were opened on public squares. Men left their business and stepped into the ranks. A few days later, when the brave defenders of Fort Sumter reached New York, the air was alive with floating banners. Flowers, fruits and delicacies were showered upon the one hundred and twenty-nine courageous men who had so gallantly withstood the onslaught of six thousand. Crowds seized the heroes and carried them through the streets on their shoulders. The South was mad with victory. It was believed that its independence had been already gained. Several days after the bombardment this picture was secured of the historic fort in South Carolina, about which centered the beginning of a great war. It was taken in four sections and this is a panoramic view of them all. The photograph did not fall into the possession of the Government, but was held for many years by a Confederate naval officer, Daniel Ellis, commander of the twenty-gun ram "Chicora" and at one time in command of Fort Sumter. It is now in possession of James W. Eldridge of Hartford. It corrects the erroneous impression that the fort was demolished in 1861. It stood the bombardment with but slight damage, other than a few holes knocked in the masonry as this picture testifies. In saluting the American flag before the evacuation on April 15, Private Daniel Hough was killed and three men wounded by the premature explosion of one of their own guns.

"JOHN BROWN'S body lies a-mouldering in the grave; his soul is marching on!"

In every public meeting, through village and town, along the lines of recruits marching to the front, around the army campfires, this song became the battle-cry. It had been but three years since John Brown, with seventeen whites and five negroes, seized the United States Arsenal at Harper's Ferry, Virginia, and began the freeing of slaves. It required eighteen hours and 1,500 militia and marines to subdue the ardent abolitionist. He took refuge in the armory engine house. The doors were battered down. Eight of the insurgents were killed. Brown, with three whites and a half dozen negroes, was captured and hanged. The Confederates planned its capture, but upon their approach on the eighteenth of April, in 1861, three days after the firing on Fort Sumter, they found only the burning arsenal. They held the coveted position with 6,500 men, but fearing the attack of 20,000 Unionists, deserted it. It was held by the Union troops until 1862, when, on the fifteenth of September, Stonewall Jackson bombarded the town and forced its surrender. The Union loss was 80 killed, 120 wounded, 11,583 captured. The Confederate loss was 500. In this engagement were the brave boys of the 12th New York State Militia; 39th, 111th, 115th, 125th and 126th New York; 32nd, 60th and 87th Ohio; 9th Vermont; 65th Illinois; 1st and 3rd Maryland "Home Brigade;" 15th Indiana Volunteers; Phillips' Battery; 5th New York; Graham's, Pott's and Rigby's Batteries; 8th New York; 12th Illinois, and 1st Maryland Cavalry. It was during these days that the Army of the Potomac engaged the Confederate forces in bloody conflict at Turner's and Crampton's Gap, South Mountain, Maryland, leaving Harper's Ferry again in the hands of the Union.

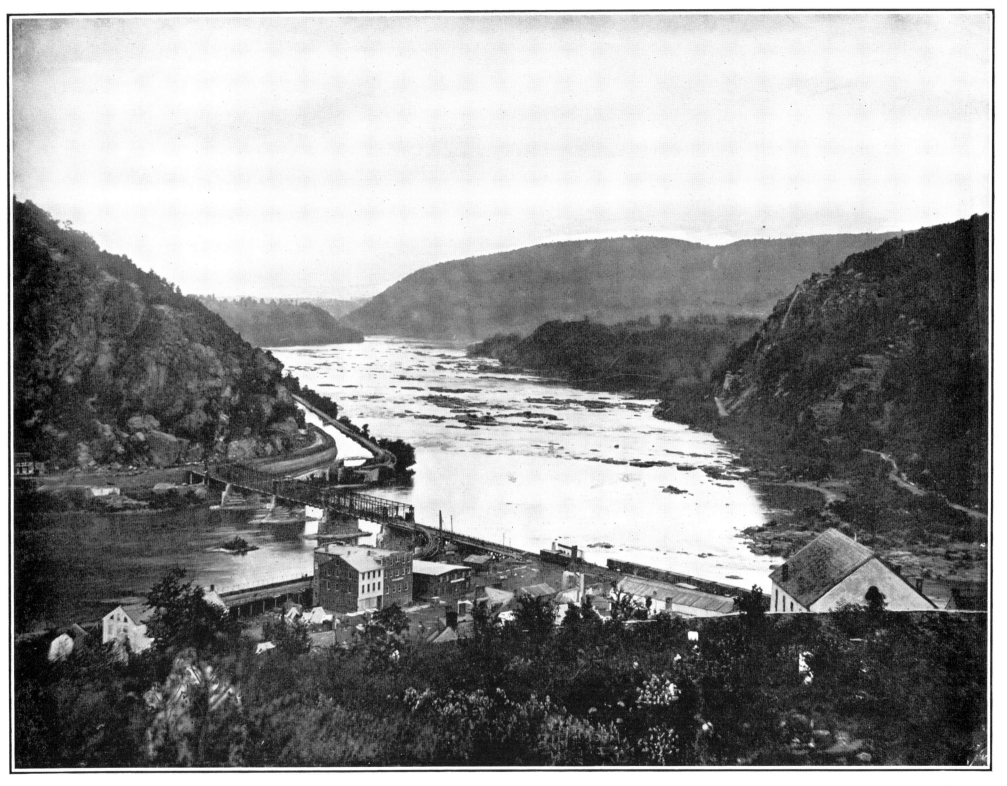

PHOTOGRAPH TAKEN AT HARPER'S FERRY

THERE is not a fleet on the seas that can withstand a modern battery if kept under fire by proper obstructions. Modern sea-coast artillery can destroy a vessel at a single shot. The watchdog that guarded the waterway to the National Capital in the Civil War was Fortress Monroe. The old stone fort, partially protected by masses of earth that sheltered it from the view and fire of the assailant, challenged the ugliest iron-clads to pass through Hampton Roads. Fortress Monroe early became the base of operations and under its protection volunteer regiments were mobilized. When the 2nd New York Volunteers reached the fort, about six weeks after the firing on Fort Sumter, the 4th Massachusetts Volunteers had come to the assistance of the regular garrison of four companies of artillery on duty day and night over their guns. Something of the conditions may be understood by the statement of an officer who says that his men had to appear on parade with blankets wrapped about them to conceal a lack of proper garments, and sometimes stood sentinel with naked feet and almost naked bodies. The volunteers arrived faster than provisions could be furnished and there was a scarcity of food. So great was the difficulty in procuring small arms that some of the soldiers were not really fitted for war during the year of 1861. The Government operations were centered around Fortress Monroe and President Lincoln personally visited the headquarters to ascertain the actual conditions. Brady was admitted behind the parapets with his camera and secured this photograph of one of the heaviest guns in the great fortification.

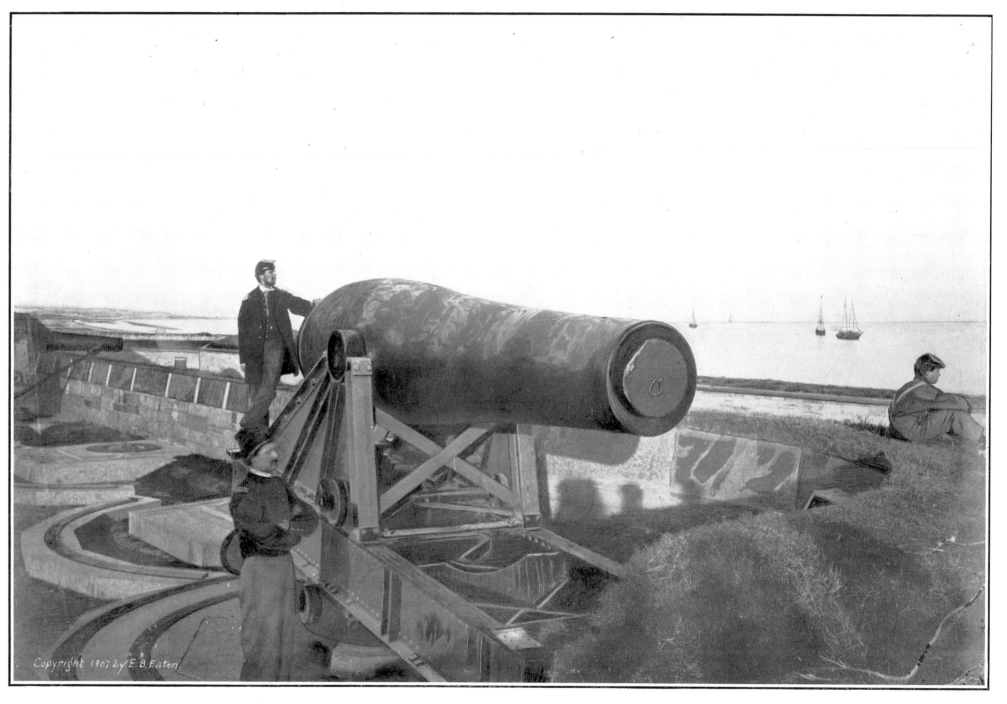

Copyright 1907 by E. B. Eaton.

PHOTOGRAPH TAKEN AT FORTRESS MONROE

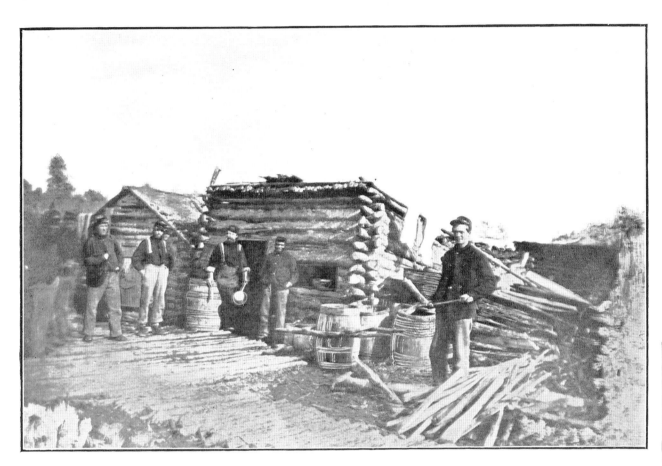

THE charge of the cavalry is an intense moment on the battlefield. At the time of the Civil War nothing was known of the snap-shot process in photography and Brady tried frequently throughout the four years to secure negatives of the cavalry. It seems to have been an impossibility under the long "time exposure process." He did, however, succeed in securing negatives of horses. Frequent opportunity to try to secure a photograph of the cavalry, is proven by the fact that there were 3,266 troops, or more than 272 regiments, in defense of the Government. This picture is found in Brady's collection and shows the cavalry depot at Giesboro Point, Maryland, just outside of Washington. At the beginning of the war the mounted men were used as scouts, orderlies, and in outpost duty. General "Joe" Hooker finally turned a multitude of detachments into a compact army corps of 12,000 horsemen. The gallant horseman, "Phil" Sheridan, under instructions from General Grant, organized three divisions of 5,000 mounted men, each armed with repeating carbines and sabers. It was with this force that Sheridan met the Confederate cavalry at Yellow Tavern, near Richmond, and demonstrated the importance of mounted troops by great military powers. One of the most magnificent scenes in the war was when 10,000 horsemen moved out on the Telegraph Road leading from Fredericksburg to Richmond, and the column, as it stood in "fours," well closed up, was thirteen miles long and required four hours to pass a given point.

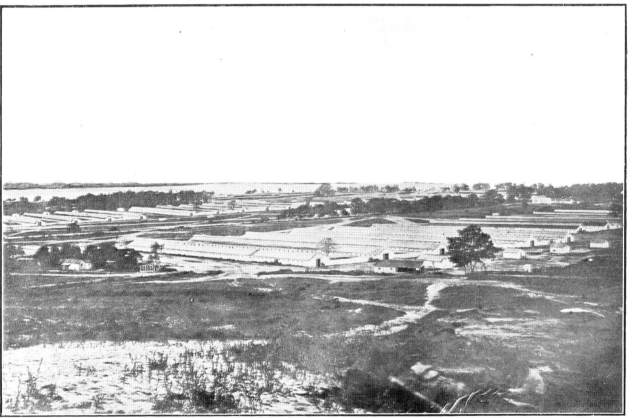

TO feed the millions of fighting men in both armies during the years 1861 to 1865, was an enigma equalled only by the problem of ammunition. After the diets of hardtack on the long marches there is no memory dearer to the heart of the old veteran than a good, old-fashioned "square meal" from the log-cabin kitchen in the camp. This is a typical scene of one of these winter camps. They were substantially built of logs, chinked in with mud and provided on one end with a generous mud chimney and fireplace. The most "palatial" afforded a door and a window. Roaring fires burned on the hearths. With the arrival of the soldiers, knapsacks and traps were unpacked. The canteen was hung on its proper peg. The musket found its place on the wall. The old frying pan and tin cup were hung near the fire. There was to be a real "old home feast." The soldiers crowded around the sutler's tent dickering over canned goods and other luxuries which cost perhaps a half-month's pay. The log settlement was all astir. Smoke issued from the mud chimneys. Crackling fires and savory odors lightened the hearts of the warriors and the community of huts rang with joviality, laughter and song. Stories of the conflict were told as the soldiers revelled over the hot and hearty meal and not until the late hours did the tired comrades wrap themselves in their blankets and fall onto their beds of pine needles or hard board bunks.

"CAPTURE the National Capital, throw the city into confusion and terror by conflagration, seize the President and his Cabinet, and secure control of the Government." This was the first cry of the Confederacy. Thousands of volunteers were moving toward the city in answer to the call for men to save the Nation. Orders were issued to hold back the enemy from crossing the bridges that entered Washington. Two batteries were thrown up at the east end of the Upper, or Chain Bridge, and a heavy two-leaved gate covered with iron plates pierced for musketry, was constructed at the center of the bridge. Blockhouses at Arlington Heights and the battery at Georgetown Heights, guarded the Aqueduct Bridge. The largest approach to Washington was the famous Long Bridge, a mile in length, and connecting the National Capital with Alexandria, Virginia, the gateway to the Confederacy. Three earthen forts commanded its entrance. All soldiers of the Army of the Potomac remember Long Bridge. It was over this structure that a hundred thousand men passed in defense of their country, many of them never to recross it. This was one of the strategic points in the first days of the war and consequently one of the first pictures taken by Brady, with its sentinel on duty and the sergeant of the guard ready to examine the pass. No man ever crossed Long Bridge without this written oath: "It is understood that the within named and subscriber accepts this pass on his word of honor that he is and will be ever loyal to the United States; and if hereafter found in arms against the Union, or in any way aiding her enemies, the penalty will be death."

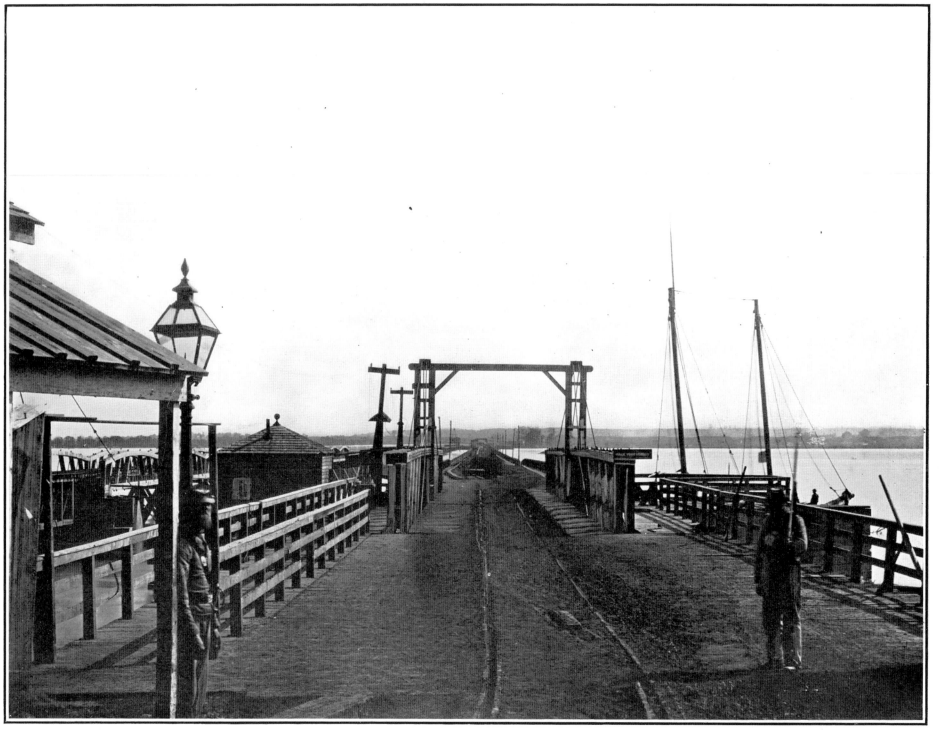

PHOTOGRAPH TAKEN AT LONG BRIDGE ENTRANCE TO WASHINGTON

THERE is nothing impossible to any army in time of war. Bridges are thrown across rivers in a night; roads are constructed as the line advances; telegraph wires are uncoiled in the wake of the moving regiments. To protect from a delay that might mean defeat, the army frequently carried its own "bridges" with it. These army or pontoon bridges consisted of boats over which planks were thrown to span the waterways. This view shows two of the boat's wheels ready for the march. Each pontoon wagon is drawn by six mules. These pontoons were always getting stuck in the mud, and the soldiers, struggling along under their own burdens, were obliged to haul on the drag ropes, and raise the blockade. Probably no soldier will see this picture without being reminded of the time when he helped to pull these pontoons out of the mud, and comforted himself by *shouting at the mules.* A view is also shown of a pontoon bridge across the James River ready for the approach of the army. It was often necessary to establish an immediate telegraph service between different points in the lines. This photograph shows one of the characteristic field telegraph stations. An old piece of canvas stretched over some rails forms the telegrapher's office, and a "hardtack" box is his telegraph table; but from such a rude station messages were often sent which involved the lives of hundreds and thousands of soldiers. The building of corduroy roads to allow ammunition and provision trains to pass on their journeys was of utmost importance. An hour's delay might throw them into the hands of the enemy. Many disasters were averted by the ingenuity of the engineers' corps.

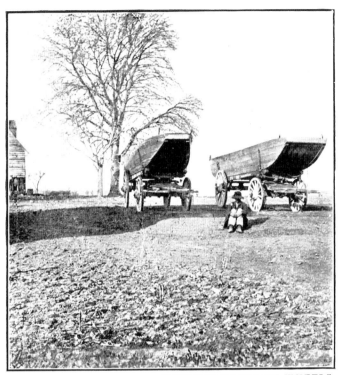

PONTOON BOATS ON WHEELS

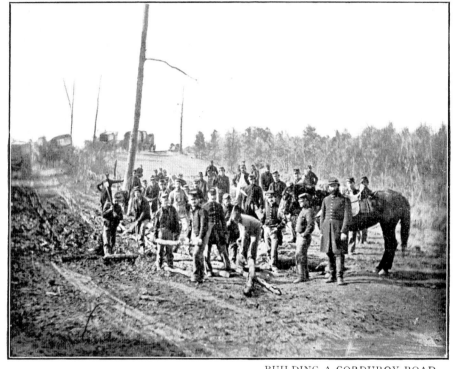

BUILDING A CORDUROY ROAD

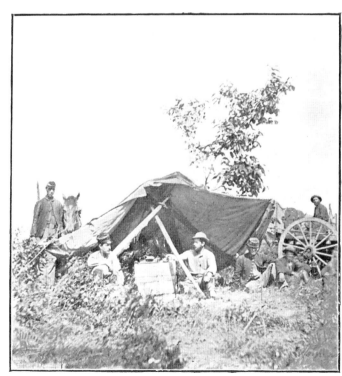

FIELD TELEGRAPH STATION IN OPERATION

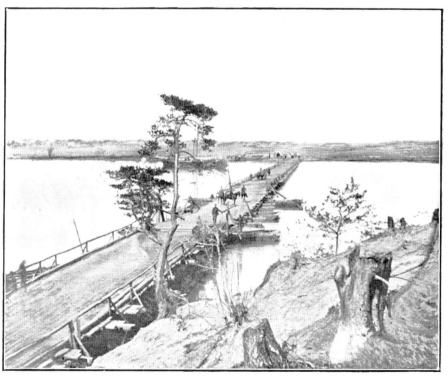

PONTOON BRIDGE ACROSS JAMES RIVER

"IF any one attempts to haul down the American flag, shoot him on the spot!" The order rang from town to town. Old Glory waved in the breeze defiantly. "The flag of the Confederacy will be hoisted over Washington within sixty days," came the retort from the far South. "Only over our dead bodies," replied the men of the North. The National Government discovered that a conspiracy had been in operation to denude its armories and weaken its defenses. Political influences had secretly disarmed the incoming administration, scattering the regular army in helpless and hopeless positions far from the seat of the Government and beyond its call in an emergency. Northern forts had been dismantled and the munitions from Northern arsenals had been dispatched to Southern vantage grounds to be used in case of necessity. The treasury had been depleted and the Government was on the verge of bankruptcy. Eleven of the historic old states of the Union had withdrawn and formed a new republic, the "Confederate States of America." These were the conditions that confronted Lincoln in his first days of the Presidency. Plots were rampant to take his life. His steps were shadowed by Secret Service detectives to safeguard him against assassins, and he was practically held a prisoner in the White House. In further protection the defenses around the city were strengthened. From every hillside grim guns turned their deep mouths into the valleys until a chain of fortifications made the city impregnable. Brady secured permission to take his cameras into these fortifications. This is the best negative which he secured. It is taken behind the breastworks at Fort Lincoln, near Washington.

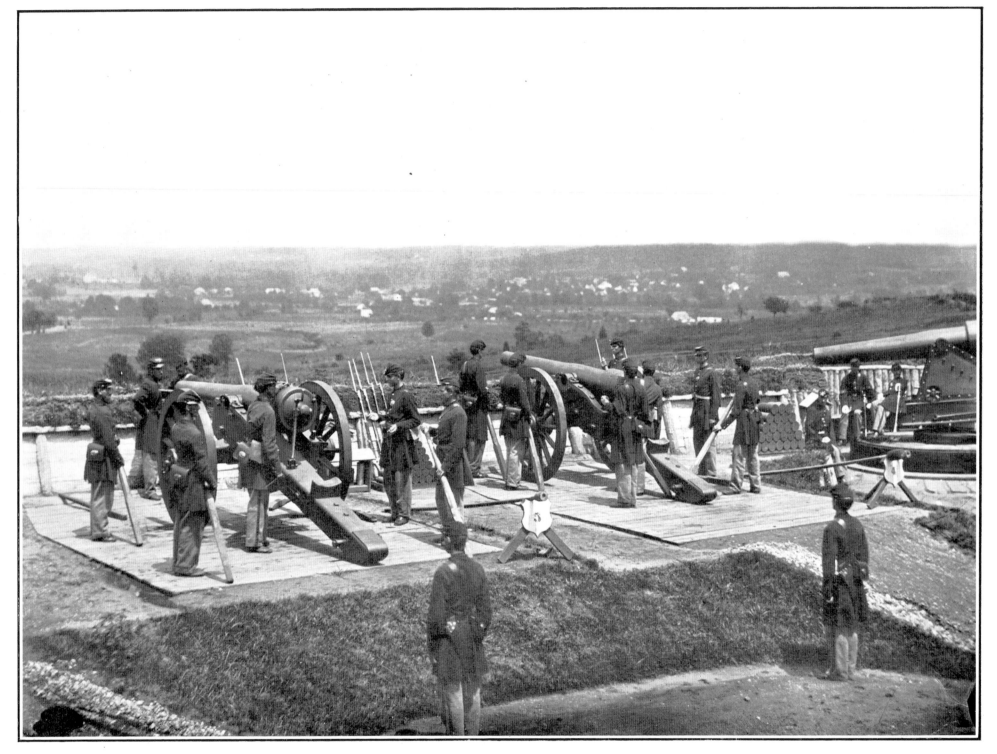

PHOTOGRAPH TAKEN AT FORT LINCOLN

THE first serious collision of the two great armies of divided Americans took place at Bull Run, in Virginia, on the twenty-first of July, in 1861. The Government had confined its operations almost wholly to the protection of Washington, and the public demand for more aggressive action was loud and alarming. The Confederate pickets had become so confident that they advanced within sight of the National Capital. Accusations were strong against the seeming desire of the Government to evade the enemy. Charges of deliberate delay and cowardice came from the North. "On to Richmond," the stronghold of the Confederacy, was the demand. So great became the public clamor that, despite the judgment of military authorities, 29,000 Federals under McDowell advanced against the 32,000 Confederates under Beauregard, driving them back only to be repulsed, after one of the hardest and strangest combats that military history has ever recorded. The Union ranks were so demoralized that they retreated without orders and straggled back to Washington, although a strong stand might have turned the tide of battle. The Union loss was 481 killed; 2,471 wounded and missing, besides 27 cannon and 4,000 muskets. The Confederate loss was 378 killed; 1,489 wounded and missing. Brady's cameras were soon on the field. He did not reach it in time, however, to secure pictures of the fighting armies. One of his negatives shows the historic stream of Bull Run along which the battle occurred. Another negative shows the field over which the hardest fighting took place. A third negative is that of Sudley Church, which was the main hospital after the conflict. It was here that, after a long detour, the Union forces found a vulnerable point and crossed to meet the enemy. Brady also secured a negative of Fairfax Court House, one of the outposts of the Confederacy, in this campaign.

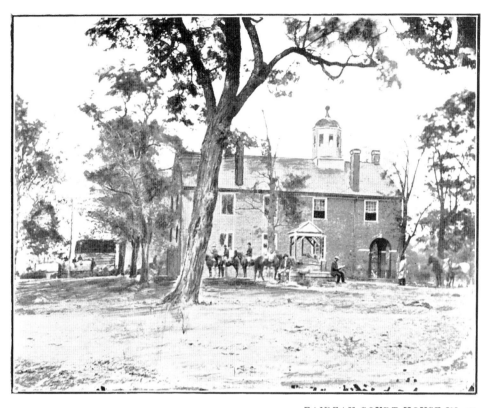

FAIRFAX COURT HOUSE IN 1861

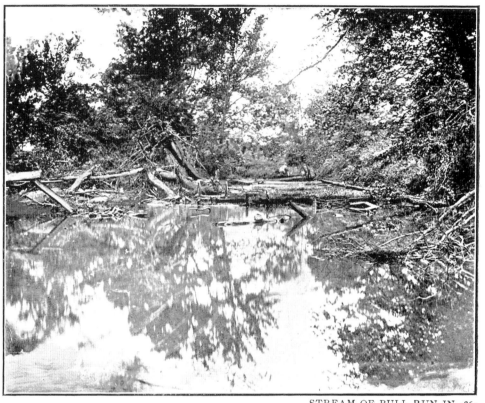

STREAM OF BULL RUN IN 1861

SUDLEY'S CHURCH AND FORD AT BULL RUN

BATTLEFIELD OF BULL RUN IN 1861

THE man behind the gun risks his life on his faith in the ammunition train to keep him supplied with powder and shell. An old warrior estimates that an army of 60,000 men, comprising a fair average of infantry, cavalry, artillery and engineers must be provided with no less than 18,000,000 ball cartridges for small arms, rifles, muskets, carbines and pistols for six months' operation. In the field an infantry soldier usually carries about sixty rounds. The lives of the men depend upon the promptness of the ammunition trains. To supply these 60,000 men requires one thousand ammunition wagons and 3,600 horses. The wagon constructed for this service will carry 20,000 rounds of small-arm munition. The cartridges are packed in boxes and the wagon is generally drawn by four to six horses or mules. Several wagons are organized into an "equipment," moving under the charge of an artillery, and there are several such "equipments" for an army of this magnitude, one for each division of infantry, a small portion for the cavalry, and the rest in reserve. Early in the Civil War a chemist suggested to General McClellan that he could throw shells from a mortar that would discharge streams of fire "most fearfully in all directions." McClellan replied: "Such means of destruction are hardly within the category of civilized warfare. I could not recommend their employment until we have exhausted the ordinary means of warfare." The Government preferred to depend largely upon these silent, ghost-like wagons, with their deadly loads of millions of cartridges, pressing toward the battle lines throughout the conflict. This picture shows an ammunition train of the Third Division Cavalry Corps in motion with the army encamped on the distant hills. It is one of Brady's best negatives.

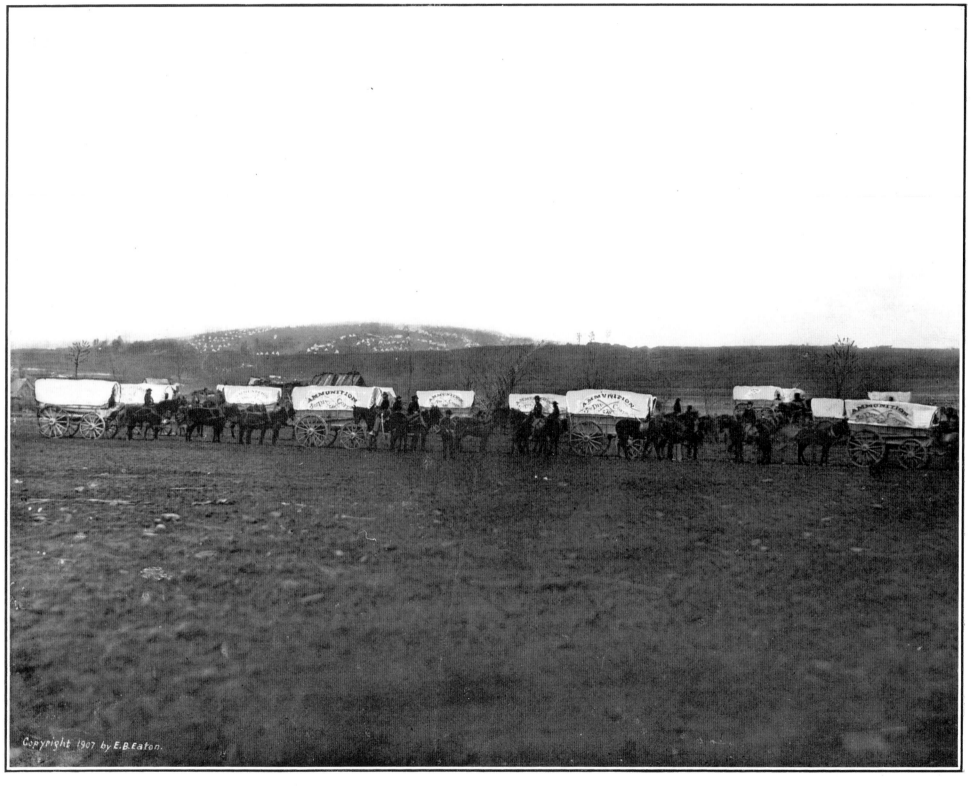

Copyright 1907 by E. B. Eaton.

PHOTOGRAPH TAKEN AS AMMUNITION TRAINS WERE MOVING

SLAVE pens were common institutions in the days of negro bondage in America. The system had developed from the early days of colonization and was for many generations a legitimate occupation throughout the country. So many rumors, false and true, were told of the "pens" that Brady schemed to secure photographs of some of them. Early in 1861 he succeeded in gaining entrance to one of the typical institutions in Alexandria, Virginia. The results are here shown. The cell rooms with their iron-barred doors and small cage windows relate their own story. While they were installed by the larger slave traders they were wholly unknown on most of the old Southern plantations. A picture is also here shown of the exterior of the "slave pen" kept at Alexandria with the inscription over the door, "Price, Birch & Co., Dealers in Slaves." This shows the proportions to which the system had grown in the greatest republic in the world. Enormous fortunes were being accumulated by some dealers who had thrown aside sentiment and humanity and were herding black men for the market. With the outbreak of the war many of the slaves sought the protection of the Union Army, while others, who had kind masters, were willing to remain on the plantations. Mr. Brady secured several photographs of these typical slave groups. The one here shown is a party of "contrabands" that had fled to the Union lines. Another familiar scene in 1861 was the pilgrimage of poor whites to the Union ranks. When the troops passed through many of the mountain villages, these frightened white sympathizers would hastily gather their scanty belongings, pile them onto an old wagon, desert their homes and follow the army, to be passed on from line to line until they reached the North.

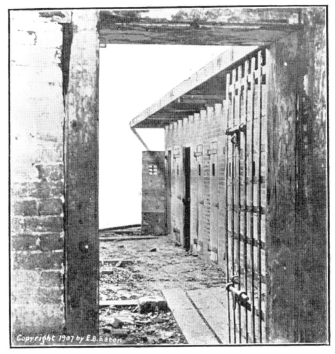
IRON-BARRED CELLS IN AN OLD SLAVE PEN

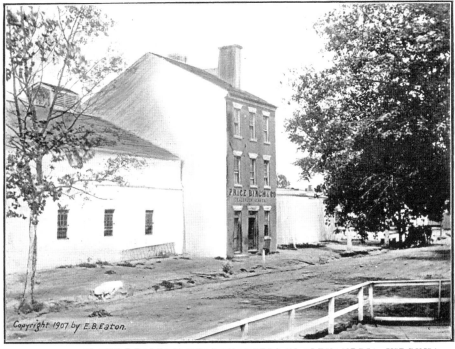
SLAVE DEALERS' HEADQUARTERS IN ALEXANDRIA, VIRGINIA

REFUGEES LEAVING THE OLD HOMESTEAD

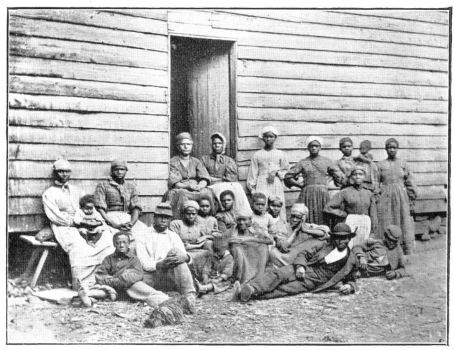
CONTRABANDS IN WAKE OF THE UNION ARMY

ONE of the greatest secret forces in the Civil War was the electric telegraph. Wires were uncoiled as the army moved on its march toward the enemy and over them passed the hurried words that frequently saved hundreds and thousands of lives. While England was the first to experiment with the new science on the battlefield, the war in America demonstrated its permanent importance in the maneuvers of armies. Brady was much interested in the development of telegraphy as a factor in war and never missed any opportunity to take a photograph of the field telegraph corps as they passed him on marches. This picture shows one of the construction corps in operation. The wires were laid as each column advanced, keeping the General in command fully informed of every movement and enabling him to communicate from his headquarters in the rear of the army with his officers in charge of the wings. The military construction corps laid and took up these wires as fast as an infantry regiment marches. An instant's intelligence may cause a charge, a flank or a retreat. By connecting with the semi-permanent lines strung through woods and fields, into which the enemy would have little reason to venture unless aroused by suspicion, the commander on the field is kept informed of the transportation of troops and supplies and the approach of reinforcements. It was also the duty of the military construction corps to seize all wires discovered by them and to utilize them for their own army or tear them down. Constant watch is kept for these secret lines. Great care must also be taken that false messages do not pass over them. Their destruction is generally left to the cavalry. The heavy construction wagons, carrying many miles of telegraph wire in coils, were drawn by four horses.

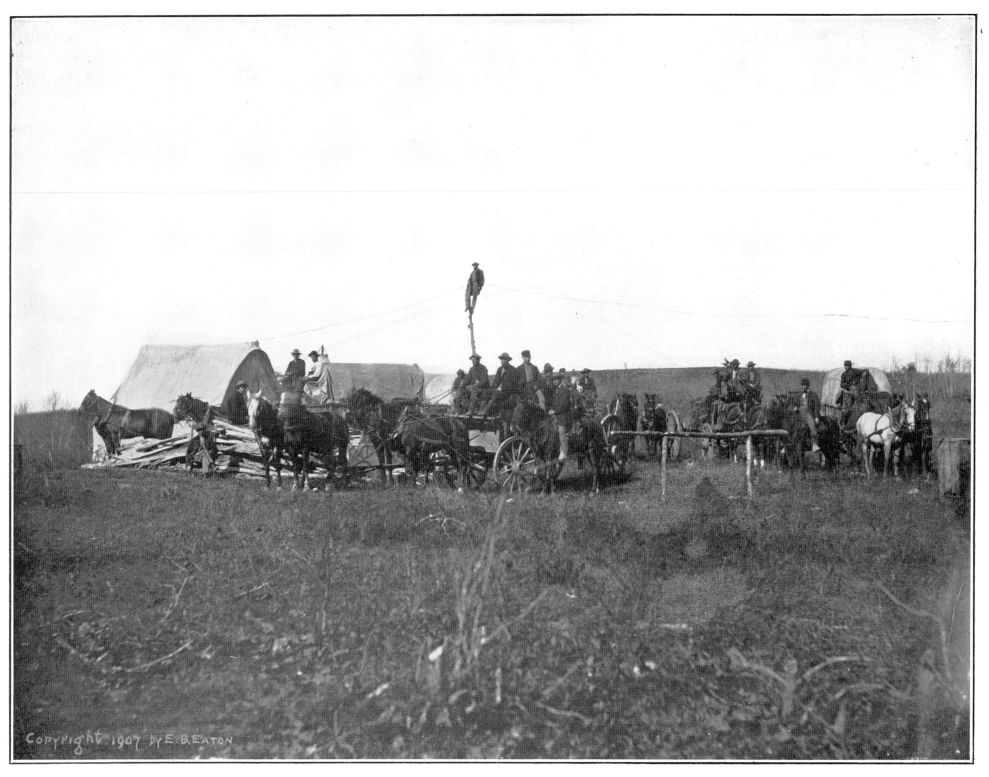

PHOTOGRAPH TAKEN AS MILITARY TELEGRAPH WAS BEING STRUNG

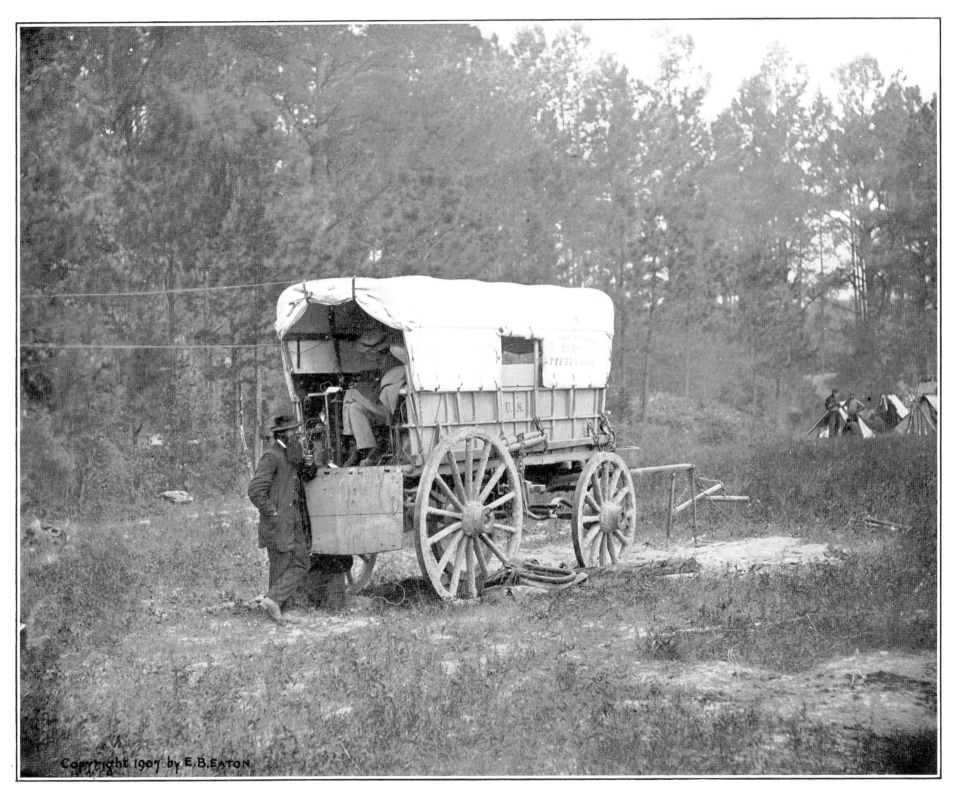

PHOTOGRAPH TAKEN AS FIELD TELEGRAPH WAGON WAS SENDING MESSAGE

TELEGRAPH stations in wagons were not uncommon sights to the soldiers between the years of 1861 to 1865. Great responsibility rested upon the operators who halted alongside the road to send a message back to headquarters that might change the whole course of events and defeat into victory. The operators in the Civil War stood by their posts like sentinels. The confidential communications of commanders and the movements of the morrow were intrusted with them, but not in a single instance is one known to have proven false to that trust. It was part of the duty of the telegraph service to take messages from the scouts sent out to ascertain the resources of the country, the advantages of certain routes, and the general lay of the land. Every click of the instrument transmitted secrets upon which might depend the rise or fall of the nation. These field telegraph wagons, drawn by horses, carried the instruments and batteries which had but recently been invented by an American scientist, and by which an electric spark shot messages through wire in the fraction of a second's time. The War of 1861 proved for all time the advantages of this new science. It left the signal corps to attend to only short-range communications and lightened the duties of mounted orderlies, conveying messages in a flash of electricity that had hitherto taken a day's reckless riding on horseback. While it saved the orderlies from many hazardous journeys there were many more where the telegraph wires did not penetrate and dependence was still placed on the dashing mounted messenger. The chief service of the electric telegraph was to maintain communication between corps and divisions and headquarters. It was also utilized in some of the brilliant strokes of the Secret Service in forestalling deep-laid plots.

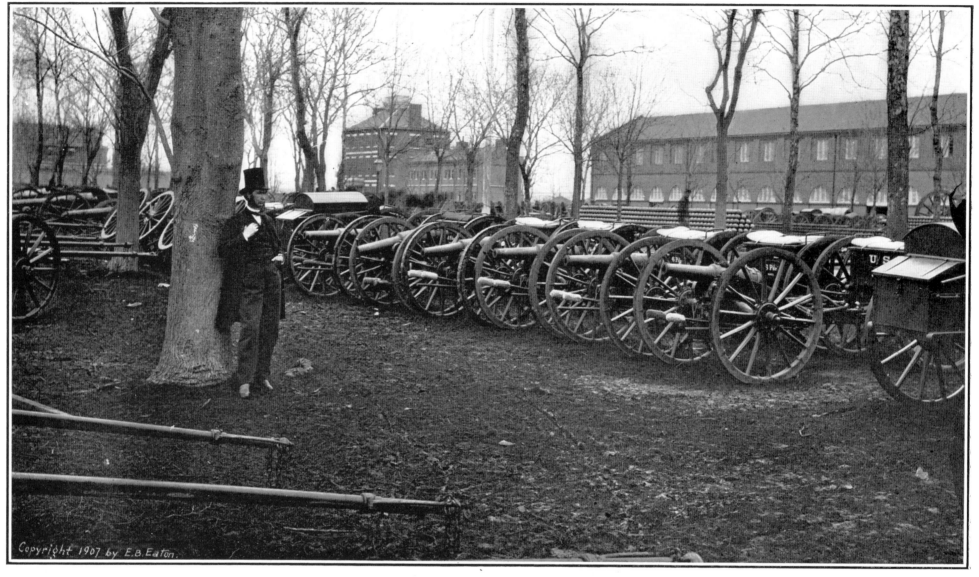

Copyright 1907 by E. B. Eaton.

PHOTOGRAPH TAKEN IN AN ARSENAL AT WASHINGTON

THE downfall of Washington in the first days of the war would have meant the downfall of the Republic. What changes this would have wrought in the history of the Western Continent can never be known. Its probabilities were such that the Treasury Building was guarded by howitzers, the Halls of Congress were occupied by soldiers, the Capitol building became a garrisoned citadel. Lincoln was virtually imprisoned by guards in the White House, and the streets were patrolled by armed men. Troops were quartered in the Patent Building. The basement galleries of the Capitol were converted into store-rooms for barrels of pork, beef and rations for a long siege. The vaults under the broad terrace on the western front were turned into bakeries where sixteen thousand loaves of bread were baked every day. The chimneys of the ovens pierced the terrace and smoke poured out in dense black clouds like a smoldering volcano. Ammunition and artillery were held in readiness to answer a moment's call. So intense was the excitement that one of the generals in command at the Government arsenal exclaimed: "We are now in such a state that a dog-fight might cause the gutters of the Capital to run with blood." There was the clank of cavalry on the pavements, the tramp, tramp of regiments of men whose polished muskets flashed in the sunlight as they moved over Long Bridge. Cavalcades of teams and white-topped army wagons carrying provisions, munitions of war and baggage followed in weird procession. Brady was then in Washington negotiating with the Government and the Secret Service for permission to follow the armies with his cameras. This is one of the pictures that he took at that time, showing the artillery and cannon-balls parked at the National Capital.

NO one, except the men who did it, can ever know the tremendous difficulties overcome in preparing an army for warfare. The transformation of a nation of peaceful home-lovers to a battle-thirsty, fighting populace is almost beyond human understanding. To arm them instantly with the implements of war is a problem hardly conceivable. When the first guns of the Civil War were belching their death-fire, all the man-killing weapons known to civilization were being hurried to the front. There were flint and percussion and long-range muskets and rifles; bayonets and cavalry sabers; field and siege cannon; mortars and sea-coast howitzers; projectiles, shot, shell, grape and canister; powder, balls, strap and buck-shot; minie balls and percussion caps; fuses, wads and grenades; columbiads and navy carronades; lances, pistols and revolvers; heavy ordnance and carriages. Europe was called upon to send its explosives across the sea. Caves were opened for the mining of nitre, lead and sulphur. Factories were run day and night for the manufacture of saltpeter. On land and sea the greatest activity prevailed. This photograph was taken on the twenty-sixth day of August in 1861, when the ammunition schooners, accompanying the fleet from Fortress Monroe on the expedition to Fort Hatteras, N. C., were passing through Hampton Roads. The fleet, sailing under sealed orders, in command of Flag Officer Silas H. Stringham, arrived before sunset. Two days later, in conjunction with the troops of the 9th, 20th, and 99th New York Volunteers, under General Benjamin F. Butler, it forced the surrender of Fort Hatteras without the loss of a man and took seven hundred prisoners. The Confederates lost about fifty killed and wounded.

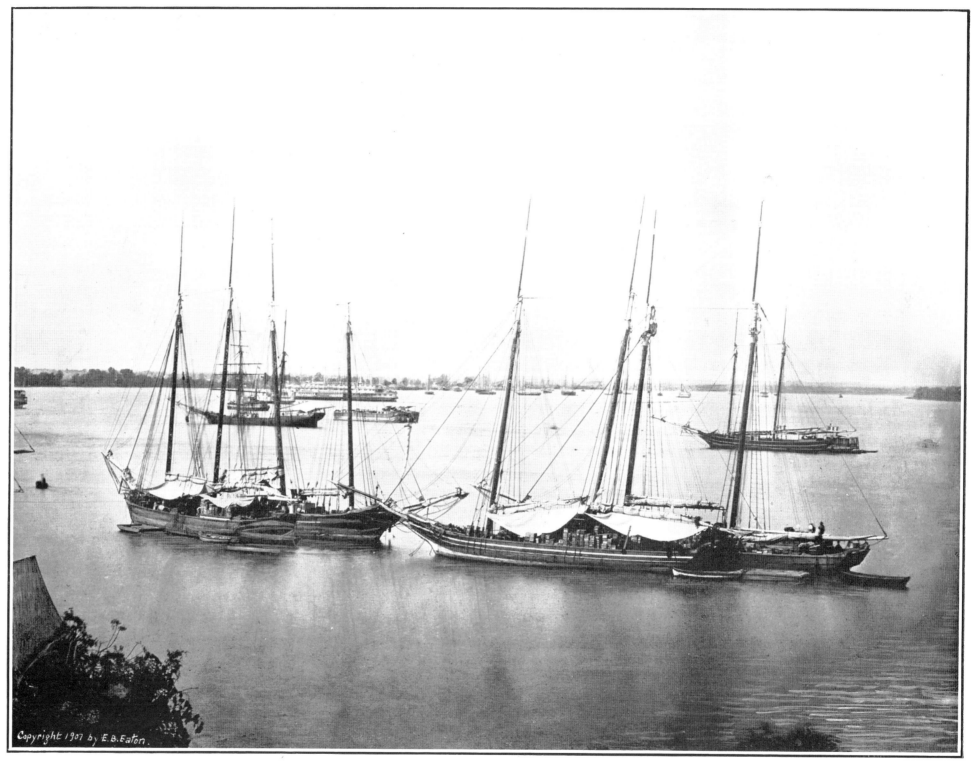

PHOTOGRAPH TAKEN IN HAMPTON ROADS—AMMUNITION SCHOONERS

SPIES lived in the White House according to the rumors in 1861, and every council of the Administration was reported to the enemy. Whether this is true or not has never been verified, but by some mysterious channel the Administration's plans invariably fell into the hands of the Confederates. One of the first instances of this is the expedition to Port Royal on the South Carolina coast. This was one of the finest harbors along the South Atlantic and it was planned to take it from the Confederates and use it as a base for future Union operations. The most careful preparations were laid for two months. On the twenty-ninth of October, in 1861, fifty vessels under sealed orders with secret destination sailed from Hampton Roads. The fleet had hardly left the range of Fortress Monroe when the full details of its sealed orders reached the Confederates at Port Royal. Off Cape Hatteras it ran into a severe gale; one transport was completely wrecked, with a loss of seven lives; another transport threw over her cargo; a storeship went down in the storm, and a gunboat was saved only by throwing her broadside battery into the sea. The fleet was so scattered that when the storm cleared there was only a single gunboat in sight of the flagship. Undismayed by the misfortune, within a few hours the vessels that had withstood the tremendous gale were moving on to Port Royal. Several frigates that had been blockading Charleston Harbor joined them and on the morning of the seventh of November the attack was made on Fort Walker at Hilton Head and Fort Beauregard on St. Helena Island. The guns of the fleet wrought dreadful havoc. The stream of fire was more than the entrenched men had expected or could endure. The troops fled across Hilton Head in panic from Fort Walker. When the commander at Fort Beauregard looked upon the fleeing soldiers he abandoned his position and joined the retreat. A flag of truce was sent ashore but there was no one to receive it, and soon after two o'clock the National colors were floating over the first permanent foothold of the Government in South Carolina, a Confederate stronghold.

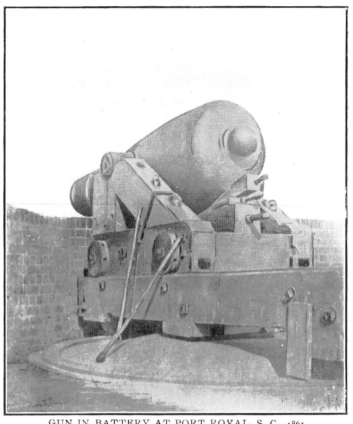

GUN IN BATTERY AT PORT ROYAL, S. C., 1861

COOSAW FERRY, PORT ROYAL ISLAND, S. C.

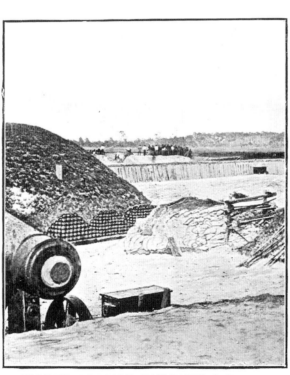

FORT BEAUREGARD, BAY POINT, S. C., 1861

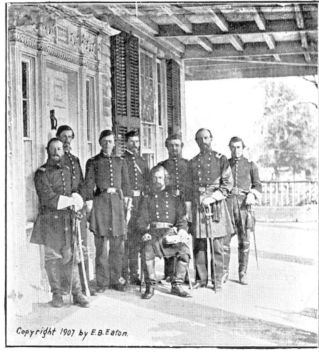

GENERAL ISAAC I. STEVENS' STAFF, BEAUFORT, S. C.

THE AMERICAN PEOPLE, in their one hundred and twenty years of "Life, Liberty and the Pursuit of Happiness," have had but three wars with the outside world. They have enjoyed a greater immunity from armed encounter than any of their neighbors. Other than the grievous struggle which we have had with our own people, it may be fairly said that we have been blessed by Peace.

As if by magic the hundreds of thousands of volunteers were armed with the munitions of War and marched to the battle-front. The great Lincoln, under the constitutional provisions, was commander-in-chief of the citizen armies, and worked in conjunction with his War Department at Washington. The military genius of a trained fighter was needed and from the outbreak of the War until November 6, 1861, Brevet-Lieutenant Winfield Scott was in command; then came Major-General George B. McClellan, a man of great caution, until March 11, 1862. From that time until July 12, 1862, the Government was without a general commander until Major-General Henry W. Halleck took control and continued till March 12, 1864. It was then that Lieutenant-General Ulysses S. Grant was called upon to end the struggle. Under these military leaders the great fighting force of volunteers was organized into armies. The first of these patriot legions was the Army of the Potomac.

Army of the Potomac was called into existence in July, 1861, and was organized by Major-General George B. McClellan, its first commander; November 5, 1862, Major-General A. E. Burnside took command of it; January 25, 1863, Major-General Joe Hooker was placed in command, and June 27, 1863, Major-General George G. Meade succeeded him.

Army of Virginia was organized August 12, 1862. The forces under Major-Generals Fremont, Banks, and McDowell, including the troops then under Brigadier-General Sturgis at Washington, were consolidated under the command of Major-General John Pope; and in the first part of September, 1862, the troops forming this army were transferred to other organizations, and the army as such discontinued.

Army of the Ohio became a power, November 9, 1861. General Don Carlos Buell assumed command of the Department of the Ohio. The troops serving in this department were organized by him as the Army of the Ohio, General Buell remaining in command until October 30, 1862. when he was succeeded by General W. S. Rosecranz. This Army of the Ohio became, at the same time, the Army of the Cumberland. A new Department of the Ohio having been created, Major-General H. G. Wright was assigned to the command thereof; he was succeeded by Major-General Burnside, who was relieved by Major-General J. G. Foster of the command of the Department and Army. Major-General J. M. Schofield took command January 28, 1864, and January 17, 1865, the Department was merged into the Department of the Cumberland.

Army of the Cumberland developed from the Army of the Ohio, commanded by General Don Carlos Buell, October 24, 1862, and was placed under the command of Major-General W. S. Rosecranz; it was also organized at the same time as the Fourteenth Corps. In January, 1863, it was divided into three corps, the Fourteenth, Twentieth and Twenty-first; in September, 1863, the Twentieth and Twenty-first Corps were consolidated into the Fourth Corps. October, 1863, General George H. Thomas took command of the army, and the Eleventh and Twelfth Corps were added to it. In January, 1864, the Eleventh and Twelfth Corps were consolidated and known as the Twentieth Corps.

Army of the Tennessee was originally the Army of the District of Western Tennessee, fighting as such at Shiloh, Tennessee. It became the Army of the Tennessee upon the concentration of troops at Pittsburg Landing, under General Halleck; and when the Department of the Tennessee was formed, October 16, 1862, the troops serving therein were placed under the command of Major-General U. S. Grant. October 24, 1862, the troops in this Department were organized as the Thirteenth Corps; December 18, 1862, they were divided into the Thirteenth, Fifteenth, Sixteenth and Seventeenth Corps. October 27, 1863, Major-General William T. Sherman was appointed to the command of this army; March 12, 1864, Major-General J. B. McPherson succeeded him; July 30. 1864, McPherson having been killed, Major-General O. O. Howard was placed in command, and May 19, 1865, Major-General John A. Logan succeeded him.

Army of the Mississippi began operations on the Mississippi River in Spring, 1862; before Corinth, Mississippi, in May, 1862; Iuka and Corinth, Mississippi, in September and October, 1862.

Army of the Gulf operated at Siege of Port Hudson, Louisiana, May, June, and July, 1863.

Army of the James consisted of the Tenth and Eighteenth Corps and Cavalry, Major-General Butler commanding and operating in conjunction with Army of the Potomac.

Army of West Virginia was active at Cloyd's Mountain, May 9 and 10, 1864.

Army of the Middle Military Division operated at Opepuan and Cedar Creek, September and October, 1864.

During the year 1862, Brady's men followed these legions. Both armies were maneuvering to strike a decisive blow at the National Capital of either foe—one aiming at Washington and the other at Richmond. The scenes enacted in these campaigns are remarkable in military strategy, and Brady's men succeeded in perpetuating nearly every important event.

Cameras were also hurried to the far South and West where great leaders with great soldiers were doing great things. Several of these cameras arrived in time to bear witness to the bravery of the men of the Mississippi, who were waging battle along the greatest waterway in North America—the stronghold of the Confederacy and the control of the inland commerce of the Continent.

THE first naval conflicts of the Civil War took place early in 1862. On the ninth of March, the revolving turret iron-clad "Monitor" met the enormous Confederate ram, "Merrimac," in Hampton Roads. Both powerful vessels forced the attack and stood under the fiercest bombardment only to again invite assault. After four hours of the nerviest fighting that the seas had ever known, the adversaries withdrew, undefeated, to repair their respective damages. Brady secured several photographs of these vessels immediately after the engagement. One of them on this page shows part of the deck and turret of the "Monitor;" near the port-hole can be seen the dents made by the heavy steel-pointed shot from the guns of the "Merrimac." While the news of this conflict was amazing even old Europe, naval operations along the American coast were creating consternation. On the first anniversary of the Fall of Fort Sumter the National navy, in an attempt to sweep the Confederates from the Atlantic coast, bombarded Fort Pulaski in Georgia. All day long the bombardment was terrific and firing did not cease until nightfall, when five of the guns of the fortress were silent. All night long four of Gillmore's guns fired at intervals of fifteen or twenty minutes and at daybreak the onslaught became furious. At two in the afternoon a white flag appeared from its walls. The spoils of victory were the fort, forty-seven heavy guns, a large supply of fixed ammunition, forty thousand pounds of gun powder, a large quantity of commissary stores; three hundred prisoners and the port of Savannah was sealed against blockade runners—all this with the loss of but one killed on each side. Brady seems to have had unusual foresight. He was nearly always in the right place at the right time and these negatives picture the ruins of Fort Pulaski.

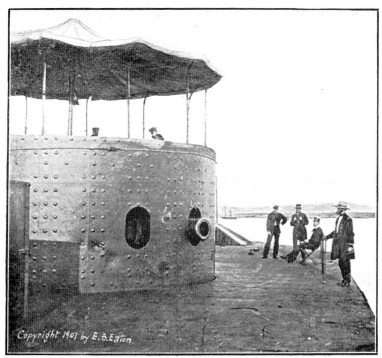

ORIGINAL "MONITOR" AFTER HER FIGHT WITH THE "MERRIMAC"

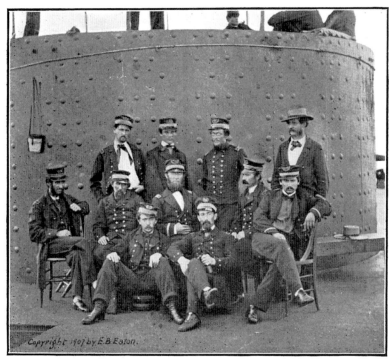

OFFICERS ON BOARD "MONITOR," JULY 9, 1862, AT HAMPTON ROADS

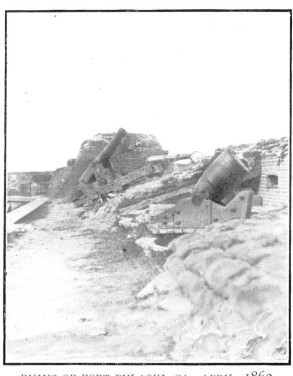

RUINS OF FORT PULASKI, GA., APRIL, 1862

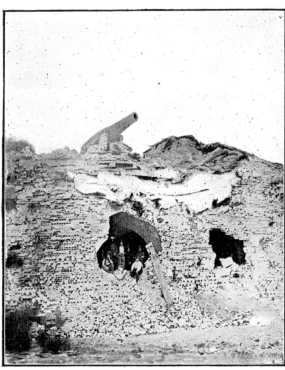

THE BREACHFORT AT PULASKI AFTER BATTLE

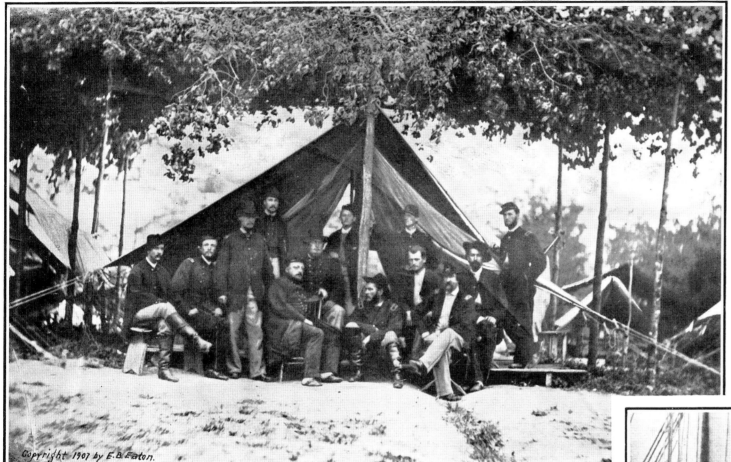

WITH flags flying and bands playing "The Star Spangled Banner," the troops from the transports, which brought fifteen thousand men under command of General Benjamin F. Butler, marched into New Orleans on the first day of May in 1862. Crowds of men and women surged the sidewalks cursing the Yankees and hurrahing for Beauregard, Bull Run and Shiloh. When Butler established military government over New Orleans the city had a population of about 140,000. About 13,000 of these were slaves. Nearly 30,000 of the best citizenship were fighting in the Confederate ranks. The city was on the verge of starvation. More than a third of the population had no money and no means of earning it. Prices rose enormously. Butler contributed a thousand dollars of his own money to relieve the suffering. Supplies were hurried from all sources and sold under Butler's orders at cost to those who had funds. The price of flour fell from sixty to twenty-four dollars a barrel. Butler proved to be a great organizer. The people were set to work cleaning and improving their city. His administration was always humane. The execution of a gambler who tore down the American Flag from the mint, and the condemning of a gang of thugs was his only show of the iron hand. This photograph shows Major-General Butler, with his staff, as he appeared in his fighting days. When leaving Lincoln and his cabinet to start on his expedition, Butler exclaimed: "Good-bye, Mr. President; we shall take New Orleans or you will never see me again!" With Farragut he kept his promise.

THE most powerful fleet that had ever sailed under the American Flag entered the deltas of the Mississippi River on the eighteenth day of April, in 1862, to force the surrender of the largest and richest city of the Confederacy. The strategic value of New Orleans was greater than that of any other point in the Southern States. Its export trade in cotton and sugar was larger than any city in the world. The great fleet had sailed from Hampton Roads on the second of February under the command of a man sixty years old, who was born in Tennessee, but offered himself to the Union cause—David G. Farragut. This photograph was taken as he stood on the deck of his flagship "Hartford." From the firing of the first gun on New Orleans a rain of iron fell upon the forts. During the first twenty-four hours Captain David Porter's gunners dropped fifteen hundred bombs in and around the forts. The night was hideous with fiery meteors and the day dense with smoke and flame. The roar of the artillery was deafening and shattered the windows in the houses for many miles. For six days and nights the terrific bombardment raged. When Farragut attempted to run the gauntlet to the metropolis of the gulf he swept the shores with a continuous fire of twenty-six thousand shells—a million and a half pounds of metal. The Confederates pushed a fire raft down the river to the daring admiral's flagship and the "Hartford" burst into flame. While one part of the crew fought the fire, the others poured metal from her guns onto the enemy. On the twenty-sixth day of April, Farragut entered the harbor to New Orleans and on the twenty-ninth unfurled the Stars and Stripes in the city.

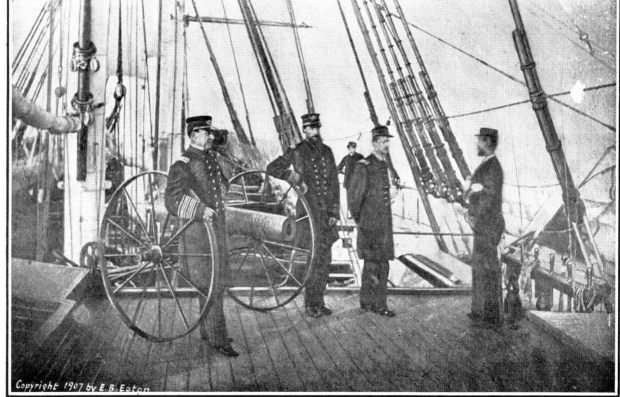

THE heaviest battery of artillery ever mounted in the world, up to 1862, was before Yorktown when the Union army was maneuvering to enter Richmond from the south. The intention was to shell the Confederates out of a strongly intrenched position by overwhelming fire. This photograph was taken inside of the fortification that threatened to annihilate an entire army. In it were huge demons of death—that were hitherto unknown in warfare—capable of throwing 900 pounds of iron at one broadside into the lines of the enemy. There were five 100-pounder and two 200-pounder Parrot rifled cannon. The topography of the country would not admit of engagements with unfortified lines. The Confederates concentrated their forces in the woods. The Union commanders at first despised picks and shovels. They insisted that all defenses except those naturally available were beneath a soldier's dignity. The battles of the East and West were being fought on open ground. The campaign against Richmond, however, proved the necessity of defenses to protect the lines from unexpected attacks from the hidden enemy. The Confederates became uneasy over this shift of fighting front and the magnitude of the preparations at Yorktown so astounded them that they abandoned the position. On May third the great battery threw a charge into the Confederate stronghold. It was intended to open the bombardment on the following morning, but at dawn it was found that the Confederates had evacuated. The heavy artillery was known as Battery No. 1, and manned by Company B, First Connecticut Heavy Artillery. It became a matter of discussion throughout the world. Military attachés from many foreign powers visited the breastworks to report the situation to their governments.

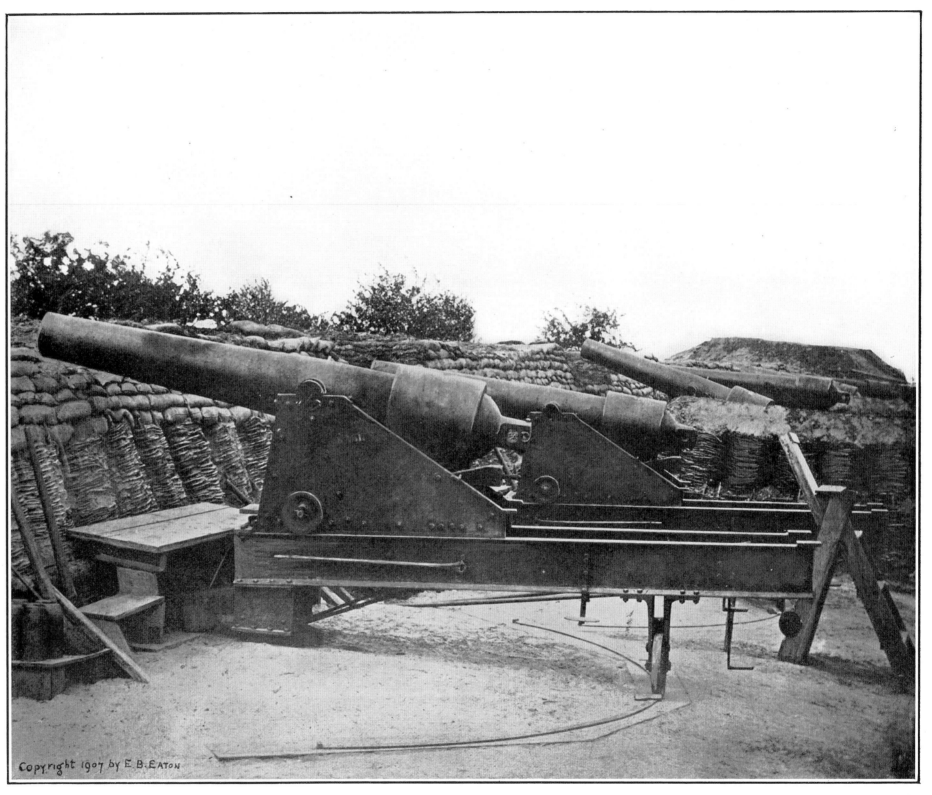

Copyright 1907 by E. B. Eaton

PHOTOGRAPH TAKEN BEHIND THE BREASTWORKS AT YORKTOWN, VA., IN 1862

AT sunrise of the fourth of May, in 1862, the Union troops entered the deserted Confederate works at Yorktown and found seventy-one heavy guns, a large number of tents, with ammunition and materials of war. The works were found to be of scientific construction and great strength and undoubtedly could have withstood the heavy fire from the heaviest battery in the world. This photograph shows the remains of one of the heavy Confederate guns blown into atoms rather than leave it to the Union forces. Fragments of the gun strew the ground, together with shell and grape-shot. The soldiers seen in works are Union Zouaves. The Confederate forces of 50,000 men under Magruder were pursued by McClellan's 85,000 Union soldiers to Williamsburg, after which the enemy retired unmolested behind the lines of Richmond. While Brady was taking his photographs at Yorktown, he met the distinguished Prince de Joinville and his royal companions of the House of Orleans, who, for pure love of adventure, had come from France and were following the Army of the Potomac as aides-de-camp, being permitted to serve without taking the oath of allegiance, and without pay. The noblemen were eating dinner in camp when Brady secured this picture. A few days later Brady met the Battery C, 3rd U. S. Flying Artillery, on the road to Fair Oaks and secured a remarkable photograph. Another picture in this campaign is the ruins of the Norfolk navy-yard. It had been the chief naval depot of the Confederates, but on the tenth of May, 1862, General John E. Wool, with 5,000 men, entered the city. The navy-yard, with its workshops, storehouses and other buildings had been wrecked, but two hundred cannon fell into the hands of the Union forces. The Confederate ironclad "Merrimac" tried to escape up the James, but grounded and was blown up.

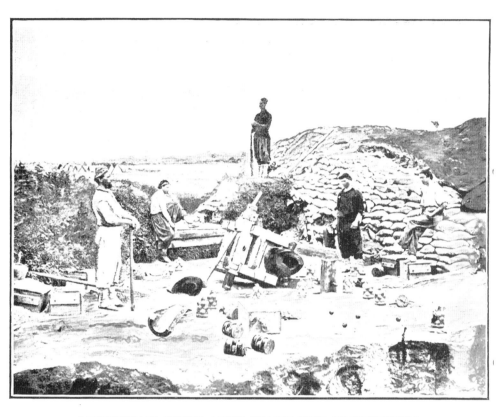

CONFEDERATE WORKS AFTER EVACUATION OF YORKTOWN

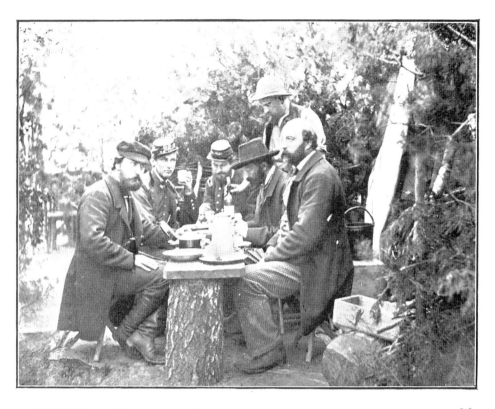

ADVENTUROUS EUROPEAN NOBLEMEN WITH ARMY OF THE POTOMAC IN 1862

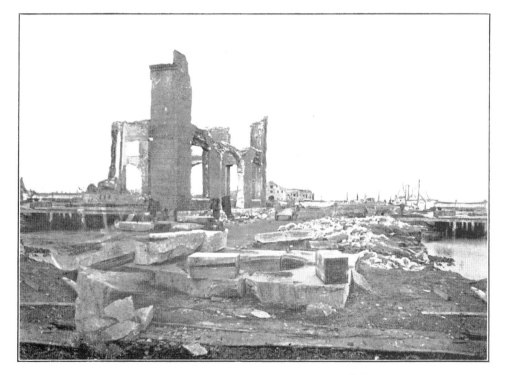

RUINS OF NORFOLK NAVY YARD IN 1862

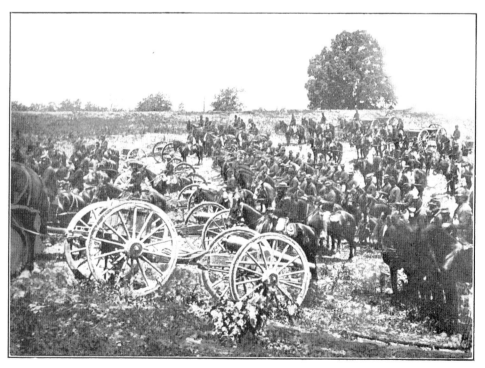

FLYING ARTILLERY ON ROAD TO FAIR OAKS

AFTER the evacuation of Yorktown on the fourth of May, in 1862, this picture was taken. It shows the generals of the Army of the Potomac in full uniforms after the hard siege, and at the very time when they were maneuvering to drive back the Confederates, forcing them to stand in defense of the Capital of the Confederacy—Richmond. It was through the personal friendship of Major-General McClellan that Brady was allowed to take this rare photograph. The warriors lined up in front of the camera on the field at Yorktown. In the center is General McClellan—a man in whose veins flowed the blood of Scotch cautiousness—"Be sure you're right, then go ahead!" He was but thirty-six years of age when he held the great army under his control. From boyhood he had been a military tactician. When twenty years old he was graduated from West Point, standing second in his class, and distinguished himself for gallantry in the Mexican War. Six years before the outbreak of the Civil War, when only thirty years old, McClellan was in Crimea and two years later he submitted his report to the Government and resigned from the army to become vice-president and chief engineer of the Illinois Central Railroad. In 1860, he was general superintendent of the Ohio and Mississippi Railroad. When the call swept across the continent for troops to preserve the Nation, the old war spirit was aroused and McClellan was one of the first to respond.

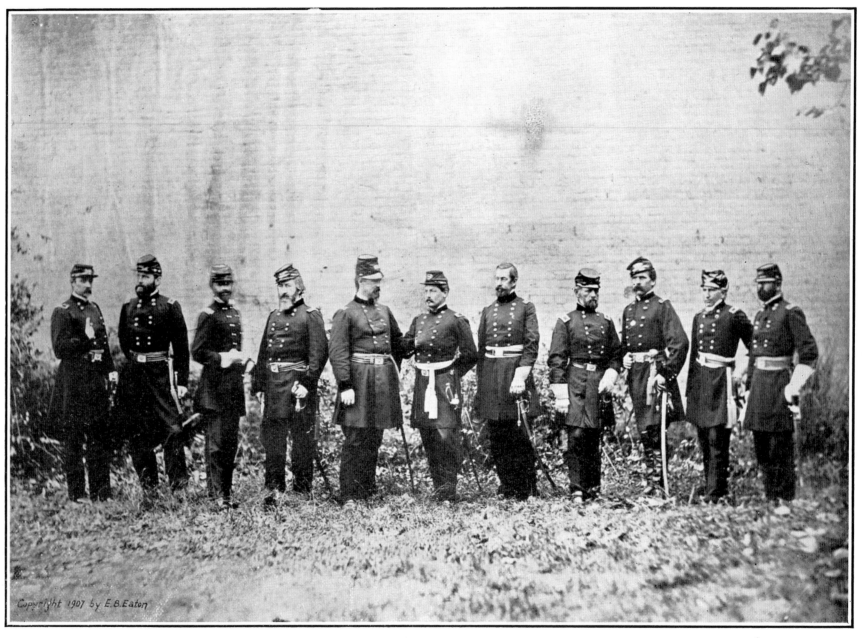

PHOTOGRAPH TAKEN AT YORKTOWN OF MCCLELLAN AND HIS OFFICERS IN 1862

BRADY'S cameras took an active part in the campaign about Richmond, the Capital of the Confederacy. Four of the old negatives are here reproduced. The first is a view of light field-works on the Chickahominy, near Fair Oaks. The men are at the guns ready to receive the attack and the infantry are hurrying into line on the right and left of the battery. The second photograph is where the battle raged hottest in June, 1862. In the rear of the battery of howitzers in the foreground, is the left of Sickle's brigade in line of battle. Near the twin houses, seen still further in the rear, the bodies of over 400 Union soldiers were buried after the battle. The Confederate loss was 7,997 men killed, wounded and missing; the Union loss, 5,739. The headquarters of the army, at the opening of the seven days' fight, was at Savage Station, where vast amounts of rations, forage, ammunition and hospital stores were distributed for the use of the troops. This station fell into the hands of the enemy together with many of our sick and wounded soldiers during the seven days' battles. One of these views gives a glimpse of the field hospital at Savage Station during the battle. The wounded were brought in by the hundreds and laid on the ground and the surgeons may be seen leaning over them. During the Peninsula Campaign in 1862, the army balloon was a valuable aid in the signal service. This view shows Professor T. S. C. Lowe in his balloon watching the battle of Fair Oaks. He can easily discern the movements of the enemy's troops and give warning to the generals. The balloon rises to the desired elevation and is anchored to a tree.

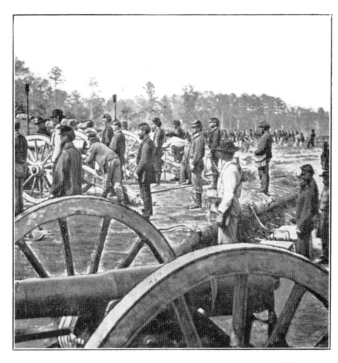

ARTILLERY IN LINE AT FAIR OAKS IN 1862

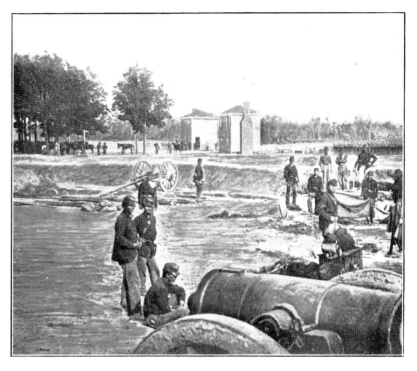

BATTERY OF HOWITZERS IN BATTLE OF FAIR OAKS

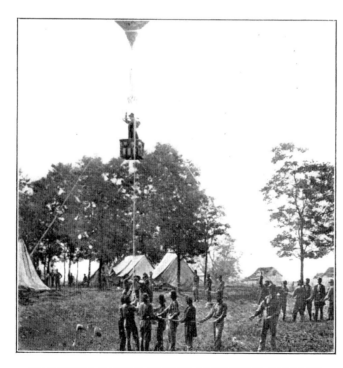

WATCHING BATTLE OF FAIR OAKS FROM BALLOON

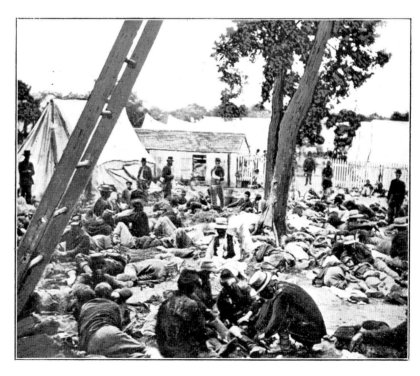

THE WOUNDED AT SAVAGE STATION AFTER THE BATTLE

DESPERATE battles day and night crimsoned the fields in the siege about Richmond. McClellan called for reinforcements to force his way into the city, but they failed to arrive. So dismayed was he that he sent this warning to Stanton at Washington: "If I save this army now, I tell you plainly that I owe no thanks to you, or any other person in Washington." This photograph shows the Grapevine Bridge on the Chickahominy over which McClellan passed his army. This bridge was built by the 15th New York Engineer Corps. All the supplies that could be taken in the wagon trains were hurried over Grapevine Bridge and the remainder were burned or abandoned. Hundreds of artillery charges were opened. Powder was scattered over the pile and barrels of oil poured on. At Savage Station a railroad train loaded with ammunition was set on fire, then sent, with the locomotive throttle wide open, to plunge from the broken tracks into the river, each car exploding as it reached the surface of the stream. Grapevine Bridge was destroyed and Jackson held away from the Battle of Gaines' Mill, which undoubtedly saved the Army of the Potomac from capture. Through Mechanicville, Gaines' Mill, Savage Station, Peach Orchard, White Oak Swamp and Malvern Hill the Union soldiers fought their way from the twenty-sixth of June to the first of July, finally escaping to Harrison's Landing on the James River after a loss of 15,249 men. The Confederates had beaten them back from Richmond at a cost of 17,583 men. McClellan set up his base of operations at Harrison's Landing and remained a menace to Richmond.

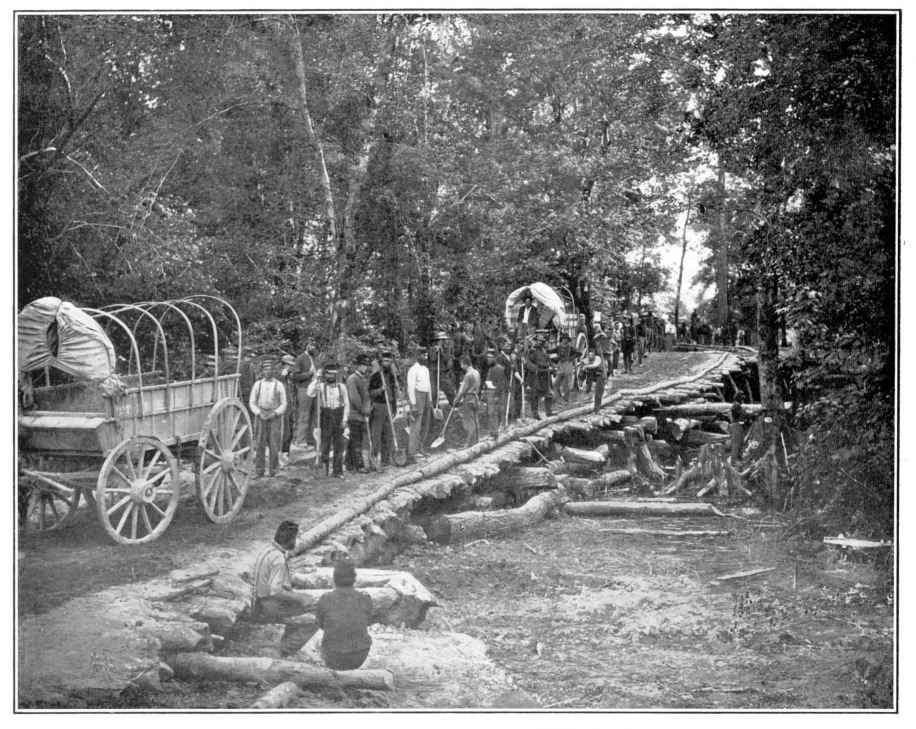

PHOTOGRAPH TAKEN AT GRAPEVINE BRIDGE OVER THE CHICKAHOMINY

BRILLIANT strokes came like flashes of lightning. With McClellan still setting his heart on taking Richmond, "Stonewall" Jackson was making threatening moves towards Washington. Demonstrations were begun to plant fear in the Government and cause sufficient alarm to order the withdrawal of McClellan to the defense of Washington. This daring ruse was successful inasmuch as it completely upset the plans to take Richmond, and the seat of battle was almost instantly transferred to the North. There was no denying it; Washington stood in abject fear of the brilliant Jackson. His presence in the vicinity of the National Capital caused much uneasiness. The stand against him came at Cedar Mountain, known from its hard fight as Slaughter Mountain, on the ninth of August, 1862. At a cost of about 1,400 men, the Union army frustrated Jackson and depleted his forces to the extent of 1,307. Brady's cameras were with the army at Cedar Mountain. The first photograph was taken just as one of the batteries was fording a tributary of the Rappahannock. Another picture was taken of the Union camp on the battlefield. The Confederate general, Charles S. Winder, was struck by a shell while leading his division on the field. He was taken to the house shown in one of these photographs where he died. The marks of the shells can easily be seen in the roof. It was about this time, at Harrison's Landing, that Brady met the famous Irish Brigade which was then fighting in the defense of Washington, under Brigadier-General Thomas Francis Meagher, who had taken prominent part in a recent rebellion in Ireland. A group of officers of the sturdy Irish Brigade sat before one of Brady's cameras. The charges of this brigade are among the most daring in warfare.

OFFICERS OF IRISH BRIGADE AT HARRISON'S LANDING IN 1862

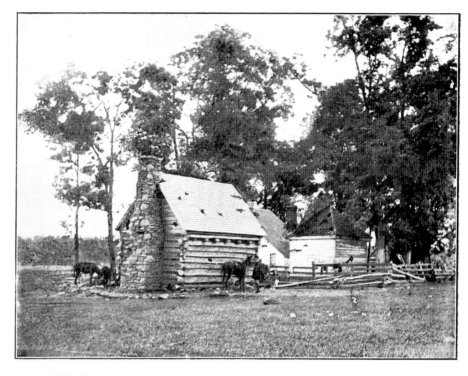

HOUSE AT CEDAR MOUNTAIN WHERE GENERAL WINDER DIED

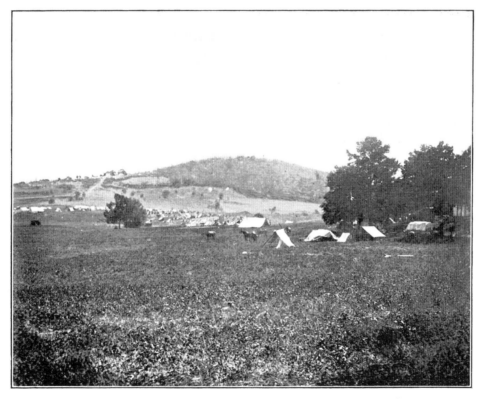

CAMP AND BATTLEFIELD ON CEDAR MOUNTAIN IN 1862

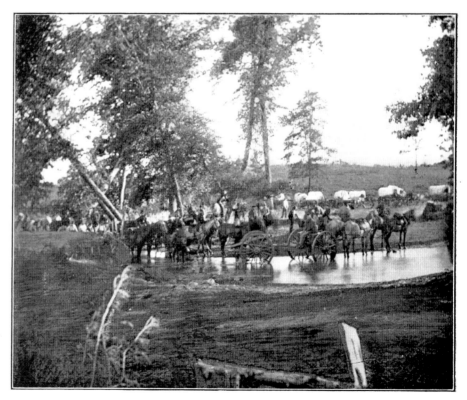

BATTERY FORDING STREAM NEAR CEDAR MOUNTAIN IN 1862

ONE hundred and sixty thousand men fought in the Union lines in the Peninsula campaign. When Lincoln reviewed the army at Harrison's Landing, in 1862, he saw only eighty-six thousand men. The remainder had been removed by casualties on the field or disease. Fifty thousand had fallen victims to fever or malaria. The president and his cabinet were dissatisfied with the conditions and General Henry Wager Halleck, who had been showing much ability in the West, was summoned to Washington and appointed commander-in-chief. McClellan was practically deposed from the Potomac. The Army of Virginia, under command of General John Pope, was instructed to cover Washington and guard the Shenandoah entrance to Maryland. In taking command of this division, Pope said to his men: "I have come to you from the West, where we have always seen the backs of our enemies." The Confederates were mapping routes on a large scale. Bragg was to advance on Louisville and Cincinnati; Lee was to invade Maryland and march upon Washington, Baltimore and Philadelphia. The capture of these three cities was to assure the Independence of the Confederacy. Lee had 150,000 men and two-thirds of them were to be taken on this invasion. This is the scheme that was being worked out when the two armies met on the thirtieth day of August at Manassas. The Confederate troops poured onto the Federal lines and forced them back beyond Bull Run until the darkness of the night stopped the pursuit. Bridges were burned and railroads destroyed by the Union Army as they withdrew toward Washington, making brave stands to hold back the enemy, only to be driven back to the banks of the Potomac with 7,800 missing and dead, while the Confederate lines had 3,700 vacancies.

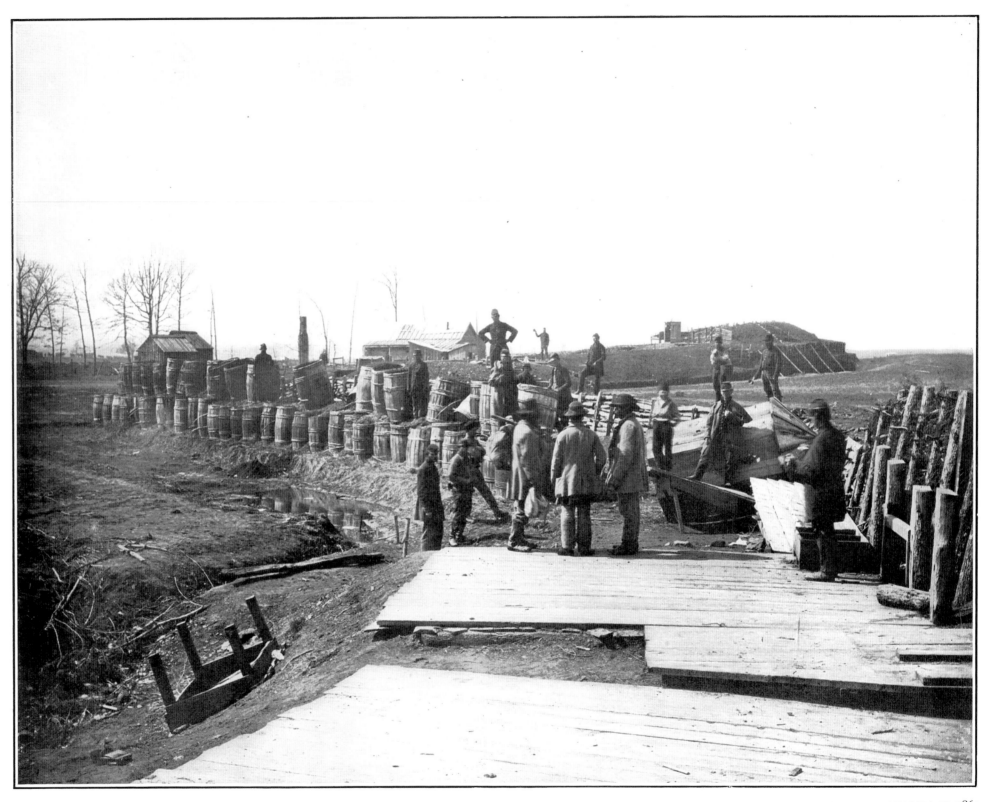

PHOTOGRAPH TAKEN BEHIND CONFEDERATE FORTIFICATIONS AT MANASSAS IN 1862

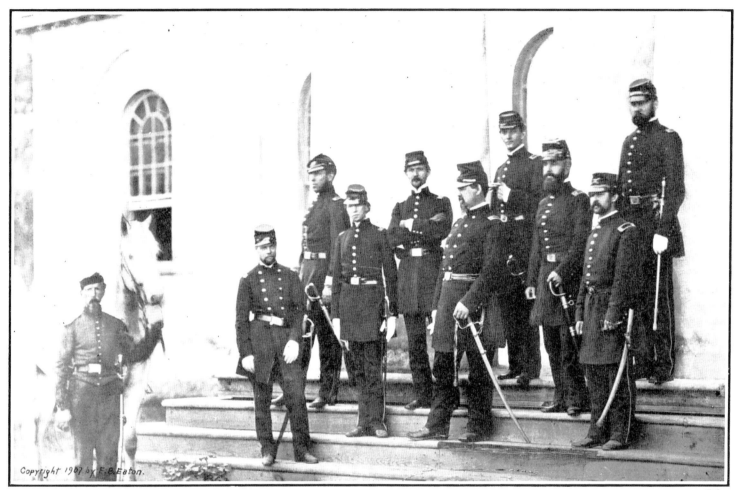

GENERAL IRVIN McDOWELL AND OFFICERS IN 1862

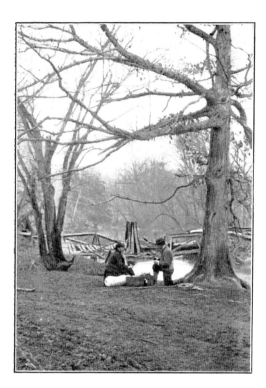

RUINED BRIDGE AT MANASSAS

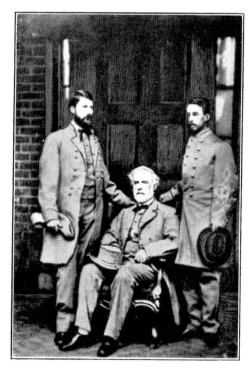

GENERAL ROBERT E. LEE AT MANASSAS

CONSTERNATION was caused in Washington by the terrible slaughter at Manassas, on the thirtieth of August, in 1862. The Federal Army was driven from the Virginia valley. The mighty Confederate generals Lee, Jackson, and Longstreet, renewed their hopes of entering the National Capital and pushing into Pennsylvania and Maryland, and as one enthusiastic Southerner exclaimed: "The Confederate flag will yet wave over Faneuil Hall in Boston." It was but thirteen months since the Union Army met a fearful defeat along this same stream of Bull Run. After a three weeks' campaign, the Federals, under Major-General John Pope, were forced to retire and hastened to the defense of Washington which they believed to be in instant danger of attack. It was in a volley of heavy fire that General Phil Kearney fell dead from his saddle. Kearney and Lee had been personal friends before the war and Lee sent the body of his old friend back to the Union headquarters under a flag of truce. During this campaign, Brady secured an excellent photograph of Major-General Irvin McDowell and staff, who had been in the first battle of Bull Run and now commanded the Third Army Corps. He also made the acquaintance of General Robert E. Lee, who had assumed command of the Confederate Army in Virginia in the second battle, two months before. Standing at Lee's right is Major-General G. W. C. Lee and on his left Colonel Walter Taylor of the Confederates.

TIRED and hungry, the Federal soldiers were driven from the Virginia Valley. The cutting off of supplies had placed them in a precarious condition. There was nothing left for them to do but retreat to the nearest provisions. Even the 4,000 horses in the cavalry were so broken down and footsore that not more than 500 of them were fit for riding. The only considerable depot of supplies was at Manassas Junction and it had fallen into the hands of the Confederates. A strong body of cavalry under "Jeb" Stuart, with 500 infantry, had raided it during the night three days before the battle. These stores were destroyed by the Confederates as a safer way to force back the Federals by starvation. While they brought little succor to the rank and file of the Confederate army they left the Union soldiers without food. One of Brady's cameras reached Manassas Junction shortly after the destruction and this is the negative that was taken. The railroad train is wrecked, the engine is derailed, and the cars have been looted. 50,000 pounds of bacon, 1,000 barrels of corned beef, 2,000 barrels of salt pork, 2,000 barrels of flour, two train loads with stores and clothing, large quantities of forage, 42 wagons and ambulances, 200 tents, 300 prisoners, 200 negroes, eight pieces of artillery with their horses and equipments, and 175 horses other than those belonging to the artillery fell into the possession of the enemy. Immense quantities of quartermasters' and commissaries' stores were burned. Only rations enough for a single day were saved by the captors. The conflict was too hot and the action too swift to allow carrying them along on the movement into the North. With these provisions gone the Union army was in dire want.

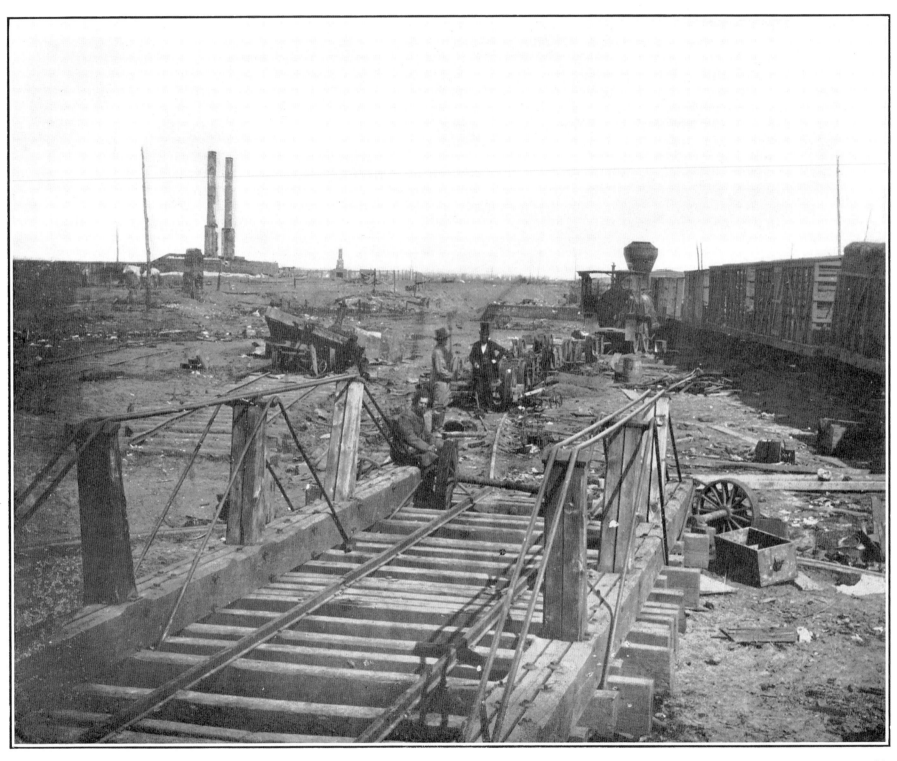

PHOTOGRAPH TAKEN AT RUINS OF MANASSAS JUNCTION, VIRGINIA, IN 1862

THE pursuit by the Confederates toward the very gates of Washington, after the route of the Union army along Bull Run, was stopped only by the thoughtfulness of the retreating Federals in destroying their bridges. Lee, in his report after the battle, says: "After a fierce combat, which raged until after nine o'clock, Pope's Union Army was completely defeated and driven beyond Bull Run. The darkness of the night, his destruction of the Stone Bridge after crossing, and the uncertainty of the fords, stopped the pursuit." This photograph is an actual verification of the truth of Lee's excuse. Brady arrived on the following day and this picture shows the ruins as he found them. It would have been foolhardy for an army in the blackness of night to have attempted to tramp through wreckage, the extent of which they knew nothing, and water the depth of which was questionable. Bull Run was a treacherous stream with its rocks and holes. Moreover, the Confederate soldiers, after the fearful struggle through which they had passed, were not in a condition to travel through the night in drenched and mud-soaked clothing. The Union forces at the fierce battle of Manassas were: Army of Virginia, under Pope—1st Corps under Major-General Franz Sigel; Third Corps under Major-General Irvin McDowell; Second Corps under Major-General Nathaniel P. Banks; Army of the Potomac—Third Corps under Major-General S. P. Heintzelman; Fifth Corps under Major-General FitzJohn Porter; Ninth Corps under Major-General Jesse L. Reno.

PHOTOGRAPH TAKEN AT RUINS OF STONE BRIDGE OVER BULL RUN IN 1862

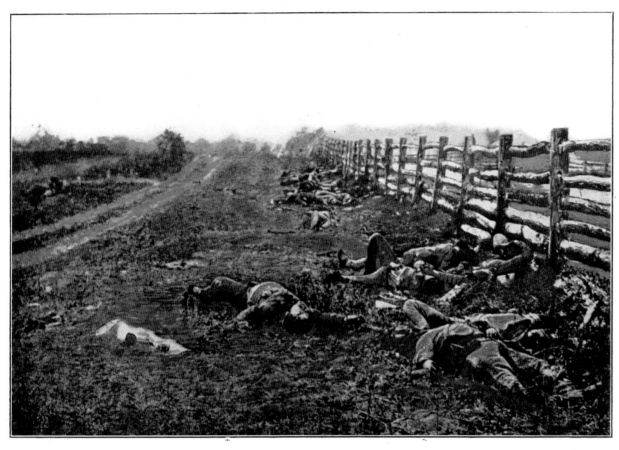

THE DEAD ALONG HAGERSTOWN ROAD AFTER BATTLE OF ANTIETAM

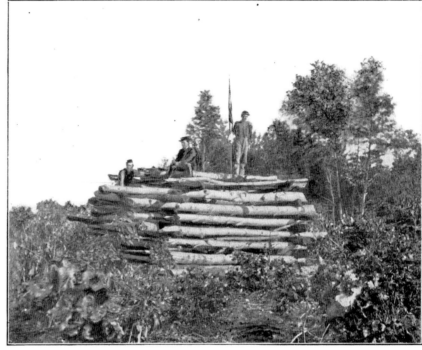

SIGNAL CORPS WATCHING BATTLE FROM HILLSIDE AT ANTIETAM

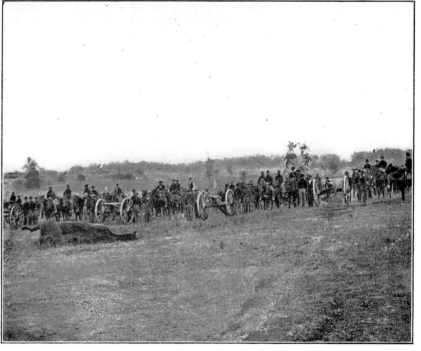

ARTILLERY AFTER THE BATTLE OF ANTIETAM

THRILLED with the victory at Manassas, the second Bull Run, the leader of the Confederacy, Jefferson Davis, ordered an immediate movement to the North with all the chances of glorious triumph in his favor. It was conceded even by the military tacticians of the Government that Lee could march to Washington with probabilities of entrance. He was aware that a direct attack was feasible, but he desired to cross the Potomac into Maryland and enter the National Capital from the north, thus giving him a free route to the great municipalities of the North. It is probable that he even had visions of the capture of New York. While developing this military strategem he met the Federals in the open at Antietam. It was the seventeenth of September in 1862. General McClellan was in command and Lee's fondest dreams were blasted. The men of both armies fought as they never fought before. Brady's cameras were soon on the scene and secured many negatives of this bloody day. The one above reveals the west side of Hagerstown Road after the battle. The bodies of the dead are strewn thickly beside the fence, just as they fell. The guns succeeded in getting an excellent range of this road, and slaughtered the enemy like sheep. This view of some of the men just as they fell, is only a glimpse of many groups of dead in that terrible combat. Brady "caught" the Independent Pennsylvania Battery E, well known as Knapp's Battery, shortly after the battle.

THIS is believed to be the first photograph ever taken of armies in battle on the Western Continent. The historic negative was taken from the hill overlooking the battle of Antietam. It shows the artillery in terrific conflict and the fire belching from the cannon's mouth. The clouds of smoke rising from the valley tell the fearful story of that seventeenth day of September, in 1862, when 25,899 Confederates were killed, wounded and captured at the cost of 12,469 Union men. On the left of the lines stand the reserve artillery waiting for the call to action. One can almost hear the voice of "Little Mac" urging his men on to victory. The defeat at Manassas, and the destruction of Pope's trains, with the hot haste in which the troops had passed through Washington, gave no time for the issuance of shoes, socks or other necessaries. The men who had tramped through the Chickahominy swamps and down the Virginia Valley were ragged and bleeding, but when the order rose above the tumult: "Give ground to the right," a mighty cheer swept along the lines as a cavalry of horsemen galloped madly to the front, for the men in the ranks knew that McClellan was coming. There was not a man at Antietam who did not know that it was a last desperate chance to thwart the great Lee from marching on to Washington, and possibly Baltimore and Philadelphia. The people in the North eagerly awaited the news. The National Capital was almost in a state of panic. It was the hardest fought and bloodiest single day's battle of the war and more men were killed than in any single day's fight during the conflict.

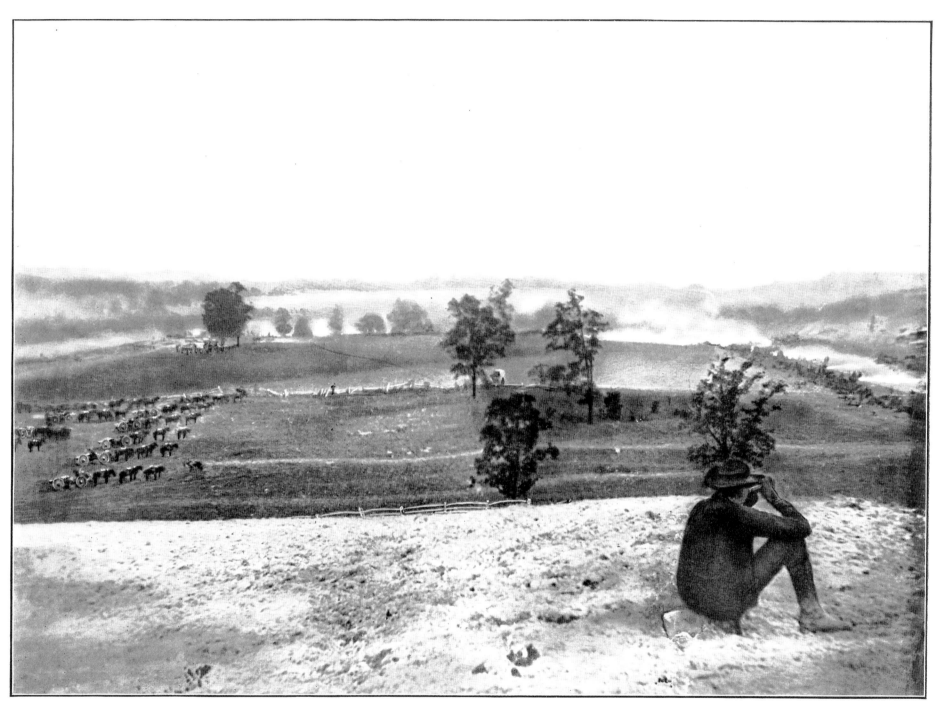

PHOTOGRAPH TAKEN DURING THE BATTLE OF ANTIETAM IN 1862

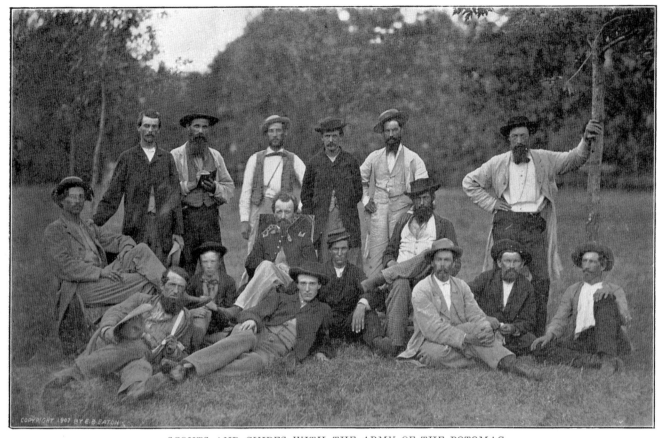

SCOUTS AND GUIDES WITH THE ARMY OF THE POTOMAC

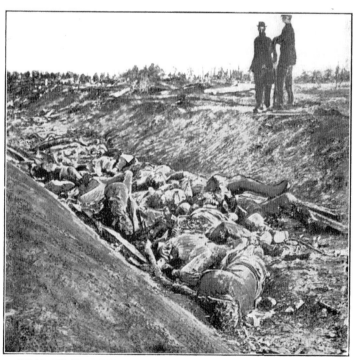

GENERAL JOSEPH HOOKER AND HIS FAVORITE HORSE AT ANTIETAM

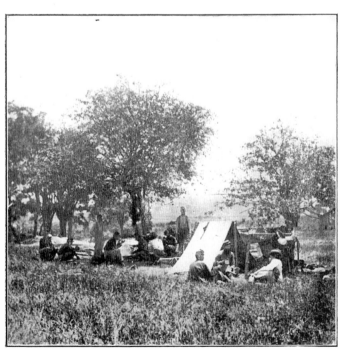

PICKETS IN THE LEAD OF THE ARMY IN 1862

THE scouts and guides of the Civil War saved the armies from many defeats by their shrewdness and bravery. Upon them rested the great responsibility of leading the soldiers through the unknown country to advantageous and safe positions. During the Peninsula campaign in 1862 a group of these men sat before one of Brady's cameras. A photograph was also secured at a reserve picket station near the Potomac. The advance picket was a short distance ahead and upon the approach of the enemy began firing, and gradually fell back on these reserves, who keep up a continuous fire as they retire slowly, fighting as they go, giving time for the army to form into line for battle. About this same time an excellent picture was secured of "Fighting Joe" Hooker standing beside his horse. Hooker was seriously wounded at Antietam and borne from the field. Still another photograph shown here is the "Sunken Road" or "Bloody Lane" at Antietam, in which the Confederate dead lay three deep for a distance of half a mile. This ditch was used by the Confederates as a rifle pit. A Union battery succeeded in getting an excellent range of the road and this view, taken the day after the battle, shows the dead just as they fell. It is a scene of slaughter that few men have ever seen and its horrors are here preserved in detail by the camera.

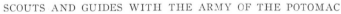

DEAD IN SUNKEN ROAD AFTER BATTLE OF ANTIETAM

STONEWALL JACKSON, in speaking of the battle of Antietam, said: "The carnage on both sides was terrific. The hottest fight seemed to center about Dunker Church, where there were no less than four charges and counter-charges. Each army had taken and retaken the ground until it was literally carpeted with dead and dying men." The Confederates posted a battery of light artillery outside of the little building used for religious services by the sect known as the Dunkers. This photograph shows where one gun of the battery stood. The dead artillerymen and horses, and the shell-holes through the little church, prove how terrible a fire was rained onto this spot by the Union batteries. Another view on this page shows the dead collected for burial after the battle of Antietam. The wounded were taken from the battlefield to an improvised hospital which consisted of canvas stretched over stakes driven into the ground. A view is here given of one of these hospitals in which wounded Confederate prisoners are being relieved of their suffering. One of the most interesting of these photographs is Burnside Bridge. With fixed bayonets the Union soldiers started on their mission of death, rushing over the slope leading to the bridge, and engaging in fierce combat with the enemy. The fire that swept it was more than they could stand and they were obliged to retire. Two heavy guns were placed in position and aimed upon the Confederates. In a maddening charge, the bayonets again flashed in the light and the Union soldiers swept everything before them, planting the Stars and Stripes on the opposite bank. Five hundred of their men lay dead behind them. By this time Burnside had crossed the stream and after a quick encounter the battle was ended with both armies severely punished and neither inclined to resume the fight.

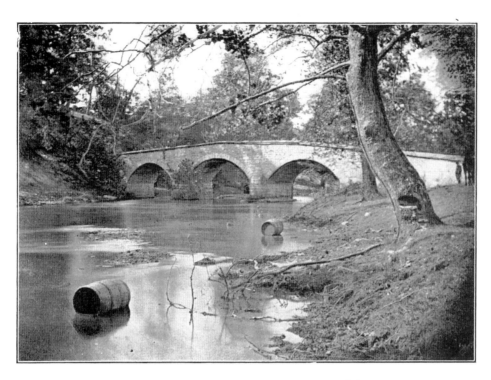

BURNSIDE BRIDGE AT ANTIETAM IN 1862

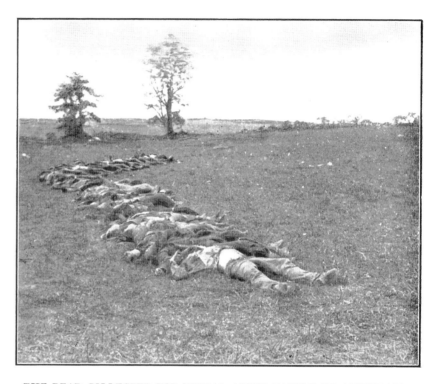

THE DEAD COLLECTED FOR BURIAL AFTER BATTLE OF ANTIETAM

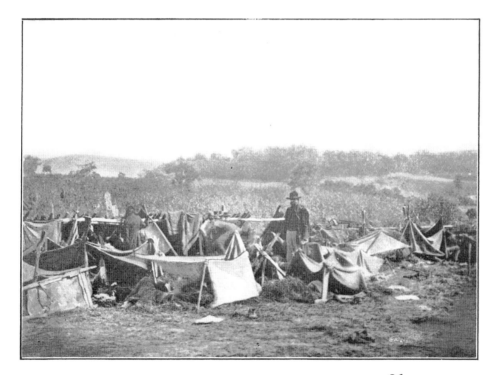

FIELD HOSPITAL AT ANTIETAM BATTLEFIELD IN 1862

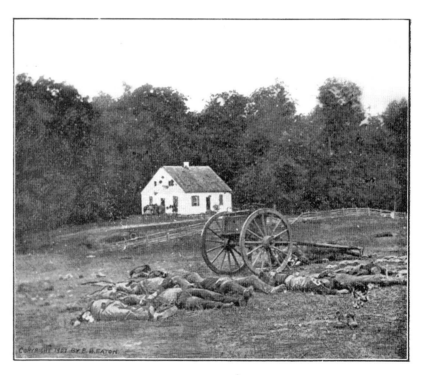

DEAD ARTILLERYMEN AT DUNKER'S CHURCH, ANTIETAM

THE last echo of the guns of Antietam had hardly died away when the great Lincoln and the cautious McClellan stood literally at swords' points at the very instant when the Confederacy was repulsed and weakened. Lincoln was positive that this was the opportune moment to take the offensive and drive the Confederates into the South. McClellan insisted that his soldiers were suffering; that they needed shoes and supplies; that the cavalry horses were fatigued. He felt that the Government had been saved by his men and that the administration should now provide them with proper clothing and food before they plunged again into the wilderness. President Lincoln hurried to the battlefield of Antietam on the first of October, in 1862, to learn the real condition. While the president and "Little Mac" were seated in General McClellan's tent about noon on the third of October, with maps and plans on the table before them, discussing the situation, Lincoln submitted to having this photograph taken. The silk hat of the president lies on the table over which is thrown an American flag. It is a remarkable likeness of the great American and the negative is treasured as one of the most valuable contributions to our National records. In speaking of this visit, McClellan said: "We spent some time on the battlefield and conversed fully on the state of affairs. He told me that he was entirely satisfied with me and with all that I had done; that he would stand by me. He parted from me with the utmost cordiality. We never met again on this earth." On the following morning Lincoln returned to Washington. Two days later McClellan received an order from Washington to immediately move onto the enemy and engage them in battle. The breach between the two men was now irreparable. McClellan believed that it was the influence of Stanton whom he had accused of working deliberately against him. It was nineteen days before he began the movement and on the fifth of November, Lincoln issued this order: "By direction of the president it is ordered that Major-General McClellan be relieved from the command of the Army of the Potomac, and that Major-General Burnside take command of that army."

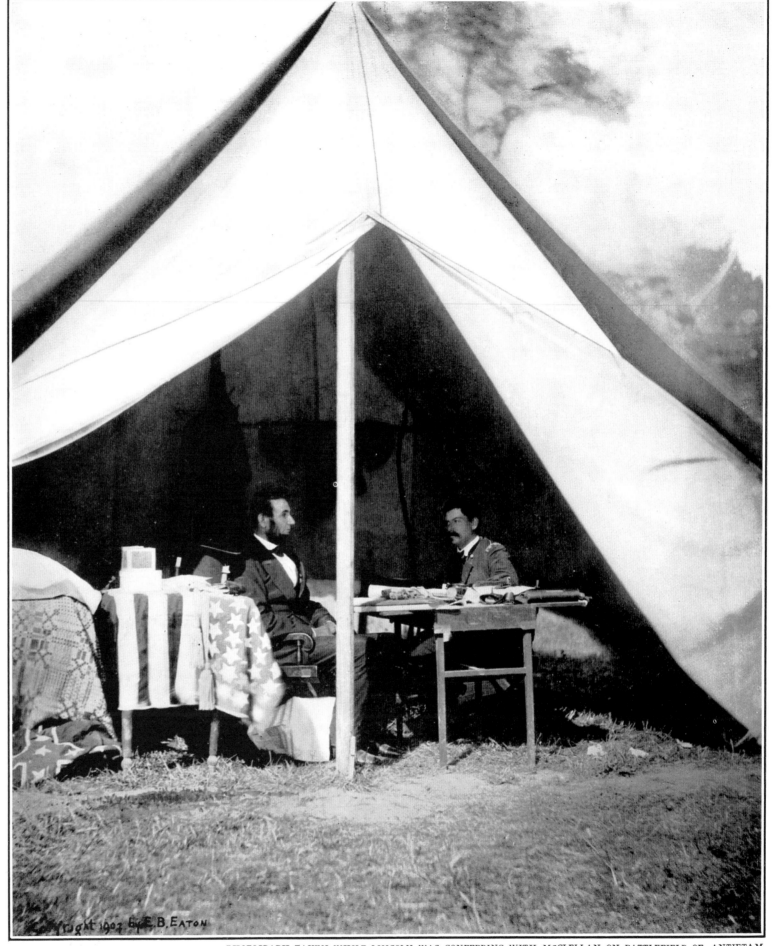

PHOTOGRAPH TAKEN WHILE LINCOLN WAS CONFERRING WITH MCCLELLAN ON BATTLEFIELD OF ANTIETAM

WHEN Lincoln visited the battlefield of Antietam, he was accompanied by Allan Pinkerton, chief of the Secret Service, known under the alias of Major Allen. On the morning of the third of October, 1862, when he was leaving McClellan's tent to look over the army in camp, he again stood before one of the war cameras and this rare photograph is the witness. Comparatively few of this generation have any clear idea of how the real Lincoln looked as he passed through the heart-rending ordeal from 1861 to 1865. This photograph shows him in his characteristic attitude. At his right stands Pinkerton, one of the shrewdest detectives that the world has produced. The officer in uniform is Major John A. McClernand, who was appointed to command the Army of the West and fought at Fort Donelson, Shiloh and Vicksburg, but who was in the East at this time. From Lincoln's visit resulted McClellan's deposal. Never before or since has such a scene been witnessed in any army as the one when McClellan took leave of his officers and soldiers. Seated on a magnificent steed, at the head of his brilliant staff, he rode down the lines, lifting his cap as the regimental colors fell into salute. Whole regiments dropped their muskets to cheer their hero. The tears came to McClellan's eyes and the vast army shook with emotion. As he was boarding the train troops fired a salute. Impassioned soldiers wildly insisted that he should not leave them, and uttered bitter imprecations against those who had deprived them of their beloved commander. It was a moment of fearful excitement. A word, or a look of encouragement, would have been the signal for a revolt, the consequences of which no man can measure. McClellan stepped to the platform of the car. He spoke slowly but appealingly: "Stand by General Burnside as you have stood by me, and all will be well!" A calm fell over the soldiers and they bade farewell to their idolized commander. McClellan, upon reaching Washington, remained less than an hour and proceeded at once to Trenton. From that time he never again saw Lincoln, or Stanton, or Halleck.

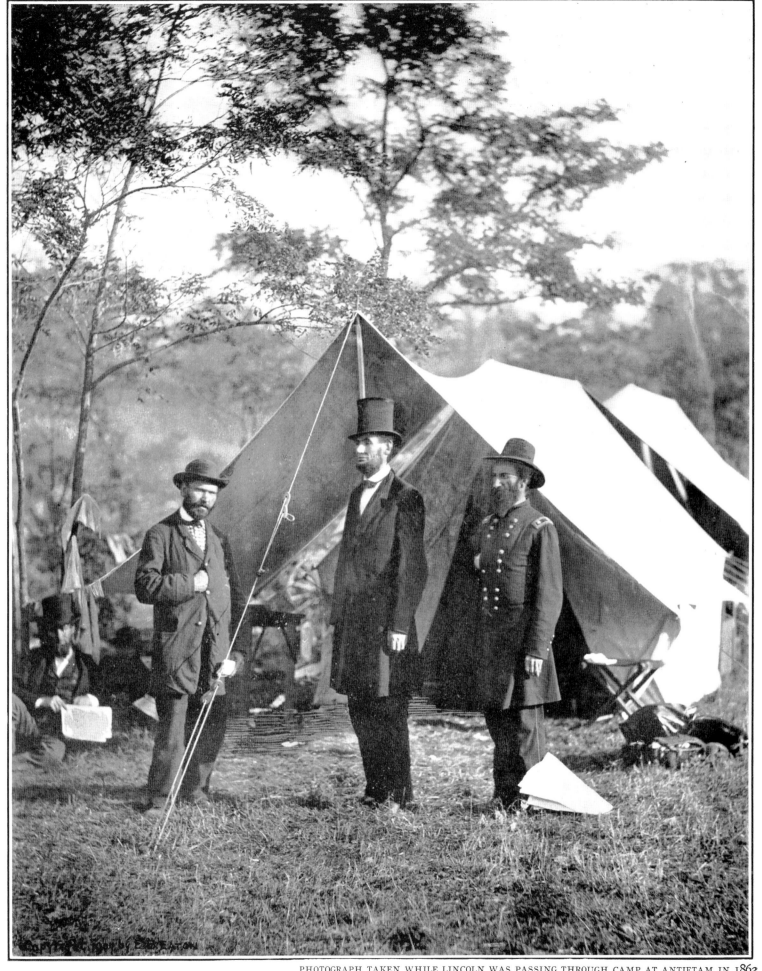

PHOTOGRAPH TAKEN WHILE LINCOLN WAS PASSING THROUGH CAMP AT ANTIETAM IN 1862

A FEW days after Burnside replaced McClellan in command of the Army of the Potomac, this photograph was taken while he was with his staff at Warrenton, Virginia, in the middle of November, in 1862. Burnside is here seen in the midst of his officers, with one hand characteristically tucked into his coat and the other holding a written military order. Burnside was a graduate of West Point and when twenty-four years old helped to take the Capital in the Mexican War. He had also been an Indian fighter and during those days made a journey of over a thousand miles across the plains in seventeen days, accompanied by only three men, to carry dispatches to President Filmore. At twenty-nine years of age he resigned from the United States Army and invented the Burnside rifle. He was one of McClellan's intimate friends, and while a civilian he was engaged with him on the Illinois Central Railroad. Burnside was in New York when the Civil War broke out and hurried to the front in command of the First Rhode Island Volunteers. He fought at the first battle of Bull Run and commanded an expedition that stormed the North Carolina coast. He was in the famous Battle of Roanoke Island and Newbern and as a reward for these successes he was given the rank of major-general. He later fought the Battle of Camden, attacked and reduced Fort Macon, and during the Peninsula Campaign fought at the Battle of South Mountain and Antietam. When Lincoln first offered Burnside the command held by McClellan it is said that he refused it three times. Not until he knew that his friend must go did he concede to the wishes of the president. When Burnside took command of the Union forces he was but thirty-nine years old, but an experienced warrior.

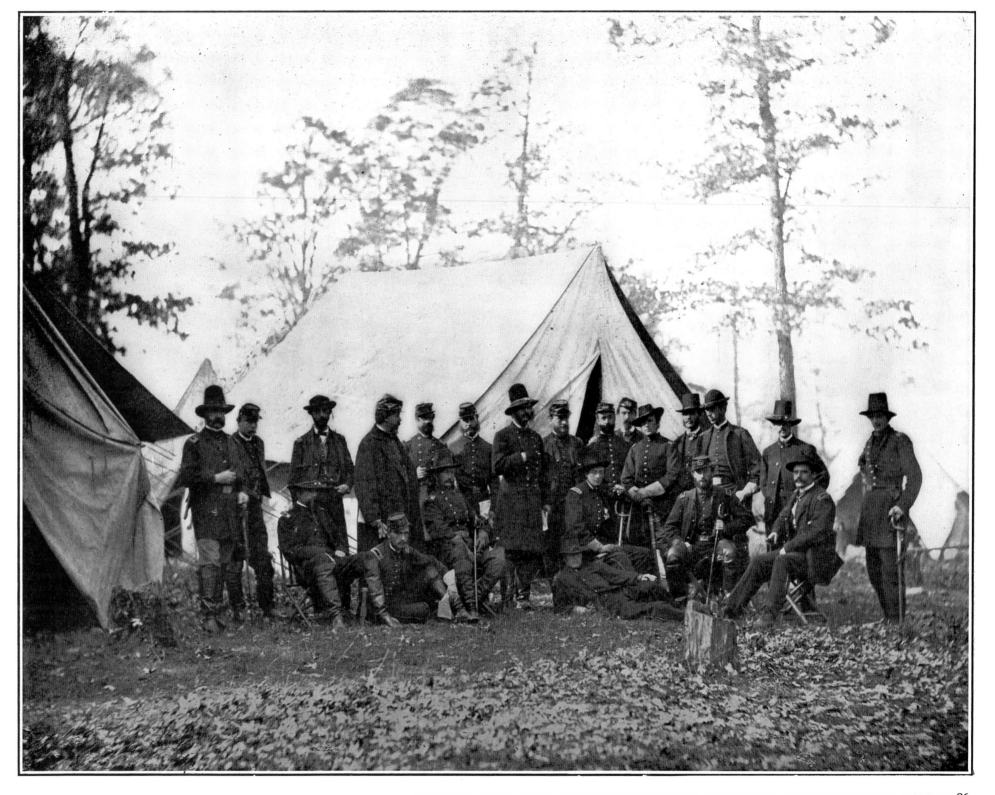

PHOTOGRAPH TAKEN WHILE MAJOR-GENERAL AMBROSE E. BURNSIDE WAS ENCAMPED WITH HIS STAFF IN 1862

GENERAL EDWIN V. SUMNER AND STAFF IN PENINSULA CAMPAIGN IN 1862

SHORTLY after the battle of Antietam this photograph was taken of General Sumner, who was distinguished for gallantry on that bloody field. Sumner is seen standing on the steps in the center of a group of officers. At this time he was a warrior sixty-six years of age and had seen a long life of hard fighting. He was born during the first days of the American Republic, in the year 1796. When twenty-three years old he became a second lieutenant in the United States Infantry and served with distinction during the Black Hawk War. He later had command of a cavalry school and at the outbreak of the Mexican War he led an attack against five thousand lancers and was breveted colonel. With the cessation of this conflict he took charge of the Department of New Mexico, and was later ordered to Europe on official business. Upon his return he entered into border warfare and defeated the Cheyenne Indians. When Lincoln was elected president, Sumner was selected to accompany him from Springfield to Washington and was promoted brigadier-general. Sumner was active in the Peninsula Campaign and was promoted to major-general. He fought through the Maryland Campaign, and at Antietam his corps made one of the fiercest charges over the field, carrying destruction and death. He commanded the right wing at the battle of Fredericksburg and was ordered to the West, but while preparing to depart he died suddenly.

WHILE the campaigns against Richmond and Washington were being waged, hard fighting was taking place in the Southwest. Grant was in command of the Army of the Tennessee. Buell was near Chattanooga, facing Bragg who threatened Louisville. Rosecranz was at the head of the Army of the Mississippi and occupied Alabama and Northern Mississippi. Terrific engagements had taken place at Fort Donelson and Shiloh, Tennessee. The Guerilla Campaign was being waged in Missouri. There were frequent clashes in Kentucky and Arkansas, but Mississippi seemed to be the battle-ground. Corinth, in that state, was considered the military key to Tennessee. It was in the conflict for the control of this coveted position that the Confederates made one of their bravest charges. A photograph is here shown of Fort Robinette which was protected by Federal guns. The Southerners charged almost to the cannon's mouth, only to be swept back by the murderous shower of lead. The second charge stands as a wonderful example of human courage. Colonel Rogers of Texas, led the column, and scaled the breastwork, falling inside. Three charges were made, but the Confederates were finally forced to retreat. The Federal loss at this battle of Corinth in killed, wounded and missing was 2,359; the Confederates left behind them 9,423.

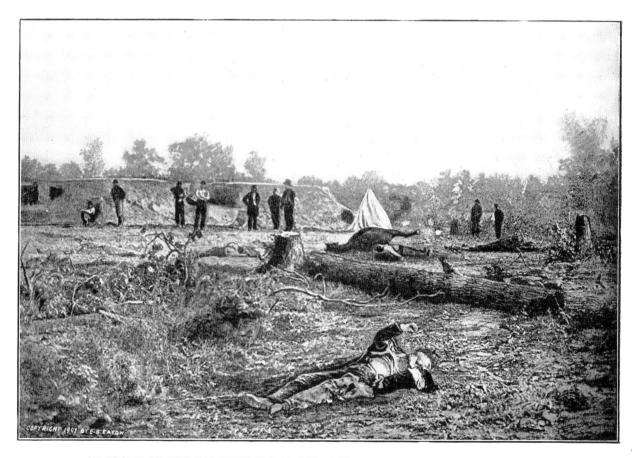

IN FRONT OF THE EARTHWORKS AT FORT ROBINETTE IN CORINTH, MISSISSIPPI

WITH colors flying, armament in first-class condition, and soldiers well-clothed and fed, the Union lines under the new command of Burnside began offensive operations against Virginia. This had been Lincoln's long desire. The scene of action was now to be forced away from the National Capital. On a bright morning in November, the men who had served under McClellan marched in three grand divisions to their new campaign. The Rappahannock was reached on the seventeenth, but the bridge across the river had been destroyed by the Confederates who were intrenched in Fredericksburg on the opposite bank. Pontoons promised by the Government had not yet arrived. "Where are my pontoons?" wired Burnside. "They will start to-morrow," came the reply from the War Department. It was the tenth of December before the engineers could build their bridges and in the meantime ill-feeling had arisen between Burnside and the Government. The fatal delay had enabled Lee to concentrate his army on Marye's Heights, overlooking Fredericksburg. The work of building five bridges across the Rappahannock was begun under a drawn musketry fire from the opposite bank of the river. Nearly every blow of a hammer cost a human life. Burnside ordered his artillerymen to open fire on the city. Fredericksburg became a mass of ruins. This photograph shows abutments of the destroyed bridge. The trees are cropped short by the artillery fire from the Union guns. The Confederate sharpshooters were concealed in the buildings on the opposite river front. Burnside ordered his men to cross the river on a line of pontoon boats. The sharpshooters were driven from their shelter while the bridge building was completed. The river was crossed. At dawn, the twelfth of September, both armies stood ready for combat.

PHOTOGRAPH TAKEN ON THE RAPPAHANNOCK RIVER AFTER DESTRUCTION OF BRIDGE TO FREDERICKSBURG IN 1862

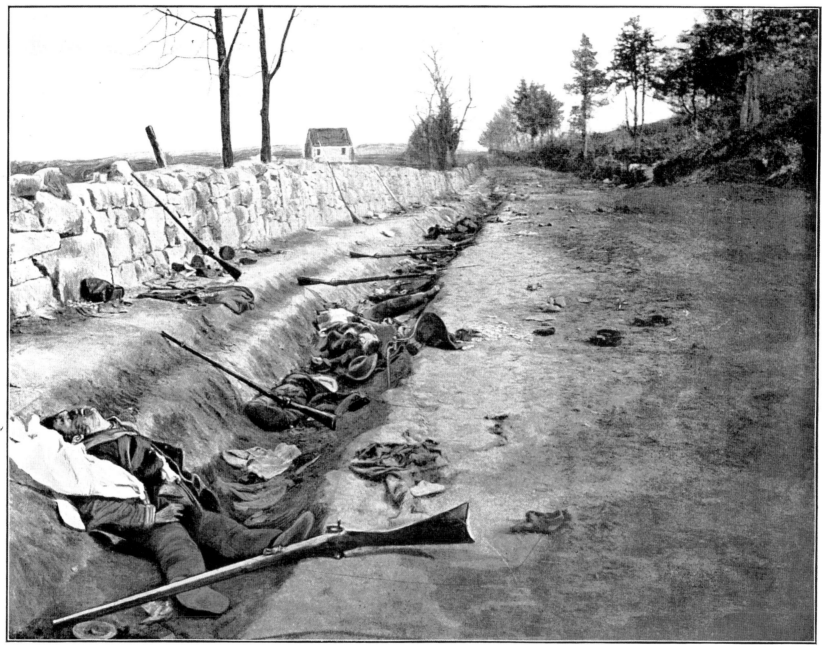

PHOTOGRAPH TAKEN ALONG THE SUNKEN ROAD AT FREDERICKSBURG AFTER THE BATTLE IN 1862

CONFRONTED by sheets of flame, the Union Army made its attack on Fredericksburg on the morning of the thirteenth of December, in 1862. The Confederates occupied the Heights with a line five and a half miles long and fortified with earthworks and artillery. The Federals moved through the town under a heavy fire of Confederate batteries. Marye's Hill was protected at its base by a stone wall, back of which was a sunken road, occupied by two brigades of Confederate infantry. The charging columns of the Union Army were rushing across the open ground under a fierce artillery fire when suddenly they were confronted by a rain of lead from the sunken road back of the stone wall. Nearly half of the charging column was shot down and the remainder fell back. Five thousand more charged in the same manner. Some of them approached within twenty yards of the wall, but fell back, leaving two thousand of their number on the field. Twelve thousand men were again charged against Marye's Heights, but scarcely four thousand returned. The Union ranks were depleted by 12,355, while the Confederates held their position with a loss of but 4,576, and the Federal Army withdrew across the Rappahannock and Lee held Fredericksburg.

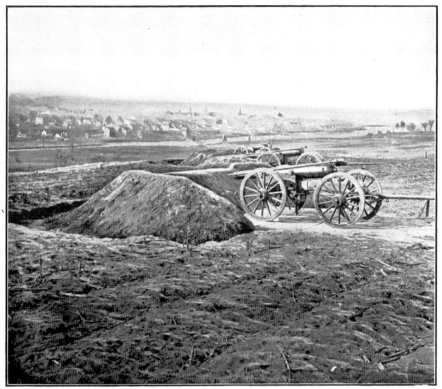

ARTILLERY DEFENSES ON THE BATTLEFIELD OF FREDERICKSBURG IN 1862

FIGHTING GROUND ALONG THE CHICKASAW BAYOU

POISONED SPRING OF CHICKASAW BAYOU

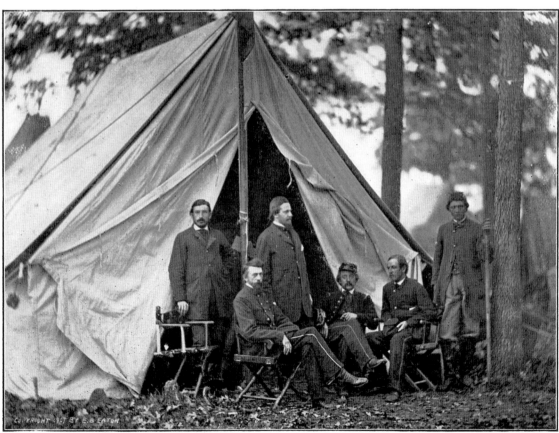

MEDICAL CORPS OF ARMY OF POTOMAC IN CAMP UNDER SURGEON JONATHAN LETTERMAN

THE end of 1862, in the Civil War, found the army in the East in camp at Falmouth, Virginia, after severe reverses. In the Southwest a vigorous campaign was being waged by the heroes of Iuka and Corinth, Mississippi. Grant was in supreme command of the Federal corps in northern Mississippi. A movement was in operation against Vicksburg. Sherman was attempting to get into the rear of the city by the Chickasaw Bayou road which ran from the Yazoo battlefield to the Walnut Hills, six miles above the city. His column of thirty thousand men was defeated and driven back with dreadful slaughter on the twenty-eighth and twenty-ninth of December. Rosecranz was established at Nashville, while Bragg was putting his men into winter huts at Murfreesboro, Tennessee. The Federal troops enjoyed Christmas in camp and on the following morning, in a cold rain, the Army of the Cumberland advanced to Stone River where it enters the Cumberland River just above Nashville. At sunrise on the last day of 1862, Rosecranz's army met Bragg's forces with a deafening roar of artillery and musketry that fairly caused the earth to tremble. The fighting on both sides was of a determined character. The fields were literally covered with dead and dying men. Victory was claimed by both the Federals and the Confederates. Photographs are here shown of Chickasaw Bayou and the deadly Poison Spring on the battlefield; also an excellent portrait of the medical corps of the Army of the Potomac, in camp under charge of Dr. Jonathan Letterman, a prominent battlefield surgeon.

EVERY AMERICAN citizen pledges his "life, fortune and sacred honor" to the truth that "all men are created free and equal," and that they are endowed by their Creator, with certain "unalienable rights." It was fidelity to this oath, as sacred as life itself, that led the American people to rush" to arms" to defend it.

The mobilization of a volunteer army, of freemen born and bred in the arts of peace, never was known until the new Republic of the Western Hemisphere championed the cause of Liberty and common manhood. Battle-trained monarchies declared that it could not be maintained; that the hundreds of thousands of men who were offering their services to their country could never stand the severe exposures and deprivations of warfare. The tongues of the Nations knew not what they were talking. These men were fighters, not by training or nature, but by an honest impulse of the heart they were patriots. It was not love of adventure that urged the strongest men of the North to leave home and family and shoulder a musket under the Stars and Stripes; nor was it a brutal love of combat that marshalled the best manhood of the South to the flag of the Confederacy. It was an impulse that no people had ever before felt. It was a sense of justice that was early kindled in the American Heart with the first tidings of the Declaration of Independence.

While the anguish of the Civil War was brooding over the Nation, mountain and valley, plain and forest, farm and factory—from ocean to ocean—offered its strongest manhood in defense of the country. New York, the largest state in the Western World, sent the greatest number of men to the line of battle—448,850; then came Pennsylvania with 337,936; Ohio with 313,180, and Illinois with 259,092. Indiana came to the front with 196,363; Massachusetts with 146,730, and Missouri brought 109,111.

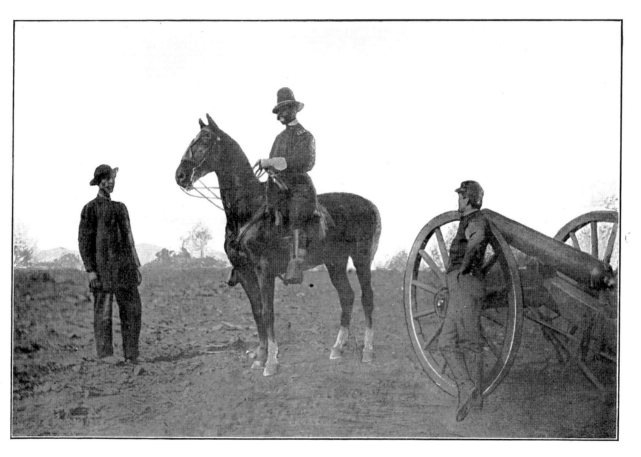

MAJOR-GENERAL AMBROSE EVERETT BURNSIDE ON HIS HORSE ON THE BATTLEFIELD IN 1863
One day during the interval between the defeat at Fredericksburg, Virginia, and the siege at Knoxville, Tennessee, General Burnside was mounted on his favorite charger, viewing his army maneuvers in the distance, when one of the Brady cameras was brought into focus and, with the General's permission, the negative was secured—General Burnside valued this photograph highly

Wisconsin offered 61,327 of her sons; Michigan, 87,364; New Jersey, 76,814; Iowa, 76,242; Kentucky, 75,760; Maine, 70,107, and Connecticut, 55,864.

Maryland marched under the Stars and Stripes with 46,638; New Hampshire with 33,937, Vermont with 33,288; West Virginia, 32,068; Tennessee, 31,092; Minnesota with 24,020; Rhode Island, 23,236, and Kansas, 20,149.

From the Pacific Coast, California answered with 15,725; District of Columbia contributed 16,534 to the support of the Government; Delaware furnished 12,284 men; Arkansas, 8,289; New Mexico, 6,561. The Southern State of Louisiana, dear to the heart of the Confederacy, came to the support of the Union with 5,224; Colorado with 4,903; Nebraska, 3,157; North Carolina, 3,156; Alabama, 2,576. The border state of Texas sent 1,965; far-away Oregon, 1,810; Florida, 1,290; Nevada, 1,080; Washington gave 964; Mississippi, 545, and Dakota, 206. These are the contributions of the states. The Negro Race, the freedom of which was one of the results of the War, supported their cause with 186,097 troops, while the Indian Nation sent 3,530. In the regular army there were enlisted during the War about 67,000 men. There were thousands of brave soldiers who fought in the Civil War, claiming no Commonwealth as their home, but who joined the ranks as Common Americans.

The spirit which animated the American People is shown by several occasions when troops were needed to avert impending disaster, and they poured into the army from remote states with incredible speed. The year 1863 witnessed the battles of Chancellorsville and Gettysburg, of Vicksburg and Chickamauga and Chattanooga. It was the turning point in the struggle and Brady's cameras caught many of the most dramatic scenes worthy of reproduction.

"FIGHTING Joe" Hooker is one of the notable figures of the Civil War. When a boy of fourteen years, he entered West Point and served in the Mexican War in the same regiment with "Stonewall" Jackson. His early life was crowded with hard fighting and when thirty-nine years of age he resigned from the army and went to California, where he became superintendent of the National Road and also entered into agriculture. He answered the call to arms in 1861 and entered into the defense of Washington. During the battles around Fair Oaks, Hooker led his men courageously into many daring positions. His bravery at Malvern Hill gave him the rank of major-general, and at Antietam he fell wounded before the Confederate guns while trying to force the army into a complete surrender. He commanded the center at Fredericksburg. On the twenty-sixth of January, 1863, he was appointed to the command of the Army of the Potomac and began its thorough reorganization. On the twenty-eighth of April he crossed the Rappahannock and arrived at Chancellorsville two days later. On the second of May, a fearful onslaught was made by "Stonewall" Jackson—his old comrade of the Mexican War as a foe. "Stonewall" Jackson was wounded by one of his own sentinels. His men, who were devoted to him, lost heart, and, after a battle of three days, Hooker succeeded in withdrawing his army in safety, after losses in killed, wounded and missing of 16,030 against a Confederate loss of 12,281. This photograph of Hooker and his staff was taken shortly after this battle at Chancellorsville. Hooker may be seen sitting in the second chair from the right. This is considered an excellent likeness of the warrior.

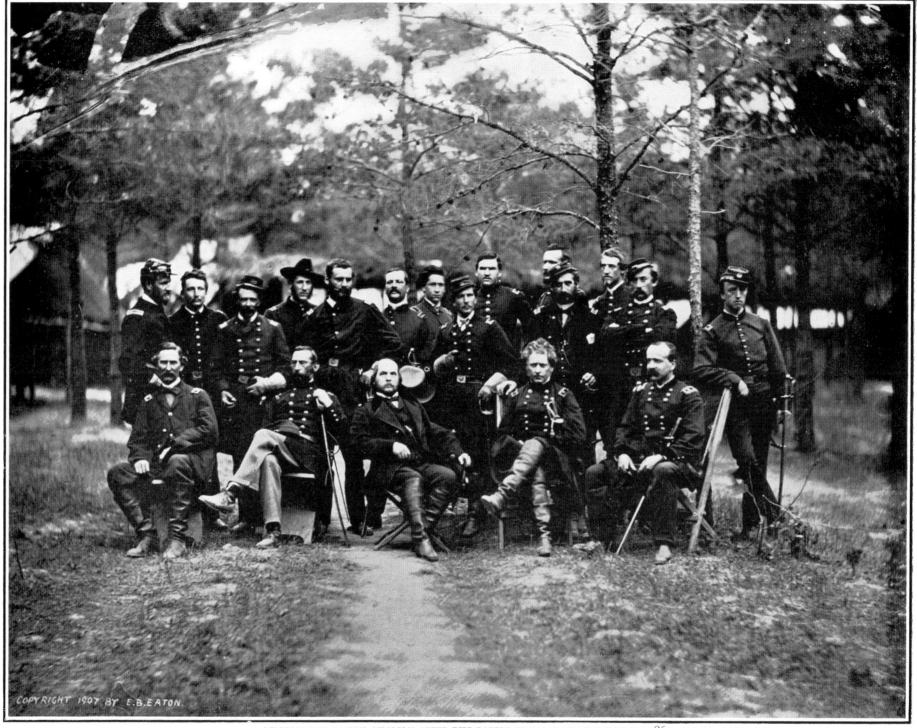

PHOTOGRAPH TAKEN SHORTLY AFTER THE BATTLE OF CHANCELLORSVILLE IN 1863—MAJOR-GENERAL JOSEPH HOOKER AND STAFF

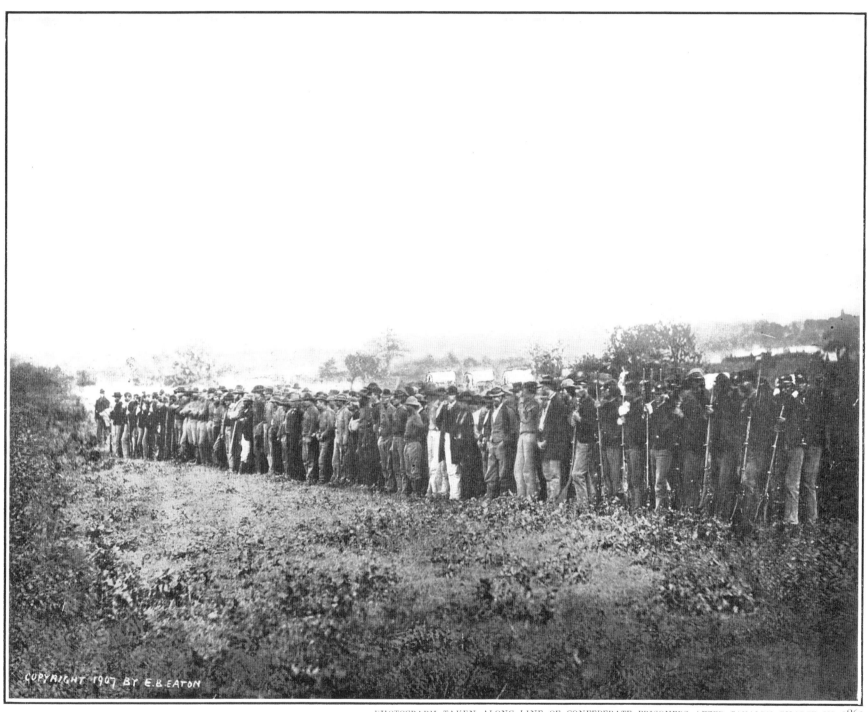

COPYRIGHT 1907 BY E.B.EATON

PHOTOGRAPH TAKEN ALONG LINE OF CONFEDERATE PRISONERS AFTER CAVALRY CHARGE IN 1863

THE retreat from Chancellorsville began on the fourth of May, in 1863. In the midst of a pouring rain, with ammunition wagons and cavalry struggling hub-deep through the mud, the Federals moved back to the Rappahannock. The ponderous batteries, with heavy wheels wrapped in blankets, passed over the road. Then came the ordnance supply trains, swathed in strips of cloth, followed by columns of hurrying infantry. During the remainder of May, neither of the armies assumed an offensive attitude. Lee, now in high hopes, began preparations for a second invasion in Maryland. Panic again seized the people of the North. Lincoln called on Pennsylvania for 50,000 militia; Ohio, 30,000; New York, 20,000; Maryland and Virginia, 10,000 each. The Army of the Potomac had lost all of its two years' service men and its strength did not reach 100,000. The Confederacy had been endeavoring for months to induce England to recognize it as a separate nation, but learned that it must first conquer Northern territory. Lee's movements began early in June and resulted in frequent skirmishes as he approached the Potomac. This photograph was taken immediately after one of these encounters at Aldie, Virginia, on the seventeenth of June, 1863. The Confederate cavalry, under "Jeb" Stuart, was guarding the passes of the Bull Run mountains and watching Hooker's Army. There was a succession of cavalry combats and many Confederates were taken prisoners. This view shows a group of Confederates under a Union guard composed largely of negro soldiers.

IN the stirring scenes of war there is nothing more exciting than to see a battery take position in battle. On the sixth of June, in 1863, this picture was secured by the government photographers just as the artillery was going into action on the south bank of the Rappahannock River. It is one of the earliest attempts to secure a photograph at the instant of motion and was taken at a strategic moment during Sedgwick's reconnoisance. An artilleryman who remembers the day says that while a battery has not the thrill of the cavalry charge, nor the grimness of a line of bayonets moving to slaughter, there is an intense emotion about it that brings the tears to the eyes and the cheers to the throats of battle-scarred veterans. Every horse on the gallop, every rider lashing his t am and yelling; through ugly clumps of bushes; over fallen logs and falling men—the sight is one that can never be forgotten. The guns jump from the ground as the heavy wheels strike a rock or lunge from a ditch, but not a horse slackens his pace, not a cannoneer loses his seat. Six guns, six caissons, sixty horses, eighty men race for the brow of the hill. Boom! Boom! The ground shakes and trembles. The roar shuts out all sound from a line several miles long. Shells shriek through the swamps, cutting down great trees, mowing deep gaps in regiments of men. It is like a tornado howling through the forest, followed by billows of fire. There are men to-day who will look upon this picture and live again the scenes which it recalls. Artillery is the great support of armies and often saves them from defeat.

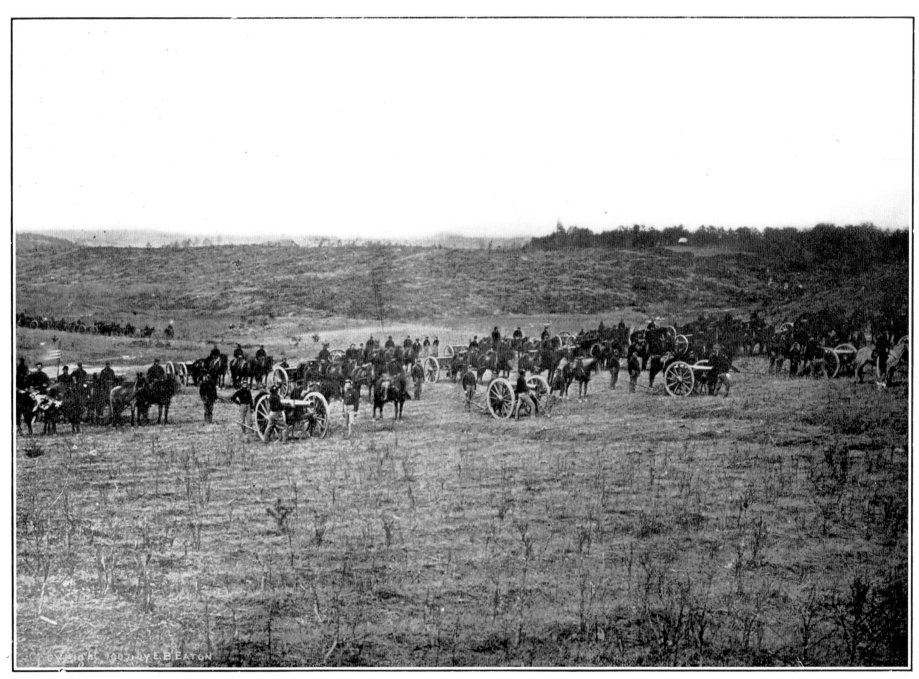

PHOTOGRAPH TAKEN AS ARTILLERY WAS GOING INTO ACTION ON THE RAPPAHANNOCK IN 1863

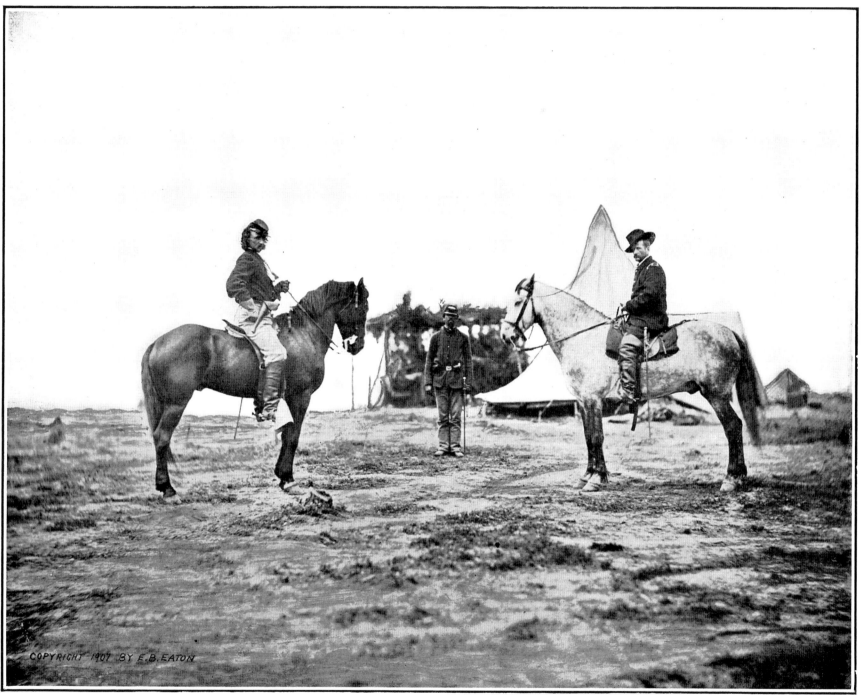

PHOTOGRAPH TAKEN WHILE CAPTAIN GEORGE A. CUSTER AND MAJOR-GENERAL ALFRED PLEASONTON WERE AT BRANDY STATION, VIRGINIA, IN 1863

THERE have been few men in American wars more daring than General George A. Custer. As a cavalryman, he won a place in military history by his bravery. Custer was a captain on the staff of General Pleasonton during the operations early in 1863. This photograph was taken near Brandy Station, Virginia, in June, 1863. It shows Custer on his black war-horse conferring with Pleasonton who is astride a gray charger. The Confederate cavalry had succeeded in breaking a part of the Federal rank. Pleasonton turned in his saddle and called to Custer: "Ride to our right and get the battery in position to reply to these infernal guns." Custer spurred his horse into the thunder of cannon and the crash of musket and carbine volleys. "The man is lost," muttered Pleasonton. Suddenly, emerging from the bank of smoke, the Union batteries wheeled into view under the rapid fire. Custer dashed across the field. From that moment he became a notable figure in the war. He was then but twenty-three years of age, but was immediately appointed by Lincoln a brigadier-general of volunteers. In speaking of him, General Pleasonton said: "I regard Custer as one of the finest cavalry officers in the world, and, therefore, have placed him in command of what is no doubt the best cavalry brigade in the world." Custer was about six feet tall, with sharp blue eyes, and light hair hanging over his shoulders. He had a slight impediment in his speech and uttered a shrill yell as he rushed like an avalanche at his foe. He wore a black velvet jacket, slouched hat and a red scarf cravat.

THE Army of the Potomac lay massed about the city of Frederick. Lee was rushing toward the Susquehanna. Hooker disagreed with Halleck at Washington regarding his method of attack and resigned his command, requesting instant release from further responsibility. Lincoln accepted the resignation and appointed General George G. Meade to the chief command. In the midst of this momentous campaign the great army changed leaders. This photograph was taken shortly after Meade began his operations. It shows him with his generals of the Army of the Potomac. Meade occupies the chair in the center of the picture. At this time he was about forty-eight years of age. He had graduated from West Point when nineteen years old, but resigned the following year and remained out of the army for the next six years, but returned in the period preceding the Mexican War, after which he was engaged in the survey of the northern lakes. He was one of the first to respond to the call in 1861. He took part in the early engagements of the Army of the Potomac and was in the Battle of Mechanicsville and Gaine's Mills and the Battle of Newmarket Crossroads. When Hooker was wounded at Antietam, Meade took charge of a corps and continued the brave fight during the remainder of the day. He had two horses killed under him and was slightly wounded, but did not leave the field. At Fredericksburg he led his men boldly to the Confederate works. In the Battle of Chancellorsville, Meade's corps carried the earth-works and fought fearlessly. On the twenty-eighth day of June, in 1863, Meade assumed command of the Army of the Potomac. The tide of battle seemed to turn with his appointment and his victories are almost unparalleled.

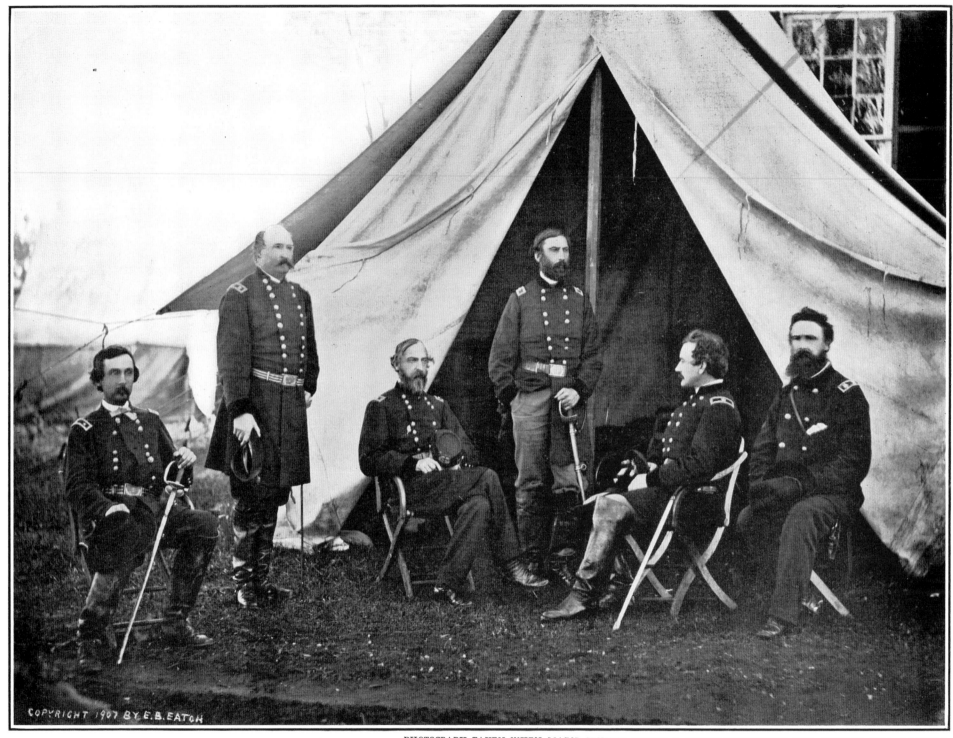

PHOTOGRAPH TAKEN WHEN MAJOR-GENERAL GEORGE G. MEADE COMMANDED THE ARMY OF THE POTOMAC

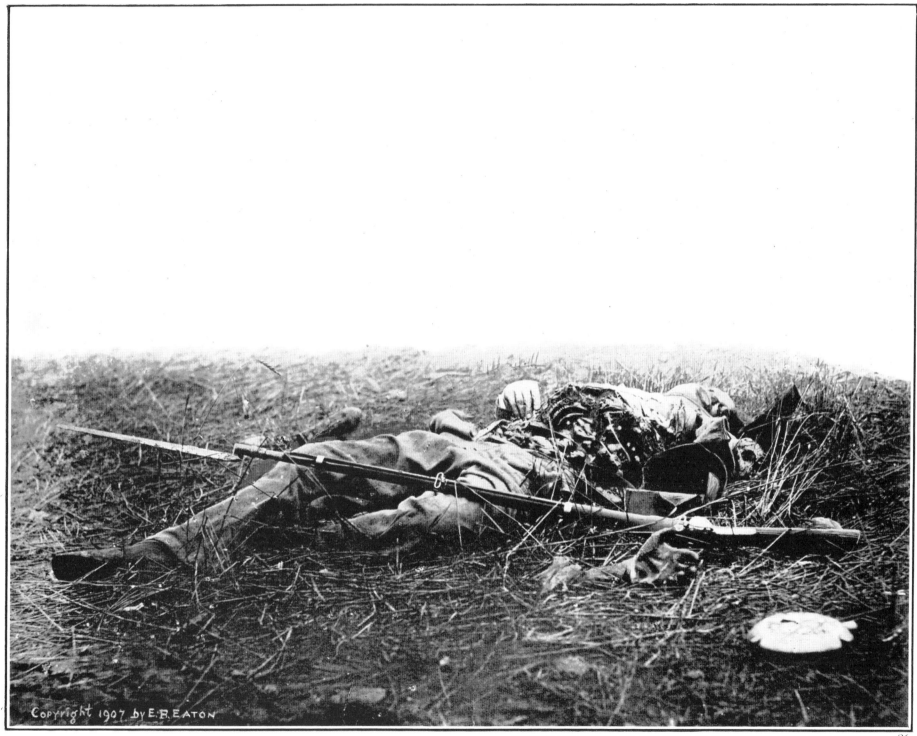

Copyright 1907 by E.B. EATON

PHOTOGRAPH TAKEN ON THE FIELD OF GETTYSBURG AFTER THE BATTLE IN 1863

THE turning point of the Civil War is the Battle of Gettysburg. From that day the Confederate cause began to wane. Few battles of modern times show such great percentage of loss. Out of the one hundred and sixty thousand men engaged on both sides, forty-four thousand were killed or wounded. Brady's cameras reached the field of battle in time to perpetuate some of its scenes. The ghastliness of the pictures is such that it is with some hesitation that any of them are presented in these pages. It is on the horrors of war, however, that all pleas of peace are based. Only by depicting its gruesomeness can the age of arbitration be hastened. It is with this in mind that this photograph is here revealed. There is probably not another in existence that witnesses more fearful tragedy. The photograph is taken on the field of Gettysburg about nineteen hours after the last day's battle. It shows a Union soldier terribly mutilated by a shell of a Confederate gun. His arm is torn off and may be seen on the ground near his musket. The shell that killed this soldier disemboweled him in its fiendishness. This picture is as wonderful as it is horrible and should do more in the interest of peace than any possible argument. Something of the bloodshed on the battlefield of Gettysburg may be understood when it is considered that the battlefield, which covered nearly twenty-five square miles, was literally strewn with dead bodies, many of them mutilated even worse than the one in this picture. The surviving veterans of Gettysburg have seen war's most horrible aspects. Gallant and daring commanders led those brave men in that three days' inferno, from the first to the third of July, in 1863.

BOROUGH OF GETTYSBURG IN 1863—SCENE OF ONE OF WORLD'S GREATEST CONFLICTS

GETTYSBURG witnessed some of the hardest fighting that the world has ever seen. This photograph was taken a short time after the battle in 1863. This little borough became a field of carnage. In the surrounding hills occurred the terrific conflict of Big Round Top and Little Round Top, Seminary Ridge and Cemetery Ridge, and Culp's Hill, the Bloody Wheatfield and Peach Orchard. A view is given of the little house in which General Meade made his headquarters. On the first day of battle this house was in direct range of the artillery fire rained by the Confederates on the Union lines just before Pickett's great charge. The horses of General Meade's aides were hitched to the fence and trees near the house. Sixteen of these horses were killed during the artillery fire, and their dead bodies are seen in the road.

MEADE'S HEADQUARTERS ON CEMETERY RIDGE

LEE'S HEADQUARTERS ON SEMINARY RIDGE

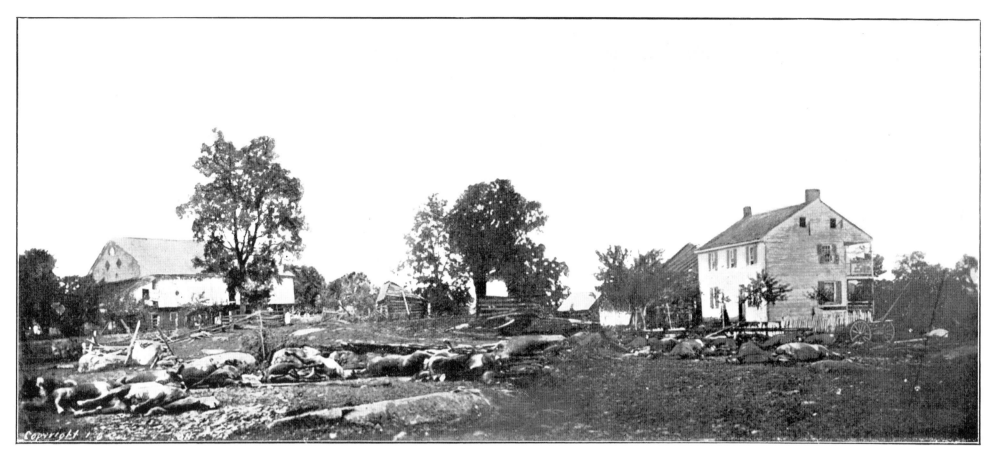

DEAD ARTILLERY HORSES AFTER FIGHT AT TROSTLE'S HOUSE AND BARN IN GETTYSBURG

SOME knowledge of the slaughter of Gettysburg may be gained by this picture of Trostle's house and barn at which was stationed a Union battery of light artillery. This view shows where the guns stood. Sixty-five of the eighty-eight artillery horses were left dead on the field. About this time, on the last day of the greatest battle of the war, Pickett made his fierce charge, which is one of the mightiest in history. It was witnessed by the two great armies in the middle of the afternoon of a summer day—a most spectacular tragedy of magnificent courage. It has been said that Gettysburg was the common soldier's battle and that its great results were due, not so much to military strategy as to the intelligent courage and the magnificent heroism of the brave soldiers.

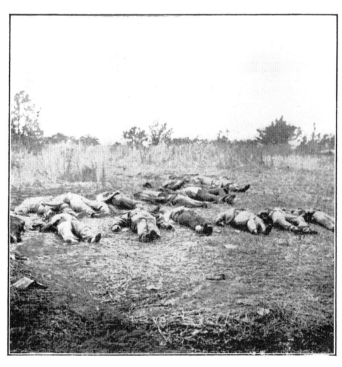

CONFEDERATE DEAD ON GETTYSBURG "WHEATFIELD"

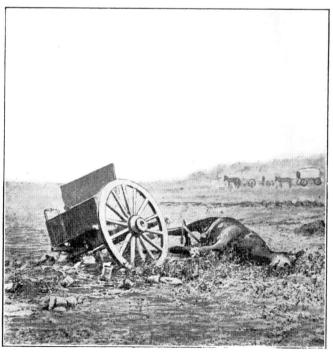

SHATTERED CAISSON—GETTYSBURG "PEACH ORCHARD"

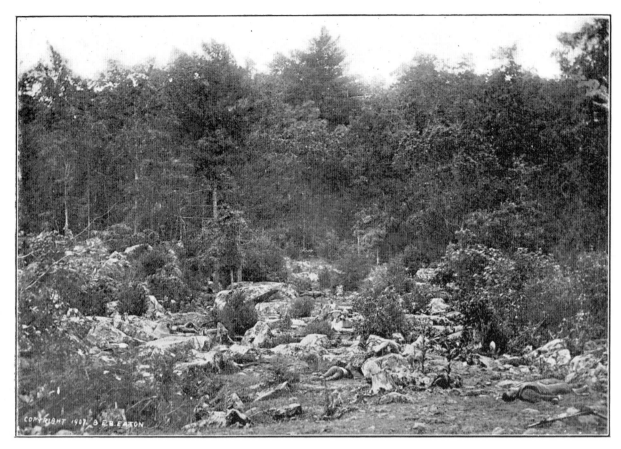

DEAD AMONG THE ROCKS OF LITTLE ROUND TOP ON GETTYSBURG BATTLEFIELD

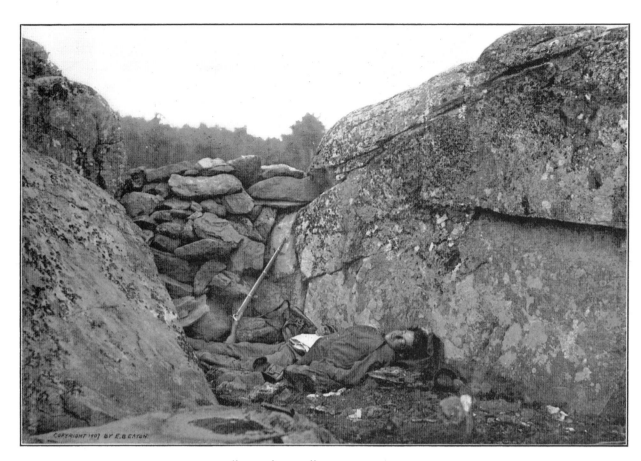

DEAD SHARPSHOOTER IN "DEVIL'S DEN" ON LITTLE ROUND TOP AT GETTYSBURG

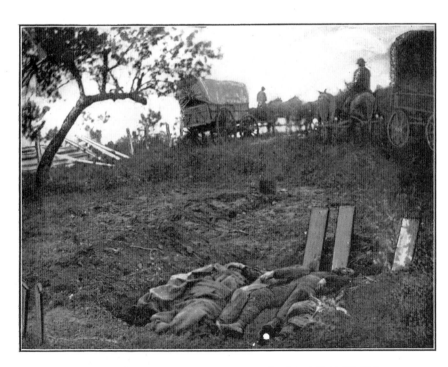

UNCOVERED CONFEDERATE GRAVE AT GETTYSBURG

GETTYSBURG is the "Waterloo of the American Continent." A photograph is here shown of the dead soldiers lying on the battlefield. To silence Hazlett's Battery, which was posted on the summit of Little Round Top, the Confederates pushed their sharpshooters among the rocks in the mountain. A few hours before these photographs were taken one of these sharpshooters mortally wounded General Weed, who was directing the movement of his troops from the summit. Lieutenant Hazlett, who was an old schoolmate of the fallen general, was commanding the battery and hastened to take the dying words of his friend and comrade, when he, too, fell dead, pierced by a bullet from the dread sharpshooters. Like a flash the guns of the battery were turned on the "Devil's Den" from which came the fatal shots as this picture attests.

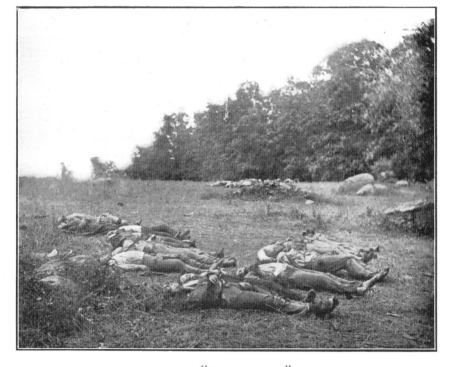

CONFEDERATE DEAD IN "WHEATFIELD" AT GETTYSBURG

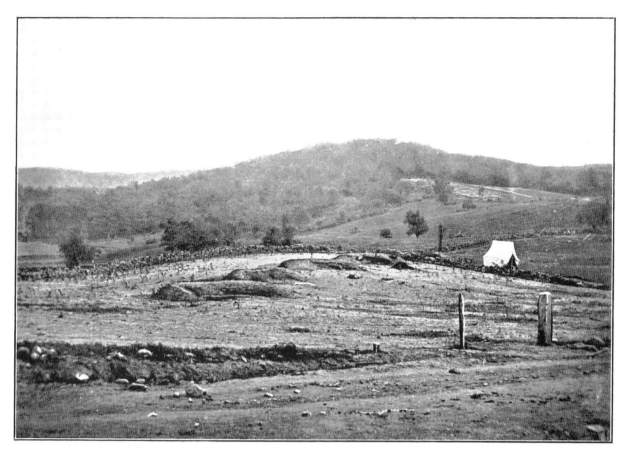

EARTHWORKS AT CULP'S HILL AT GETTYSBURG IN 1863

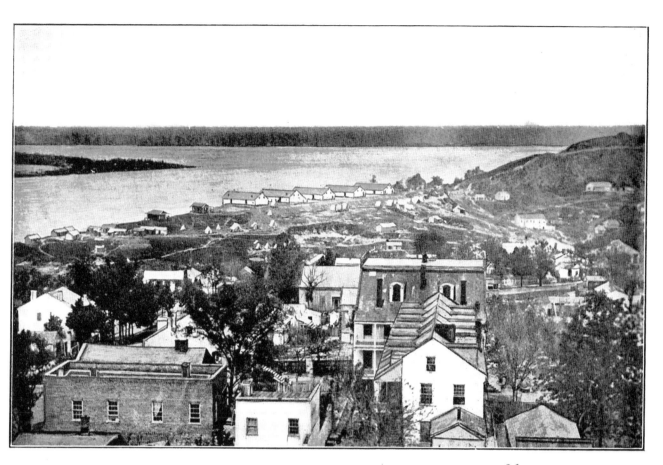

TENTS ALONG RIVER FRONT AT VICKSBURG, MISSISSIPPI, IN 1863

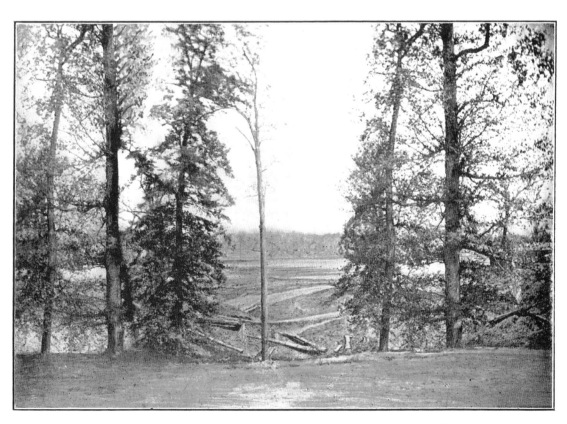

BATTLEFIELD OF BIG BLACK RIVER IN MISSISSIPPI IN 1863

AS the tide of battle drifted to the West in 1863, the war photographers hurried to the region of the Mississippi. Grant had been pursuing his operations toward Vicksburg. With Sherman and McClernand, he was maneuvering to take the key to the South by storm. A photograph is here shown of Champion Hills near Big Black River territory, on the outskirts of Vicksburg, where the armies first met. The Confederates held a strong line of earthworks on the eastern bank of the river. The Federals, before a heavy fire of musketry, crossed a ditch, delivered a terrific volley, and clambered over the breastworks with empty muskets. The Confederates, in falling back, found that their comrades had set fire to both of the bridges and were compelled to surrender. Two thousand prisoners, eighteen pieces of artillery, six thousand stand of small arms, and many commissary stores were captured. General Lawler's Brigade led the charge. The battle lasted four hours. On the eighteenth of May, 1863, the Federals began crossing the Big Black by felling trees on both banks so that they tumbled into the river and interlaced, using bales of cotton instead of boats. On the morning of the twenty-second, with furious cannonading, the last assault on the defences of Vicksburg was made. This campaign is a remarkable military exploit. In twenty days Grant crossed the Mississippi River with his entire force, moved into the rear of Vicksburg, fought and won four distinct battles, captured the State Capitol, and destroyed the Confederate arsenals and manufactories. His troops marched one hundred eighty miles with only five days' rations from the quartermaster, and captured over six thousand prisoners, twenty-seven cannon and sixty-one field pieces. All this was accomplished by forty thousand brave men against sixty thousand.

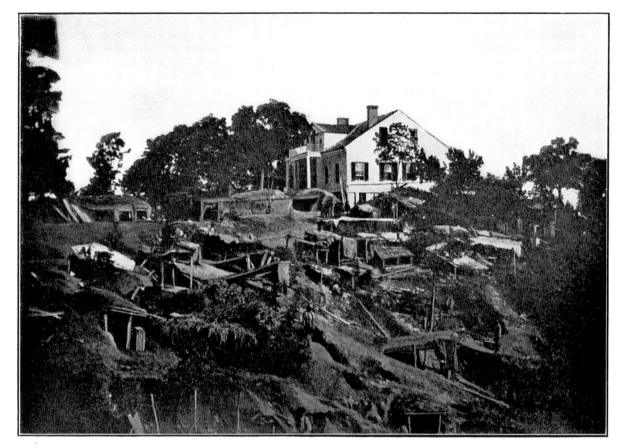

BOMB-PROOF CAMP IN UNION LINES IN FRONT OF VICKSBURG

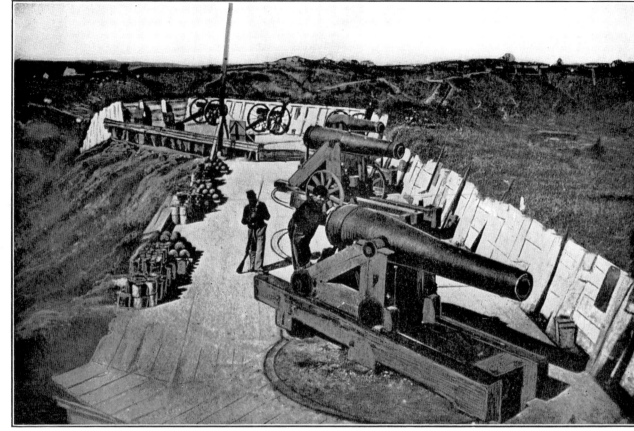

BEHIND THE ENTRENCHMENT AT BATTERY SHERMAN BEFORE VICKSBURG

THE Confederate works held by Pemberton at Vicksburg were seven miles long. Grant's lines about the city extended over fifteen miles. Commander Porter brought down all his mortar boats on the Mississippi and began a fusilade of six thousand mortar shells a day, while the land batteries threw four thousand. In the meantime, famine stalked through Vicksburg on the thirty-sixth day of the siege. Mule and dog meat, with bean flour and corn coffee formed the daily fare. The earth trembled under the concussions from the Army and Navy cannon and the entire forest was set on fire. The Confederate general, on the morning of July third, proposed an armistice, preparatory to recapitulation. Grant met the Confederate commander under an oak tree. At ten o'clock on the morning of July fourth, General Logan began a march into Vicksburg and hoisted the American ensign over the court-house. The fall of Vicksburg and the defeat of Lee at Gettysburg occurred on the same day and lifted the hearts of the Northern people to a sense of thanksgiving, for it was believed that the war was now over. During the siege the Confederate loss was fifty-six thousand men. Grant captured more than sixty thousand muskets, light and heavy artillery, with a vast amount of other property, such as locomotives, cars, steamboats and cotton. The Federal loss during the siege was about 9,000 killed, wounded and missing. The war cameras followed the Union Army into the captured city and the old negatives vividly picture the conditions. A camera was taken to the bomb-proof quarters of Logan's Division and into Battery Sherman. These negatives are here reproduced.

About this same time several cameras were taken into the far South and one of the first negatives was taken at Big Black River Station in Mississippi and another at New Orleans when the commissioned officers of the 19th Iowa Infantry were being brought in from Camp Ford, Texas, as exchanged prisoners of war.

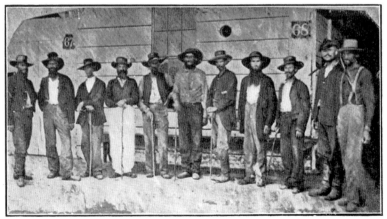

PRISONERS OF WAR FROM TEXAS

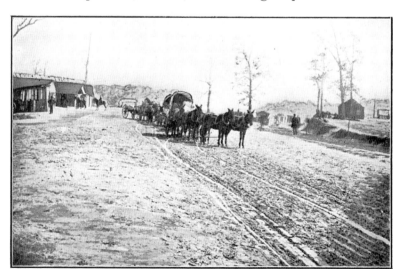

BIG BLACK RIVER STATION IN MISSISSIPPI

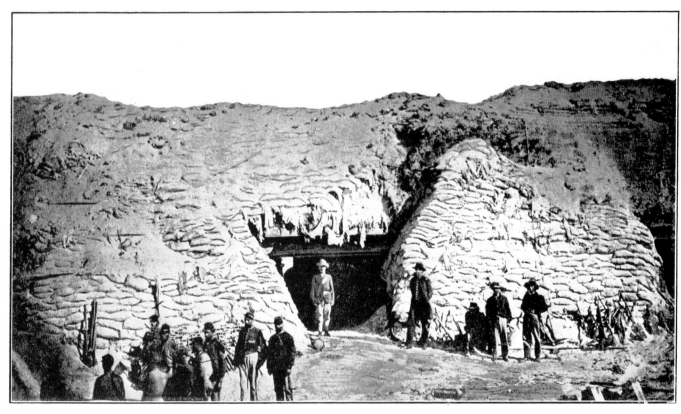

BOMB-PROOF AT FORT WAGNER UNDER HEAVY FIRE IN 1863

THE Government at Washington believed that it was now time to secure the reparation for the firing on Fort Sumter which had precipitated the War. Sumter, during the entire conflict had been the center of a radius of forts which now had over three hundred guns mostly of the heaviest caliber. It held a strong position on the Atlantic Coast and protected the land movements about South Carolina. Fort Sumter barred the main channel. On Sullivan's Island were Fort Moultrie, Fort Beauregard, Battery Bee and sand bag batteries at the extremity. On James's Island stood Fort Johnson, Fort Ripley and smaller forts. Castle Pinckney lay in front of the city, and on Morris Island there were Battery Gregg, Fort Wagner, and a battery on Lighthouse Inlet. All the channels were blocked with huge iron chains, and an immense hawser buoyed with empty casks, extended from Fort Sumter to Fort Ripley, the entire harbor being blocked with torpedoes. Brady's cameras lay in the Union lines and occasionally were ventured toward the Confederate fortifications. Many negatives of exteriors were obtained at a distance. After the forts fell into the Government control the cameras were taken behind the breast-works. These remarkable negatives are now exhibited and reveal the secrets of the Confederates. The picture of the bomb-proof at Fort Wagner, under heavy fire in 1863, reveals the ingenuity of the engineers in both armies in utilizing every available substance in protecting the soldiers. The Confederates constructed many strong fortifications and they fell only under the severest bombardment from the heaviest guns of the Federal troops.

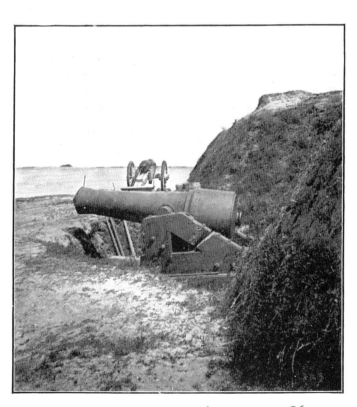

FORT JOHNSON ON JAMES' ISLAND IN 1863

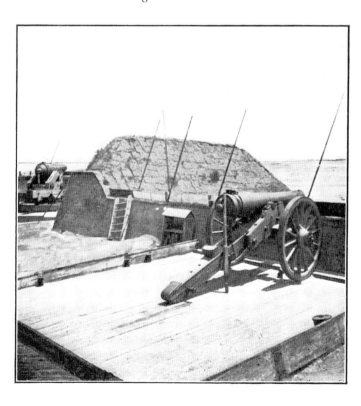

FORT MARSHALL ON SULLIVAN'S ISLAND IN 1863

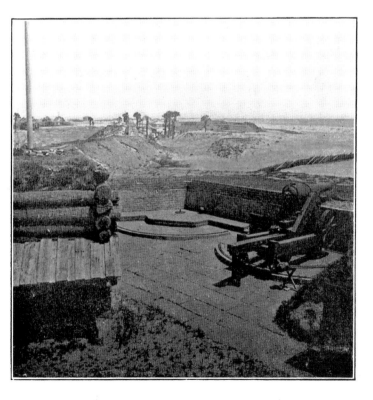

INTERIOR OF FORT MOULTRIE ON SULLIVAN'S ISLAND

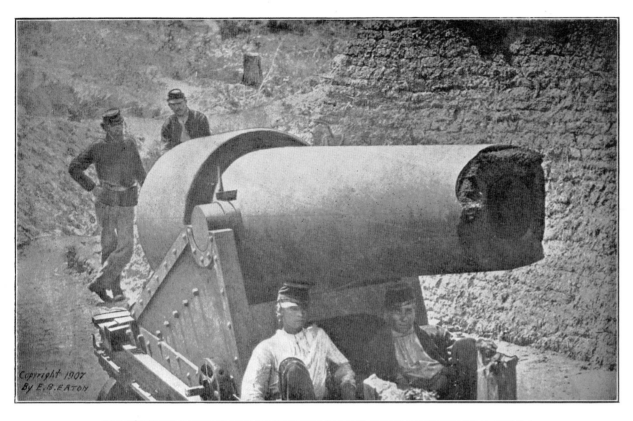

300-POUNDER PARROTT GUN IN BATTERY STRONG AFTER BURSTING OF MUZZLE

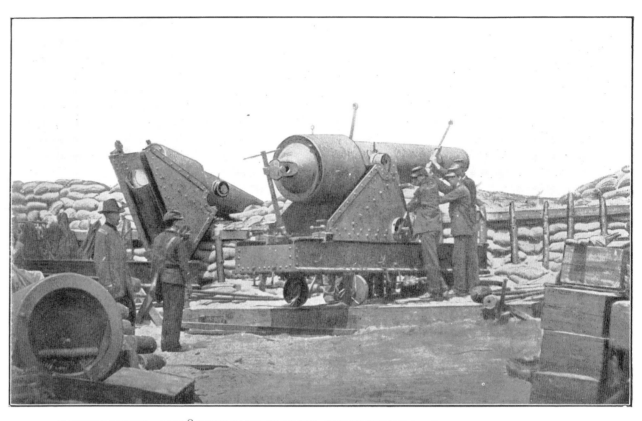

BATTERY BROWN—TWO 8-INCH PARROTT RIFLES, ONE OF WHICH BURST DURING BOMBARDMENT

FIVE 10-INCH SIEGE MORTARS IN BATTERY REYNOLDS FIRING AGAINST FORT SUMTER

NAVAL BATTERY OF TWO 80-POUNDER WHITWORTH'S—BREECHING BATTERY AGAINST FORT SUMTER

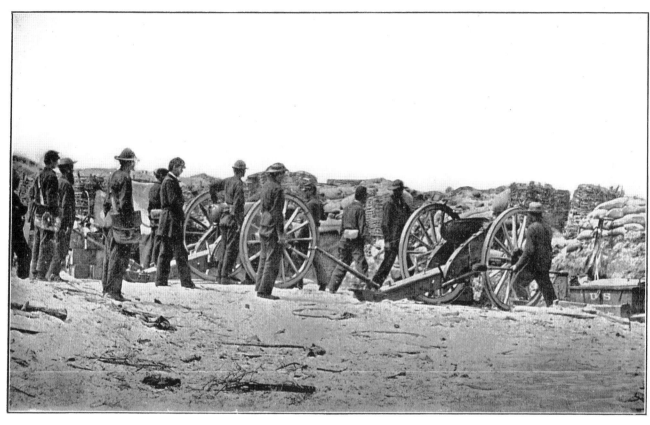

SECTION OF BIRCHMEYER'S BATTERY IN SECOND PARALLEL

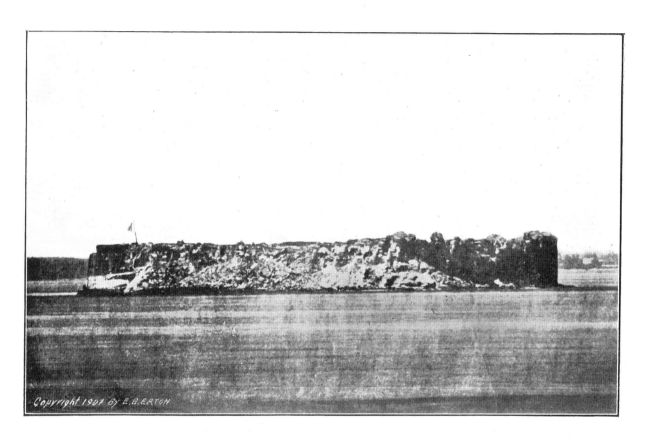

FORT SUMTER IN RUINS AFTER BOMBARDMENT IN 1863

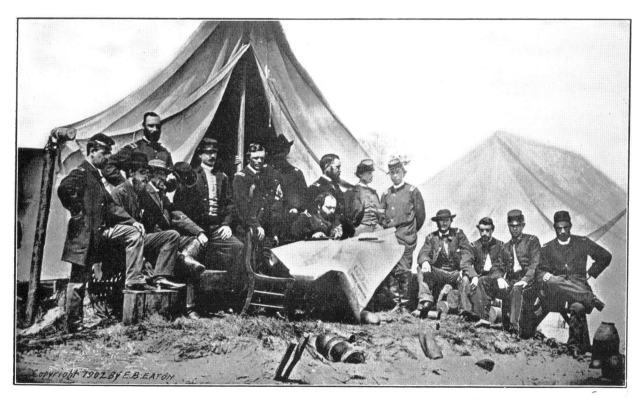

MAJOR-GENERAL QUINCY A. GILLMORE AND STAFF IN 1863

EARLY in 1863 the Government decided that Fort Sumter must be reduced. Admiral Dahlgren was given full charge of the undertaking. On the eighteenth of July, the land forces under General Quincy A. Gillmore began siege. He erected batteries across Morris Island and commenced fire on Fort Wagner while Dahlgren attacked both Fort Wagner and Fort Sumter. Fort Wagner responded with only two guns which led Gillmore to believe that the Confederates were demoralized. The Federal troops were within two hundred yards of the fort before the Confederates opened grape fire. A flash of musketry blazed from the parapet. The daring Federals rushed at the fort and clambered up the exterior slope. It was here that Joseph Alvan Wooster, color bearer for the Sixth Connecticut, performed the valiant deed that cost him his life. He climbed along in advance of the line and triumphantly placed his flag on the parapet. A Confederate soldier sprang forward and placed the muzzle of his musket on Wooster's heart and fired. General Putnam rushed to the rescue with a brigade, only to be killed, with nearly every commissioned officer in his command. The remnants of Strong's and Putnam's command retired, having lost over half of their strength. General Gillmore, and his staff, in charge of the land forces at Charleston allowed the war photographers to turn the lens on them in camp. The general was born in Black River, Loraine County, Ohio, and had graduated from West Point. In 1861 he was placed on General W. T. Sherman's staff on the South Carolina Expedition. During February, 1862, he commenced opperations for the attack of Fort Pulaski, on the Savannah River, Georgia. On April 28, 1862, he was promoted to a brigadier-generalship of volunteers. In September, 1862, he was ordered to the West as Commander of the District of Western Virginia, of the Department of the Ohio. He was afterwards assigned to the command of one of the Divisions of the Army of Kentucky. He assumed command of Department of South Carolina June 12, 1863.

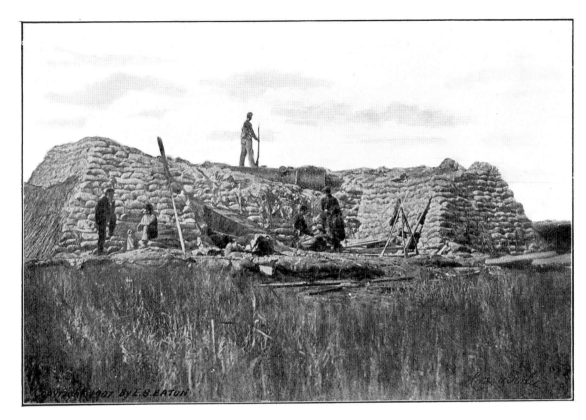

THE 8-INCH PARROTT RIFLE GUN, "SWAMP ANGEL" AFTER BURSTING

ON the ninth of August the Federal cannon were within three hundred and thirty yards of Fort Wagner and the guns were trained on Fort Sumner and Battery Gregg. General Gillmore had a small battery placed in a marsh west of Morris Island, on which was an eight-inch Parrott Gun nick-named the "Swamp Angel." It had a range of five miles and threw its enormous shells into the city of Charleston. The Confederate fortifications were reinforced by General Beauregard and maintained a continuous fire from over two hundred guns. On the seventeenth of August, Gillmore had twelve heavy guns on Morris Island, and the simultaneous assault by batteries and infantry was directed against Fort Sumter. For seven days this terrible fusilade continued. Over one hundred thousand shells and shot were thrown into the fort which was battered into ruins. The bombardment of Fort Sumter was begun on the fifth of September and continued for forty-two hours. An assault was planned for the ninth, but when daylight came it was found that several forts were abandoned. It was supposed that Fort Sumter was tenantless. A boat load of soldiers was sent to take possession. As they landed, a terrific volley of musketry was fired. The Confederates fought like tigers from covered positions in the ruins of the fort. The Federals abandoned the attempt without further molestation, satisfied with the destruction they had wrought and the successful blockade of Charleston Harbor. The views engraved by the lens on these pages lay the actual scenes of destruction before the eyes of the world. The "Swamp Angel" was one of the demons of war. Piles were driven, a platform was laid upon them, and a parapet was built with bags of sand, fifteen thousand being required. All this had to be done after dark, and occupied fourteen nights. Then, with great labor, the eight-inch rifled gun was dragged across the swamp and mounted on this platform. It was nearly five miles from Charleston, but by firing with a high elevation was able to reach the lower part of the city. The soldiers named this gun the "Swamp Angel." Late in August it was ready for work, and, after giving notice for the removal of non-combatants, General Gillmore opened fire, and produced great consternation, but at the thirty-sixth discharge the "Swamp Angel" burst, and was never replaced.

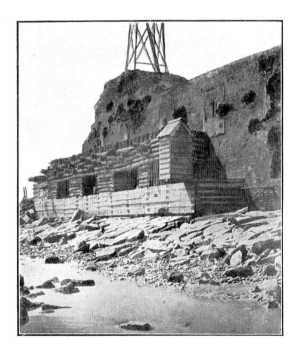

BATTERED EXTERIOR OF FORT SUMTER

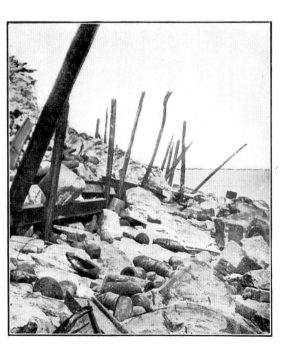

DESTRUCTION AFTER BOMBARDMENT OF SUMTER

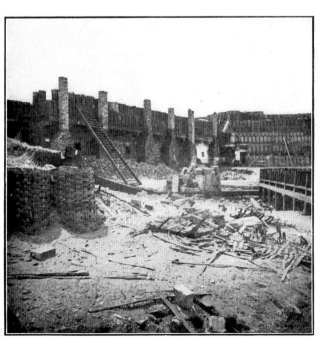

WRECKED INTERIOR OF FORT SUMTER

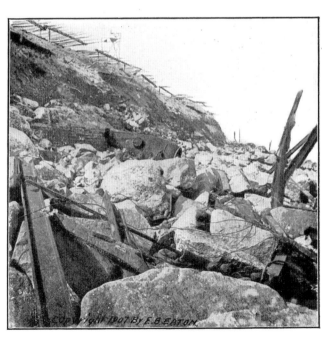

DISMOUNTED CANNON AT FORT SUMTER

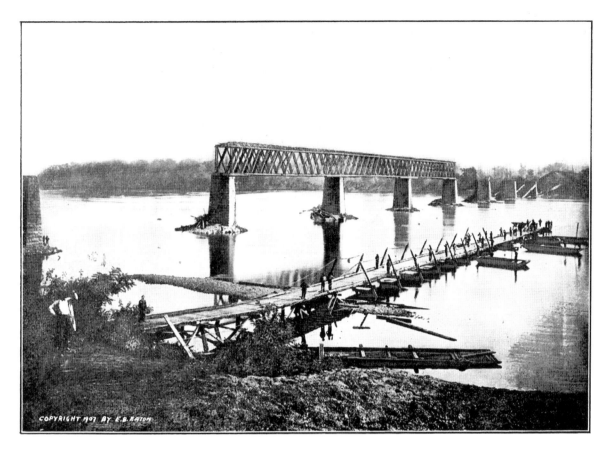

DESTROYED RAILROAD BRIDGE, BRIDGEPORT, ALABAMA—PONTOON IN COURSE OF CONSTRUCTION

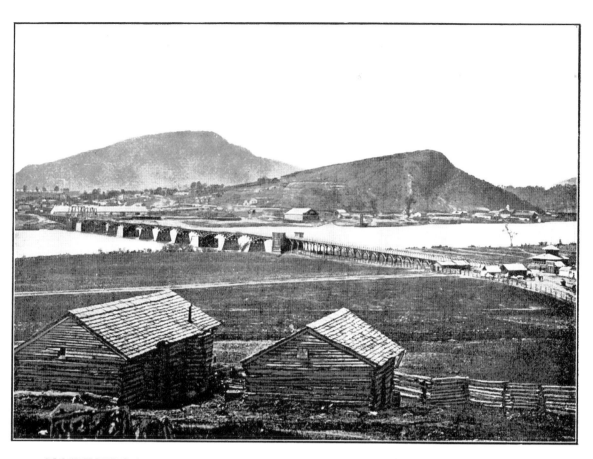

BLOCKHOUSES AND ARMY BRIDGE ACROSS TENNESSEE RIVER NEAR CHATTANOOGA

ON BATTLEFIELD OF CHICKAMAUGA CREEK—LEE AND GORDON'S MILLS

WHEN Vicksburg fell, the cheering along the Federal lines in the Mississippi Campaign aroused the attention of the Confederate pickets until it was carried clear through to Louisiana, where the Confederate forces were concentrated at Port Hudson. General Banks had succeeded Butler at New Orleans and was co-operating with Grant on the Mississippi to take possession of the Red River region and expel the Confederate forces from Louisiana and Texas. The siege of Port Hudson had been hard fought. The Confederates under General Gardner agreed that if Vicksburg had fallen their surrender was the only thing left for them. On the ninth of July, in 1863, the Confederate general at Port Hudson with visible emotion tendered his sword. It was declined because his bravery entitled him to retain it. The Federals were now in the entire possession of the Mississippi. While Grant's Army had been pounding at the gates of Vicksburg, Rosecranz was maneuvering with Bragg at Murfreesboro, Tennessee. For six months these two armies stood confronted, but met only in severe skirmishes. Rosecranz compelled Bragg to fall back from one place to another. He was driven through middle Tennessee, to Bridgeport, Alabama, where he crossed the Tennessee River, burned the bridge behind him and entered Chattanooga. The Brady cameras were in the Union lines and arrived in time to secure this negative of the ruined bridge and the pontoon bridge that was being built by the Union forces in pursuit of Bragg. A clash came at Chickamauga, a point about twelve miles from Chattanooga, on the nineteenth and twentieth of September, in 1863. It has been called the greatest battle of the West. The cannonading and the musketry was at close range and the Federal lines were being swept back when General Thomas and his men made the heroic stand that saved the Federal Army from destruction, after a loss of 15,851, killed, wounded and missing. The Confederate victory was gained at the cost of 17,804.

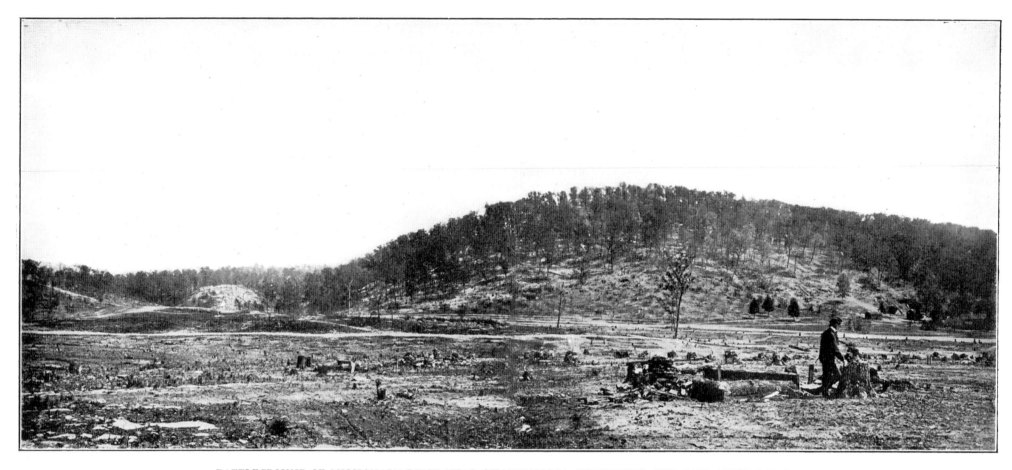

BATTLEGROUND OF MISSIONARY RIDGE NEAR CHATTANOOGA, TENNESSEE, TWO DAYS AFTER BATTLE

CHICKAMAUGA has been called the greatest battle in the West. When the smoke of the conflict had lifted, the war photographers found the Federal Army closed up in Chattanooga. The Confederate general moved to cut off all communication to the Federal lines, seizing roads, destroying the bridges and preventing access to Nashville where the base of supplies had been located. The Army of the Cumberland was reduced to the verge of starvation. Not less than 10,000 horses and mules perished. Grant was given command of the department of the Mississippi, comprising the armies and departments of the Ohio, Tennessee and Cumberland. He telegraphed to Thomas: "Hold Chattanooga at all hazards." The hero of Chattanooga replied: "I will hold the town until we starve."

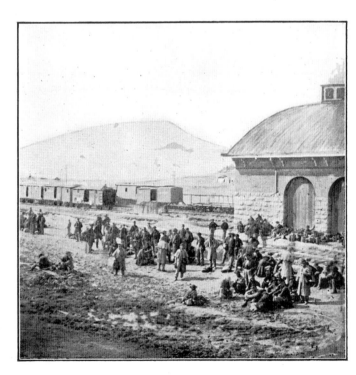

CONFEDERATE PRISONERS AT CHATTANOOGA

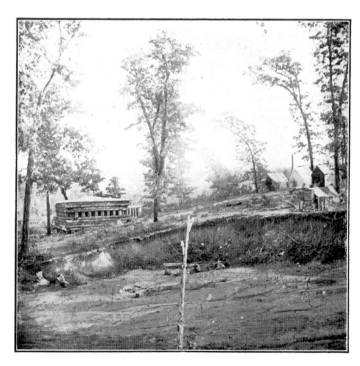

BLOCKHOUSES NEAR CHATTANOOGA

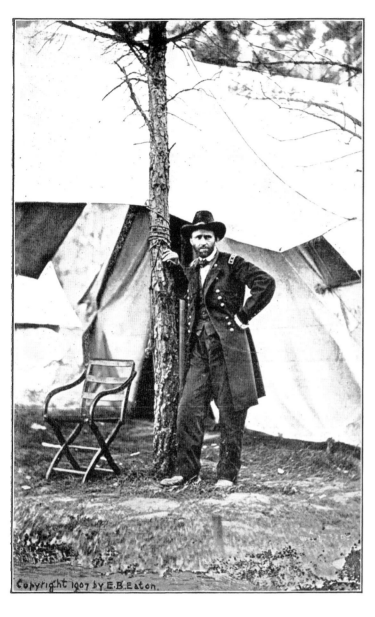

GENERAL ULYSSES S. GRANT IN MISSISSIPPI CAMPAIGN, 1863

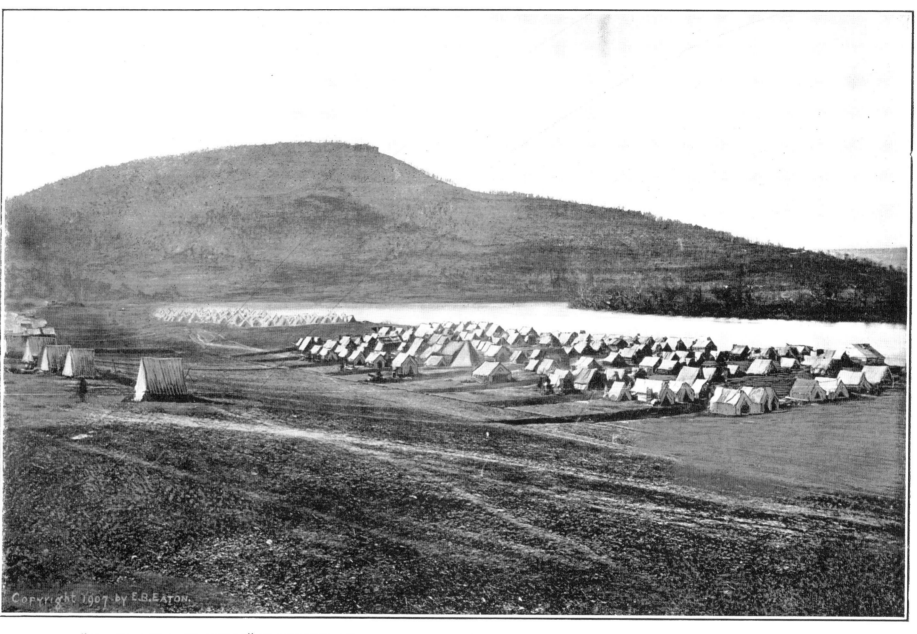

"BATTLE ABOVE THE CLOUDS" ON LOOKOUT MOUNTAIN IN TENNESSEE—ENGINEERS OF ARMY OF THE CUMBERLAND IN CAMP

THE war cameras reached Nashville on the same day that Grant entered the city, October 21, 1863, and followed him closely throughout the campaign. Grant hurried to Chattanooga and found the troops without shoes or clothing, and all food exhausted. He telegraphed to Burnside to hold Knoxville and appealed to Admiral Porter at Cairo to send gunboats to convey transports carrying rations from St. Louis for Sherman's Army, which was moving up from the Mississippi. Bragg was entrenched on Missionary Ridge, extending along the crest and across Chattanoga Valley to Lookout Mountain. The Confederate fortifications were very strong and their lines reached over the Racoon Mountain. The war cameras were taken to the foothills of Lookout Mountain, where an engineers' brigade of the Army of the Cumberland was encamped. Grant succumbed to appeals to stand before the camera and the negative is here reproduced. The haggard expression on his face shows the tremendous responsibility that rested upon him. On the twenty-third of November, in 1863, long lines of infantry moved forward and the heavy guns opened fire. The Federal lines flashed across the valley sweeping everything before them, pushing the Confederate skirmish line from their rifle pits, to the foothills of Lookout Mountain. On the twenty-fourth, Grant stood on the top of Orchard Knob, watching Hooker's men rush to the side of Lookout Mountain, leaping from one rocky ledge to another, scrambling over huge boulders, and through deep chasms in a rain of solid shot and shell. They charged almost to the muzzle of the enemy's cannon, gaining ground foot by foot, until at last they reached the foot of the Palisades, and were finally lost in the mist that veiled the mountain. For three hours the battle raged above the clouds. At sunset the mist disappeared and moonlight fell on old Lookout. The Confederate forces could be seen occupying the summit. Hooker's men scaled the Palisades. The Confederates withdrew into the woods and sought the protection of the night. At sunrise, on the twenty-fifth of November, these Kentucky soldiers unfurled the Stars and Stripes. A great cheer arose from the army in the valley.

THE Battle of Lookout Mountain is the most spectacular in history. It was impossible to carry the war camera over its rugged heights. Had they succeeded in getting to the summit, the mist that enveloped the valley would have made it impossible to have secured a single scene of the great conflict. The Federals occupied a strong position on the mountain, looking across the Chattanooga Valley to Missionary Ridge, where Bragg had concentrated his entire army. The twenty-fifth of November was a magnificent day. Seldom has a battle begun under a brighter sun. The Confederate artillery frowned from the summit of Missionary Ridge. The glittering steel of Hooker's men flashed on Lookout Mountain. The Cumberland veterans under Thomas were a solemn phalanx in the valley while Sherman's compact lines were eager for the charge. On the top of Orchard Knob stood Grant's bugler and the echoes of the "Forward" signal fell into the valley, being taken up by the other buglers in melodious refrain. Hooker's men moved down the eastern slope of Lookout Mountain, sweeping across the valley in grand lines. Bragg's batteries were centered on Sherman, who swept his men heroically forward over a succession of low hills.

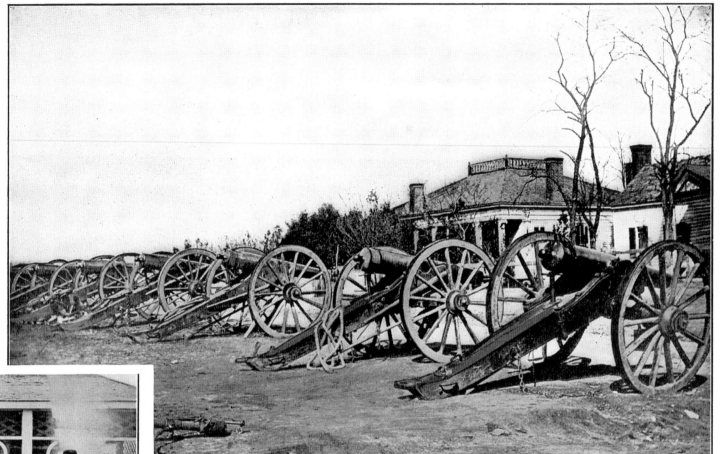

CONFEDERATE ARTILLERY CAPTURED AT MISSIONARY RIDGE— PARKED NEAR CHATTANOOGA

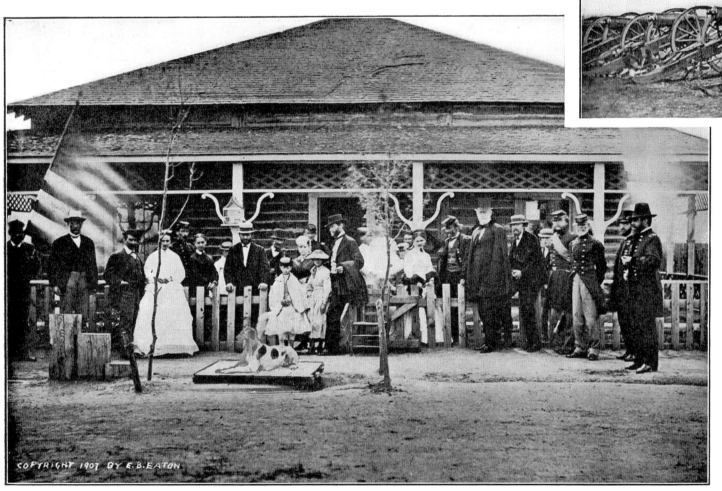

GENERALS GRANT, SHERMAN, SHERIDAN, HOOKER, HARNEY, DODGE, GIBBON, POTTER, AT FORT SANDERS

UNDER fire from the Confederates, Corse's Brigade struggled desperately for an hour and a half without gaining advantage, while Generals Loomis and Smith took possession of Missionary Ridge. At two in the afternoon occurred one of the most impressing spectacles ever witnessed on a battlefield. Union soldiers with fixed bayonets rushed into the storm of shell without firing a shot until after the skirmish line had been taken and the Sixth Brigade swept over the Confederate rifle pits. The men flung themselves to the earth to avoid the volleys of canister, grape and musketry that were hurled upon them. At sunset Sherman held Bragg's right in check; Hooker was driving at his left. The final assault on his center was begun and in twenty minutes Missionary Ridge was belching flames. Every Confederate gun and cannon was in action. The Federal soldiers rushed into the very mouth of death, reaching the crest, breeching the Confederate lines until they gave way and retreated. The cannon which they abandoned were swung and turned upon them. The victory had cost the Union Army 5,616, killed, wounded and missing, against a Confederate loss of 8,684.

THE siege of Knoxville, Tennessee, was raised late in 1863. When the news of Bragg's defeat at Chattanooga reached Longstreet, who was besieging Knoxville, he knew that Grant would now send Burnside relief. Bragg decided to carry the city by storm. The attack was to be made on Fort Sanders, a Federal fort of great strength, containing twenty-six guns. The Confederate columns forced their way through a network of wire that had been wound from stump to stump, until they finally reached the parapet. A Confederate officer sprang to the summit with the flag of his regiment and demanded surrender. Pierced by a shower of bullets, his body rolled into the ditch, his hand clutching the flagstaff. The Confederates charged again only to be repulsed. Under a flag of truce the fighting ceased while Longstreet's men carried away their dead, dying and wounded. Grant had ordered twenty thousand men under General Granger to the rescue of the besieged city, but they failed to start, and Sherman hurried to the relief. He reached Knoxville on the fifth of December and found the siege reduced and Longstreet had started for Virginia. Sherman's troops had marched four hundred miles to fight at Chattanooga, then marched one hundred and two miles to compel the Confederates to retire from Knoxville. When the news reached the North, Grant was hailed as the Nation's saviour. Congress bestowed upon him a gold medal, while Bragg, the Confederate general, went down before a storm of indignation in the South. One of the war cameras shortly after the battle was placed on the parapet of Fort Sanders, and this negative of the ruins was taken, showing the University of Tennessee.

PHOTOGRAPH TAKEN OVER THE RUINS AT KNOXVILLE, TENNESSEE, IN 1863, FROM FORT SANDERS

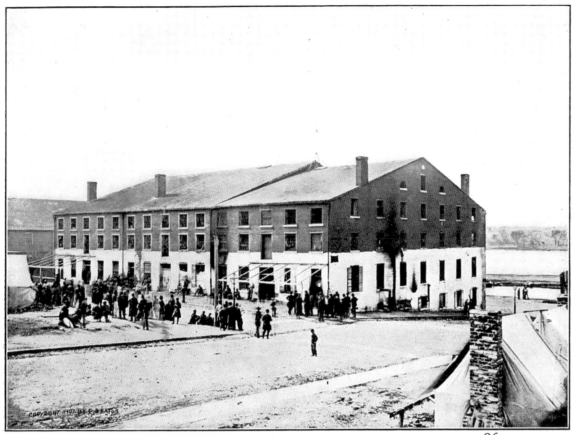

LIBBY PRISON AT RICHMOND CROWDED WITH UNION PRISONERS IN 1864

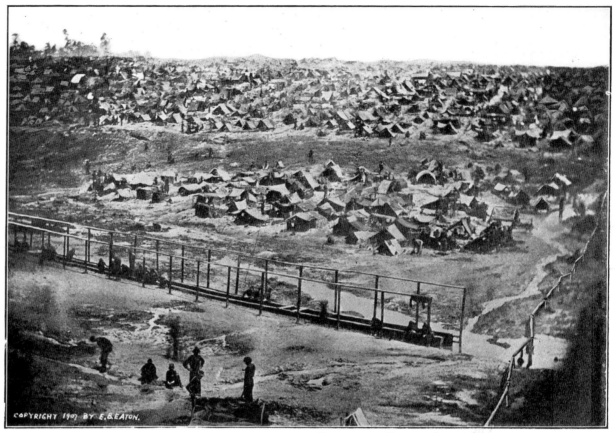

ANDERSONVILLE PRISON WITH ITS "DEAD LINE" AND "BROOK"

IT is estimated that 188,000 Union soldiers and sailors endured the hardships of the sixteen Confederate prisons during the Civil War. In the prison yards are 36,401 graves. 11,599 of those released from prisons died before reaching their homes, and 12,000 after reaching home—making 60,000 lives sacrificed in Confederate prisons. Several estimates place the deaths as high as 80,000. Strange as it may seem, the war photographers succeeded in taking their cameras behind prison walls. Three of these remarkable negatives are here revealed. The first one was taken at Libby prison, Richmond, where most of the commissioned officers were confined. In Libby, men were often shot for approaching near enough to a window for a sentry to see their heads. The other two were secured within the "dead line" at Andersonville prison in Georgia. It was an open stockade with little or no shelter, covering about 30 acres. The palisade was of pine logs 15 feet high, closely set together. Outside of this, at a distance of 120 feet, was another palisade, and between the two were the guards. About 20 feet from the inner stockade was a railing known as the "dead line," and any prisoner who passed it was instantly shot. A small stream flowed through the enclosure and furnished the prisoners their only supply of water. The cook houses and camp of the guards were placed on this stream, above the stockade. Starvation and disease drove many of the prisoners mad and they wandered across the "dead line" to end their misery. Fugitives were followed by horsemen and tracked by a large pack of blood hounds. The crowded condition of the prisons at the beginning of 1864 was appalling. There were as many as 33,000 hungry and dying men confined in Andersonville at one time, which gave a space of about four feet square to each man. Some of the other Confederate prisons were at Salisbury, North Carolina, at Florence, South Carolina, on Belle Island in the James River, at Tyler, Texas, at Millen, Georgia, and at Columbia, South Carolina. At Belle Isle the prisoners were packed so close that when they lay sleeping no one could turn over until the whole line agreed to turn simultaneously. While many imaginary pictures have been drawn from descriptions of Andersonville, it has remained for the lens to to engrave the actual scenes, and they are here perpetuated by the negatives.

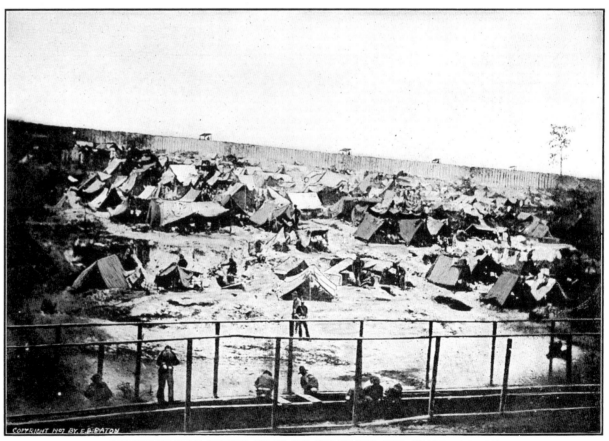

ANDERSONVILLE PRISON WITH ITS STOCKADE AND GUARD TOWERS

AMERICANS are the most loyal people on the face of the earth. Self-government encourages fidelity to Home and Country. In a nation where the *citizens are the Government*, patriotism cannot die. Unfurl the flag of a monarchy and there will be a dutiful reverence to it. Unfurl the Stars and Stripes of the Republic and there will arise a mighty ovation that thrills from the hearts of men—a spontaneous outburst that has never been heard except under the Emblem of Freedom. Liberty is everywhere the mother of patriots.

vice met the response of 87,588 men. Under the fifth proclamation, on June 15, 1863, for militia for six months' service, the ranks were recruited by 16,361 men. The calls of October 17, 1863, and February 1, 1864, brought 369,380 men. Under the call of March 14, 1864, came 292,193 men; between April 23 and July 18, 1864, there were 83,612 mustered into the United States' service. Lincoln's appeal to the manhood of the Nation on July 18, 1864 was met by 386,461 men. The last call for volunteers came on December 19, 1864, and 212,212

days. In many instances over 60,000 recruits fell into line in less than a month. At the last moment of the War, and to the very scene of surrender, thousands of men were pouring into the field.

If the world could have looked upon the marvelous spectacle of all the men who took part in the Civil War, marching five abreast, the triumphant procession would have stretched from the Atlantic, across the Continent, to the Pacific—a grand pageant of 1,696 regiments, six companies infantry; 272 regiments, two companies

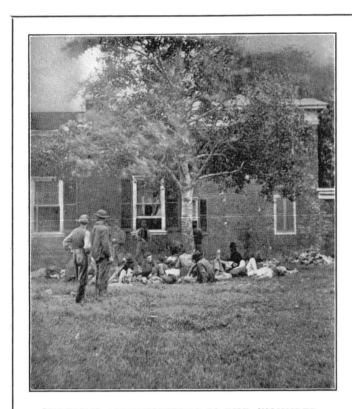

SURGEONS ADMINISTERING TO THE WOUNDED

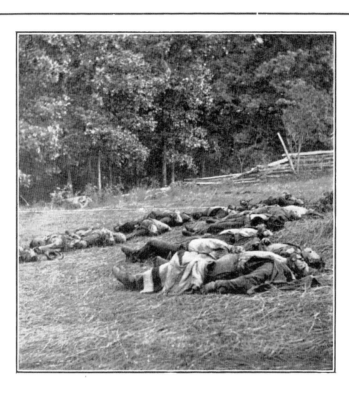

LIVES SACRIFICED FOR THEIR COUNTRY

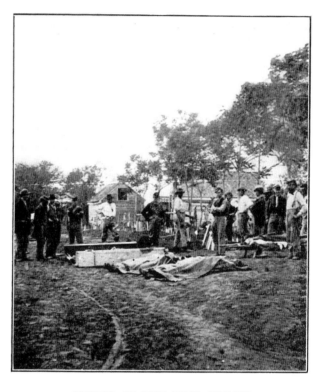

BURIAL OF THE DEAD HEROES

PHOTOGRAPHS TAKEN ON THE BATTLEFIELDS DURING THE CIVIL WAR IN THE UNITED STATES

In the Civil War the heart of American Citizenship was put to the test and it was found "tried and true." The first call for volunteers came on April 15, 1861 for 75,000 militia for three months, and 91,816 men answered. The second call was on May 3, 1861, when Lincoln asked for 500,000 men and the reply was 700,680. The third call on July 2, 1862 for 300,000 troops for three years' service to their country brought 421,465. The fourth call on August 4, 1862, for nine months' ser-

patriots marched to the battle ground to help strike the last blow of the conflict. The willingness with which these men offered their lives to their country is the greatest tribute that can ever be paid to American patriotism. After the disasters on the Peninsula over 80,000 troops were enlisted, organized, armed, and marched to the battleground within four weeks. An army of 90,000 infantry came to the front from the five states of Ohio, Indiana, Illinois, Iowa, and Wisconsin, within twenty

cavalry; 78 regiments, two companies artillery. The boys who wore the Gray could have intercepted this procession by another magnificent pageant reaching from the Canadian borders to the mountains of Mexico.

The war cameras during 1864 were taxed to their utmost. It was the hardest test that had ever been given the new science of photography. The thrilling story of this closing year is told in the rare old negatives in these pages—actual photographs taken at the scene of battle.

THE last days of 1863 were inactive. The armies in the East were going into winter quarters. Brady's men had experienced a hard year with their cameras, but had perpetuated many tragic incidents. One of the cameras was held in winter quarters at Rappahannock Station until early in 1864. It was used in recording conditions in camp and one of its negatives is here reproduced. This camp was occupied by the 50th New York Engineers. It was the duty of these engineers to construct roads, bridges and fortifications, and their services in the Civil War were of great importance. An interesting feature of this photograph is the row of pontoon boats on wheels. These pontoons are vessels, used to support the roadway of floating bridges. The boats were a small, substantial frame of wood, light of weight, and easily transported overland. By stretching them across a river an army could begin its movement to the other side within half an hour on reaching the banks. A pontoon train of the army carries about one hundred yards of pontoon bridge for each army corps, including the boats, roadway planks, etc. Early in the spring of 1864 the skirmishing began for what promised to be the deadliest year of the Civil War. Sherman organized his expedition in February against Meridian, Mississippi, a position of great importance to the Confederacy, as it controlled the railroad communications with Mobile and Wilmington. Banks began his Red River expedition in March. Meade's columns crossed the Rapidan River, in Virginia, in May. Grant was placed in command of all the United States armies in the field on March 1, 1864, while Sherman was given command of Federal armies in the West.

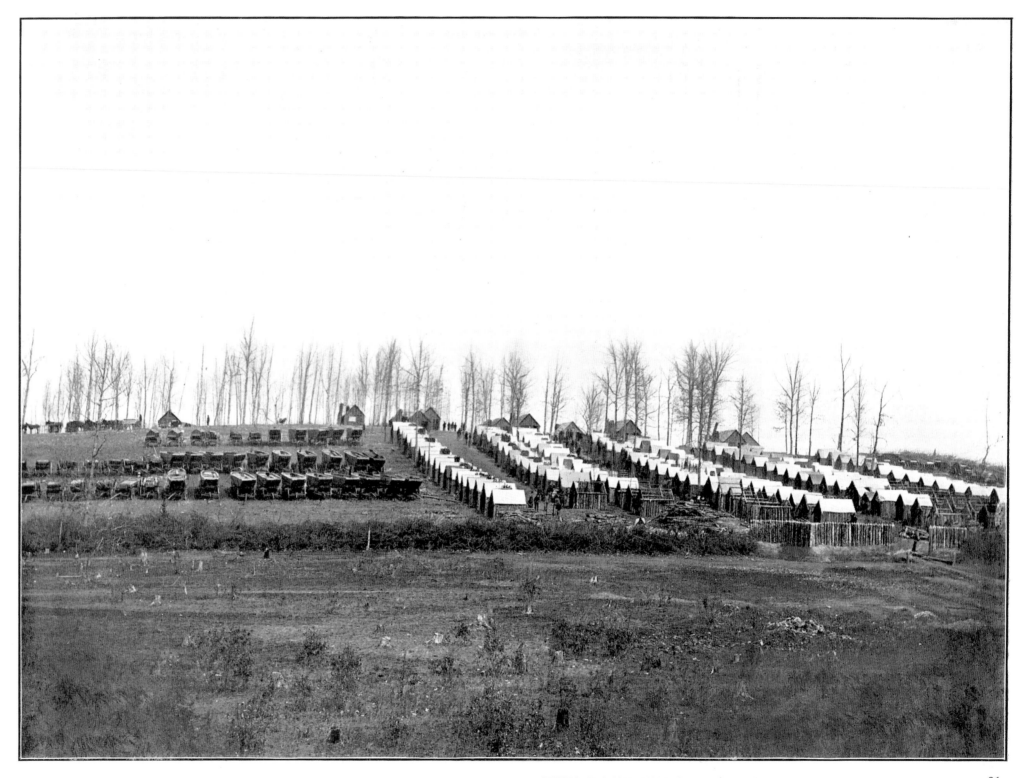

PHOTOGRAPH TAKEN IN WINTER QUARTERS AT RAPPAHANNOCK STATION, VIRGINIA, IN 1864

THE first great conflict of 1864 occurred on the fifth of May when the Army of the Potomac met Lee's forces in the Battle of the Wilderness. It was a virgin forest of oak and pine, choked with dense undergrowth. The Federal soldiers knew nothing of its entanglements, but the Confederates had full knowledge of the roads and wagon paths intersecting the woods. It was so dense that the troops found it necessary at times to move in single file. The artillery and cavalry had great difficulty in getting into the encounter, and in one of the sallies nearly all the men and horses were killed. The battle was deadly. Regiments shot into their own ranks as they fled through forest and undergrowth, becoming separated from the main line. General Longstreet, of the Confederate Army, was shot and severely wounded by his own men. Tremendous volleys of musketry rang through the woods. Dead leaves and branches were swept with flames. Men lost their way and wandered into the enemy's lines. So rapid was the fire that the muskets became hot and blistered the fingers of the soldiers. The losses in this great two-days' battle cannot be stated accurately. One estimate places the Union killed, wounded and missing at 18,387 and the Confederate, 11,400. On the afternoon of the seventh of May, Grant moved his army toward Spottsylvania Court House, fifteen miles southeast of the Wilderness Battlefield, with the intent of getting between the enemy and Richmond and compelling Lee to fight at a disadvantage. It was during these maneuvers that this photograph was taken while the artillery was stationed at the edge of the forest. The negative was taken in the full light of the noonday sun in the Spring of 1864.

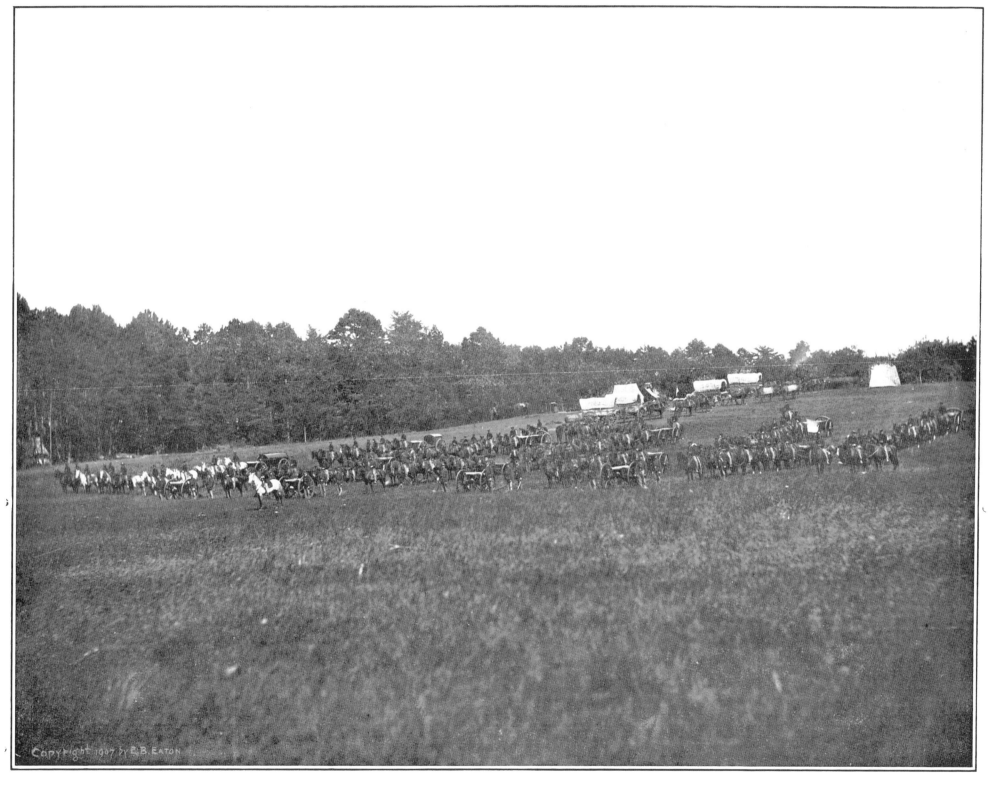

PHOTOGRAPH TAKEN WHILE ARTILLERY WAS AT EDGE OF WOODS NEAR BATTLE OF WILDERNESS IN 1864

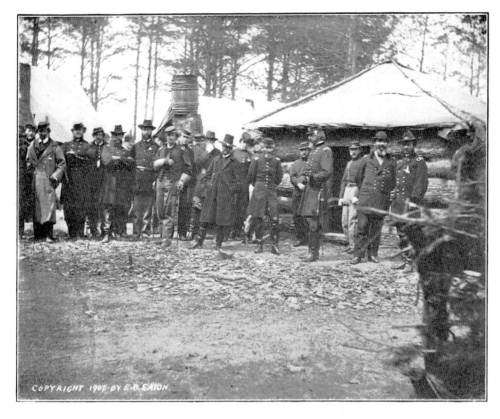

GENERAL MEADE AND GENERAL SEDGWICK WITH STAFF OFFICERS AT
RAPPAHANNOCK STATION, MARCH, 1864

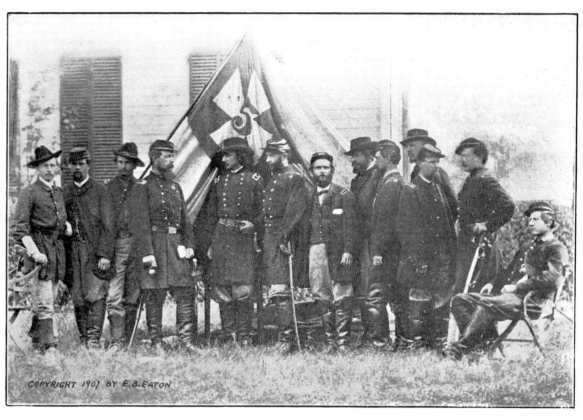

MAJOR-GENERAL G. K. WARREN AND STAFF AT BEVERLY HOUSE,
SPOTTSYLVANIA

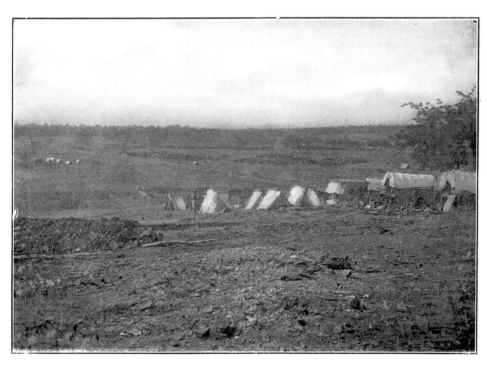

LOOKING TOWARDS SPOTTSYLVANIA COURT HOUSE FROM BEVERLY
HOUSE, HEADQUARTERS OF GENERAL WARREN IN MAY, 1864

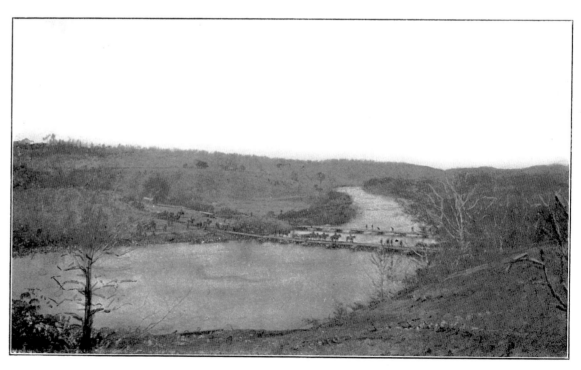

GERMANIA FORD, RAPIDAN RIVER, WHERE TROOPS CROSSED IN GRANT'S CAMPAIGN AGAINST
RICHMOND BEFORE BATTLE OF THE WILDERNESS

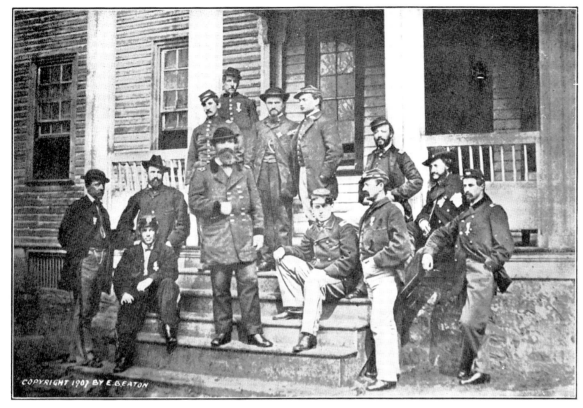

MAJOR-GENERAL JOHN SEDGWICK AND STAFF—SEDGWICK WAS KILLED AT SPOTTSYLVANIA IN 1864

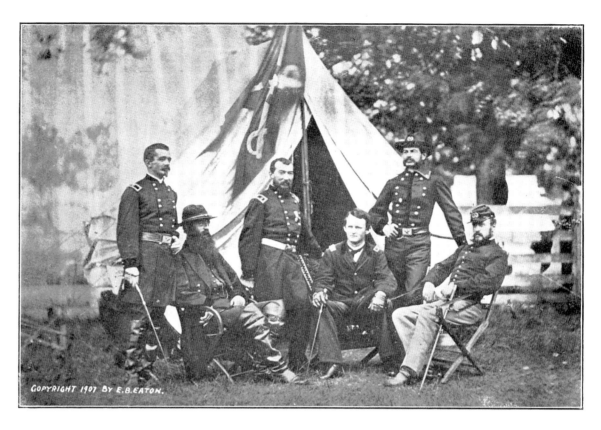

GENERALS OF THE CAVALRY CORPS—SHERIDAN, MERRITT, DAVIS, GREGG, TORBERT AND WILSON

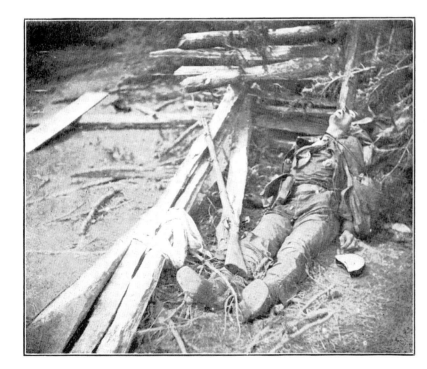

CONFEDERATE DEAD ON THE BATTLEFIELD OF SPOTTSYLVANIA COURT HOUSE IN 1864

BOTH armies faced each other in full force at Spottsylvania Court House in the forenoon of the ninth of May, 1864. The Brady cameras arrived with the Government supply trains and perpetuated the historic scenes. While the Union lines were placing their batteries, they were annoyed by sharpshooters, and General Sedgwick was killed. His death was a great loss to the Federals, just as Jackson's had crippled the Confederacy. During the first day at Spottsylvania the Federals lost fully 10,000 men, while the Confederates' loss was very nearly 9,000. The unburied bodies of 3,000 men lay scattered along the slopes of the ridges and under the trees. Out of the 200,000 Federals and Confederates who rushed into battle on the fifth of May, 43,000 were either dead, wounded, or prisoners, after three days of fighting. During the week the fighting extended along the Fredericksburg road, Laurel Hill and Ny River, reaching to Swift Creek and Cloyd's Mountain. The Army of the Potomac, since it crossed the Rapidan River, had lost nearly one-fourth of its men in the brief space of eight days, and now had a fighting force of only 87,000. The photograph of the Confederate dead was taken near Spottsylvania Court House, May 12, 1864, after Ewell's attack.

SLING CART USED IN HAULING CAPTURED CONFEDERATE ARTILLERY AT DREWRY'S BLUFF ON THE JAMES RIVER IN 1864

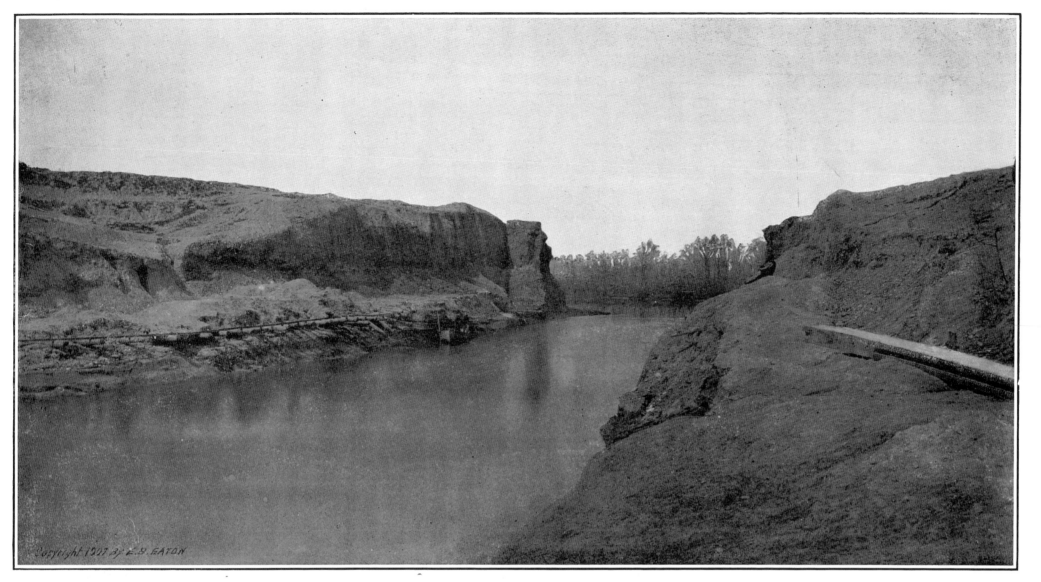

DUTCH GAP CANAL ENTERING JAMES RIVER IN VIRGINIA—BUILT UNDER SEVERE FIRE

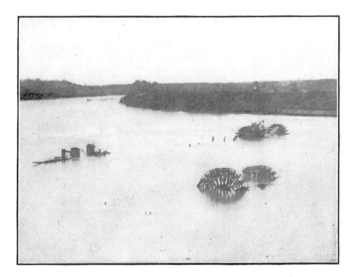

OBSTRUCTIONS IN JAMES RIVER NEAR DREWRY'S BLUFF

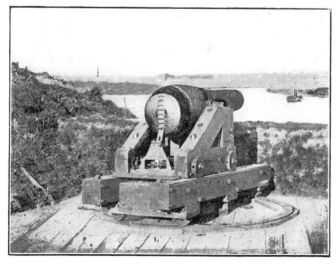

CONFEDERATE FORT DARLING AT DREWRY'S BLUFF

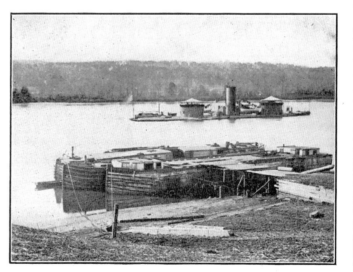

AIKEN'S LANDING, WHERE PRISONERS WERE EXCHANGED

WHILE Grant was moving toward Richmond from the north, Butler was forcing his way from Yorktown on the south, threatening Richmond from the peninsula as McClellan had done two years before. It was at this time that the photographs here shown were taken in May, 1864. Butler succeeded in destroying part of the road from Petersburg to Richmond. He received word that Lee was in full retreat for Richmond, with Grant close upon his heels. One of the extreme southern positions in the defense of Richmond was Fort Darling at Drewry's Bluff. On the thirteenth of May, Butler succeeded in carrying a portion of the outer lines, capturing a considerable amount of artillery, but on the sixteenth he was repulsed and fell back upon Bermuda Hundred. A powerful Confederate battery on the James River barred the bridge toward Richmond. Butler conceived the idea of cutting a canal through the narrow neck of land known as Dutch Gap for the passage of the monitors. A photograph was taken of this canal, which was constructed under a severe and continuous fire. The dredge and steam pump used were bomb-proof. The greater part of the excavation was done by colored troops, who sought cover, from the bombardment of the enemy, in earthen dugouts that covered the site of the work. The canal was only 174 yards long, 43 yards wide at the top, 27 yards at the water level, and 13 5-10 yards at a depth of 15 feet below water level. It cut off 4¾ miles of river navigation and the excavation was nearly 67,000 cubic yards. The war photographers secured many negatives of these operations and several of the most important ones are shown on these pages. One of them was taken at Aiken's Landing, where the flag-of-truce boat from Richmond came to discharge her cargo of poor, starved, and often dying Union prisoners, and received in exchange the same number of healthy, well-fed rebels from our guards. Two or three rough old canal boats, and the grim old monitor there at anchor, but above all the glorious old Stars and Stripes, and on the shore the loving hearts and kindly hands of friends. The soldiers called it "the gate into God's country."

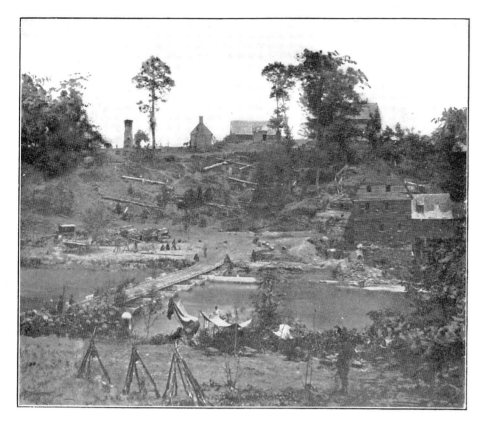

PONTOON BRIDGE AT JERICHO MILLS ON NORTH ANNA RIVER, VIRGINIA

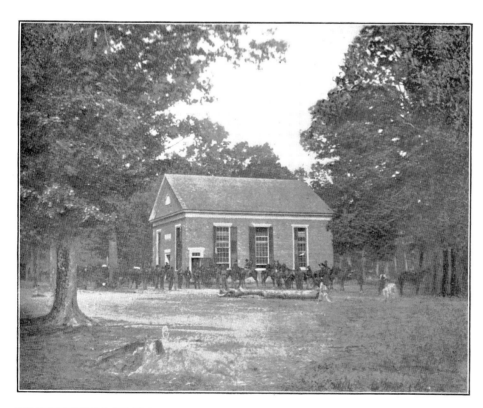

HEADQUARTERS OF GRANT AND MEADE AT MASSAPONAX CHURCH, VIRGINIA

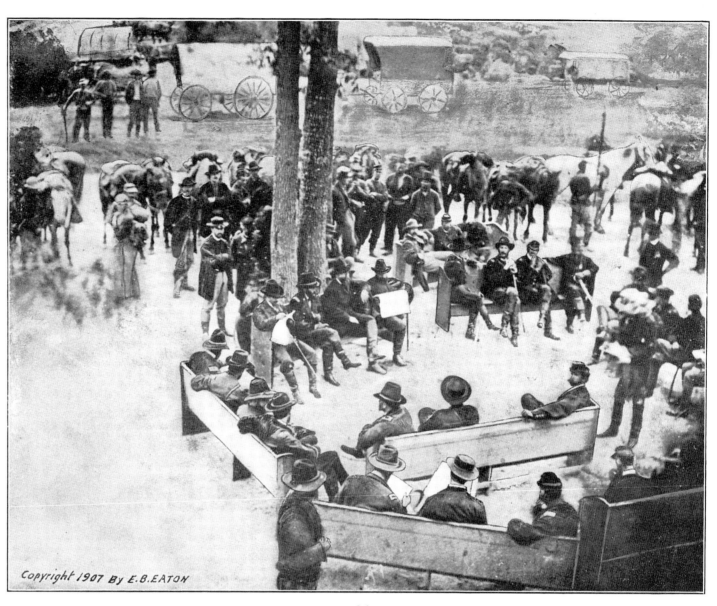

COUNCIL OF WAR AT MASSAPONAX CHURCH, VIRGINIA, IN 1864—GENERALS GRANT AND MEADE, ASSISTANT SECRETARY OF WAR DANA AND STAFF OFFICERS

AFTER the battle of Spottsylvania Court House the war photographers exposed many negatives, during the five days that the relative positions of the two armies remained unchanged. Grant and Lee were engaged in brilliant strategy. Grant had thrown out his left until it rested on Massaponax Church. While the great General was in council of war at this place on the twenty-first of May, 1864, a remarkable photograph was taken. In the reproduction on this page it will be seen that the pews have been brought out under the trees and the officers are gathered to discuss the situation. Grant is sitting on the bench against the trees. With him are General Meade, Assistant Secretary of War, Charles A. Dana, and the staff officers. This was a critical time. The Union losses had been heavy and Lee had not yet been outwitted. This photograph is of much historic significance. In advance of Grant's movements, General Sheridan had started on a raid, with 10,000 sabres, and reaching the North Anna River, captured Beaver Dam Station, destroyed ten miles of railroad track and three freight trains containing a million and a half Confederate rations. Here he was fiercely assaulted by "Jeb" Stuart, but he succeeded in crossing the North Anna River by Ground-Squirrel Bridge and proceeded toward Richmond as far as Yellow Tavern, six miles from the Confederate Capital. Stuart fell mortally wounded and died in the city of Richmond. Sheridan then attempted to capture the works around Richmond, and Custer crossed the first line and seized two pieces of artillery and one hundred prisoners. Lee had fallen back from the North Anna River and assumed a position still covering Richmond. A photograph was taken of the pontoon bridge constructed across the North Anna River at Jericho Mills, where General Warren's five corps crossed on the twenty-third of May. The Federal base of supplies was shifted to the White House on the Pamunkey River where the remainder of the Federal Army crossed on the twenty-eighth of May, followed by the war cameras.

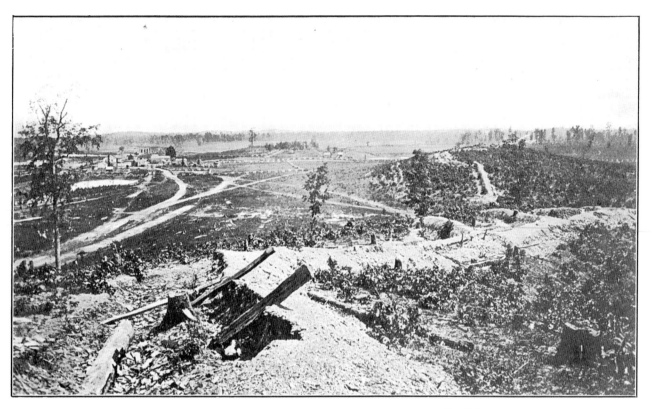

BATTLEFIELD AT RESACA, IN GEORGIA, MAY 13-16, 1864

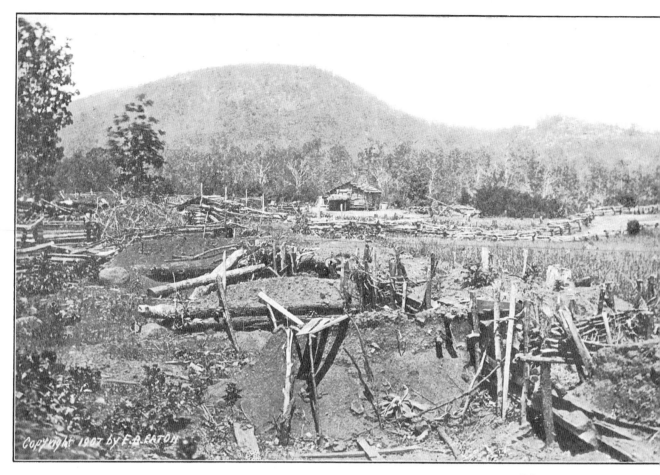

BATTLEGROUND ON KENESAW MOUNTAIN, GEORGIA, IN JULY, 1864

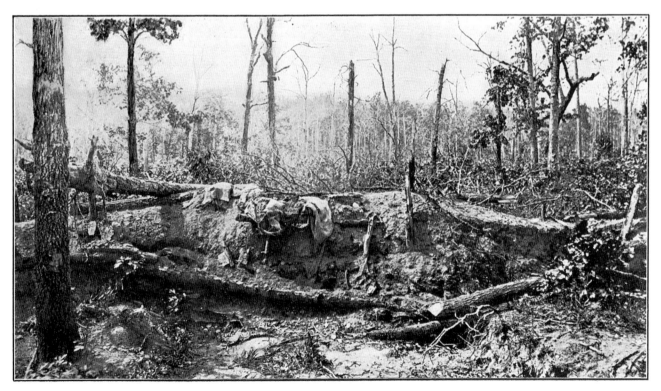

BATTLEFIELD OF NEW HOPE CHURCH, IN GEORGIA, MAY 25 TO JUNE 4, 1864

WHILE Grant was moving on toward Richmond, Sherman's armies of Arkansas, Cumberland, Ohio and Tennessee, with 352,000 men distributed in many garrisons over this wide expanse of territory, was moving against Atlanta, Georgia. Opposed to Sherman was Lieutenant General Joseph E. Johnston, who commanded all the Confederate troops in the West, including the men of Bragg's old army. Atlanta was of equal importance with Richmond. It was a great railroad center and it contained the Confederate depots, mills, foundries and the manufactories of military supplies. Sherman had moved simultaneously with the Army of the Potomac, on the second day of the Battle of the Wilderness. On the thirteenth of May, Sherman's men met the Confederates at Resaca, Georgia. There was brisk, sharp fighting all along the line. On the night of the fifteenth the Confederates abandoned the town and crossed the Oostenaula River, setting fire to the bridges. At dawn of the sixteenth the Federals entered Resaca and began a vigorous pursuit, and the camera recorded the scene of the abandoned entrenchments. The field across which the Confederates withdrew may be seen in the distance. The Confederates concentrated their forces near New Hope Church on the twenty-fifth, and attacked the advancing Union troops but were driven back with heavy loss. The war photographers here secured a photograph of the entrenchments in the woods where there was continuous fighting for six days. The Federal Army forced its way through the mountainous country to the towering peaks of Kenesaw Mountain, Lost Mountain, and Pine Mountain. On all these heights the Confederates had signal towers. The outlying hills were occupied by batteries. The cameras were carried to the heights of Kenesaw Mountain and taken into its entrenchments. Sherman's troops climbed this slope, through its tangled wood and rifle pits, in the face of a steady musketry and artillery fire. This really ended the first movement of Sherman's campaign against Atlanta. Sherman's losses during May and June were over 2,000 killed and 13,000 wounded. Johnston's losses were about 1,200 killed and nearly 14,000 wounded. During the fifty-four days, both armies were depleted by 3,200 killed, 27,000 wounded,

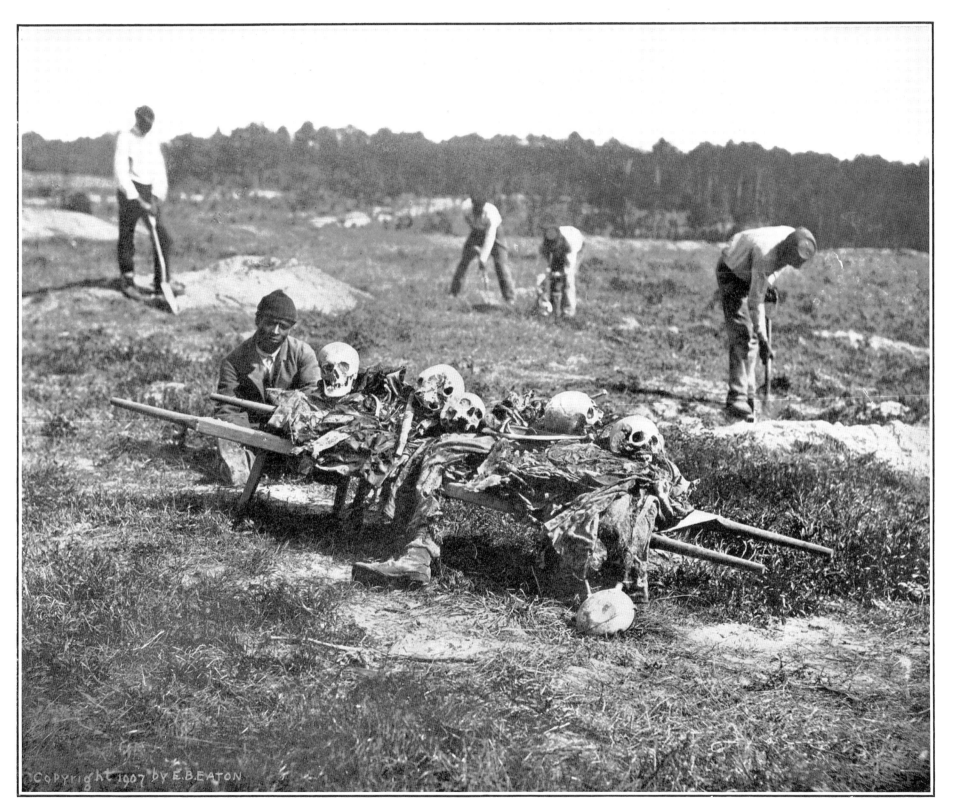

GRANT and Lee met at Cold Harbor in a desperate struggle on the first day of June in 1864. The following day was occupied by a general massing for the deadly encounter. Meade's army moved silently on the enemy at daylight on the third and the result was the fiercest battle of the entire war. There was a drizzling rain. The armies could hardly see the faces of their antagonists. Not a shot was fired until they were upon each other. One hundred thousand muskets simultaneously began their murderous work at a range of sixty to seventy yards. Two hundred pieces of artillery added to the deafening roar. It was the tragedy of Fredericksburg and Gettysburg re-enacted. The Union soldiers pressed toward the solid mass of lead and flame from the Confederate entrenchments only to be forced back. At times they swept to the breastworks against the torrents of musketry and mounted the parapets. The assault lasted but twenty minutes and the Union Army lost in killed, wounded and missing over 14,000 men; the Confederate loss has been estimated at 1,700. The two armies stayed at Cold Harbor for ten days, working on their field entrenchments, and fighting whenever either side grew bold. Lee remained immovable in his entrenchments before Richmond and on the afternoon of the sixteenth of June, Grant's army, horse, foot and artillery, had crossed the James River. On the seventh of June the dead were buried and the wounded gathered during an armistice of two hours. This is a ghastly view, showing the process of collecting the remains of Union soldiers who were hastily interred at the time of the battle. This photograph was taken on the battlefield months after the battle, when the Government ordered the remains gathered for permanent burial. The grinning skulls, the boots still hanging on the bones, the old canteen, all testify to the tragedy.

PHOTOGRAPH TAKEN WHILE SKELETONS OF DEAD SOLDIERS WERE BEING REMOVED SEVERAL MONTHS AFTER BATTLE OF COLD HARBOR

SHERMAN, in his campaign in Georgia in 1864, was much interested in the cameras that followed his army and urged the photographer to take negatives of every movement as his forces pushed the Confederates toward Atlanta. On the morning of July 3, 1864, the Stars and Stripes fluttered on the crest of old Kenesaw Mountain. All the Federal corps were in rapid motion, and on Independence Day Sherman could distinguish the houses of Atlanta only nine miles away. General Johnston withdrew into the city and a storm of indignation swept the Confederacy. Johnston resigned his command and was succeeded by General J. B. Hood. Sherman set his troops in motion for the city on the seventeenth of July. On the nineteenth, the troops were so near Atlanta, and were meeting such feeble resistance that it was supposed the Confederates were evacuating, until they poured out of their entrenchments and opened furious fire on the north side of Peach Tree Creek. The war cameras were busily engaged and one of the negatives is an abandoned Confederate fortification on the road leading to Atlanta. A camera was taken into this fort shortly after its capture by Sherman. It shows the extent to which the Confederates had protected themselves. It is one of the rare pictures in which chevaux-de-frise construction is shown. It is here seen that the defense is a temporary obstruction by placing rails in a row with their pointed ends directed against the enemy. They impeded the advance of the foe and afforded cover for the defenders. During the conquest of Georgia the Confederates were much awed by the Brady "what is it?" wagons. It is the first time that field photography was witnessed in the far South.

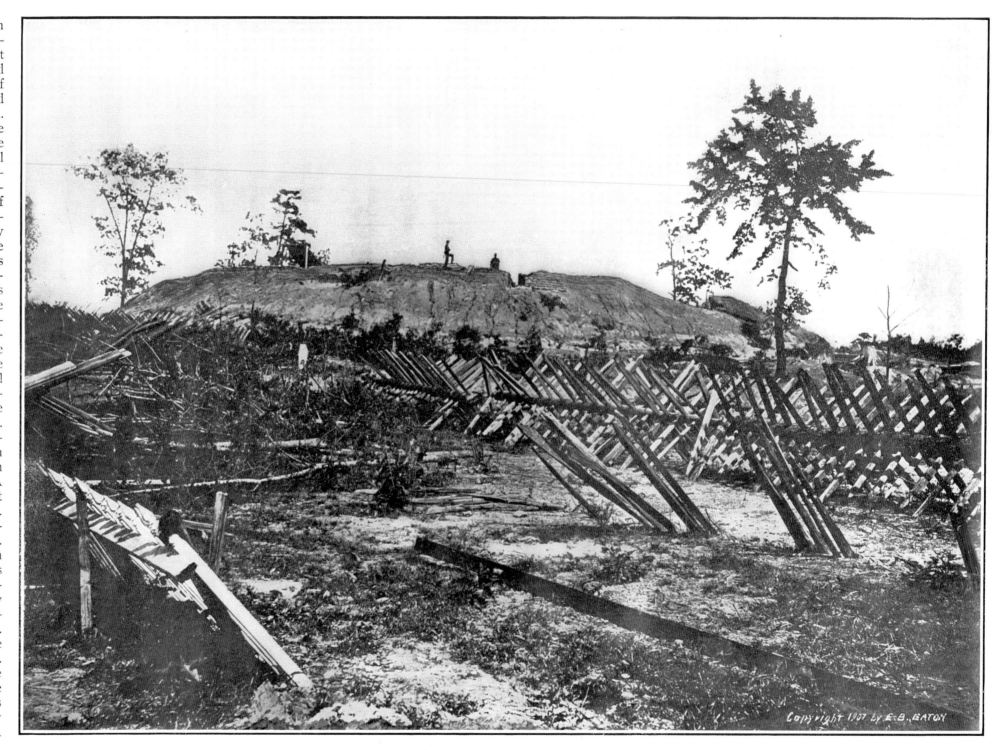

PHOTOGRAPH TAKEN AT A CONFEDERATE FORT ON MARIETTA ROAD, NEAR ATLANTA, GEORGIA, AFTER CAPTURE BY SHERMAN, SEPTEMBER 2, 1864

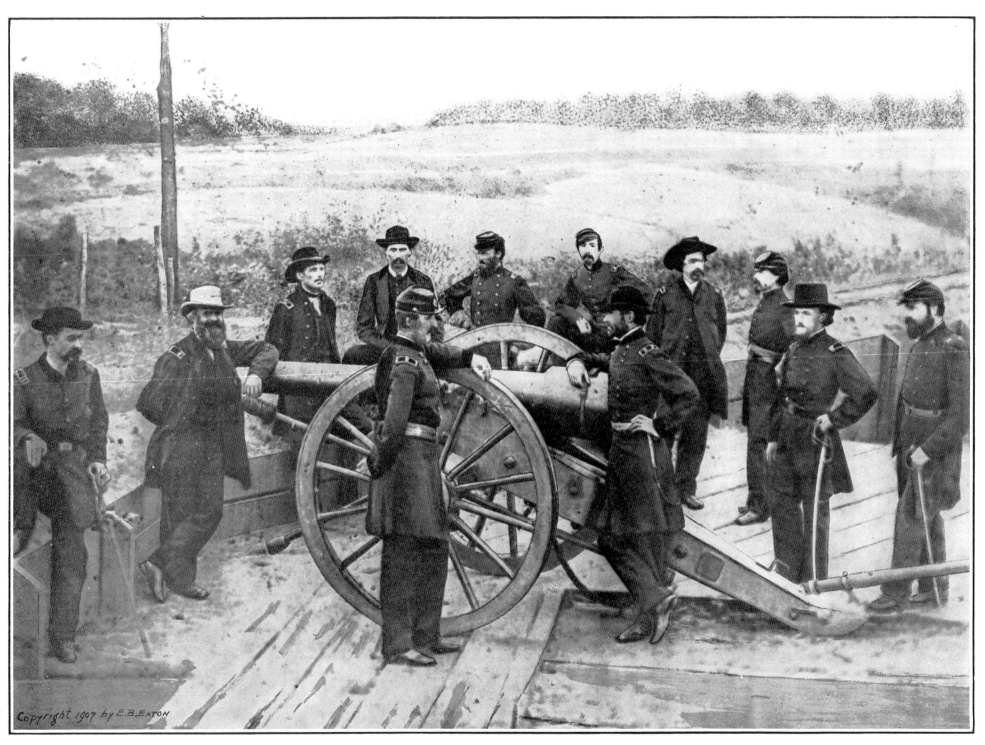

Copyright 1907 by E. B. EATON

PHOTOGRAPH TAKEN ON THE LINES BEFORE ATLANTA, GEORGIA, IN 1864—GENERAL WILLIAM TECUMSEH SHERMAN AND STAFF

WHILE Sherman's Army was literally standing at the gates of Atlanta, this photograph was taken. The great general was with his staff in a Federal fort on the outlying hills. He was leaning on the breech of the cannon in one of his most characteristic attitudes. At this time Sherman was forty-four years of age. When sixteen years old he had entered West Point as a cadet, through the influence of his father, who was a Supreme Court judge in Ohio. At twenty years of age he entered the United States regular army and during the Mexican War was engaged in service in California. When thirty-three years of age, Sherman resigned from the army and became President of the State Military Institute of Louisiana. At the outbreak of the Civil War he left the South and offered his services to the Union. He was a colonel at the Battle of Bull Run. After that battle, when the Northern Army was reorganized, Sherman was appointed Brigadier-General of Volunteers and commanded the Department of the Cumberland. He demanded 200,000 men to reach the Gulf, but it was refused and he was ordered into Missouri. He was for a time inactive but came to the front again at Shiloh in command of a division under Grant. His bravery secured his promotion to Major-General and he became active in the campaign around Vicksburg. He then entered into the Mississippi Campaign and led the forces against Atlanta, resulting in his famous march to the sea. This photograph was taken on the eighteenth day of July, in 1864, on the lines before Atlanta. Sherman was much interested in the new science of photography and he always protected the cameras.

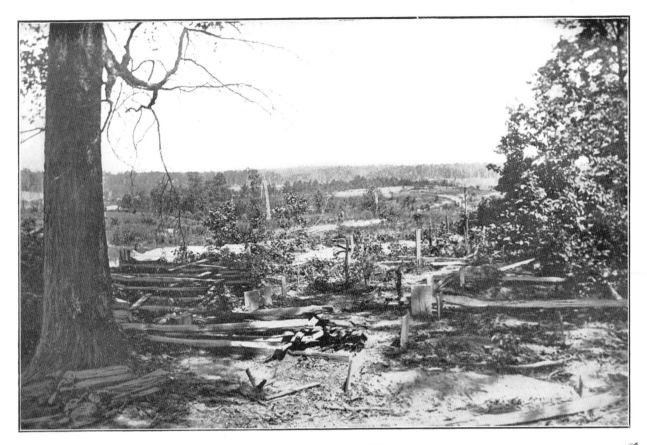

BATTLEFIELD OF PEACH TREE CREEK, GEORGIA, JULY 20, 1864—HOOD'S FIRST SORTIE NEAR ATLANTA

WHERE GENERAL MCPHERSON WAS KILLED, JULY 22, 1864, NEAR ATLANTA—HOOD'S SECOND SORTIE

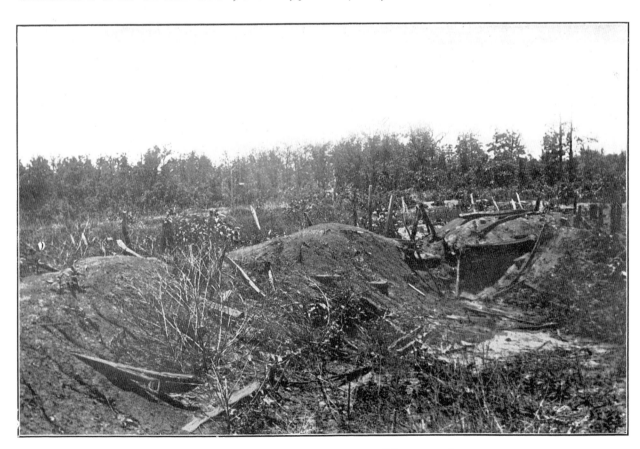

BATTLEFIELD AT ATLANTA, GEORGIA, JULY 22, 1864—HOOD'S SECOND SORTIE

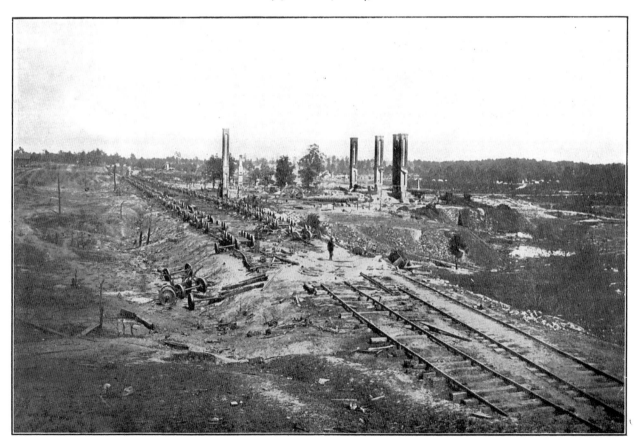

MILL AND RAILROAD DESTROYED BY CONFEDERATES ON EVACUATION OF ATLANTA, SEPTEMBER 2, 1864

CAPTAIN JOHN A. WINSLOW AND OFFICERS ON DECK OF "KEARSARGE" ON RETURN TO AMERICA AFTER DESTRUCTION OF THE "ALABAMA" IN THE ENGLISH CHANNEL

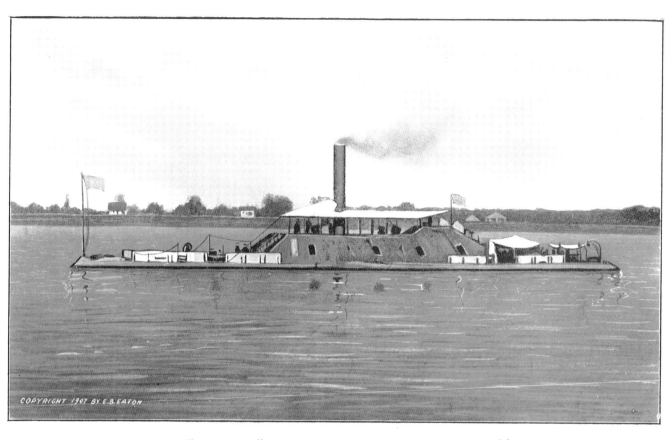

CONFEDERATE IRONCLAD RAM "TENNESSEE" CAPTURED AT MOBILE BAY AUGUST 5, 1864, BY ADMIRAL FARRAGUT

ATLANTA was evacuated by the Confederates on the first day of September, in 1864 after a long, hard siege. The formal surrender was made by the Mayor on September second and the city became a military depot governed by military law. During this campaign of four months the Federals lost 31,680 men; the Confederates 34,986. The war photographers secured many negatives of the battlefields in the siege around Atlanta. A view is here shown of Peach Tree Creek where the Federal loss was 1,710 and the Confederate 4,796. Another camera was taken to the woods where the Union general, McPherson, was killed in Hood's second sortie outside of the city. The daring commander rode directly into the enemy's line, without knowledge of danger. An interesting picture is that of the earth-works before Atlanta, during Hood's first sortie, in which the Union losses were 3,641, and the Confederate 8,499. The destruction that was wrought during the siege of Atlanta is perpetuated by many of these negatives. While the armies were making these decisive blows, the "Kearsarge" 3,000 miles away, met and sunk the Confederate ship, "Alabama," in the English Channel on Sunday morning, June 19, 1864. The "Alabama" had been roaming the seas nearly two years, capturing and burning American merchantmen. Another important naval conflict occured on the 5th of August when Admiral Farragut gained possession of Mobile Bay, Alabama, and the war cameras caught a picture of the rebel ram, "Tennessee," the ironclad captured at that time by Farragut.

DEVASTATION ON "MARCH TO THE SEA"

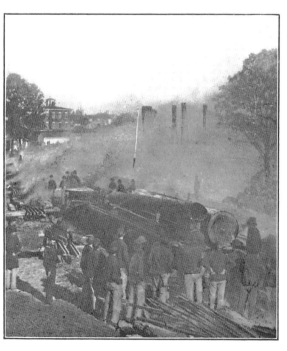

SHERMAN'S MEN DESTROYING RAILROAD

CONFEDERATE DEFENSES AT CHATTAHOOCHIE RIVER BRIDGE, GEORGIA, IN 1864

BATTLEGROUND OF ALLATOONA PASS, IN GEORGIA, OCTOBER 5, 1864

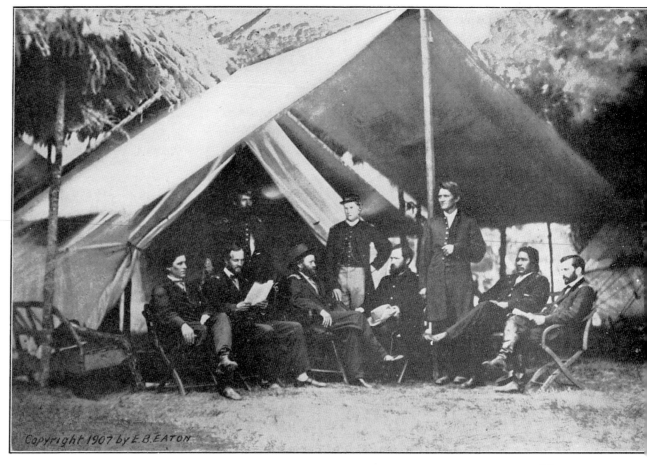

GENERAL U. S. GRANT AND STAFF AT CITY POINT, VIRGINIA, IN AUGUST, 1864

WHILE the combined armies under Sherman lay in and around Atlanta until October, 1864, the war photographers were used extensively. Fierce encounters took place early in that month around Kenesaw Mountain and along Allatoona Pass. During this famous encounter Sherman stood on the top of Kenesaw. General Corse, who was leading the Union Division into combat, sent him this message: "I am short a cheek bone and one ear, but am able to whip all hell yet." It was to this that Sherman made his famous reply: "Hold the fort, for I am coming." Sherman began his famous march to the sea on the fifteenth of November. As the columns left Atlanta the Federal engineers applied their torches to the depot, roundhouse, and the machine shops of the Georgia railroad. The columns extended to the northern part of the city. Stores, warehouses, hotels, and mills with many private dwellings, were destroyed to the value of more than three millions of dollars. Amid the fierce heat and roar Sherman rode out of Atlanta on the afternoon of November 16th. The great army for five consecutive weeks swept across Georgia. The 62,000 men, 20,000 horses and mules, marched 300 miles in a route from 20 to 60 miles wide. The army captured twenty million pounds of corn and fodder, three million rations of bread and meat, one million rations of coffee and sugar and 350 miles of railroad track were destroyed. Sherman estimated the property losses at over one hundred millions of dollars. The Federal losses during the campaign were but 63 men killed on the field, 245 wounded, and 259 missing. The Confederacy was severed and a decisive step taken toward ending the Civil War.

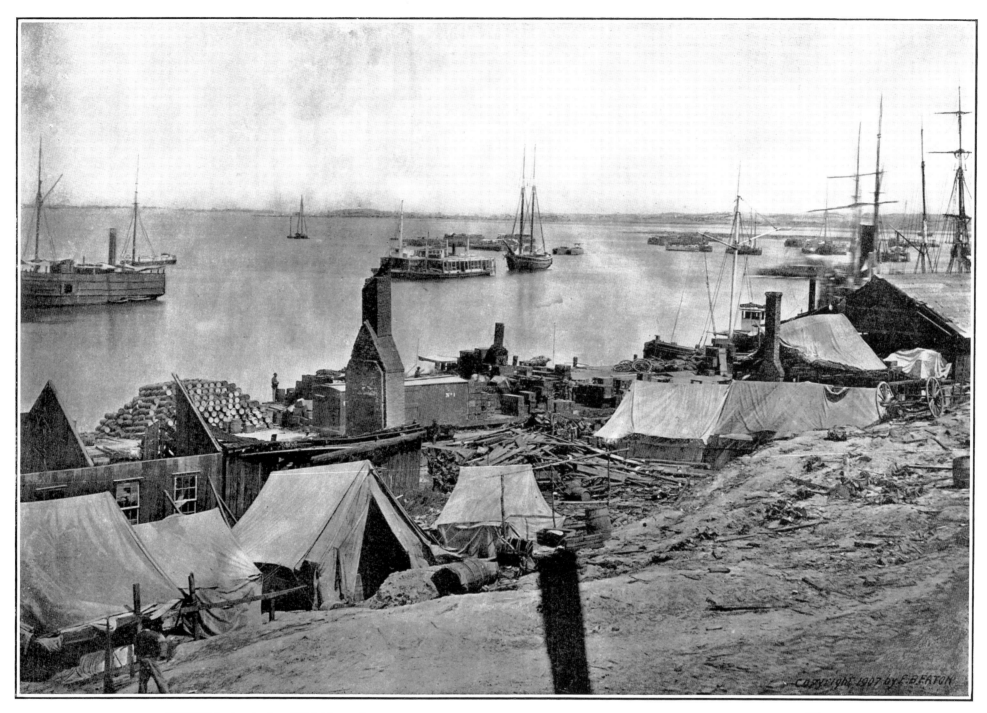

DESTRUCTION FROM EXPLOSION OF ORDNANCE BARGES AT WHARVES AT CITY POINT, VIRGINIA, AUGUST 9, 1864

WHILE Sherman was marching from Chattanooga, Tennessee, to Atlanta, Georgia, on his famous march to the sea, Grant was laying siege on Petersburg, Virginia, twenty-two miles south of Richmond. This was the central point for five railroads, giving communication with the Carolinas and Southern Virginia. Its possession by Federal troops would cut off Richmond and force the evacuation of the Confederate Capital. Lee was strongly intrenched around Petersburg.

For a time during the summer there was hot fighting every hour in the day and frequently far into the night. The two armies were ready to fight to a finish. The Union Army was preparing itself for the final stroke and the conflicts were constant. It was during this campaign that the battles of New Market Heights and Cedar Creek were fought and Sheridan made his famous ride down the Shenandoah Valley to Winchester. Grant's base of supplies was at City Point on the James River. On the ninth

day of August, in 1864, there was an explosion of the ordnance barges and a war camera was hurried to the scene and secured this negative on the same day. At the same time, while General Grant was in conference with his staff in his tent at the army headquarters, the war photographers secured the picture shown on the preceding page. The general may be seen in the center of the group, sitting in the chair, with his hat characteristically pushed back on his head and his legs crossed. This is an interesting negative.

IN the closing months of 1864 events occurred in rapid succession in the southwest. The Confederates, under Hood, driven from Georgia by Sherman, invaded Middle Tennessee. General Price began his invasion of Missouri and destroyed property valued at three millions of dollars and seized a vast quantity of supplies. The Union forces, under General Thomas, were concentrated at Nashville. There were continual skirmishes and at nightfall, on the sixteenth of December, General Thomas ordered his troops into line of battle, with the intent of driving Hood's Army from the territory. In a terrific fire of musketry, grape and canister, the Federals pushed forward. In the next two days the Confederates lost all their artillery. General Thomas took four thousand, five hundred prisoners, nearly three hundred being officers. The fleeing Confederate columns left nearly three thousand dead and wounded on the ground, while the Federal loss was three hundred. The weather was very cold, but Thomas pursued his foe relentlessly. Hood's men were in a desperate condition, barefooted, ragged and disheartened. They were pressed to the Tennessee River where thirteen thousand were taken prisoners, and Hood's great army was practically annihilated, their small arms scattered along the roads, and cannon, caissons and wagons abandoned. Hood took the remnants of his army into Mississippi where he was relieved from command by his own request and retired minus the arm he left at Gettysburg and the leg he left at Chickamauga. On the thirtieth day of December, in 1864, Thomas went into winter quarters. One of the last photographs of the year was taken in Fort Negley, Nashville, Tennessee, showing the ironclad casemates and the interior of the fort.

PHOTOGRAPH TAKEN IN FORT NEGLEY AT NASHVILLE, TENNESSEE, SHOWING IRONCLAD CASEMATES, IN 1864

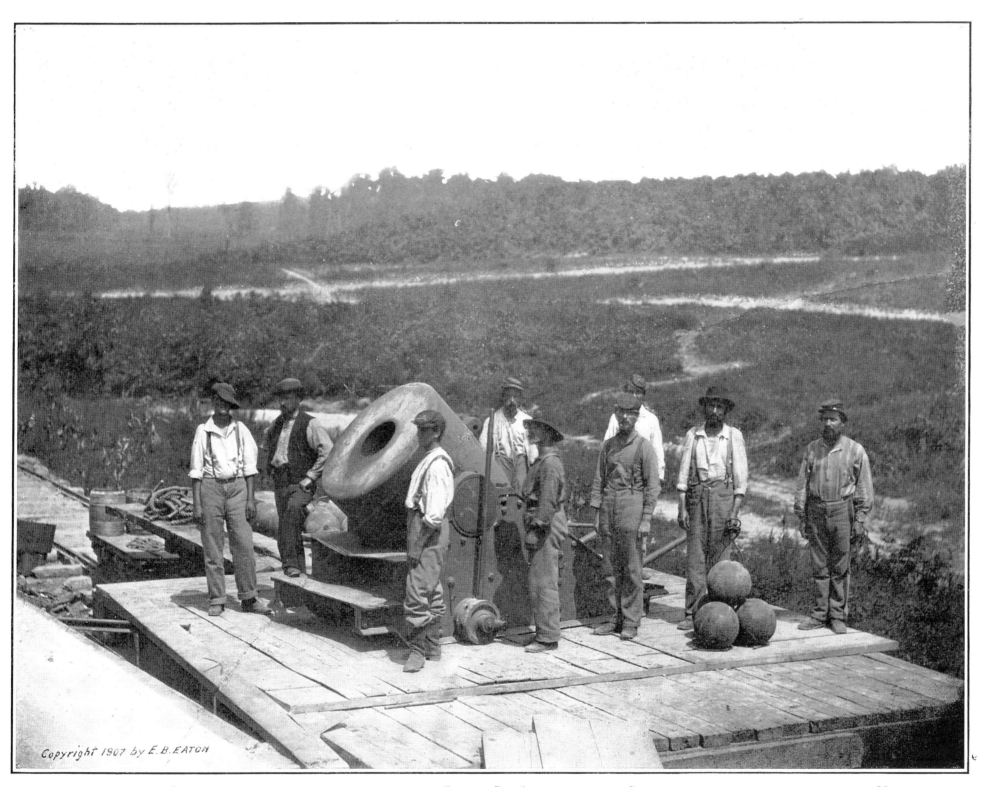

Copyright 1907 by E.B. EATON

THE last days of 1864 closed with the Army of the Potomac and the Army of the James maintaining the siege about Petersburg. Nearly every hour of the day and night the air was filled with the roar of siege cannons and mortars. Brady and Gardner had several of their cameras at the siege of Petersburg. Many rare negatives are to-day witnesses of this great event. The picture shown on this page was taken during the siege. It shows the thirteen-inch "Dictator," known as the "Petersburg Express," mounted on a flat freight car made strong for this purpose. It was on the military railroad outside of Petersburg and moved continually along the line, throwing its huge death-dealing bombs into the city. Some of the mortars were mounted on very strong, special-made cars, protected with roofs of railroad iron. Grant's line was twenty-five miles long, but with its parallels extending over ninety miles. The two forts nearest the city of Petersburg were known by the soldiers as Fort Hell and Fort Damnation. From their casemates the movements of the soldiers of the beleagured city were distinctly visible. The guns of these two advanced forts were never silent. At nightfall, the pickets, with one hundred and fifty rounds of ball cartridges, left for the outposts, and many of them never returned. The night was made hideous by the roar of huge siege guns, the sudden crashes of musketry and the crack of rifle shells. The openings of the breastworks were so filled with shot during this siege that in time of truce the soldiers would dig the narrow openings out with their fingers. On the next page is shown a photograph taken April 2, 1865, in Confederate trenches at Petersburg just after their capture by the daring Union troops.

PHOTOGRAPH TAKEN ON GRANT'S MILITARY RAILROAD WHEN THE 13-INCH MORTAR "DICTATOR" OR "PETERSBURG EXPRESS" WAS THROWING SHELLS INTO PETERSBURG IN 1864

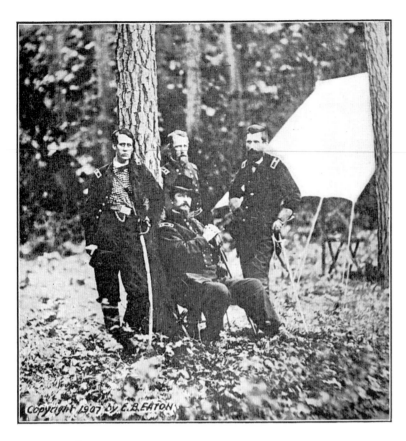

GENERALS HANCOCK, BARLOW, BIRNEY AND GIBBON

SIEGE OF PETERSBURG, VIRGINIA—PHOTOGRAPH TAKEN JUST BEFORE ITS FALL IN 1865

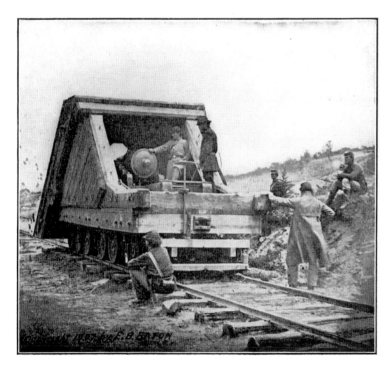

RAILROAD BATTERY IN FRONT OF PETERSBURG DURING SIEGE

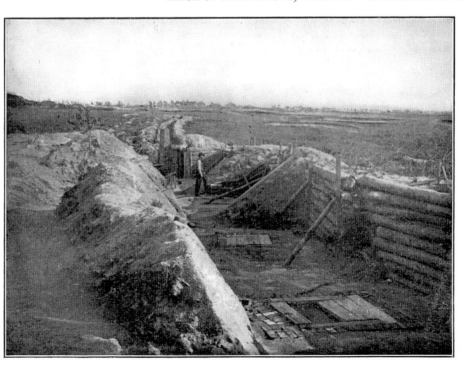

EARTHWORKS IN FRONT OF PETERSBURG—FEDERAL LINES AT FORT MORTON

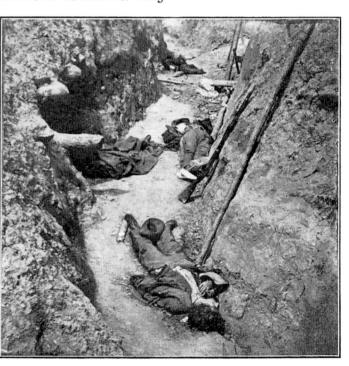

DEAD CONFEDERATES IN TRENCHES AT PETERSBURG

DEEDS of valor on the battlefield have been sung from the earliest ages, but there is no epoch in the world's history when men have shown more magnificent courage, or greater devotion to principle, than in the Civil War of the United States. The days of ancient knighthood never saw more gallant fighters, no lancer ever met a worthier foe. It was the grandest spectacle of heroism that eyes have ever witnessed. At the battle-front, in prison pit, in hospital, or wounded on the field—no men ever endured more intense suffering.

The only National debt we can never pay is the debt we owe to the men who offered their lives that the United American Nation might live to become the greatest power in the human race. The heroic sacrifices will never be known. It has been variously estimated from three hundred thousand to a million lives. The Government records 44,238 men as having been killed in battle; 49,205 dying of wounds and injuries; 186,216 succumbing to disease; 24,184 expiring from unknown causes; and 526 suicides, homicides and executions. Thousands of men disappeared during the conflict and have never been heard from since. The surgeon-general's records give 280,040 wounded in battle; 184,791 missing or captured; 26,168 dying while prisoners of war. The medical records state that 6,049,648 cases were brought into the hospitals, great numbers of whom were sent home to die. The Confederate losses can never be ascertained but it is very probable that the price that America paid for the preservation of the Union was a million of its manhood.

The crisis of 1865 held not only the future of the United States in the balance, but threatened to change the political divisions of the world. The American Nation, which is the "freest, richest and most powerful" nation under the skies, would have been divided into two weakened republics, each struggling for existence, disputing the ownership of rivers and coast, engaged in continual border uprisings, and finally becoming the prey of the powerful nations of Europe—only to be soon

"When 'Greek meets Greek' the tug of war
 Is sure to follow fierce and strong;
What wonder that the bloody strife
 'Twixt North and South was four years long!
Four hundred thousand of our brave
 Gave up their lives that we might be
A Nation, powerful and great,
 The fitting home of Liberty.
America will surely stand
 The first and foremost of the earth:
The Queen of Nations she shall be,
 And all her sons have royal birth.

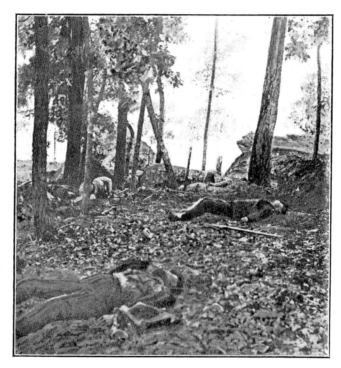

FOR THE SAKE OF THEIR COUNTRY—Photograph taken by Brady on the battlefield during the Civil War

"The Goddess of sweet Liberty
 Still smiles upon her gallant knights
Who bravely sprang to her defense,
 And fearless fought to keep our rights.
Then cheer our heroes, grim and old,
 And let them feel while yet alive,
We honor them for what they did
 From sixty-one to sixty-five.
All honor to our sacred dead,
 And honor well the living, too,
Our Veterans of the Civil War,
 These noble boys who wore the blue."

devoured by encroaching monarchies of the Eastern Hemisphere.

The problem was settled for all ages in 1865. The American Nation rose from the ruins of War like a young giant. Grasping the hand of the North and the South, it clasped them together with the grip of brotherhood and the sacred pledge, "United we stand; divided we fall." Long live America, the Land of the Free and the Home of the Brave! The vast armies, "strong enough to have conquered a hemisphere, vanished like a vision and the men who fought side by side through the perils of four years of Civil War, laid down their arms, changed their uniforms of blue and gray for the apparel of everyday life, and took up once more the peaceful occupations they had abandoned to serve their country."

The Spring of 1865 can never be forgotten by the men who went through it. It was a time of intense excitement and overflowing enthusiasm which carried itself almost to pandemonium. The war cameras, which had perpetuated the last wonderful scenes of the conflict, were taken to Washington and New York, and the Summer fell upon a peaceful people.

It is the avowed mission of these pages to lay before the present generation the vision of War in all its horror that those who look upon them may pledge themselves to the furtherance of the day "when a cannon will be exhibited in public museums, just as an instrument of torture is now, and people will be amazed that such a thing could have been;" the day when "those two immense groups, the United States of America, and the United States of Europe," and the United States of Asia and of Africa, "will be seen placed in the presence of each other, extending the hand of fellowship across the oceans, exchanging their produce, their commerce, their industries, their arts, their genius; clearing the earth, peopling the desert, improving creation under the eye of the Creator, and uniting for the good of all, these two irresistible and infinite powers—the fraternity of men and the power of God!"

THE first days of 1865 around Petersburg were a hard strain on the soldiers. The winter's siege had been severe. The Confederates were desperate. Unable to break the Federal lines at Dinwiddie, Five Forks, or any of the many combats that were continually taking place, defeat and annihilation awaited them. On the first of April the entire artillery forces in the trenches before Petersburg began a tremendous cannonading which continued until dawn. The Union troops during the night tightened their lines around Petersburg until the following morning, which was Sunday. At daylight, on Monday, the third of April, Lee evacuated Petersburg and the Union forces entered the city about nine o'clock. Cameras were soon taken through the gates and during the day several photographs were taken, including a negative of the trenches containing the dead. This photograph shows a company of colored infantry. There were 186,097 colored troops enlisted in the Civil War. In many conflicts they showed great bravery, especially during the siege of Petersburg. An instance of their great courage was the attempt to break through the Confederate lines by tunneling under one of the fortifications and blowing it up with the charge of eight thousand pounds of powder. In the smoke of the explosion the colored troops charged through the crater and up the slope beyond, only to meet with a terrific fire in which hundreds of colored heroes were mown down like grass, with no hope of anyone reaching the crest, but they held to the charge until ordered to retire. The engagements around Petersburg during its last nine months cost the Union Army more than thirty thousand men.

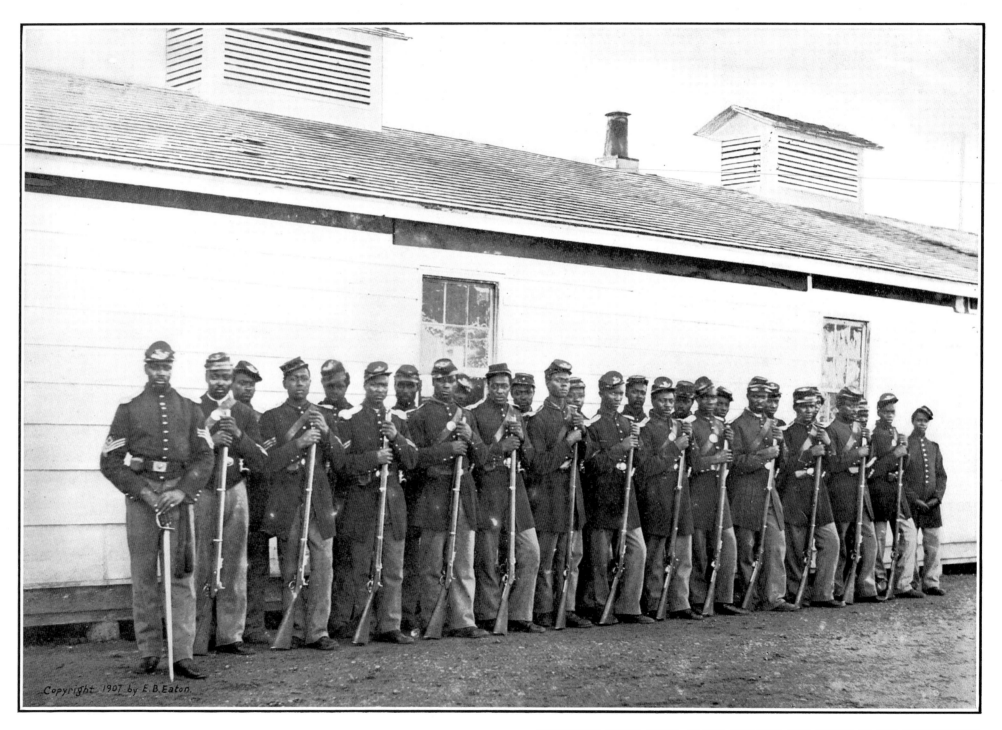

Copyright 1907 by E. B. Eaton

PHOTOGRAPH TAKEN WHILE COLORED INFANTRY WAS MOVING TO THE BATTLEGROUND

THIS witness of a remarkable sight is so old that it will be noted that the tree at the right of the picture is being eaten away from the original negative. It lays before the eyes of all generations the view of the first wagon train entering Petersburg with provisions for the starving inhabitants after one of the greatest sieges in history. It was on Sunday night, about ten o'clock, the second day of April, in 1865, that the resolute Lee marshalled his troops for the evacuation of Petersburg. At three on the following morning the stronghold of the Confederacy was left to the Union forces. At nine on the same morning General Grant rode into the deserted city. The remaining inhabitants were panic-stricken and in a destitute condition. Many of them had escaped with their beloved leader while others, in abject terror, secluded themselves in their homes. Grant, with his staff, rode quietly through the streets until he came to a comfortable-looking brick house, with a yard in front, where he dismounted and took a seat on the veranda. The gentle manner of the great general found a response in the hearts of those who had feared him. Citizens soon gathered on the sidewalk and gazed with curiosity on the Union commander. News of the hunger of the people was hurried along the line. Great wagon trains of provisions struggled for miles through roadways choked with prisoners, stragglers and wounded. This photograph was taken as the first division, loaded with barrels of flour, pork, coffee, sugar, and other necessaries, rolled into Petersburg. With the brotherly affection that even the madness of war cannot destroy, the men in blue came to those devoted to the gray, not as enemies, but as fellowmen ever willing to relieve the suffering. The humanity of war is here exemplified.

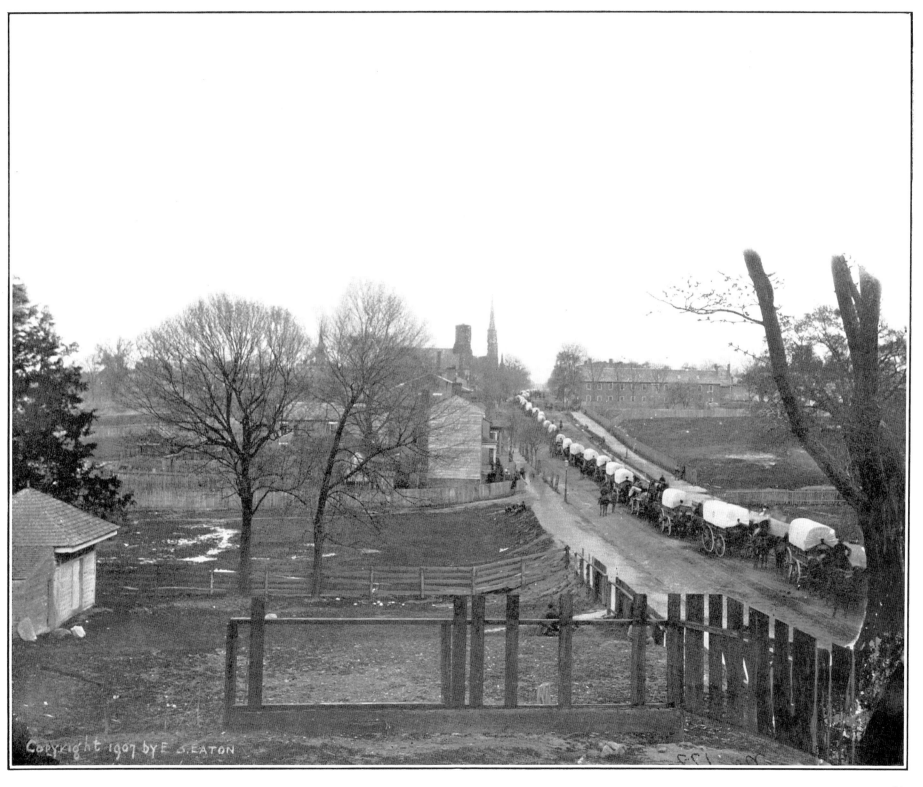

Copyright 1907 by E. S. Eaton

PHOTOGRAPH TAKEN WHILE GOVERNMENT PROVISION TRAINS WERE ENTERING PETERSBURG AFTER EVACUATION IN 1865

COPYRIGHT 1907 BY E. B. EATON.

PHOTOGRAPH TAKEN AS GUNBOAT "SANTIAGO DE CUBA" SAILED ON THE FORT FISHER EXPEDITION

THE largest fleet that had ever been assembled under one command in the history of the American Navy concentrated before Fort Fisher, North Carolina, late in 1864. It included nearly sixty vessels, of which five were ironclads, and the three largest United States steam frigates, "Minnesota," "Colorado" and "Wabash," and was accompanied by one of the war cameras. The total number of guns and howitzers of the fleet were over six hundred, and the weight of projectiles at a single discharge of all the guns, both broadsides, was over twenty-two tons. The Atlantic and Gulf coast were almost entirely in the Government possession and the Navy was prepared to strike its decisive blow. Fort Fisher was now the most important Confederate naval position. The first attack took place in the night of December twenty-third, when a powder-boat was exploded under the towering walls of the old fort. It was believed that it was leveled to the ground, but in the morning the grim fort stood absolutely uninjured with its flag floating defiantly. An attack was then led by the ironclads, followed by the monitors and frigates. A naval officer in describing it says: "Their sides seemed a sheet of flame, and the roar of their guns like a mighty thunderbolt." The enemy took refuge in their bomb-proofs. Owing to misunderstanding between army and navy the fort was not taken. An excellent photograph was secured of one of the gunboats in the Fort Fisher expedition—the "Santiago de Cuba," and the negative is one of the finest naval pictures ever taken.

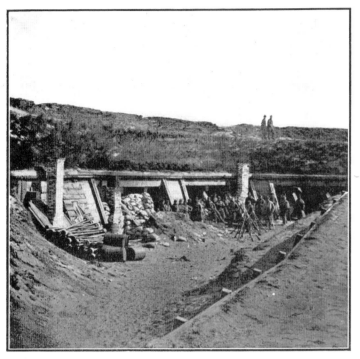

INTERIOR VIEW OF FORT FISHER IN 1865

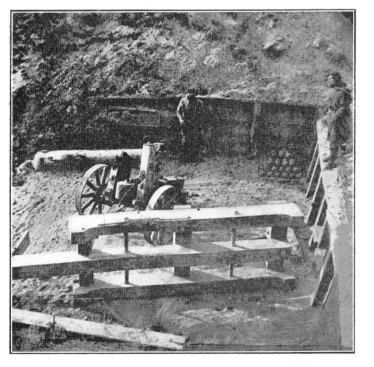

DISMANTLED GUN AT FORT FISHER IN 1865

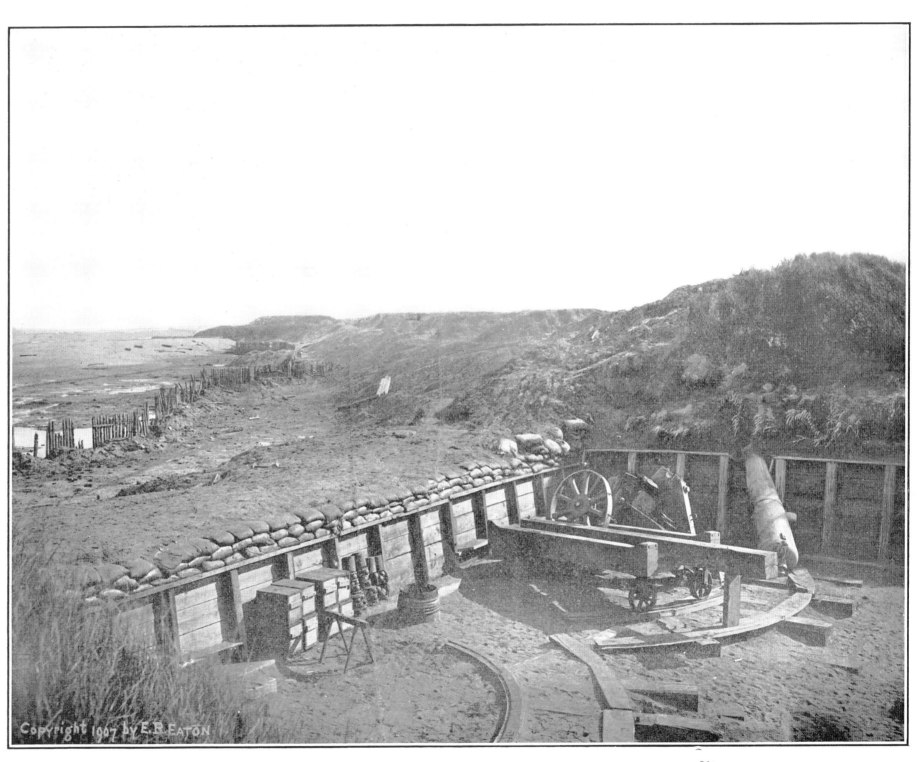

Copyright 1907 by E. B. Eaton

PHOTOGRAPH TAKEN AT FORT FISHER, NORTH CAROLINA, SHOWING DESTRUCTION OF GUN CARRIAGE IN 1865

THE last stronghold of the Southern Confederacy on the Atlantic Coast fell early in 1865. On the twelfth of January operations were agreed upon for the final assault on Fort Fisher and a photograph was taken of the fleet as it lay off the coast. On the morning of the thirteenth the ironclads opened a terrific fire. Fort Fisher was at this time much stronger than at the first attack. Troops had reinforced the garrison. Damages from the first bombardment had been repaired and new defenses added. In describing the downfall of the fort one who participated says: "I believe there had never before been such a storm of shell in any naval engagement. At noon on the fifteenth the attempt was made for the sailors and marines to land. From thirty-five of the sixty ships of the fleet boats were lowered, and with flags flying, pulled toward the beach in line abreast, a most spirited scene. The sailors were armed with cutlasses and pistols. The great land battery, the artillery and a thousand rifles opened fire from Fort Fisher. The daring sailors found themselves packed like sheep in a death pen, under a most galling fire." The army pressed forward under General Terry's command, fighting its way from traverse to traverse, overpowering the garrison, and finally driving the Confederates from their last refuge. Fort Fisher fell on the fifteenth of January. The casualties in the fleet amounted to 309, while Terry's command lost 110 killed and 536 wounded—a total of nearly 1,000 men. With the fall of Fort Fisher and its seventy-five guns, the Confederates abandoned Fort Caswell and all the works on Smith's Island; all those between Caswell and Smithville up to the battery on Reeve's Point on the west side of the river. This photograph of the fleet that took Fort Fisher shows the ships assembling off the coast. The negative was secured under much difficulty.

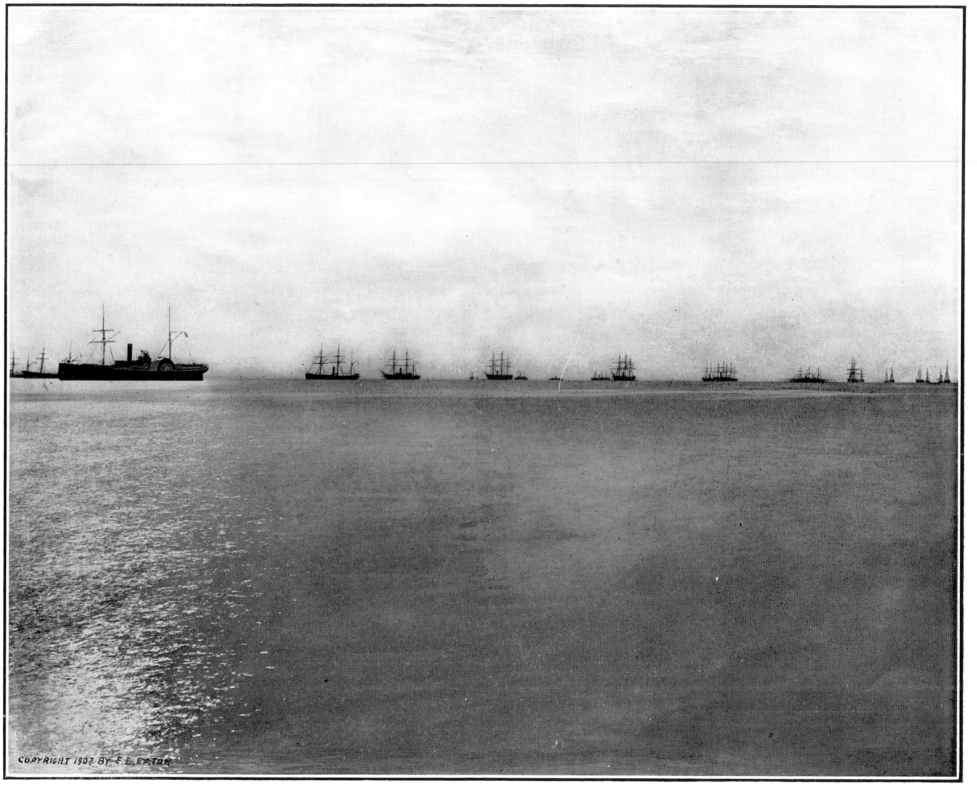

COPYRIGHT 1907 BY E.E.EATON

PHOTOGRAPH TAKEN AS GREATEST FLEET CARRYING AMERICAN FLAG WAS PREPARING TO ATTACK FORT FISHER IN 1865

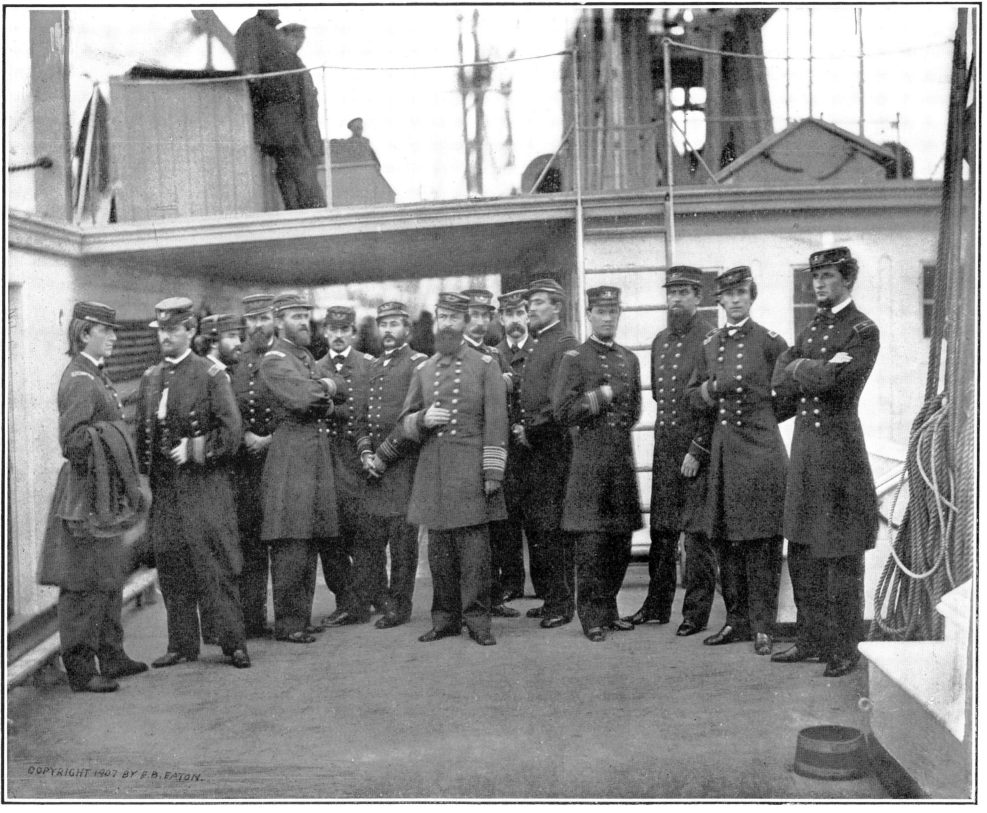

COPYRIGHT 1907 BY E. B. EATON.

THE Civil War was a great practical demonstration of naval vessels propelled by steam. The whole system of naval tactics had undergone a great change. The guns had become vastly more powerful; war ships were now protected by a light armor, and the torpedo had found its way into successful employment. The normal strength of the Navy at the beginning of the war was ninety vessels; fifty of these were sailing ships, worthy vessels in years gone by, but now left behind by progress. There were forty vessels propelled by steam and many of these were scattered on the high seas. As the war progressed, the Navy was increased and at its close had nearly six hundred ships, including every variety of merchantman and river steamboat roughly adapted in navy-yards for war services. There were built or projected during the war nearly sixty ironclads. At the beginning of the war the total number of officers of all grades in the Navy was 1,457, and during its progress the number was increased to 7,500, chiefly from the merchant marine. The normal strength of seamen, which was 7,600, rose during the war to 51,500. The South entered upon the war without any naval preparation and with very limited resources, but by purchases and seizures equipped a considerable fleet. Toward the close of the conflict the war photographers secured a large number of negatives during naval demonstrations. Among those here presented is Admiral David D. Porter and staff on his flagship, "Malvern," on the Fort Fisher Expedition. The gallant admiral may be seen standing in the center of the group. A picture is on the following page of Major-General A. H. Terry and staff, in command of the land demonstrations around Fort Fisher, and on whom special honors were conferred by Congress for his courageous leadership in the attack. These photographs witness the last great naval demonstration of the war.

PHOTOGRAPH TAKEN WHILE ADMIRAL PORTER AND STAFF WERE ON FLAGSHIP "MALVERN" IN FORT FISHER EXPEDITION IN 1865

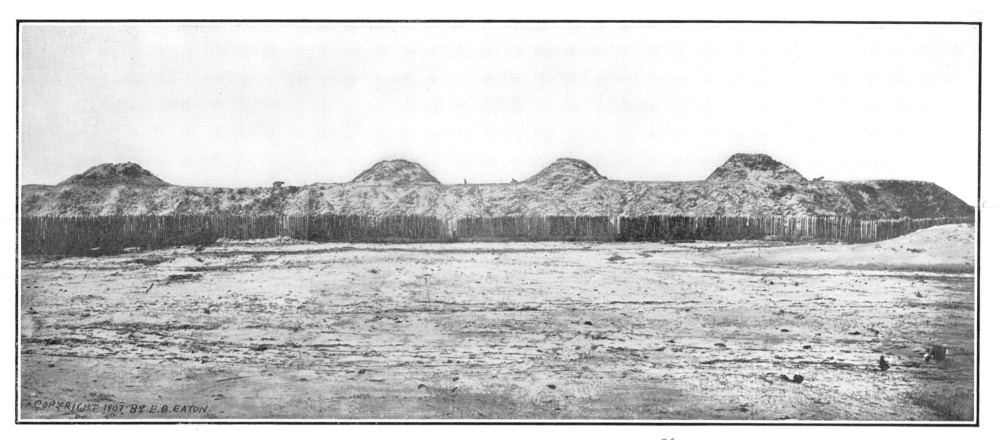

PANORAMIC VIEW OF FORT FISHER, NORTH CAROLINA, IN 1865

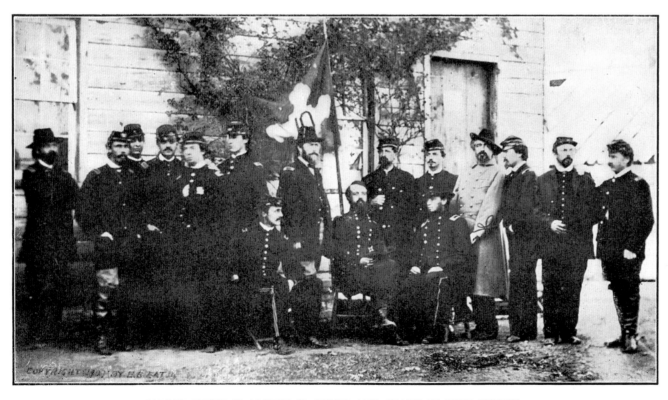

MAJOR-GENERAL ALFRED H. TERRY AND STAFF AT FORT FISHER

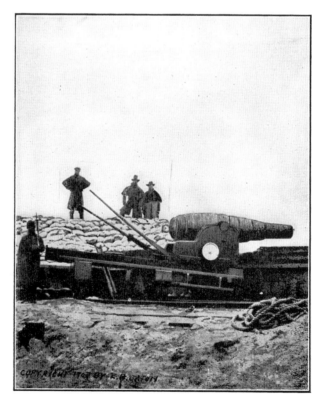

ENGLISH ARMSTRONG GUN IN FORT FISHER

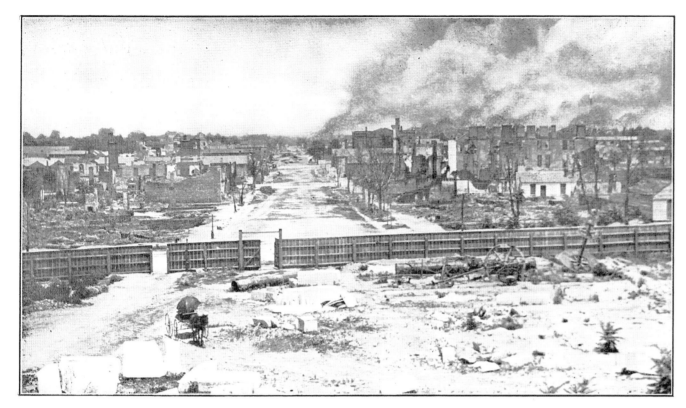

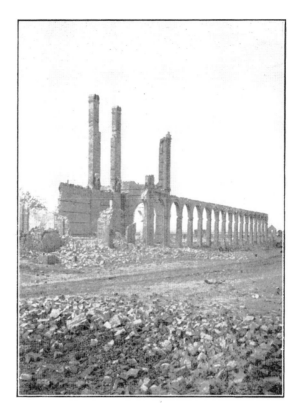

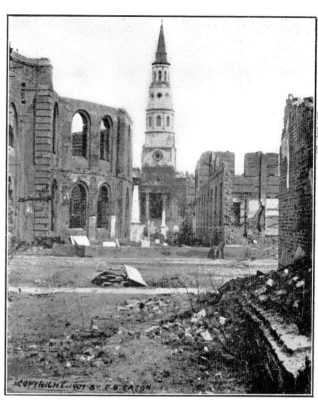

RUINS OF COLUMBIA, SOUTH CAROLINA, FROM THE CAPITOL—SHELLED
BY SHERMAN, FEBRUARY 16, 1865—PHOTOGRAPH TAKEN BY BRADY WHILE RUINS WERE SMOKING

RUINS OF DEPOT WHERE TWO HUNDRED PERSONS
WERE BLOWN UP ON EVACUATION OF CHARLESTON

RUINS OF SECESSION HALL AT CHARLESTON AFTER
SURRENDER, FEBRUARY 18, 1865

THE final blows of the Civil War came quick and sharp. Grant had taken Petersburg; Thomas had annihilated the Confederate forces under Hood along the Mississippi River; Sherman had swept through Georgia and overrun the Carolinas. Exactly four years after the inauguration of Jefferson Davis as President of the Confederacy, historic Columbia and Charleston, South Carolina, surrendered. The closing days sowed flame and devastation. The war cameras followed Sherman's Army into Columbia and the old negatives tell the tragedy of the destroyed Confederate cities. One of them here reproduced is historic Secession Hall in ruins. It was here that the first Ordinance of Secession was passed. This view shows the historic edifice as it appeared when the Union troops took possession of the city. Adjoining the Hall is the ruins of Central Church, and in the background is St. Phillips Church. The fall of Columbia occurred on February 12, 1865. Charleston surrendered the following day, and the Federal Government took possession. One of these photographs shows the ruins of the Northeastern Railroad Depot at Charleston where two hundred persons were blown up on the day of evacuation, February 17, 1865. Sherman moved on through North Carolina and fought his last battle at Bentonville, where the National loss was 1,604 men and the Confederate loss 2,342. During these last days of the war occurred a disaster on the Mississippi River. The "Sultana" was on her journey from New Orleans to St. Louis, receiving on board 1,964 Union prisoners from Columbia, Salisbury, Andersonville and other Confederate prisons. Anxious to proceed North, little heed was given that the ship was already carrying a heavy load of passengers on board, occupying every foot of available space on all the decks to the tops of the cabins and the wheelhouse, and on the twenty-seventh of April, when about eight miles above Memphis, one of her boilers blew up. The dead at the scene numbered 1,500.

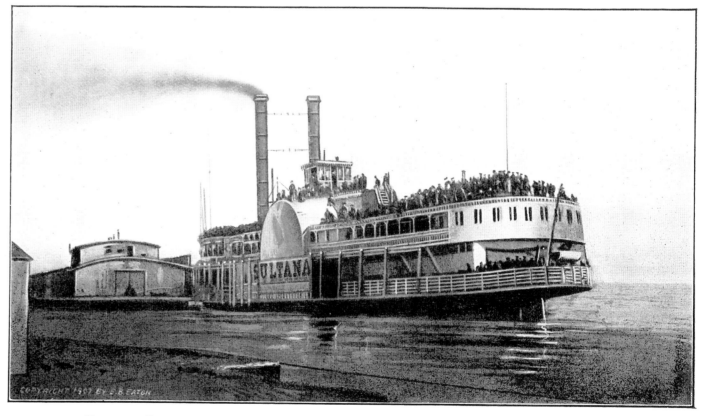

STEAMER "SULTANA" CONVEYING EXCHANGED UNION PRISONERS—DESTROYED IN MISSISSIPPI RIVER IN 1865

IN the hospitals of the army during the Civil War 6,049,648 cases were treated by the officers of the Medical Department. The medical skill of the surgeons and physicians is evidenced by the fact that only 185,353 of these patients died during their detention in the hospitals. While a large number of these soldiers suffered from gunshot wounds, the disease of chronic diarrhœa was nearly as fatal, and its deadliness was closely followed by the ravages of typhoid fever and lung diseases. It is estimated that 285,245 men were discharged during the war for disability. A tribute should be paid to the nobility of the hospital corps. Many noble men and women did great service to their country in relieving the sufferings that followed the battles. After many of the terrific conflicts the ground was strewn with the dead and dying. The wounded, in whom there was a hope of life, were given immediate care and hurried on stretchers to nearby houses and barns from which floated the yellow flag of the Medical Department. Large hospital tents were erected near the scene of battle. At times all the rooms in the surrounding farmhouses were full of wounded; the injured men were laid on cornstalks and hay in the barns. Sometimes it was impossible to find shelter for them all and they were laid on boards inclined against fences. Many of the large trees formed a shelter for a temporary hospital, where the men were laid in rows while the attendants administered to their wants. In no previous war in the history of the world was so much done to alleviate suffering as in the War of 1861-1865. But notwithstanding all that was done, the wounded suffered horribly. After any great battle it required several days and nights of steady work before all the wounded men were gathered.

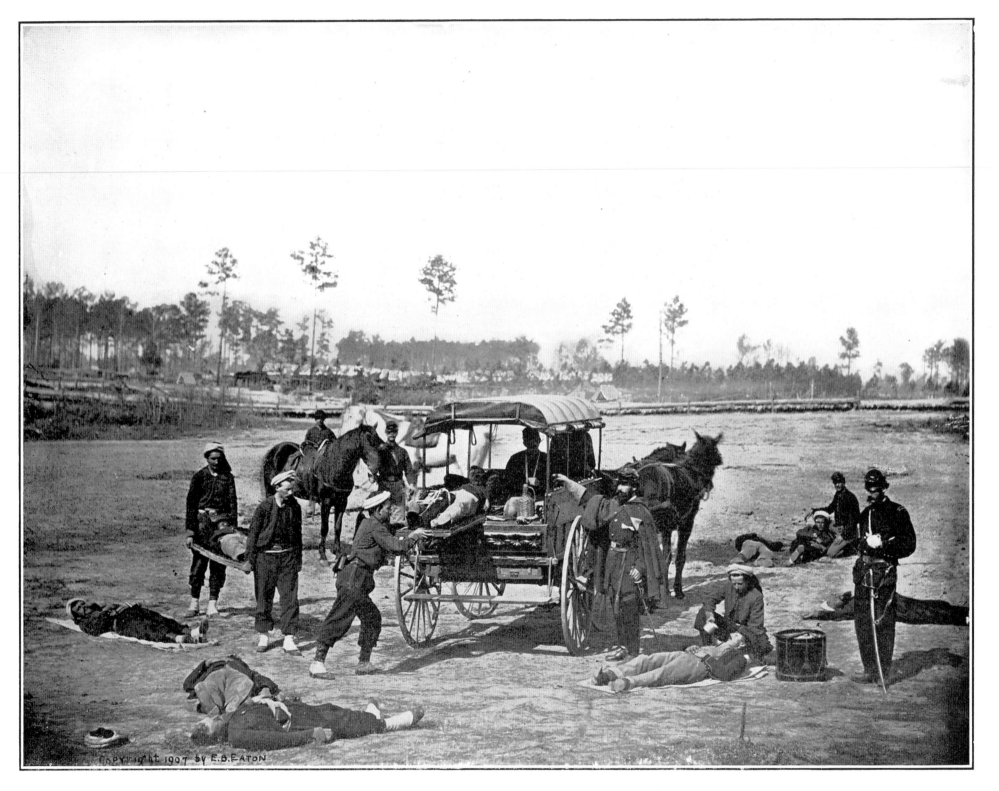

PHOTOGRAPH TAKEN WHILE AMBULANCE CORPS WERE REMOVING WOUNDED SOLDIERS TO THE FIELD HOSPITAL

SMOKESTACK OF EXPLODED RAM "VIRGINIA" IN 1865

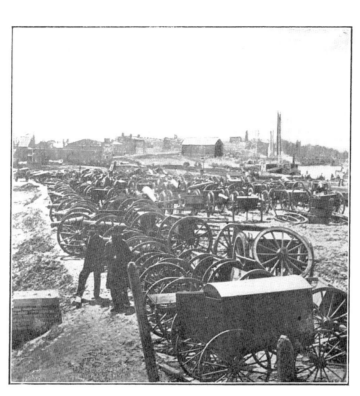

CONFEDERATE ARTILLERY ON WHARVES NEAR RICHMOND

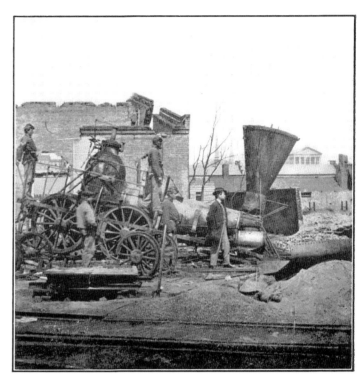

RUINED LOCOMOTIVE AFTER FALL OF RICHMOND IN 1865

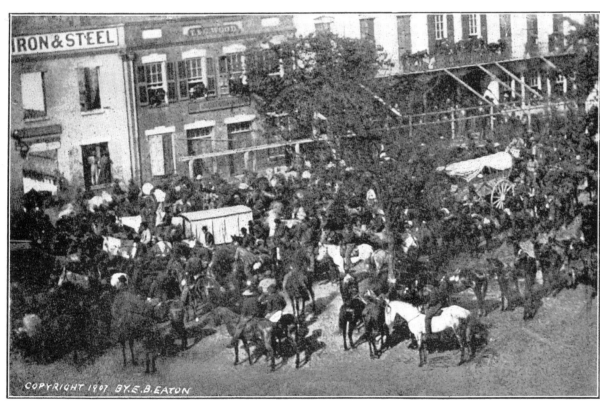

AMBULANCE CONVEYING JEFFERSON DAVIS AFTER HIS CAPTURE—PASSING
THROUGH THE STREETS OF MACON, GEORGIA

JEFFERSON DAVIS was at St. Paul's Church, in Richmond, at the usual hour of Sunday morning worship when he received the message that Petersburg was being evacuated and Lee's lines were irreparably broken. The sexton walked up to Davis's pew and whispered a few words in the President's ear. The members of the Cabinet received similar calls. From church to church the note of warning was communicated. By two o'clock everybody in Richmond knew that the city was to be abandoned. The Presidential party with difficulty made its way through the excited crowd which thronged and blocked the streets. Davis began his flight by boarding a train and went as far as Danville where, on April 4, 1865, he began to establish a new seat of government. The following day he issued a proclamation to his people, only to again flee to Greensborough, North Carolina, where he remained in a railroad car. On reaching Charlotte, he threw off the semblance of authority and planned to reach Texas. The flight was continued through South Carolina and into Macon, Georgia. In the meantime, a reward of $100,000 was offered for the apprehension of Davis. He was finally captured in a camp in the woods near Irwinsville, Georgia, while trying to escape in a lady's waterproof coat, gathered at the waist, with a shawl thrown over the head, and carrying a tin pail. This remarkable photograph was taken while the Confederate President was being carried as a prisoner in an ambulance through the streets of Macon. He was conveyed to Fortress Monroe, for safe keeping, on May 22, 1865, and was finally allowed his freedom on bail and never brought to trial. Brady entered Richmond with his cameras a few hours after the departure of Davis and these negatives witness the ruins. The great tobacco warehouses had been destroyed and the ironclad rams on the river had been blown up. The city was being pillaged. The Union troops entered as conquerors and immediately set to work with a will to extinguish the flames which wrought great destruction and havoc.

RICHMOND was a mass of flames on the third of April, in 1865. As the Federal forces entered the city it was a scene of terrible splendor. The explosion of magazines caused the earth to rock and tremble as with the shock of an earthquake. The flames were leaping from building to building until thirty squares were ablaze, consuming over one thousand structures. Prisoners were liberated from the penitentiary and the torch was applied to it. Men, women and children, faint from hunger, fled from their homes. The provision depots were battered at the doors and forced open in the demoniacal struggle against starvation. The gutters ran with whiskey, and men fell to their knees and lapped it as it flowed through the streets. The clatter of the hoofs of the horses added to the tumult as the Union troops entered the city. At daylight the approach of the Federal forces could be plainly discerned. The war cameras came into Richmond with the army. The Union soldiers began to fight the flames, blowing up houses to check their advance. There was a cavalry rush for Libby prison to bring freedom to the Union soldiers confined within its walls, but upon reaching it not a guard nor an inmate remained. The doors were wide open. An old negro placidly remarked: "Dey's all gone, massa!" The day following a mighty cheer was heard near the abandoned residence of Jefferson Davis. President Lincoln walked down the street with his usual long, careless stride. After viewing the situation and impressing upon the officers his desire that they exert the most humane influences, Lincoln returned to Washington. One of the most valuable negatives in the Civil War collection is the ruins of Richmond on the day that Lincoln inspected the condition of the city.

PHOTOGRAPHS TAKEN OF THE RUINS AT RICHMOND THE DAY AFTER ITS EVACUATION IN 1865

WHEN Lee, with the remnant of his army, fled from Richmond and Petersburg, he was closely pursued by Grant and attacked vigorously at every approach. For seventy miles it was a race that was marked by a long track of blood. There were collisions at Jestersville, Detonville, Deep Creek, Paine's Cross Roads, and Farmville. At Sailor's Creek the Confederate lines were broken by Custer. The Confederate General Ewell, with four other generals and his entire corps, were captured and on the eighth of April the Southern Army, under Lee, was completely surrounded. Lee had but 28,000 men left and his brave dead were lying in heaps along the route of his retreat. Hemmed in at Appomattox Court House a last desperate effort was made to cut through the Federal cavalry. He was gaining ground when Sheridan's bugles rang out the signal for a general charge and a halt was called under a flag of truce. The two historic armies never exchanged another shot. General Lee left his camp on the morning of April 8 and was conducted to the McLean house, where he found General Grant awaiting him. The actual surrender took place on April 12, 1865. The Confederate officers and men were paroled. Lee returned to his men and bade them farewell. The scene was one of the most pathetic in the records of war. The Confederate veterans wept like children as they looked upon the face of their beloved leader. His last words to his men were: "You will take with you the satisfaction that proceeds from the consciousness of duty faithfully performed. I earnestly pray that a merciful God will extend to you His blessing and protection." A few hours after Lee's surrender this photograph was taken at Appomattox.

PHOTOGRAPH TAKEN AT THE McLEAN HOUSE AT APPOMATTOX THE DAY THAT LEE SURRENDERED TO GRANT, APRIL 9, 1865

IT is here in these closing pages the sad duty of these wonderful old negatives to record one of the deepest tragedies in the history of the world. In it the greatest Republic of the earth, at the close of the most terrific conflict ever waged by fellow countrymen, saw its champion of Liberty fall at the hands of an assassin. The great Lincoln looked forward to years of peace among a re-united people. On the night of April 14, 1865, he was murdered at Ford's Theater. The bitter tidings swept the country. The American Nation was bowed down with grief. The rendezvous of the conspirators was found to be the house of Mrs. M. E. Surratt, located in the very heart of Washington. Mrs. Surratt, her daughter Anna, Miss Fitzpatrick and a Miss Holahan were arrested. George A. Atzerott, and one named Powell, were later captured. The principal assassin, John Wilkes Booth, was found eleven days after the murder and was shot when he refused to surrender. His companion, Harold, who had been a fugitive with him, was taken prisoner. The trial of the conspirators took place in Washington before a military commission. On July 6, 1865, sentence was pronounced and on the following day the four conspirators—Harold, Atzerott, Powell and Mrs. Surratt—were hanged. Two of Brady's cameras were taken into the prison yard and placed near the scaffold. When the warrant was being read one camera was used and the historic view is now in the Eaton Collection. When the drop was sprung, the second negative was exposed and the tragic scene is here recorded. Mrs. Surratt is hanging at the left. The ghastliness was such that many of the guards turned their heads. It is believed to be the first time that the camera has been used to perpetuate the execution of political conspirators. The negatives are in excellent condition and their historic value is beyond purchase.

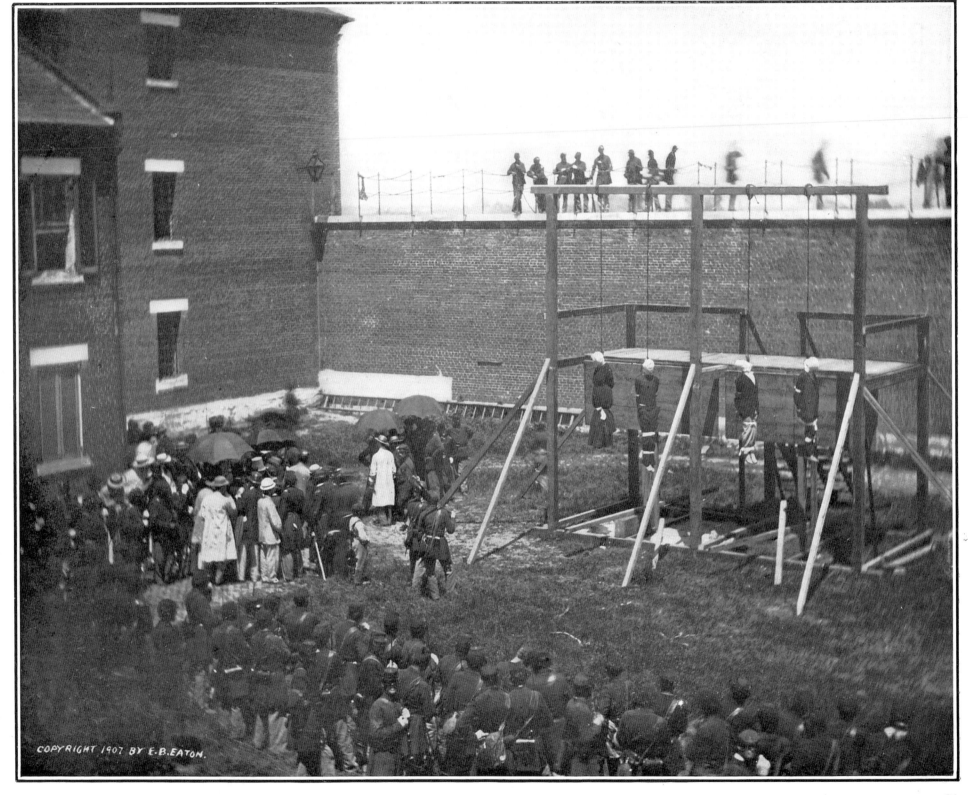

PHOTOGRAPH TAKEN IN PRISON YARD IN WASHINGTON AT HANGING OF MRS. SURRATT AND THE LINCOLN ASSASSINATION CONSPIRATORS IN 1865

THE funeral procession of Lincoln as it passed through New York was witnessed by nearly a million people. The body was taken to Springfield, Ohio, his old home town to which he had not returned since he left it to go to Washington as President of the United States. Lincoln was buried at Oak Ridge Cemetery, about two miles from Springfield. Immediately after the close of the war the Government began inquiry into the cruelties alleged to have taken place in many of the prisons. The result was the arrest of Captain Henry Wirtz, the jailor at Andersonville. He was given trial before a military commission and convicted of brutally murdering Union prisoners. Wirtz was sentenced to death and hanged on the tenth of November, 1865. The execution took place in Washington within short distance of the National Capitol, and Brady's cameras were taken into the prison yard. The negative was taken as the condemned man stood on the scaffold, with head bowed, listening to the reading of his death warrant. Another negative was secured after the noose had been tightened around his neck and the drop had been sprung. The photographs perpetuate a tragic moment. It will be seen that the soldiers on guard were standing at "attention." The evidence against Wirtz was overwhelming. Many witnesses testified to the cruelty of the accused man and the horrors enacted within the dead lines at Andersonville. Prisoners were forced to go forty-eight hours without food. Many of them became insane; others committed suicide. There were deliberate, cold-blooded murders of peaceable men. No opportunities were afforded for cleanliness and the prisoners were covered with vermin. The execution of Wirtz met public approval and this photograph shows him in his last moments of life.

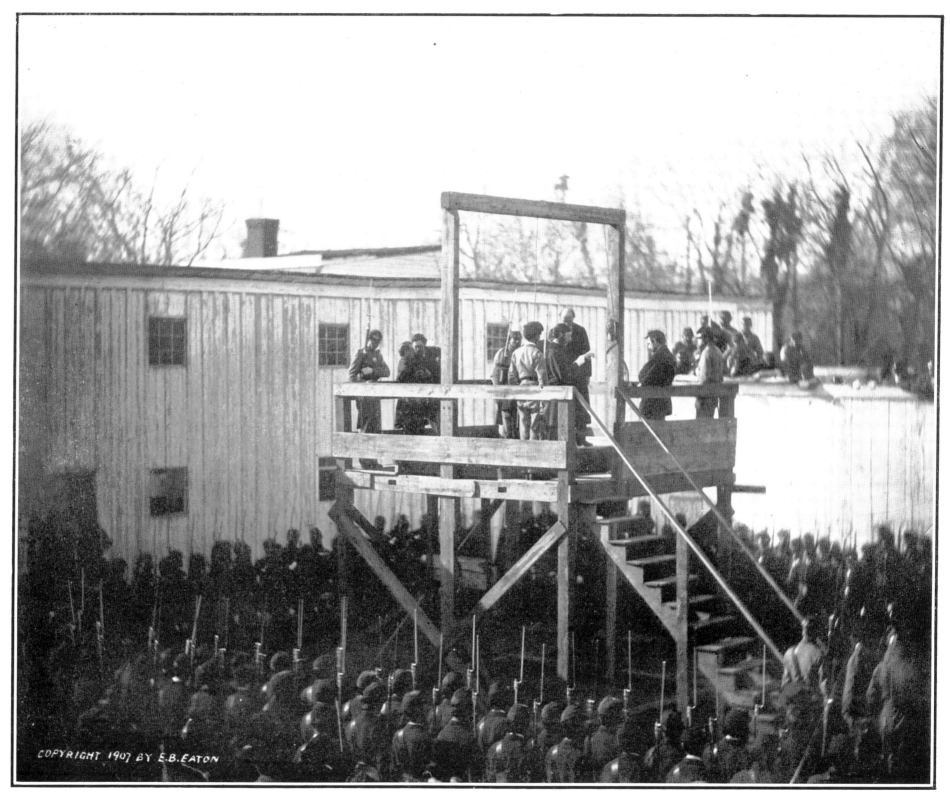

PHOTOGRAPH TAKEN WHILE DEATH WARRANT WAS BEING READ TO WIRTZ, THE KEEPER OF ANDERSONVILLE PRISON IN 1865

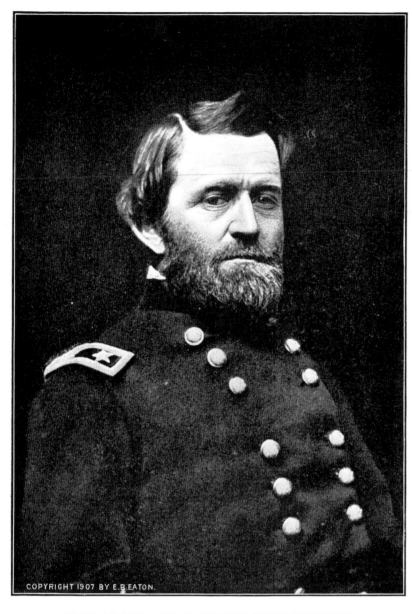

HERO OF THE AMERICANS WHO WORE THE BLUE

Ulysses Simpson Grant—Born at Point Pleasant, Ohio, April 27, 1822—Died at Mt. Gregor, New York, July 23, 1885—Graduated from West Point in 1843 and fought gallantly under the Stars and Stripes in the War against Mexico—Commander-in-chief of the victorious Union Army in the Civil War in the United States—This photograph was taken when he was forty-two years of age, during the Civil War, and was never before published—It is protected by copyright

AMERICANS—true to the blue or true to the gray—bow in reverence to the memory of these two great fellow countrymen—the greatest leaders that mankind has ever followed. Under the same beloved flag they fought in their early days, only to stand arrayed against each other as foes in their latter days, and to finally die as loyal Americans. Never before has the public looked upon these photographs, which were taken by the war cameras at Appomattox at the end of the war. When Lee offered his sword to Grant it was courteously returned to him. The two gallant generals lifted their hats and parted forever. Grant mounted his horse, and started with his staff for Washington. Lee set out for Richmond, a broken-hearted man. The armies returning from the field were brought to Washington for a grand review and mustered out of service. The news of Lee's surrender passed from army to army through the South and West, and six weeks later the last gun had been fired and musket laid down in the Civil War of the United States. In closing these pages, acknowledgment is made to the many eminent historians whose scholarly works have been consulted and quoted in narrating the incidents surrounding these photographs. Mr. Edward B. Eaton, who has prepared this remarkable presentation from his valuable collection; Mr. Francis T. Miller, the editor and writer of this book; and Mr. George E. Tracy, associated with Mr. Eaton in placing this volume before the public, wish to express their appreciation for the cordial interest taken in the work by the department commanders of the Grand Army of the Republic, many of whom testify to having seen the Brady cameras on the battlefield when these negatives were being taken. To these men—and to all who witnessed the scenes herein perpetuated—this book is dedicated with the benediction of the victorious Grant:

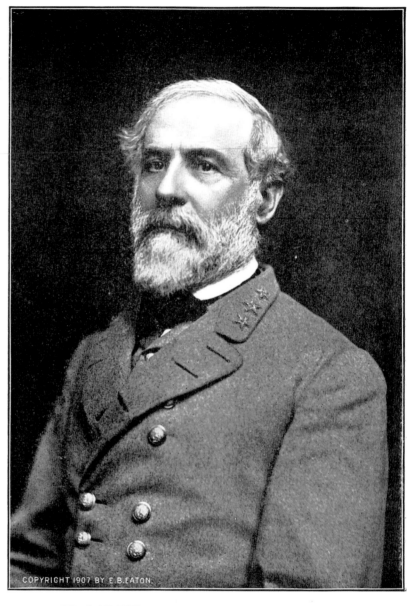

HERO OF THE AMERICANS WHO WORE THE GRAY

Robert Edward Lee—Born at Stratford, Virginia, January 19, 1807—Died at Lexington, Virginia, October 12, 1870—Graduated at West Point in 1829 and fought gallantly under the Stars and Stripes in the War against Mexico—Commander-in-chief of the vanquished Confederate Army in the Civil War in the United States—This photograph was taken when he was fifty-seven years of age, during the Civil War, and was never before published—It is protected by copyright

"LET US HAVE PEACE"

THE ASSOCIATED PUBLISHERS OF AMERICAN RECORDS
PRESS OF THE DORMAN LITHOGRAPHING COMPANY
NEW HAVEN, CONNECTICUT

HALFTONE ENGRAVINGS BY ROBERT WELLER, HARTFORD, CONNECTICUT

DEDICATED
TO THE
AMERICAN SOLDIER

THE EDWARD B. EATON COLLECTION OF ORIGINAL PHOTOGRAPHS OF THE CIVIL WAR

PARTIAL LIST OF THE SEVEN THOUSAND NEGATIVES TAKEN UNDER THE PROTECTION OF THE SECRET SERVICE BY MATHEW B. BRADY AND ALEXANDER GARDNER ON THE BATTLEFIELDS OF THE CIVIL WAR IN THE UNITED STATES DURING THE YEARS 1861—1862—1863—1864—1865—AND NOW SAFELY STORED IN THE PRIVATE VAULT OF THE OWNER AT HARTFORD, CONNECTICUT

THE Eaton Collection of Original Photographs of the Civil War, the full history of which is given in the introductory to this Volume, is now for the first time unveiled to the public. In presenting the reproductions in this book the owner of this remarkable collection has protected them fully by copyright and warns the public against infringers. Mr. Eaton is the sole owner of these original negatives, which are valued at $150,000, and henceforth, any other reproduction must be with his written authority or it is an infringement. That the public may become fully acquainted with the negatives in this official collection, experts are now at work drawing two prints from each negative, protecting them under copyright, and identifying, arranging and preparing them for a complete catalogue. In several instances the label which the photographer placed on the negatives when he made the photograph, over forty years ago, has been lost. These are being carefully identified by veterans of the Civil War who offer affidavits to having been on the scene. At present there are still many views that are labeled "unknown." It is near-

ing a half century since the sun painted these real scenes of that great War, and some negatives have undergone chemical changes which make it difficult to secure "prints" from them. There can be no substitution, as the scenes represented on the old glass plates have passed away forever. The great value of these pictures is apparent. Several negatives are entirely past printing and all of them require retouching by old-time photographers who understand the process. Even to the thinning ranks of heroes of the Civil War the scenes of 1861-1865 are but a fading memory; cherished, it is true, and often called up from among the dim pictures of the past, but after all, only the vision of a dream. Artists have painted and sketched and engraved, with more or less fidelity to fact and detail, those "scenes of trial and danger." Their pictures can be but imaginary conceptions of the artist. Fortunately, our Government authorized courageous photographers to skillfully secure with their cameras the reflection, as in a mirror, of the thrilling scenes of the conflict. These views vividly renew the memories of the war days. The camp, the march, the battlefields, the

forts and trenches, the wounded, the prisoners, the dead, the hurriedly-made graves, and many other of those once familiar scenes are photographically portrayed and perpetuated.

As a record of a crisis in the history of the world, these negatives are worth their weight in gold. Their value is such that they cannot be handled, except with great care, or removed for exhibition purposes. They are in a vault in Hartford, Connecticut, where the owner is very willing to allow the public, especially the Veterans of the Civil War, to examine them. It is desired to have the old negatives become of as much service to the public-at-large as possible and for this purpose is compiled this partial catalogue from the collection. Whenever the condition of the negative permits, Mr. Eaton is willing to allow the privilege of printing a proof. This is especially granted to Old Soldiers or Grand Army Posts who desire certain original photographs of scenes in which they participated. The service of this collection, inasmuch as it pertains to commendable purposes, is here extended to the American People who are no longer "Federal" and "Confederate."

THIS is a partial list of the negatives in the Eaton Collection of Original Negatives taken on the Battlefields during the Civil War of the United States, under the protection of the Secret Service. They include all phases of army life. The cameras followed, not only the Eastern Army and the Army of the West, but accompanied the Naval Fleets and were present in many demonstrations. Veterans of the Civil War are cordially invited to visit Hartford and inspect these negatives. Proofs will be taken from any negative here registered, for Grand Army Veterans or Posts, providing sufficient reasons are given with the request, which should be sent direct to the owner of the collection, Mr. Edward B. Eaton, Hartford, Connecticut.

ARMY OF POTOMAC.

APRIL, 1861, TO AUGUST, 1861.

Three Months' Campaign.

Long Bridge, Washington, D. C., L.7824.
Christ church, Alexandria, where General Washington attended, S.2301.
Marshall House, Alexandria, Va., S.1189.
Slave-pen, Alexandria, Va., L.7264, S.1003, S.1174.
Ruins of Norfolk navy-yard, S.984.
Ruins of Harper's Ferry arsenal, S.655.
Ruins of bridge across Potomac River at Berlin, S.658.
Fairfax court-house, S.298.
Fairfax seminary, S.2322.
Fairfax church, S.2323.
Taylor's tavern, near Fall's Church, S.2320.
Cub Run, S.307.
Bull Run, S.1111.
Battlefield of Bull Run, S.1046.
Ruins of stone bridge, Bull Run, L.7082, S.310, S.312.
Sudley church, S.315, S.316, S.1017, S.1148.
Sudley Ford, Bull Run, S.313, S.314.
Thorburn's house, Bull Run, S.317.
Matthews's house, Bull Run, S.318.
Robinson's house, Bull Run, S.319, S.1176.
Ruins of Henry's house, Bull Run, S.320.
Headquarters of General Beauregard (confederate) at Manassas, S.327.
Stone church, Centreville, S.302.
Mrs. Spinner's house, near Centreville, S.308, S.309.
Grigsby House (Stevens's house), near Centreville, S.1163, S.303.
Soldiers' graves, Bull Run, S.321.
Dedication of monument on battlefield of Bull Run, L.7362, L.7363, L.7364.
Monument on battlefield of Bull Run, S.7532, S.1193, S.1194.

ARMY OF POTOMAC.

AUGUST, 1861, TO MARCH, 1862.

Headquarters of General McClellan at Fairfax Court House, Va., (also used by General Beauregard,) L.7142, S.299.
Camp of Tenth Massachusetts Infantry, S.2421.
Signal tower near camp of Fourteenth New York Infantry, S.2352.
Camp of Thirty-fifth New York Infantry, S.2422.
Camp of Seventy-first New York Infantry, S.2413, S.2415.
Camp of Thirty-first Pennsylvania Infantry, Queen's farm, near Fort Slocum, Virginia, S.2409, S.2410, S.2412.
Camp scenes in camp of Thirty-first Pennsylvania Infantry, S.2405, S.2406.
Review of Dwight's brigade, S.2419, S.2420.
Newspaper dealer in camp, C.1378.
Sunday services in camp of Sixty-ninth New York Infantry, S.3713.
Professor Lowe's balloon, S.2349, S.2350.

ARMY OF POTOMAC.

MARCH, 1862, TO JULY, 1862.

Peninsula Campaign.

Battery No. 1, in front of Yorktown, L.7094, S.361, S.362, S.363, S.364, S.365.
Battery No. 4, in front of Yorktown, S.373, S.374, S.375, S.376, S.377, S.378, S.379, S.380.
Naval battery in front of Yorktown, S.463.
Battery Magruder (confederate), Yorktown, S.2360, S.2361, S.2362.
Confederate fortifications, Yorktown, S.450, S.451, S.452, S.453, S.458, S.1026, S.2364, S.2365, S.2366, S.2367, S.2368, S.2369, S.2425.
Confederate fortifications, Yorktown, with exploded gun, S.455.
Ravine at Yorktown in which confederate magazines located, S.147.
Confederate water battery at Gloucester Point, S.454, S.457, S.460, S.461.

Yorktown Landing, S.2383.
Artillery park at Yorktown Landing, S.2358.
Wagon park at Yorktown Landing, S.2357.
Sally-port at Yorktown, S.2371.
Street view in Yorktown, S.2372.
Court-house, Yorktown, S.2375, S.2376.
Church, used as Second Corps hospital, Yorktown, S.2374.
Baptist church and hospital of Third Division, Sixth Corps, Yorktown, S.2373.
Cornwallis's headquarters during Revolutionary war, S.2336.
Headquarters of General Magruder (confederate), Yorktown, Va., S.449.
Cornwallis Cave, Yorktown, used by confederates for magazine, S.2379, S.2380.
Captain Perkins's "Secesh," horse captured at Cornwallis Cave, Yorktown, S.2381.
Confederate winter quarters near Yorktown, S.2377.
Camp scene in front of Yorktown—quarters of Dr. Grant and Dr. Dwight, of French's brigade, S.2378.
Farnhold's house, near Yorktown, May, 1862, S.360.
Moore's house, near Yorktown, S.462.
Clark's house, near Yorktown—used as hospital, S.371.
House used by General La Fayette during Revolutionary war as Headquarters, S.369, S.372.
Tabb's house, Yorktown, L.7413.

Camp Winfield Scott, headquarters Army of Potomac, in front of Yorktown, May, 1862:
—views of camp, S.350, S.367, S.368.
—Prince de Joinville, Duc de Chartres, Comte de Paris, English army officers, and officers of General McClellan's staff, S.352, S.353, S.354.
—staff and foreign officers at General McClellan's headquarters, S.429, S.355.
—Prince de Joinville, Duc de Chartres, and Comte de Paris at mess table, S.356, S.358.
—group of staff officers at General McClellan's headquarters, S.388.
—group of English officers at General McClellan's headquarters, S.638.
—topographical engineers, S.366.
—group at photographer's tent, S.349.
—Captain Custer, U. S. A., and Lieutenant Washington, a confederate prisoner, May, 1862, S.428.
—orderlies and servants, S.359, S.444.
Camp at General Andrew Porter's headquarters in front of Yorktown, May, 1862, S.370.
General Andrew Porter's staff, May, 1862, S.389.
Generals Franklin, Slocum, Barry, and Newton, and staff officers, May, 1862, S.381, S.382.
Embarkation at Yorktown for White House Landing, S.2363.

Encampment of Army of Potomac at Cumberland Landing:
—view of camp, S.7597, L.7598, L.7519, L.7648, S.1180.
—views making panoramic view, S.1076, S.1186, S.1212, S.1213, S.1214, S.1219.
—views making panoramic view, S.1215, S.1216, S.1217, S.1218.
—seven views making one panoramic view, S.1220, S.1221, S.1222, S.1223, S.1224, S.1225, S.1226.
Foller's house, Cumberland Landing, S.385.
Contrabands at Foller's house, Cumberland Landing, S.383.
White House Landing, S.2485.
Conway Landing, S.2490.
View of river below White House Landing, S.2489.
The White House, former residence of Mrs. Custis Washington, S.384.
Ruins of the White House, S.2486.
Camp of Christian Commission, at White House Landing, S.2487.
Ruins of bridge across Pamunkey River, near White House Landing, S.386.
Saint Peter's church, near White House, where General Washington was married, S.2302, S.2303.
Headquarters Army of Potomac, at Savage Station, June, 1862, S.468.
Field hospital, at Savage Station, after battle of June 27, 1862, S.491.

Battlefield of Fair Oaks:
—house used as hospital for Hooker's division during the battle, S.478, S.479.
—house used as hospital, S.480.
—house near which over four hundred soldiers were buried, S.470.
—Sickles's brigade coming into line in distance, S.471.
—Quarle's house, S.474.
—earthworks at extreme front, S.472.
—Robinson's house, at Fair Oaks Station, June, 1862, S.473.
Fort Richardson, near Fair Oaks Station, June, 1862, S.475.
Fort Sumner, near Fair Oaks Station, June, 1862, S.476.
Camp Lincoln, near Fair Oaks, June, 1862, S.430.

Battery,—First New York Artillery Battalion, near Fair Oaks, June, 1862, S.443, S.640.
Robertson's Battery of Horse Artillery, Battery B, Second United States Artillery, near Fair Oaks, June, 1862, S.642, S.439.
Benson's Battery of Horse Artillery, Battery M, Second United States Artillery, near Fair Oaks, June, 1862, S.433, S.641.
Gibson's Battery of Horse Artillery, Battery C, Third United States Artillery, near Fair Oaks, June, 1862, S.431.
Officers of Brigade of Horse Artillery, near Fair Oaks, June, 1862, S.434, S.639.
General Stoneman, General Naglee, and staff officers, near Fair Oaks, June, 1862, S.436, S.438, S.445.
Gun captured by Butterfield's brigade, near Hanover Court House, S.2353, S.2354.
Mechanicsville, Va., S.909.
Elliston's Mill, battlefield of Mechanicsville, S.920.
Gaines's Mill, Va., S.932.
Battlefield of Gaines's Mill, Va., unburied dead, S.914, S.916.
Engineer Corps making corduroy roads, June, 1862, S.656.
Bridge across Chickahominy River, built by Fifteenth New York Engineers, S.489.
Grape Vine Bridge across Chickahominy River, L.7383.
Bridge across Chickahominy River, S.930.
Bridge across Chickahominy River, Mechanicsville Road, S.913.
Telegraph station, Wilcox's Landing, S.2351.
Westover House, James River, S.2334, S.2335.
Westover Landing, James River, S.620.
Officers of Third and Fourth Pennsylvania Cavalry, Westover Landing, S.623, S.629.
General W. W. Averell and staff, Westover Landing, S.635.
Headquarters of Signal Corps camp at Harrison's Landing, S.621.
General Sedgwick, Colonel Sackett, and Lieutenant-Colonel Colburn, Harrison's Landing, August, 1862, S.653.
Group of officers that graduated in class of 1860, United States Military Academy, Harrison's Landing, August, 1862, S.624.
Major Myers, Lieutenant Stryker, and Lieutenant Norton, Harrison's Landing, August, 1862, S.626.
Group of officers belonging to Irish brigade, Harrison's Landing, July, 1862, S.627.
Lieutenants Jones, Bowen, and Custer, May, 1862, S.387.

ARMY OF POTOMAC.

JULY, 1862, TO SEPTEMBER, 1862.

Pope's Campaign.

Centreville, after its evacuation by confederate army in March, 1862:
—confederate barracks, L.7212, S.331, S.332, S.648, S.1045.
—confederate fortifications, S.305, S.334, S.333, S.1144, S.1145.
—headquarters of (confederate) General Johnston, S.303.
Manassas, after its evacuation by confederate army in March, 1862:
—destruction of railroad, L.7197.
—confederate fortifications, S.7171, S.323, S.543, S.544, S.545, S.546.
Yellow hospital, Manassas, July, 1862, S.650.
Headquarters of General McDowell, near Manassas, July, 1862, S.646, S.647.
Our photographer, near Manassas, July, 1862, S.651.
Battlefield of Cedar Mountain:
—general views, S.500, S.506, S.511.
—west view of the field, S.504.
—dead horses, S.510.
—house in which General Winder (confederate) was killed, S.501, S.502.
—house used as confederate hospital, S.507.
—Mrs. Hudson's house, S.505.
—Slaughter's house, position of confederate battery, S.508.
Federal battery fording a 'tributary of the Rappahannock River on day of battle of Cedar Mountain, S.520.
Hazel River, S.521.
Culpeper, Va.:
—general views of town, S.216, S.527, S.530.
—court-house, S.523.
—railroad depot, S.528, S.529.
—street views, S.524, S.525, S.526.
Troops building bridge across north fork of Rappahannock River, near Fauquier Sulphur Springs, S.512, S.513, S.515.
Fugitive negroes fording Rappahannock River, escaping from advance of confederate army, S.518, S.519.
Fauquier Sulphur Springs hotel, S.537, S.542.
Rappahannock station, S.522.
Rappahannock bridge, S.514, S.517.
Warrenton, Va.:
—street views, S.532, S.534.
—court-house, S.533.
—railroad depot, S.535, S.536.
—church, S.736.
Catlett's Station, August, 1862, S.594.
Destruction of railroad rolling stock on Orange & Alexandria Railroad, S.593.
Battlefield of Manassas:
—ruins of Mrs. Henry's house, S.320.
—Thorburn's house, S.317.
—Matthews's house, S.318.
—Robinson's house, S.319, S.1176.
Bridge across Bull Run, built by Engineers of McDowell's corps, August, 1862, S.547.

Picket post near Blackburn's Ford, Bull Run, S.645.
Sudley Ford, Bull Run, S.313, S.314.
Sudley church, S.315, S.316, S.1017, S.1148.
Ruins of stone bridge, Bull Run, L.7082, S.310, S.312.
Ruins of bridge at Blackburn's Ford, Bull Run, S.2338.
Bull Run, S.1111.
Cub Run, S.307.
Stone church, Centreville, S.302.
Mrs. Spinner's house, near Centreville, S.308, S.309.
Grigsby House (Stevens's house), near Centreville, S.1163, S.303.
Fairfax court-house, S.298.
Monument on battlefield of Groveton, L.7299, S.1193.

ARMY OF POTOMAC.

SEPTEMBER, 1862, TO NOVEMBER, 1862.

Antietam Campaign.

Battlefield at Antietam:
—view of part of the field on the day of the battle, S.671.
—view on Antietam Creek, S.597.
—signal station on Elk Mountain, L.7270, L.7563, S.633.
—Antietam bridge, S.1178, S.1179.
—Antietam bridge, looking up stream, L.7214, S.578.
—Antietam bridge, looking down stream, L.7093, S.609.
—Antietam bridge, southeastern view, S.608.
—Antietam bridge, northeastern view, S.607.
—Antietam bridge, eastern view, S.583, S.610, S.614.
—Burnside bridge, looking up stream, S.609.
—Burnside bridge, northeastern view, S.615.
—Burnside bridge, southeastern view, S.600, S.601.
—Burnside bridge, southwestern view, S.613.
—Burnside bridge, northwestern view, S.612.
—Miller's house, L.7019.
—Newcomer's mill, S.582.
—Sherrick's house, S.598.
—Rullet's house, S.575.
—Ruins of Mumma's house, S.574.
—Real's barn, S.591.
—General Hooker's headquarters during the battle, S.576.
—Dunker church, S.573, S.1196.
—bodies of dead confederate soldiers alongside the fence on Hagerstown road, S.559, S.560, S.566, S.567.
—bodies of dead confederate soldiers near Sherrick's house, S.554, S.555, S.571.
—views on the field where Sumner's corps charged, S.552, S.562, S.564, S.568.
—views in the ditch on the right, showing many dead confederates, S.553, S.563, S.565.
—bodies of dead confederate soldiers, S.325, S.326, S.567.
—burying the dead, S.551, S.557, S.561, S.569.
—graves of federal soldiers at Burnside bridge, S.585.
—a lone grave, S.570.
—confederate wounded at Smith's barn after the battle; Dr. Hurd, of Fourteenth Indiana, in attendance, S.588, S.589, S.590, S.592.
President Lincoln in General McClellan's tent at headquarters Army of Potomac, October, 1862, S.602.
General Marcy and other officers at headquarters Army of Potomac, October, 1862, S.603.
Blacksmith's forge and horse-shoers, at headquarters Army of Potomac, September, 1862, S.587.
Group at secret-service quarters, headquarters Army of Potomac, October, 1862, S.631.
Major Allen Pinkerton, at secret-service quarters, October, 1826, S.618.
Sharpsburg, Md., September, 1862, S.595, S.599.
Lutheran church, Sharpsburg, Md., September, 1862, S.596.
Pontoon bridges and ruins of stone bridge across Potomac River at Berlin, October, 1862, S.7437, S.616.
Harper's Ferry, W. Va.:
—general views, L.7443, L.7649, S.654.
—Maryland Heights, L.7132, L.7441, S.1002.
—Loudoun Heights, L.7072.
—Maryland and Loudoun Heights, L.7133.
—Bolivar Heights, L.7187.

ARMY OF POTOMAC.

NOVEMBER, 1862, TO JUNE, 1863.

Fredericksburg Campaign.

Generals of the Army of the Potomac, November 10, 1862, L.7380.
General A. E. Burnside and staff, Warrenton, Va., November, 1862, L.7186, L.7379, L.7382, L.1049.
Acquia Creek Landing:
—distant views, S.673, S.674, S.681.
—wharves, L.7014, L.7446, L.7643, S.682.
—quartermaster's office, L.7108, S.176.
—commissary depot, S.680.
—group at hospital, L.7355.
—clerks at commissary depot, L.7322, L.7533.
—employees at quartermaster's wagon-camp, L.7323.
—Lieut.-Col. Sawtelle, Captain Forsyth, Dr. Wright, Lieut. Col. Porter, and others, at Acquia Creek Landing, L.7320.
Phillips's house, near Falmouth, S.677.
Lacey's house, near Falmouth, S.697, S.698.

ARMY OF POTOMAC.

June, 1864, to April, 1865.

Siege of Petersburg.

Six different views on James River at City Point, S.793, S.798, S.799, S.958, S.2452, S.2453.

Seventeen different views on the docks at City Point, L.7044, S.794, S.795, S.796, S.797, S.812, S.813, S.2456, S.2457, S.2458, S.2459, S.2460, S.2449, S.2450, S.2454, S.2455, S.3332.

View on docks at City Point after explosion of ordnance barges, L.7254, L.7255, L.7449.

Railroad depot, City Point, S.2461.

General hospital, City Point, L.7134, L.7399, L.7664.

Hospital landing and medical supply boat Planter, on Appomattox River, near City Point, L.7050, L.1038.

Group of staff officers at General Grant's headquarters, S.3401, S.3402.

Stable at General Grant's headquarters, L.7004.

Cattle corral near City Point, S.2462, S.2463.

Generals of the Army of Potomac, L.7100, L.7252.

Non-commissioned officers of General Grant's cavalry escort, City Point, March, 1865, L.7445.

Group of provost-guard at headquarters Army of Potomac, February, 1865, L.7251.

Camp of Third Pennsylvania Cavalry at headquarters Army of Potomac, February, 1865, L.7298.

Camp of Oneida Cavalry at headquarters Army of Potomac, February, 1865, L.7112.

Camp of military telegraph operators at headquarters Army of Potomac, August, 1864, S.282.

Group of officers at headquarters Army of Potomac, August, 1864, L.7135, L.7136.

Capt. H. P. Clinton and clerks, at headquarters Army of Potomac, August, 1864, L.7529, L.7537.

Military telegraph operators at headquarters Army of Potomac, August, 1864, L.7478, S.1023, S.1025, S.1030, S.1032, S.1033.

Assistant engineers and draughtsmen at headquarters Army of Potomac, November, 1864, L.7106, L.7107, L.7116.

Officers of First Massachusetts Cavalry at headquarters Army of Potomac, August, 1864, L.7390, L.7490.

Officers and non-commissioned officers of First Massachusetts Cavalry at headquarters Army of Potomac, August, 1864, L.7354, L.7391.

Company C, First Massachusetts Cavalry, at headquarters Army of Potomac, August, 1864, L.7295.

Company D, First Massachusetts Cavalry, at headquarters Army of Potomac, August, 1864, L.7392, L.7476.

Detachment of Third Indiana Cavalry at headquarters Army of Potomac, November, 1864, L.7023, L.7068.

One Hundred and Fourteenth Pennsylvania Infantry provost-guard at headquarters Army of Potomac, August, 1864:

—officers, L.7137, L.7138, L.7316, L.7602.

—officers of Company —, L.7144, L.7145, L.7173.

—Company F, L.7003, L.7038, L.7143, L.7175, L.7447.

—Company G, L.7198, L.7348.

—Company H, L.7077, L.7262, L.7263.

United States Engineer Battalion, August, 1864:

—Company A, L.7062, L.7384, L.7386.

—Company C, L.7240, L.7568.

—Company D, L.7054, L.7548.

—Essayon's Dramatic Club, L.7336, L.7439.

—Battalion headquarters, L.7065.

Camp of Fiftieth New York Engineers, November, 1864:

—colonel's quarters, Colonel Spaulding at the door, L.7059, S.1047.

—headquarters, L.7167, S.1028, S.1048.

—surgeon's quarters, L.7233.

—officers' quarters and church, L.7210, L.7213, S.344, S.3338.

—church, L.7151, S.345, S.3339, S.3340.

—commissary department, L.7060.

Officers of the Fiftieth New York Engineers celebrating the 4th of July, 1864, L.790, L.791.

Camp of Thirteenth New York Artillery, S.2495, S.2496.

Sutler's tent, Second Division, Ninth Corps, S.2448.

Winter headquarters of Sixth Army Corps, February, 1865, L.7545.

Headquarters of General O. B. Willcox, August, 1864, L.7222.

Winter quarters of photographers attached to United States Engineer Battalion, March, 1865, L.7347.

Winter camp of Second Wisconsin Infantry, February, 1865, L.7543.

Camp of chief ambulance officer of Ninth Corps, August, 1864, L.7667, S.818.

A summer camp in the woods, August, 1864, L.7152, L.7154, S.1037.

Execution of Johnson (a colored soldier) for attempted rape, June, 1864, S.783.

Troops drawn up to witness execution of a deserter, August, 1864, S.983.

Commissary depot at Cedar Level, August, 1864, S.819, L.7182, L.7645.

Surgeons of First Division, Ninth Corps, October, 1864, L.7448.

Surgeons of Second Division, Ninth Corps, October, 1864, L.7567, L.7575.

Hospital stewards of Second Division, Ninth Corps, October, 1864, L.7296, L.7571.

Surgeons of Third Division, Ninth Corps, August, 1864, L.7042, L.7063.

Surgeons of Fourth Division, Ninth Corps, August, 1864, L.7045, L.7046.

Chaplains of Ninth Corps, October, 1864, L.7049.

Employees of quartermaster of First Division, Ninth Corps, forage department, November, 1864, L.7569.

Employees of quartermaster of First Division, Ninth Corps, mechanics, November, 1864, L.7048.

Surgeon Brinton and others, October, 1864, L.7564.

Outer line of confederate fortifications captured by Eighteenth Corps on June 15, 1864:

—redoubt near Dunn's house, S.784, S.785, L.1027.

—redoubt and curtain, S.1137.

—interior view, with Cowan's 1st New York battery in occupation, S.787, S.788, S.2343.

Confederate camp captured by Eighteenth Corps, June 15, 1864, S.782.

The "Dictator"—13-inch mortar, August, 1864, L.7394, L.7463, S.820, S.822.

Railroad battery, S.1171, S.1245.

Bomb-proof soldiers' restaurant on the lines, S.1051.

General view from the signal tower, L.7631.

Bomb-proof quarters in federal camp, S.118, S.801, S.802, S.803, S.804, S.805, S.806, S.808, S.809, S.810, S.950, S.1053, S.1065, S.1073, S.3336, S.3337.

Fort Sedgwick ("Fort Hell"):

—interior views, showing bomb-proof quarters of garrison, L.7534, L.1084, S.1093, S.1094, S.1095, S.3334, S.3335.

—officer's bomb-proof quarters in Fort Sedgwick, S.1085.

—interior view of the fort, looking south from its center, L.7633.

View of federal line, looking from right of Fort Sedgwick to the left, L.7115.

Fort Steadman, interior view, S.1086, S.3341, S.3342, S.3343.

Crow's Nest battery and lookout, S.2494.

Confederate fortifications at Gracie's salient, L.7018, S.1059, S.1060, S.1061.

Fort McGilvery, confederate fortifications, S.1050, S.1052, S.1054, S.1057, S.1058, S.1063, S.1064, S.1066, S.1067, S.1068, S.1069, S.1071, S.1072, S.1074, S.1075, S.1091.

Fortifications on the lines, not known whether federal or confederate, S.35, S.950, S.1055, S.1062, S.1070, S.1096, S.1097, "High Bridge," across Appomattox River, Southside Railroad, L.7162, L.7179, L.7286, L.7287, S.1013, S.1184.

McLean's house, scene of General Lee's surrender, L.7191, L.7292, S.1210.

Appomattox court-house, L.7169, L.7189, L.7193, S.1164.

First wagon-train entering Petersburg, L.7172, S.951.

Petersburg, Va.:

—view of gas works, showing effect of bombardment, S.1021, S.1182.

—view of planing-mills, showing effect of bombardment, S.1104.

—Blandford church, L.7269, S.1089, S.1090.

—street views, S.952, S.959, L.7444.

—female seminary, L.7315.

—Michler's cottage, L.7485.

—Brant's house, L.7522.

—Appomattox River above city, S.1092.

—Johnson's mill, L.7207, S.1102, S.1103.

—merchant's mill, L.7113.

—cotton mills, S.1081, S.1082, S.1083, S.1087, S.1088, S.1098, S.1100, S.1101, S.1105, S.1106, S.1107, S.1108, S.1110, S.1112, S.1113, S.1114.

ARMY OF THE JAMES.

Bermuda Hundred Landing—distant view, taken from City Point, S.2451.

Signal tower on left of Bermuda Hundred lines, near Appomattox River, L.7006, S.1015, S.2500, S.2501, S.2502.

Army bridge across James River, near Varina Landing, L.7174, S.953, S.954.

Varina Landing, James River, S.10, S.957.

Aiken's house, near Varina Landing, James River, S.2464.

Signal station on James River, S.2503.

Transports and monitors in James River, near Deep Bottom, S.2466.

Dutch Gap Canal, L.7482, S.955, S.956, S.1121, S.1122.

Federal obstructions in Trent's Reach, James River, S.2475.

Confederate gunboat sunk in James River, above Dutch Gap Canal, S.1124.

Views on James River between Dutch Gap Canal and Drewry's Bluff, S.22, S.23, S.1128, S.1133.

Confederate obstructions in James River, near Drewry's Bluff, S.1116, S.1117, S.3350, S.3351.

Fort Darling (confederate), Drewry's Bluff, James River:

—exterior views, S.1118, S.1119, S.1123, S.1126, S.3347.

—interior views, S.55, S.56, S.1138, S.3344, S.3345, S.3346, S.3352, S.3353.

Confederate water battery, Fort Darling, Drewry's Bluff, James River, S.1120, S.3348, S.3349.

Confederate battery at Howlett House, Trent's Reach, James River:

—general views, S.13, S.14.

—traverse and gun, S.15, S.17, S.18, S.19, S.20, S.21.

Confederate battery on James River, above Dutch Gap, S.24, S.25, S.26, S.27, S.28, S.32, S.34, S.36, S.38, S.39, S.41, S.42, S.43, S.44, S.45, S.46, S.47, S.48, S.49, S.50, S.51, S.52, S.53, S.54, S.58.

Fort Brady, interior view, S.2316.

Fort Brady, building winter quarters, S.2315.

Fortifications on the lines to the right of Fort Brady, S.2314.

Fort Burnham, previously confederate Fort Harrison, S.2498.

Headquarters Tenth Army Corps, General Alfred Terry, S.2443.

Headquarters Second Division, Tenth Corps, General Birney, S.2446.

Headquarters Eighteenth Corps, General Godfrey Weitzel, S.2445.

Headquarters of General Adelbert Ames, S.2347.

General R. S. Foster's Headquarters, near Fort Brady, S.2317.

Camp of Fifth Pennsylvania Cavalry, S.2497.

Interior of Surgeon McKay's quarters, S.1024.

Surgeon McKay and others, Army of the James, L.7442.

Surgeons of Tenth Army Corps, L.7194.

Contrabands on Aiken's farm, S.2497.

CITY OF RICHMOND, VA.

In April, 1865.

General views of the city, L.7026, L.7110, L.7159, L.7623, S.875, S.3621, S.3622.

Panoramic view of the city, S.881, S.882, S.3619, S.3620.

Views in the "burnt district," S.856, S.857, S.858, S.864, S.872, S.900, S.901, S.902, S.903, S.904, S.905, S.906, S.942, S.943, S.944, S.945, S.946, S.3355, S.3356.

Ruins of Mayo's bridge, L.7574, S.874, S.1181.

Ruins of Richmond & Danville Railroad bridge, L.7546, S.853, S.869.

Ruins of Richmond & Petersburg Railroad bridge, S.846, S.870, S.885, S.3361.

Ruins of paper mill, S.867.

Ruins of arsenal, L.7561, S.848, S.861, S.863, S.879, S.887, S.888, S.889, S.907.

Ruins of State armory, L.7030, S.865.

Ruins of State armory, and view down James River, L.7111, L.7236, S.883, S.884.

Ruins of Gallego flour-mills, L.7031, S.7176, S.7177, S.854, S.886, S.908, S.939.

Haxall & Crenshaw flour-mills, S.852, S.880.

Ruins of Exchange Bank, S.3357.

Ruins of Southern Express office, S.3354.

Tredegar iron-works, L.7542, S.847, S.862, S.3358.

Views on canal basin, L.7033, S.940, S.947.

Views on the canal, L.7617, S.941, S.868, S.940.

Libby Prison, L.7616, S.859, S.873, S.895, S.3362, S.3363, S.3617.

Views on Belle Isle, S.871, S.876, S.891.

Pontoon bridge across James River, S.1011, S.3372, S.3373.

View of James River from Hollywood Cemetery, S.929.

Views of James River during freshet, S.877, S.878.

State capitol, S.3359, S.3360.

Governor's mansion, S.3378.

General Washington's headquarters, S.935.

Residence of Jefferson Davis, President of Confederate States, S.911, S.3376.

Residence of Alexander H. Stephens, Vice-President of Confederate States, S.912.

Residence of General Robert E. Lee, L.7087, S.925, S.3375.

Washington Monument, L.7028, S.855, S.919.

Henry Clay Monument, S.3383.

Monumental Church, S.928, S.3369.

First African Church, S.3368.

Saint Paul's Church, S.937.

Saint John's Church, S.3366, S.3367.

Ballard House, S.921.

Spotswood House, S.938.

City Hall, S.850, S.923.

City almshouse, S.860.

Street views, S.866, S.926, S.927, S.936.

Hollywood Cemetery:

—graves of confederate soldiers, S.931, S.1020.

—tomb of President Monroe, L.7372, S.910, S.3379.

—grave of General J. E. B. Stuart, S.3618.

Wagon-train of military telegraph corps, June, 1865, L.7183, L.7239.

Operators of military telegraph, June, 1865, L.7481.

New York newspaper correspondents' row, S.3370.

Headquarters of Christian Commission, S.3371.

ARMY OF THE TENNESSEE.

Chickasaw Bayou, Mississippi, S.394.

Battlefield of Chickasaw Bluffs, Mississippi, S.395.

Poison spring on battlefield of Chickasaw Bluffs, Mississippi, S.396, S.922.

Big Black River Station, Mississippi, S.392.

Battlefield of Big Black River, Mississippi, S.1056.

PORT ROYAL EXPEDITION.

Fort Beauregard, Bay Point, Saint Helena Island, S. C., November, 1861, S.203, S.204, S.205.

Fort Wallace (or Walker), Hilton Head, S. C., November, 1861, S.207.

Siege train, Hilton Head, S. C., November, 1861, S.166.

Graves of sailors at Hilton Head, killed during bombardment of forts, S.187.

Coosaw Ferry, Port Royal Island, S. C., S.183, S.201.

Mock battery at Seabrook Point, Port Royal Island, S. C., built by Seventy-ninth New York Infantry, S.161.

Natural arch at Seabrook Point, Port Royal, S. C., S.202.

Building pontoon bridge near Beaufort, S. C., March, 1862, S.157.

Officers' mess, at Beaufort, S. C., February, 1862, S.208.

Fiftieth Pennsylvania Infantry, Beaufort, S. C., February, 1862, S.156.

General I. I. Stevens, Beaufort, S. C., March, 1862, S.1183, S.164.

General I. I. Stevens and staff, Beaufort, S. C., March, 1862, S.163.

Signal station at Beaufort, S. C., formerly residence of J. G. Barnwell, February, 1862, S.172.

Fuller's house, Beaufort, S. C., February, 1862, S.162, S.168.

Rhett's house, Beaufort, S. C., February, 1862, S.155.

Boat landing, Beaufort, S. C., February, 1862, S.171.

Old tomb on Rhett's plantation, Port Royal Island, S. C., S.158.

Smith's plantation, Port Royal Island, S. C., S.151, S.152, S.154.

Preparing cotton for the gin, S.159.

Mill's plantation, Port Royal Island, S. C., S.169, S.211, S.1177.

Dock at Hilton Head, built by soldiers, April, 1862, S.170.

Headquarters of General Hunter at Hilton Head, April, 1862, S.209.

Army bakery, Hilton Head, April, 1862, S.210.

SIEGE OF FORT PULASKI.

Exterior view of front after bombardment, April, 1862, S.188.

Exterior view of rear, April, 1862, S.189.

Exterior view of side, April, 1862, S.193.

Distant view of breach, April, 1862, S.190.

Close view of breach, April, 1862, S.192.

Interior view of breach, April, 1862, S.191.

Interior view of rear parapet, April, 1862, S.194.

Interior view of front parapet, April, 1862, S.198.

A dismounted mortar, April, 1862, S.199.

The "Jeff Davis" gun, April, 1862, S.196.

The "Beauregard" gun, April, 1862, S.197.

Interior view of parapet with guns "Jeff Davis," "Beauregard," and "Stephens" in position, April, 1862, S.200.

FORT FISHER EXPEDITION.

Fleet of Fort Fisher Expedition in Hampton Roads, December, 1864, L.7432, S.836.

Admiral Porter's flagship Malvern, Norfolk, Va., December, 1864, L.7147.

Admiral Porter and staff on board flagship Malvern, Norfolk, Va., December, 1864, L.7227, L.7244, L.7541.

Fort Fisher:

—panoramic view of land face (part 1), L.7297, (part 2) L.7480, L.7168, (part 3) L.7170, (part 4) L.7242.

—views on land face, L.7149, L.7572, L.7635.

—first six traverses on sea face, L.7335.

—sixth to eleventh traverse on sea face, L.7577.

—from tenth traverse to end on sea face, L.7573.

—interior view of first traverse, northwest end, showing entrance to fort, L.7196.

—interior view of first three traverses on land front, L.7440, L.1229.

—interior view of a traverse on land front, L.7056, S.1236.

—interior view at southeast end, showing site of main magazine, L.7057.

—interior view of first six traverses on sea face, L.7101.

—ten different interior views of traverses, showing guns dismounted and destruction caused by bombardment, L.7061, L.7195, L.7243, L.7230, L.1233, L.1235, S.1238, S.1239, S.1241, S.1242.

—interior view of "the pulpit," L.7535, L.1240.

—Armstrong gun, L.7073, L.1234.

Battery Lamb, on sea front of Fort Fisher, L.7119, L.7622, S.1232.

Battery Buchanan, near Fort Fisher, S.1231.

Quartermaster and commissary office, near Fort Fisher, L.7209.

SIEGE OF CHARLESTON.

Fort Sumter:

—interior views, showing how walls were strengthened, S.3457, S.3458, S.3459, S.3460.

—interior views on parapet, S.3461, S.3466.

—view from parapet, S.3464.

—view from east angle of parapet, facing Morris Island, S.3465.

—interior views at time of celebrating raising United States flag, S.3454, S.3455, S.3456.

—exterior views showing cheveaux-de-frise and wires to protect against assaulting parties, S.3462, S.3463.

Lodge of Sanitary Commission, Alexandria, Va., S.1203.
Office of Sanitary Commission, convalescent camp, near Alexandria, Va., S.1204.
Office of Sanitary Commission, Fredericksburg, Va., May, 1864, S.737.
Storehouse of Sanitary Commission, Fredericksburg, Va., May, 1864, S.739.
Cooking tents of Sanitary Commission, Fredericksburg, Va., May, 1864, S.742.
Nurses and officers of Sanitary Commission, Fredericksburg, Va., May, 1864, S.741.
Wounded soldiers of Kearney's Division at Sanitary Commission, Fredericksburg, Va., May, 1864, S.740.
Office of Sanitary Commission, Gettysburg, Pa., S.238.
Camp of Sanitary Commission at Belle Plain Landing, May, 1864, S.2484.
Wagons of Sanitary Commission at Belle Plain Landing, May, 1864, S.2484.
Headquarters of Christian Commission in the field, Germantown, Va., S.2478.
Office of Christian Commission, Washington, D. C., L.7718, L.7719, L.7720, L.7721.
Camp of Christian Commission at White House Landing, Va., S.2487.
Headquarters of Christian Commission, Richmond, Va., S.3371.

MISCELLANEOUS.

Levee at Vicksburg, Miss., February, 1864, S.391.
Brazilian steamer, L.7830, S.346, S.347.
Dix's autograph letter, "Shoot him on the spot," S.3763.
Tomb of Washington's mother, Fredericksburg, Va., S.712.
Residence of John Minor Botts, L.7123, L.7124, L.7125, L.7629, S.286, S.287.
John Minor Botts and family, L.7121, L.7122.
Patellus's house, L.7745.
Agricultural College near Bladensburg, Md., L.7428.
Memorial tablet to Lieut. Henry B. Hidden, L.7462.
Captain Huff's camp at Gettysburg, L.7231, L.7232, L.7247.
Wounded Indian soldiers, S.2342.
Manner of removing wounded, L.7285, L.7381, L.7636, S.304, S.1078.
General Rufus Ingalls and group, City Point, Va., L.7284, L.7524, L.7619.
Military Telegraph Corps, Major Eckert and group, L.7487.
Group of artillery officers, Antietam, Md., September, 1862, S.579.
Captain Clark and Captain Jane, S.2356.
Two officers of General A. A. Humphrey's staff, L.7300, L.7404.
Officers of staff of General Pierce, L.7368.
Officers of staff of General Gersham Mott, L.7257.
Officers of staff of General A. McD. McCook, Brightwood, D. C., July, 1864, L.7070.
Officers of Signal Corps camp, near Washington, D. C., L.7266, L.7728, L.7729.
General Daniel Butterfield's horse, Falmouth, Va., April, 1863, L.7558.
Captain Beckwith's horse, headquarters Army of Potomac, February, 1863, L.7278.
General George G. Meade's horse, L.7370.
General U. S. Grant's horses, Cold Harbor, Va., June 14, 1864, S.2429.
General John A. Rawlins's horse, Cold Harbor, Va., June 14, 1864, S.2431.
Captain Webster's horse, headquarters Army of Potomac, March, 1864, L.7307.
Lieutenant King's horse, L.7376.
Colonel Sharpe's horse, headquarters Army of Potomac, April, 1863, L.7321, L.7536.
Major Allen (Pinkerton), of Secret Service Department, L.7468.
William Wilson, headquarters Army of Potomac, L.7757.
Mr. Talfor, engineer-draughtsman at headquarters Army of Potomac, L.7435.
J. Furey, Quartermaster's Department, October, 1863, L.7469.
A. R. Ward, artist for Harper's Weekly, L.7104, S.254.
Mrs. Tynan and sons, Frederick, Md., L.7190.
Captain Huff's clerk, L.7488.
Frank C. Tilley (or Filley), S.1624.
Discussing probabilities of next advance, S.175.
Departure from the old homestead, S.306.
A camp kitchen (tasting the soup), S.2416.
Inauguration of President Grant, L.1284, L.1285, L.1286.
Fifteen-inch gun, L.7909.
Big gun, L.7659.
Wiard guns, L.7012, L.7102, L.7832, L.7857.
Park of artillery, L.7024.
Army office wagon, L.7860.
Arrival of a negro family in the lines, S.657.
A picnic party at Antietam, S.581.
A cavalry orderly, S.619.
Camp fun, S.694.
Mule team crossing a brook, L.7131.
An old Virginia family carriage, S.743.
And a large quantity of views not yet identified.

PORTRAITS OF ARMY OFFICERS.

Note.— Groups of regimental officers are catalogued under title "Regiments and Batteries." Other groups, except generals and their staffs, are catalogued under campaigns during which taken, or under title "Miscellaneous."

Abbott, Bvt. Brig.-Gen. I. C., S.1469.
Abercrombie, Brig.-Gen. J. J., S.1526.
Abert, Bvt. Brig.-Gen. W. S., S.3178.
Adams, Lieut.-Col. A. D., 27th N. Y. Infantry, S.1964.
Adams, Bvt. Brig.-Gen. C. P., S.1749.
Adams, Bvt. Brig.-Gen. C. (in group), L.7390, L.7490.
Adams, Col. J. W., 67th N. Y. Infantry, S.2092.
Alden, Bvt. Brig.-Gen. A., Col. 169th, N. Y., S.3062.
Alexander, Col. C. N., 2d D. C. Infantry S.2155, S.3755.
Alexander, Lieut.-Col. T. L., 5th U. S. Infantry, S.1381.
Alexander, Capt. T., 80th N. Y. Infantry, S.7605.
Allaire, Bvt. Brig.-Gen. A. J., S.1917.
Allen, Col., S.1676.
Allen, Lieut.-Col. D. B., 154th N. Y. Infantry S.1444.
Allen, Bvt. Maj.-Gen. R., S.3108.
Allen, Major W., paymaster, S.3773.
Allen, Col. W. H., 1st N. Y. Infantry, S.1735.
Alvord, Brig.-Gen. B., C.4506.
Ames, Bvt. Maj.-Gen. A., S.1390, S.1728.
Ames, Bvt. Maj.-Gen. A. and staff, C.4073.
Ames, Bvt. Brig.-Gen. W., C.4666.
Anderson, Bvt. Maj.-Gen. N. L., S.3004.
Anderson, Bvt. Maj.-Gen. R., S.1376, S.1753, S.3780.
Andrews, Bvt. Maj.-Gen. C. C., S.2076.
Andrews, Bvt. Maj.-Gen. G. L., S.1470, S.3732.
Antisel, Surgeon T., S.3789.
Armstrong, Bvt. Brig.-Gen. S. C., Col. 8th U. S., S.1920.
Arnold, Bvt. Maj.-Gen. R., C.4667.
Arrowsmith, Lieut., 7th N. Y. S. M., S.2116.
Asboth, Bvt. Maj.-Gen. A., C.4591.
Aspinwall, Lieut.-Col. A., 22d N. Y. S. M., S.3733.
Astor, Bvt. Brig.-Gen. J. J., S.1807.
Audenreid, Bvt. Lieut.-Col. J. C., aide-de-camp, S.3757.
Augur, Maj.-Gen. C. C., S.1400.
Augur, Maj.-Gen. C. C. and staff, L.7118, L.7869, S.1001.
Averell, Brig.-Gen. W. W., S.1655.
Averell, Brig.-Gen. W. W. and staff, L.7576, S.635.
Avery, Bvt. Maj.-Gen. R., C.4504.
Ayres, Bvt. Maj.-Gen. R. B., S.1582.
Babcock, Lieut. C. B., 7th N. Y. S. M., S.1586.
Babcock, Bvt. Brig.-Gen. O. E., C.4505.
Bache, Capt. F. M., 16th U. S. Infantry, S.2439.
Bagley, Lieut.-Col. J., 69th N. Y. Infantry, S.1856.
Bailey, Col. B. P., 86th N. Y. Infantry, S.1866.
Bailey, Bvt. Maj.-Gen. J., S.3235.
Bailey, Bvt. Brig.-Gen. S. M., Col. 37th Pa., S.1854.
Baird, Bvt. Maj.-Gen. A., S.2115.
Baker, Col. E. D., 71st Pa. Infantry, S.1459.
Baker, Lieut. J. A., 7th N. Y. S. M., S.1665.
Baker, Bvt. Brig.-Gen. J., C.4965.
Ballier, Bvt. Brig.-Gen. J. F., Col. 98th Pa., S.2027.
Banks, Maj.-Gen. N. P., S.1321.
Banks, Maj.-Gen. N. P. and staff, C.4527, C.5194.
Banta, Lieut.-Col. W. C., 7th Ind. Infantry, S.1794.
Barlow, Maj.-Gen. F. C., S.1955.
Barnard, Bvt. Maj.-Gen. J. G., S.1568, S.1641.
Barnes, Bvt. Maj.-Gen. J. K., C.4477.
Barnett, Bvt. Brig.-Gen. J., C.5167.
Barney, Col. E. L., 6th Vt. Infantry, S.1683.
Barnum, Bvt. Maj.-Gen. H. A., S.2051.
Barrett, Maj. O. D., 11th N. Y. Cavalry, S.3832.
Barry, Bvt. Maj. R. P., 16th U. S. Infantry, S.3871.
Barry, Bvt. Maj.-Gen. W. F., S.1951, S.2018.
Barry, Bvt. Maj.-Gen. W. F. and staff, S.429.
Barstow, Bvt. Brig.-Gen. S. F. (in group), L.7957.
Bartholemew, Bvt. Brig.-Gen. O. A., S.2614.
Bartlett, Bvt. Brig.-Gen. C. G., S.3091.
Bartlett, Bvt. Maj.-Gen. J. J., S.1487, S.1769, S.2125, S.3716.
Bartlett, Bvt. Maj.-Gen. W. F., C.4597.
Bartlett, Bvt. Maj.-Gen. W. F. and staff, L.7217, L.7221.
Barton, Bvt. Brig.-Gen. W. B., Col. 48th N. Y., S.1604.
Bartram, Lieut.-Col. N. B., Ass't Adjt-Gen., S.3749.
Batchelder, Bvt. Brig.-Gen. R. N., S.2600.
Baxter, Bvt. Brig.-Gen. D. C., Col. 72d Pa., S.3014.
Baxter, Bvt. Maj.-Gen. H., S.3041.
Baxter, Bvt. Maj.-Gen. W. W., S.2034.
Baxter, Surgeon J. H., S.3833.
Bayard, Brig.-Gen. G. D., C.4668.
Bayles, Surgeon G., 4th N. Y. Heavy Artillery, S.1379.
Beal, Bvt. Maj.-Gen. G. L., S.3020.
Beatty, Brig.-Gen. J., C.4742.
Beaumont, Col. M. H., 1st N. J. Cavalry, S.1943.
Beaver, Bvt. Brig.-Gen. J. A., C.4715.
Beazell, Major J. W., paymaster, S.1395, S.1412.
Beckwith, Bvt. Brig.-Gen. E. G. (in group), C.5194.
Bedrer, Major R. P., S.1947.
Beecher, Bvt. Brig.-Gen. J. C., S.1466.
Belknap, Lieut.-Col. J., S.1841.
Belknap, Bvt. Maj.-Gen. W. W., S.2034.
Belknap, Bvt. Maj.-Gen. W. W. and orderlies, C.4060.
Bell, Lieut.-Col. T. S., 51st Pa. Infantry, S.3737.
Bendix, Bvt. Brig.-Gen. J. E., S.3201.
Benedict, Ass't Surg. A. C., 1st N. Y. Infantry, S.1458.
Benedict, Bvt. Brig.-Gen. L., S.1799.

Benham, Bvt. Maj.-Gen. H. W., S.2096.
Bennett, Gen. W. T., S.3099.
Bensel, Capt. W. P., 7th N. Y. S. M., S.1671.
Benton, Lieut.-Col. R. C., 1st Vt. Heavy Artillery, S.1355.
Benton, Bvt. Brig.-Gen. T. H., C.4544.
Benton, Bvt. Maj.-Gen. W. P., S.3775.
Berdan, Bvt. Brig.-Gen. H., S.3771.
Berry, Maj.-Gen. H. G., S.2224.
Berthond, Col. A. P., 31st N. J. Infantry, S.3738.
Betge, Col. R. J., 68th N. Y. Infantry, S.2132.
Betts, Lieut.-Col. G. F., 9th N. Y. Infantry, S.1635.
Biddle, Brig.-Gen. C. J., S.3221.
Biddle, Col. G. H., 95th N. Y. Infantry, S.1800.
Bidwell, Lieut.-Col., S.1960.
Bingham, Bvt. Maj.-Gen. H. H., S.3006.
Birdwell, Brig.-Gen. D. D., S.1723.
Birge, Bvt. Maj.-Gen. H. W., C.5178.
Birney, Brig.-Gen. D. B., S.2216.
Birney, Maj.-Gen. D. B. and staff, L.7153.
Blackman, Bvt. Brig.-Gen. A. M., S.2042.
Blair, Maj.-Gen. Frank P., S.1704.
Blair, Maj.-Gen. Frank P. and staff, L.7054.
Blaisdell, Bvt. Brig.-Gen. W., S.3111.
Blanchard, Lieut.-Col. C. D., quartermaster, S.1475.
Blenker, Brig.-Gen. L., S.1738.
Blunt, Bvt. Brig.-Gen. A. P., S.1813.
Bogert, Lieut. J. W., 7th N. Y. S. M., S.1588.
Bohlen, Brig.-Gen. H., S.2091.
Bonneville, Bvt. Brig.-Gen. B. L. E., S.1968.
Bostwick, Maj., 12th N. Y. S. M., S.1767.
Bostwick, Lieut. C. B., 7th N. Y. S. M., S.1662.
Bostwick, Col. H., 71st N. Y. Infantry, S.1578.
Boughton, Bvt. Brig.-Gen. H., S.2035.
Bourri, Col. G., 68th N. Y. Infantry, S.1519.
Bowen, Bvt. Maj.-Gen. James, S.1952.
Bowerman, Bvt. Brig.-Gen. R. N., S.2652.
Boyd, Maj. C., 5th N. Y. Infantry, S.1450.
Boyle, Brig.-Gen. J. T., S.3078.
Brackett, Col. A. G., 9th Ill. Cavalry, S.1649.
Bradley, Capt. J., quartermaster, S.1573.
Bragg, Brig.-Gen. E. S., 6th Wisc. Infantry, S.1367, S.2036.
Brandenstien, Capt. H., 46th N. Y. Infantry, S.1824.
Brannon, Bvt. Brig.-Gen. J. M., S.1490.
Breck, Bvt. Brig.-Gen. S., S.2663.
Brewster, Bvt. Brig.-Gen. W. R., L.7579, S.1842.
Brewster, Bvt. Brig.-Gen. W. R. and staff, L.7343, L.7580.
Brice, Bvt. Brig.-Gen. B. W., C.4490.
Briggs, Brig.-Gen. H. S., S.1707.
Britt, Lieut.-Col. J. W., 57th N. Y. Infantry, S.1548.
Broadhead, Bvt. Brig.-Gen. T. F., Col. 1st Mich. Cavalry, S.1958.
Brooke, Bvt. Maj.-Gen. J. R., S.3046.
Brooks, Bvt. Maj.-Gen. W. T. H., S.3054.
Brown, Lieut.-Col., S.3772.
Brown, Lieut.-Col. A. C., 13th N. Y. Infantry, S.1463.
Brown, Brig.-Gen. E. B., S.3228.
Brown, Maj. F., paymaster, S.2169.
Brown, Bvt. Brig.-Gen. H. L., Col. 145th Pa. Infantry, S.3107.
Brown, Col. J. M., 100th N. Y. Infantry, S.2603.
Brown, Bvt. Brig.-Gen. N. W., C.4669.
Brown, Bvt. Maj.-Gen. O., S.3076.
Brownlow, Bvt. Brig.-Gen. J. P., 1st Tenn. Cavalry, S.3077.
Brumm, Maj. G. W., 50th Pa. Infantry, L.7271.
Brusie, Ass't Surg. L., 3d Ind. Cavalry, S.1889.
Buchanan, Bvt. Maj.-Gen. R. C., C.4793.
Buck, Surg. E. J., 18th Wisc. Infantry, S.3798.
Buck, Lieut.-Col. S. L., 2d N. J. Infantry, S.1706.
Buckingham, Brig.-Gen. C. P., S.2175.
Buckland, Bvt. Maj.-Gen. R. P., C.4741.
Buell, Col. C., 169th N. Y. Infantry, S.3740.
Buell, Maj.-Gen. Don Carlos, S.1551.
Buford, Maj.-Gen. J., S.2171.
Buford, Maj.-Gen. J. and staff, C.4061.
Buford, Maj.-Gen. N. B., S.1547.
Bunting, Lieut. T. B., 7th N. Y. S. M., S.1663.
Burbank, Bvt. Brig.-Gen. S., Col. 2d U. S. Infantry, S.3101.
Burger, Capt. A. A., S.2237.
Burgess, Col., S.3739.
Burke, Bvt. Brig.-Gen. J. W., C.5176.
Burling, Bvt. Brig.-Gen. G. C., Col. 6th N. Y. Infantry, S.3102.
Burnett, Bvt. Brig.-Gen. H. L., Judge Advocate, S.2056.
Burnham, Col. G. S., 22d Conn. Infantry, S.1477, S.3736.
Burns, Brig.-Gen. W. W., S.3098.
Burnside, Maj.-Gen., and Brady, the Photographer, S.2433.
Burnside, Maj.-Gen. A. E., S.1625.
Burnside, Maj.-Gen. A. E. and staff, L.7186, L.7379, L.7382, S.1049.
Burt, Lieut.-Col. E., 3d Me. Infantry, S.3779.
Bussey, Bvt. Maj.-Gen. C., S.4643.
Busteed, Brig.-Gen. Richard, S.2180.
Butler, Lieut. E. K., 69th N. Y. S. M., S.2255.
Butler, Maj.-Gen. B. F., S.1406, C.4028.
Butler, Maj.-Gen. B. F. and staff, C.4208.
Butterfield, Maj.-Gen. D., L.7540, S.1651.
Buxton, Surg. B. F., 5th Me. Infantry, S.1389.
Cadwalader, Maj.-Gen. G., C.4670.
Cadwell, Bvt. Maj.-Gen. J. C., S.1457.
Cadwell, Bvt. Maj.-Gen. J. C. and staff, S.441, S.580.
Callis, Bvt. Brig.-Gen. J. B., C.4740.
Cameron, Col. J., 79th N. Y. Infantry, S.1637.
Campbell, Col. D., 4th Pa. Cavalry, S.1724.
Campbell, Bvt. Brig.-Gen. E. L. (in group), L.7957.
Campbell, Surg. J., S.3725.
Campbell, Bvt. Brig.-Gen. J. A., C.4786.

Canby, Maj.-Gen. E. R. S., S.3173.
Candy, Bvt. Brig.-Gen. C., Col. 66th Ohio Infantry, S.2181.
Capehart, Lieut.-Col. C. E., 1st W. Va. Cavalry, S.1623.
Capron, Bvt. Brig.-Gen. H., C.4579.
Carleton, Bvt. Brig.-Gen. C. A., S.3003.
Carlin, Bvt. Maj.-Gen. W. P., C.4659.
Carmen, Bvt. Brig.-Gen. E. A., Col. 13th N. J. Infantry, S.1386.
Carpenter, Maj. J. W., paymaster, S.1720.
Carpenter, quartermaster, S.1687.
Carr, Bvt. Maj.-Gen. J. B., S.2228.
Carrington, Brig.-Gen. H. B., S.3060.
Carroll, Bvt. Maj.-Gen. S., S.1913, S.3866.
Carroll, Bvt. Maj.-Gen. S. S. and staff, L.7051.
Carson, Bvt. Brig.-Gen. C., S.2620.
Carter, Bvt. Maj.-Gen. S. P., S.3056.
Carter, Lieut. L., 50th Pa. Infantry, L.7410.
Cary, Col. W. H., S.3787.
Casey, Maj.-Gen. Silas, S.1710.
Casey, Maj.-Gen. Silas and staff, C.4566.
Cass, Col. T., 9th Mass. Infantry, S.3774.
Cassidy, Bvt. Brig.-Gen. A. L., 93d N. Y. Infantry, S.2187, S.3068.
Catlin, Bvt. Maj.-Gen. I. S., C.4501.
Chamberlain, Lieut.-Col. G. E., 1st Vt. Heavy Artillery, S.3735.
Chamberlain, Bvt. Maj.-Gen. J. L., S.1859.
Chambers, Brig.-Gen. A., S.3052.
Chandler, Surg. C. M., 6th Vt. Infantry, S.2148.
Chapman, Bvt. Brig.-Gen. G. H., S.2441.
Chapman, Bvt. Brig.-Gen. G. H. and staff, S.2442.
Chapman, Lieut.-Col. A. B., 57th N. Y. Infantry, S.1398.
Charles, Col. E. C., 42d N. Y. Infantry, S.2005.
Chase, Adjt. D. L., 78th and 102d N. Y. Infantry, S.1779.
Cheeseman, Surg. T. M., 7th N. Y. S. M., S.1491.
Chetlaine, Bvt. Maj.-Gen. A. L., S.2616.
Chickering, Bvt. Brig.-Gen. T. E., S.3092.
Childs, Lieut.-Col. J. H., 4th Pa. Cavalry, S.1869.
Chipman, Bvt. Brig.-Gen. N. P., C.4500.
Christensen, Bvt. Brig.-Gen. C. T., S.3009.
Christian, Bvt. Brig.-Gen. W. H., S.2138.
Chrysler, Bvt. Maj.-Gen. M. H., S.3051.
Church, Surg. W. H., S.1691.
Churchill, Bvt. Brig.-Gen. S., S.1460.
Chustill, Maj. W. B., S.1959.
Cilley, Bvt. Brig.-Gen. J. P., C.5160.
Clark, Captain E., 7th N. Y. S. M., S.1684.
Clark, Bvt. Brig.-Gen. G., C.4720.
Clark, Bvt. Brig.-Gen. G. W., C.4645.
Clark, Bvt. Maj.-Gen. W. T., S.1580, S.1880.
Clarke, Bvt. Maj.-Gen. H. F., S.1902, C.5194.
Clay, Bvt. Brig.-Gen. C., S.3000.
Clay, Maj.-Gen. C., C.4671.
Clayton, Brig.-Gen. P., C.4986.
Clitz, Bvt. Brig.-Gen. H. B., Col. 10th U. S. Infantry, S.1521.
Cluseret, Brig.-Gen. G. P., S.2219.
Cobb, Bvt. Brig.-Gen. A., C.4739.
Coburn, Bvt. Brig.-Gen. J., C.4738.
Cochran, Brig.-Gen. J., S.1326.
Cogswell, Bvt. Brig.-Gen. W., 2d Mass. Infantry, S.2029.
Cogswell, Bvt. Brig.-Gen. W. and staff, C.4068.
Colburn, Lieut.-Col. A. V., aide-de-camp, L.7043.
Cole, Bvt. Brig.-Gen. G. W., S.3076.
Colgate, Lieut.-Col. C. G., 15th N. Y. Engineers, S.1923.
Collet, Col. M. W., 1st N. J. Infantry, S.1353.
Connor, Bvt. Maj.-Gen. P. E., S.2124.
Connor, Bvt. Maj.-Gen. Selden, S.1764.
Conrad, Bvt. Brig.-Gen. J., S.2661.
Cook, Maj.-Gen. A. McD., S.1744.
Cook, Bvt. Maj.-Gen. P. St. G., C.4599.
Cook, Maj. W. W., 5th N. H. Infantry, S.1929.
Cooper, Brig.-Gen. J., S.2066.
Cooper, Bvt. Maj.-Gen. J., S.3236.
Copeland, Lieut.-Col., S.1349.
Coppinger, Adjt. J. B., 83d N. Y. Infantry, S.1514.
Corbin, Bvt. Brig.-Gen. H. S., S.2617.
Corcoran, Brig.-Gen. M., S.2234.
Corley, Lieut. C., 7th N. Y. S. M., S.1570.
Corse, Bvt. Maj.-Gen. J. M., ("Hold the Fort,") C.4497.
Coster, Col. C. R., 134th N. Y. Infantry, S.3193.
Couch, Maj.-Gen. D. N., S.3768.
Coulter, Bvt. Maj.-Gen. R., C.4724.
Covode, Col. G. H., 4th Pa. Cavalry, S.1848.
Cowdin, Brig.-Gen. R., S.2217.
Cox, Maj.-Gen. J. D., C.4672.
Cox, Bvt. Brig.-Gen. R. C., C.4713.
Cozzens, Sergt. F., S.1591.
Cradlebough, Col. J. S., 114th Ohio Infantry, S.1775.
Crandall, Surg. W. B., 16th N. Y. Infantry, S.2156.
Crane, Bvt. Brig.-Gen. C. H., S.1911.
Crane, Maj. F. W., paymaster, S.1895.
Crawford, Capt. J. S., 114th Pa. Infantry, L.7037.
Crawford, Bvt. Brig.-Gen. S. J., C.4784.
Crawford, Bvt. Maj.-Gen. S. W., S.2095, S.3718, S.3807.
Creiger, Lieut.-Col. J. A., 11th N. Y. Infantry, S.1627.
Crittenden, Maj.-Gen. T. L., S.1730.
Crocker, Bvt. Brig.-Gen. J. S., S.630.
Crocker, Brig.-Gen. M. M., C.4646.
Crook, Maj.-Gen. G., C.4498, C.5121.
Cross, Col. E. E., 5th N. H. Infantry, S.1983.
Cross, Bvt. Brig.-Gen. O., S.1606.
Croxton, Bvt. Maj.-Gen. J. T., C.5096.
Cullum, Brig.-Gen. G. W., S.1712.
Cummings, Lieut.-Col. C., 17th Vt. Infantry, S.1468.
Cummins, Lieut.-Col. F. M., 124th N. Y. Infantry, S.1366, S.1621.
Cunningham, Capt., L.7483.

Cunningham, Maj., S.1451.
Curtin, Bvt. Brig.-Gen. J. J., S.2038.
Curtis, Lieut.-Col., S.1881.
Curtis, Bvt. Maj.-Gen. N. M., S.2039.
Curtis, Maj.-Gen. S. R., S.2075.
Curtis, Bvt. Brig.-Gen. W. B., S.3224.
Custer, Maj.-Gen. G. A., S.1613.
Cutler, Bvt. Maj.-Gen. L., S.1892.
Dahlgren, Col. Ulric, C.4642.
Dana, Bvt. Maj.-Gen. E. L., S.3748.
Dana, Bvt. Brig.-Gen. J. J., C.4469.
Dana, Maj.-Gen. N. J. T., S.1809.
Daniels, Maj. R. R., S.1523.
Dare, Lieut.-Col., 34th Pa. Infantry, S.2159.
Davies, Maj.-Gen. H. E., S.1654.
Davies, Maj.-Gen. T. A., S.2101.
Davis, Bvt. Brig.-Gen. E. P., S.3206.
Davis, Bvt. Maj.-Gen. H. W., S.1425.
Davis, Bvt. Maj.-Gen. Jeff C., L.7680, L.7691, S.1162, S.2021.
Davis, Bvt. Maj.-Gen. W. W. H., C.4723.
Day, Bvt. Brig.-Gen. H., S.3793.
Dayton, Bvt. Brig.-Gen. O. V., S.1777, S.2065.
Deane, Maj. C. W., S.1791.
De Golyer, Maj. S., 4th Mich. Cavalry, S.1992.
De Hautville, Capt. F. S. G., Ass't Adjt.-Gen., S.1517.
Deitzler, Brig.-Gen. G. W., S.3226.
De Joinville, Prince, S.2097.
De Lacy, Bvt. Brig.-Gen. W., S.2064.
De Lacy, Maj. W., 37th N. Y. Infantry, S.2253.
Dennison, Bvt. Maj.-Gen. A. W., C.4665.
Dent, Brig.-Gen. F. T., C.4493.
Denver, Brig.-Gen. J. W., S.1808.
Derrom, Col. A., 25th N. J. Infantry, S.3741.
De Russy, Capt. Isaac D., 1st U. S. Infantry, S.1698.
De Russy, Brig.-Gen. G. A., S.1612.
De Russy, Brig.-Gen. G. A. and staff, S.7215.
De Trobriand, Bvt. Maj.-Gen. P. R., S.2117.
Devens, Maj.-Gen. C. and staff, C.4178.
Devereaux, Bvt. Brig.-Gen. A. F., S.3066.
Devin, Bvt. Brig.-Gen. T. C., S.1872, S.2048.
Dewey, Brig.-Gen. J. A., S.3053.
Dexter, Surg. J. E., 40th N. Y. Infantry, S.1888.
Dick, Maj. M. M., 105th Pa. Infantry, S.1725.
Dickinson, Bvt. Brig.-Gen. J., S.1446.
Dilger, Capt. H., Ohio Artillery, S.3377.
Dimock, Maj. J. J., 82d N. Y. Infantry, S.1393.
Diven, Surg., S.2203.
Diven, Bvt. Brig.-Gen. A. S., S.1852.
Dix, Maj.-Gen. J. A., S.1546.
Dodd, Adjt. C. O., 5th N. H. Infantry, S.1835.
Dodd, Bvt. Brig.-Gen. L. A. (in group), L.7758.
Dodge, Brig.-Gen. C. C., S.1555, S.1566.
Dodge, Maj.-Gen. G. M., S.1672.
Dodge, Col. J. A., 75th N. Y. Infantry, S.3869.
Donaldson, Bvt. Maj.-Gen. J. L., S.2613.
Dore, Sergt., 7th N. Y. S. M., S.1619.
D'Orleans, Louis Phillipe (Comte de Paris), aide-de-camp, S.3818, S.3820.
D'Orleans, R. (Duc de Chartres), aide-de-camp, S.3818, S.3819.
D'Orville, Lieut. A., 6th N. Y. Infantry, S.2112.
Doubleday, Maj.-Gen. Abner, S.1497.
Doubleday, Col. T. D., 4th N. Y. Heavy Artillery, S.1874.
Doubleday, Bvt. Brig.-Gen. W., S.3312.
Dougherty, Surg. A. N., S.1891.
Downing, Maj. P. J., 42d N. Y. Infantry, S.2106.
Drew, Lieut.-Col. W O., 2d D. C. Infantry, S.1362.
Drinning, Maj., S.1432.
Drum, Brig.-Gen. R. C., C.4492.
Ducat, Bvt. Brig.-Gen. A. C., C.5166.
Dudley, Bvt. Brig.-Gen. W. W., S.2625.
Duffie, Brig.-Gen. A. N., S.1565, S.2154.
Duryee, Bvt. Maj.-Gen. Abram, S.1374.
Dustin, Bvt. Brig.-Gen. D., S.3847.
Dustin, Brig.-Gen. D. and staff, L.7572.
D'Utassy, Col. F. G., 39th N. Y. Infantry, S.1496, S.2184.
Dwight, Maj. W., 2d Mass. Infantry, S.1811, S.1814.
Dwight, Brig.-Gen. W., S.1694.
Dyer, Bvt. Brig.-Gen. A. B., C.5161.
Dyer, Capt. C. G., 2d R. I. Infantry, S.1686.
Easton, Lieut.-Col. L. C. (in group), L.7963.
Eaton, Bvt. Maj.-Gen. Amos B., S.1915.
Eckel, Lieut. J. S., 60th Pa. Infantry, L.7359.
Eckert, Bvt. Brig.-Gen. T. T., S.2057.
Edwards, Col. C. S., 5th Me. Infantry, S.1509.
Edwards, Brig.-Gen. J., C.4646.
Edwards, Bvt. Maj.-Gen. O., S.2028.
Elkin, Bvt. Brig.-Gen. J. A., S.1834.
Elder, Lieut.-Col. A. B., 10th N. Y. Infantry, S.3868.
Ellett, Brig.-Gen. A. W., S.1745.
Elliott, Bvt. Maj.-Gen. W. L., S.3216.
Ellis, Bvt. Brig.-Gen. A. V. H., 124th N. Y. Infantry, S.2093.
Ellsworth, Col. E. E., 11th N. Y. Infantry, S.3175.
Ely, Maj. G. B., paymaster, S.1792.
Ely, Maj. John, S.1714.
Emory, Maj.-Gen. W. H., C.4507.
English, Lieut.-Col. James, S.1350.
Enos, Maj. A. G. 8th Pa. Cavalry, S.2158.
Ent, Bvt. Brig.-Gen. W. H., S.3266.
Eustis, Brig.-Gen. H. L., S.3172.
Everett, Surg. F., S.3809.
Everdell, Col. W., 23d N. Y. S. M., S.1404.
Ewing, Lieut.-Col. C., 4th N. J. Infantry, S.1648.
Ewing, Brig.-Gen. Thomas, S.2054.

Ewing, Bvt. Maj.-Gen. H., C.4495.
Ewing, Bvt. Maj.-Gen. T., C.4484.
Fairchild, Bvt. Brig.-Gen. C., S.3202.
Fairchild, Brig.-Gen. L., S.1611.
Fairman, Col. J., 96th N. Y. Infantry, S.2232.
Farnham, Lieut.-Col. N. L., 11th N. Y. Infantry, S.1628.
Farnham, Lieut.-Col. R., 15th Vt. Infantry, S.1479.
Farnsworth, Brig.-Gen. E. J., S.2638, S.3106.
Farnsworth, Brig.-Gen. J. F., S.1894.
Farnum, Bvt. Brig.-Gen. J. E., S.1385.
Farquhar, Lieut. F. U., Engineer Corps, S.2114.
Farrell, Lieut., S.1484.
Faulke, Col. A. G., S.3867.
Ferrell, Capt. W. G., S.2130.
Ferrero, Bvt. Maj.-Gen. E., S.807, S.1652.
Ferrero, Bvt. Maj.-Gen. E. and staff, L.7053, C.5333.
Ferry, Bvt. Maj.-Gen. O. S., C.5177.
Fessenden, Bvt. Maj.-Gen. F., S.3745.
Fessenden, Bvt. Maj.-Gen. J. D., S.1914.
Finklemeier, Maj. J. P., Ass't Adjt.-Gen., S.3804.
Finley, Bvt. Brig.-Gen. C. A., C.4788.
Fisher, Bvt. Brig.-Gen. B. F. (in group), L.7848.
Fisher, Bvt. Brig.-Gen. J. W. and staff, L.7058.
Fisk, Bvt. Maj.-Gen. C. B., C.4664.
Fisk, Lieut.-Col. F. S., 2d N. H. Infantry, S.3849.
Fletcher, Maj. A. W., paymaster, S.1732.
Flint, Capt. E. A., 1st Mass. Cavalry, L.7403.
Floyd, Lieut.-Col. H. C., S.1748.
Foote, Maj. F., S.1418.
Force, Bvt. Maj.-Gen. M. F., C.5099.
Ford, Maj. G. W., 50th N. Y. Engineers, L.7166.
Forsyth, Bvt. Brig.-Gen. G. A., C.4508.
Forsyth, Bvt. Brig.-Gen. J. W., February, 1863, S.214.
Foster, Bvt. Brig.-Gen. J. A., S.1538, S.1605, S.1796.
Foster, Maj.-Gen. J. G., S.3828.
Foster, Bvt. Maj.-Gen. R. S., S.2026, S.2053.
Foster, Bvt. Maj.-Gen. R. S. and staff, C.4043, C.4201.
Fowler, Bvt. Brig.-Gen. E. B., S.3801.
Fowler, Col. Henry, S.1906.
Frank, Bvt. Brig.-Gen. P., S.3001.
Franklin, Maj.-Gen. W. B., S.3795.
Fremont, Maj.-Gen. John C., S.1315.
French, Maj.-Gen. W. H., L.7345, L.7578, S.1884.
French, Maj.-Gen. W. H. and staff, L.7501, L.7502.
Frost, Surg. C. P., 15th Vt. Infantry, S.1447.
Fry, Maj.-Gen. J. B., S.1377, S.1508.
Fuller, Bvt. Brig.-Gen. J. W., S.2031.
Fullerton, Bvt. Brig.-Gen. J. S., C.4782.
Gaines, Bvt. Maj.-Gen. E. P., S.1327.
Gansevoort, Bvt. Brig.-Gen. H. S. and staff, L.7723, L.7726, L.7738.
Gardiner, Maj. C. C., 27th N. Y. Infantry, S.1703.
Garfield, Maj.-Gen. James A., S.2218.
Garland, Bvt. Brig.-Gen. John, S.1329.
Gates, Bvt. Brig.-Gen. T. B., S.1827.
Geary, Bvt. Maj.-Gen. J. W., S.2033.
Geddes, Bvt. Maj.-Gen. J. L., S.3064.
Gerhardt, Bvt. Brig.-Gen. J., S.3097.
Getty, Bvt. Maj.-Gen. G. W., S.3783.
Gibbon, Maj.-Gen. J., S.1464.
Gibbs, Bvt. Maj.-Gen. A., S.1901.
Gibson, Maj. Thomas, 14th Pa. Cavalry, S.1543.
Giesy, Bvt. Maj.-Gen. F. J., S.3190.
Gilbert, Surg. R. H., S.1552, S.3720.
Gilbert, Bvt. Brig.-Gen. S. A., C.5048.
Gillmore, Maj.-Gen. Q. A., S.2239.
Gilman, Lieut. J. H., 1st U. S. Artillery, S.1372.
Glasgow, Bvt. Brig.-Gen. S. L., C.4648.
Goddard, Capt. R. H. I., aide-de-camp, S.1498.
Goff, Bvt. Brig.-Gen. N., S.3035.
Goodell, Bvt. Brig.-Gen. A. A., C.5182.
Goodrich, Maj. Edwin R., S.1773.
Goodrich, Maj. C. S. (Surgeon), S.2229.
Gordon, Capt. G. A., 2d U. S. Cavalry, S.1482.
Gordon, Bvt. Maj.-Gen. G. H., S.1855.
Gorman, Brig.-Gen. W. A., S.1713.
Gould, Lieut.-Col. E., 5th Mich. Cavalry, S.1439.
Gould, Maj. W. P., paymaster, S.3794.
Gouley, Ass't Surg. J. W. S., S.1909.
Gowan, Bvt. Maj.-Gen. G. W., S.2624.
Graham, Bvt. Maj.-Gen. Charles K., S.1963.
Graham, Brig.-Gen. L. P., S.2631, S.3049.
Granger, Maj.-Gen. Gordon, S.1787.
Grant, Bvt. Maj.-Gen. L. A., S.3095, S.3174.
Grant, Gen. U. S., L.7947, S.1559.
Greble, Lieut. J. T., 2d U. S. Artillery, C.4655.
Greene, Bvt. Maj.-Gen. G. S., S.1867.
Greene, Bvt. Brig.-Gen. O. D., S.3019.
Gregg, Bvt. Maj.-Gen. D. McM., S.1756.
Gregg, Bvt. Maj.-Gen. D. McM. and staff, C.4067, C.4075.
Gregg, Bvt. Maj.-Gen. J. I., S.3090.
Grierson, Maj.-Gen. B. H., S.3073.
Griffin, Maj.-Gen. Charles (as Captain), S.1373.
Griffin, Maj.-Gen. C. and staff, L.7064.
Griffin, Bvt. Maj.-Gen. S. G., C.5095.
Grover, Bvt. Maj.-Gen. C. E., S.3717.
Grover, Bvt. Brig.-Gen. I. G., S.1677.
Guiney, Bvt. Brig.-Gen. Patrick M., S.3096.
Gurney, Lieut. W., 7th N. Y. S. M., S.1585.
Guss, Brig.-Gen. H. C., S.4703.
Hackleman, Brig.-Gen. P. A., C.4674.
Hagadorn, Maj. F. A., 79th N. Y. Infantry, S.1700.
Hall, Col. H. B., S.3760.
Hall, Lieut.-Col. H. H., 4th N. Y. Heavy Artillery, S.1921.

Hall, Bvt. Brig.-Gen. J. A., S.2637.
Hall, Bvt. Brig.-Gen. J. A. and staff, L.7229, L.7915.
Hall, Capt. T. E., quartermaster, L.7039.
Halleck, Maj.-Gen. H. W., S.3845.
Hallowell, Bvt. Brig.-Gen. E. N., S.2665.
Halpine, Bvt. Brig.-Gen. C. G., C.4962.
Hamblin, Bvt. Maj.-Gen J. E., S.1476, S.2150.
Hambright, Bvt. Brig.-Gen. H. A., S.3204.
Hamilton, Maj. A., aide-de-camp, S.1501.
Hamilton, Maj.-Gen. A. J., S.3875.
Hamilton, Maj.-Gen. C. S., S.1982.
Hamilton, Maj.-Gen. S., S.2230.
Hamlin, Bvt. Maj.-Gen. C., S.3200.
Hammell, Bvt. Brig.-Gen. J. S., S.2671.
Hammond, Brig.-Gen. J., C.4980.
Hammond, Brig.-Gen. W. A., Surgeon General, S.1558.
Hancock, Maj.-Gen. W. S., S.1877.
Hardenburgh, Bvt. Brig.-Gen. J. B., S.1715.
Hardie, Bvt. Maj.-Gen. J. A., S.1761.
Hardin, Brig.-Gen. M. D., S.1831.
Hardin, Brig.-Gen. M. D. and staff, L.7338, L.7429, L.7430.
Harker, Bvt. Brig.-Gen. C. G., S.3779.
Harkins, Maj. D. H., 1st N Y. Cavalry, S.3870.
Harney, Bvt. Maj.-Gen. W. S., L.7928, S.1323.
Harris, Col., S.1688. ¢
Harris, Bvt. Maj.-Gen. T M., S.2023.
Harrison, Bvt. Brig.-Gen. Benjamin, S.3039.
Harrison, Lieut.-Col. A. I., 22d Ind. Infantry, S.3776.
Harrow, Brig.-Gen. W., S.3043.
Hart, Bvt. Maj.-Gen. O. H., S.1739.
Hartsuff, Maj.-Gen. G. L., S.1534.
Hartsuff, Maj.-Gen. G. L. and staff, L.7571.
Hartwell, Bvt. Brig.-Gen. C. A. (group), L.7194.
Haskin, Brig.-Gen. J. A., S.3217.
Hatch, Bvt. Maj.-Gen. E., C.4982.
Hatch, Bvt. Maj.-Gen. J. P. and staff, S.3430.
Hatch, Col. W. B., 4th N. J. Infantry, S.3746.
Hathaway, Col. S. G., 141st N Y. Infantry, S.1448.
Haupt, Brig.-Gen. H., S.1567.
Hawes, Capt. Jas. D., 133d N. Y. Infantry, S.1597.
Hawkins, Bvt. Maj.-Gen. J. P., S.3074.
Hawkins, Bvt. Brig.-Gen. R. C., S.1511.
Hawley, Bvt. Brig.-Gen. W. and staff, L.7843, L.7844.
Haws, Lieut. G. T., 7th N. Y. S. M., S.1493.
Hayes, Bvt. Maj.-Gen. J., S.3271.
Hayes, Bvt. Maj.-Gen. R. B., S.3002.
Hayman, Bvt. Maj.-Gen. S. B., S.3058.
Hays, Bvt. Maj.-Gen. Alex., S.1645, S.1961.
Hays, Bvt. Brig.-Gen. W., S.1727.
Hays, Brig.-Gen. W. and staff, L.7833, L.7877.
Hazard, Bvt. Brig.-Gen. J. S., C.4675.
Hazen, Maj.-Gen. W. B., S.2126.
Healey, Maj. H. G., 65th N Y. Infantry, S.1421.
Heath, Bvt. Brig.-Gen. F. E., S.1361.
Heath, Bvt. Maj.-Gen. H. H., C.4488.
Hedrick, Bvt. Brig.-Gen. J. M., S.2049.
Heintzelman, Maj.-Gen. S. P., S.1384.
Heintzelman, Maj.-Gen. S. P. and staff, L.7839, S.628, S.2304.
Heiner, Maj. R. H., S.3851.
Henry, Bvt. Brig.-Gen. G. V., S.3220.
Herron, Maj.-Gen. F. J., S.1602.
Hewitt (or Hawks), Surg. C. N., 50th N. Y. Engineers, L.7401.
Hidden, Lieut. H. B., 1st N. Y. Cavalry, S.2135.
Higgins, Lieut.-Col. R., 1st Pa. Cavalry, S.1368.
Hill, Bvt. Brig.-Gen. B. H., S.2046.
Hillyer, Bvt. Brig.-Gen. W. S., S.1886.
Hinks, Bvt. Maj.-Gen. E. W., S.1542.
Hitchcock, Maj.-Gen. E. A., S.2020.
Hobart, Bvt. Brig.-Gen. H. C., S.3205.
Hoffman, Bvt. Brig.-Gen. H. C., C.5163.
Hoffman, Bvt. Maj.-Gen. J. W., C.5164.
Hoffman, Bvt. Maj.-Gen. W., L.7288, L.7679.
Holabird, Bvt. Brig.-Gen. S. B., C.4658.
Holliday, Maj. S. V., paymaster, S.1793.
Holman, Maj. O., paymaster, S.1948.
Holston, Surg. J. G. F., S.1908. ¢
Holt, Lieut.-Col. W., 31st N. Y. Infantry, S.13..
Hooker, Maj.-Gen. Joe, S.1922.
Hooker, Maj.-Gen. Joe (on horseback), C.4490.
Hooker, Maj.-Gen. Joe and staff, June, 1863, L.7950.
Hopkins, Lieut.-Col. R. H., S.1520.
Horn, Bvt. Brig.-Gen. J. W., C.4663.
Hough, Bvt. Brig.-Gen. J., C.4590.
Hovey, Brig.-Gen. A. P., S.3084.
Hovey, Bvt. Maj.-Gen. C. E., S.3219.
Howard, Maj. J., paymaster, S.1873, S.3816.
Howard, Maj.-Gen. O. O., S.3719, S.3788.
Howe, Bvt. Maj.-Gen. A. P., S.1646.
Howell, Brig.-Gen. J. B., S.2662.
Howland, Paymaster M., 7th N. Y. S. M., S.1589.
Hoyt, Bvt. Brig.-Gen. C. H., C.5162.
Hoyt, Bvt. Brig.-Gen. H. M., C.4722.
Hubbard, Bvt. Brig.-Gen. L. F., S.3110.
Hubbard, Bvt. Brig.-Gen. T. H., C.5136.
Hudson, Lieut.-Col. E. McK., aide-de-camp, S.1776.
Huff, Capt., L.7361.
Huger, Capt. J. B., S.1692.
Hughston, Col. R. S., 44th N. Y. Infantry, S.3759.
Humphreys, Maj.-Gen. A. A., S.2346.
Humphreys, Maj.-Gen. A. A. and staff, L.7397, L.7581.
Hunt, Col., S.1797.
Hunt, Bvt. Maj.-Gen. H. J., Chief of Artillery, S.1912.

Hunt, Brig.-Gen. L. C., S.1541.
Hunter, Maj.-Gen. D, S.1820.
Hunter, Bvt. Brig.-Gen. M. C., C.4601.
Hurlburt, Maj.-Gen. S. A., S.1782.
Hurst, Maj. S. H., S.1438.
Hutchinson, Bvt. Brig.-Gen. F. S., S.3225.
Hyde, Col. B. N., 3d Vt. Infantry, S.3770.
Hyde, Lieut.-Col. W. B., 9th N. Y. Cavalry, S.1471.
Ingalls, Bvt. Maj.-Gen. Rufus, S.1569.
Innes, Bvt. Brig.-Gen. W. P., C.5172.
Irwine, Surg. C. K., 72d N. Y. Infantry, S.279, S.3821.
Jackson, Brig.-Gen. J. S., S.2962.
Jackson, Bvt. Maj.-Gen. N. J., S.1413, S.3797, S.3812.
Jackson, Bvt. Brig.-Gen. S. M., S.3728.
Jacobs, Bvt. Brig.-Gen. F., S.3015.
James, Surg., S.3811.
Jameson, Adjt. A. H., 32d Pa. Infantry, S.1837.
Jameson, Brig.-Gen. C. D., S.3817.
Janeway, Col. H., 1st N. J. Cavalry, S.1658.
Jay, Capt. W., aide-de-camp, S.2246.
Jehl, Maj. F., 55th N. Y. Infantry, S.1949.
Jenkins, Col. D. T., 146th N. Y. Infantry, S.1763.
Jewett, Col. A. B., 10th Vt. Infantry, S.2165.
Jewett, Col. W. N. J., S.2164.
Johnson, Brig.-Gen. A., C.4592.
Johnson, Brig.-Gen. A. C., S.1857, S.2254.
Johnson, Maj. L. E., paymaster, S.2194.
Johnson, Maj. T., S.1842.
Johnston, Lieut.-Col. J W., 93d Pa. Infantry, S.2183.
Jones, Col. C., S.1937.
Jones, Col. Owen, 1st Pa. Cavalry, S.1938.
Jones, Surg. Henry S.1910.
Jones, Brig.-Gen. P. H., S.3268.
Jones, Maj. R., Ass't Insp.-Gen., S.1736, S.2195.
Jones, Maj. W. T., S.3850.
Jordan, Bvt. Brig.-Gen. T. J., C.4712.
Jourdan, Bvt. Brig.-Gen. J., S.1962.
Judah, Bvt. Maj.-Gen. H. M., S.1601.
Judson, Col. R. W., 142d N. Y. Infantry, S.1414.
Judson, Col. E. Z. C., S.1883.
Judson, Surg. O. A., S.3813.
Kane, Bvt. Maj.-Gen. T. L., S.1847.
Karge, Bvt. Brig.-Gen. J., S.1616.
Kautz, Bvt. Maj.-Gen. A. V., C.4575.
Kearney, Maj.-Gen. P., S.2209.
Keifer, Bvt. Maj.-Gen. J. W., C.4487.
Keim, Brig.-Gen. W. H., S.1885.
Kelly, Bvt. Maj.-Gen. B. F., S.1681.
Kelton, Bvt. Brig.-Gen. J. C., S.1427.
Keyes, Maj.-Gen. E. D., S.1634.
Kiernan, Brig.-Gen. J. L., S.1553, S.1759.
Kilpatrick, Col., S.1918.
Kilpatrick, Bvt. Maj.-Gen. J., S.340, S.341, S.1391.
Kilpatrick, Bvt. Maj.-Gen. J. and staff, L.7224, S.248, S.7516.
Kimball, Lieut.-Col. E. A., 9th N. Y. Infantry, S.3862.
Kimball, Bvt. Maj.-Gen. N., S.1647.
Kimball, Bvt. Maj.-Gen. W. K., S.2658.
King, Bvt. Maj.-Gen. J. H., S.2609.
King, Brig.-Gen. R., S.3823.
King, Bvt. Maj.-Gen. R., S.3273.
Kip, Maj. L., aide-de-camp, S.1483.
Kirby, Bvt. Brig.-Gen. D. T., C.4472.
Kirk, Brig.-Gen. E. N., S.3237.
Knap, Bvt. Maj. J. M., Ind. Battery E, Pa. Artillery, S.1790.
Knight, Lieut.-Col. F. L., 24th N. J. Infantry, S.1456.
Knight, Capt. S. F., 87th N. Y. Infantry, S.1696.
Knipe, Brig.-Gen. J. F., S.1502.
Knowles, Bvt. Brig.-Gen. O. B., C.4707.
Koltes, Col. J. A., 73d N. Y. Infantry, S.1734.
Kopp, Capt. William, S.1839.
Kron, Capt. M., 8th N. Y. Infantry, S.3861.
Krzyzanowski, Brig.-Gen. W., S.1897.
Laflin, Maj., S.1932.
Laidley, Surg. J., 85th Pa. Infantry, S.3844.
Lambert, Capt. L. J., Ass't Adjt.-Gen., S.1518.
Lander, Brig.-Gen. F. W., S.1314.
Landram, Bvt. Brig.-Gen. W. J., S.3081.
Lansing, Bvt. Brig.-Gen. H. S., S.1595.
Larned, Capt. D. R., Ass't Adjt.-Gen., S.1481.
Larrabee, Col. C. H., 5th Wisc. Infantry, S.2186.
Lawton, Col. R. B., 1st R. I. Cavalry, S.3727.
Leasure, Bvt. Brig.-Gen. D., C.4714.
Ledlie, Brig.-Gen. J. H., S.1770.
Lee, Brig.-Gen. A. L., S.1863.
Lefferts, Col. M., 7th N. Y. S. M., S.1669.
Le Gendre, Bvt. Brig.-Gen. C. W., S.1527.
Leggett, Maj.-Gen. M. D., S.2047.
Leggett, Maj.-Gen. M. D. and staff, L.7052.
Lehmann, Col. T. F., 103d Pa. Infantry, S.3814.
Lemon, Maj. Frank, S.2149.
Liebenan, Adjt. H. J., 7th N. Y. S. M., S.1664.
Lincoln, Bvt. Brig.-Gen. W. S., C.5180.
Littell, Bvt. Brig.-Gen. J. S., C.4718.
Littlejohn, Bvt. Brig.-Gen. D. C., C.4662.
Locke, Brig.-Gen. F. T., S.2601.
Lockwood, Brig.-Gen. H. H., S.3104.
Logan, Maj.-Gen. John A., S.1900.
Long, Bvt. Maj.-Gen. E., C.5174.
Loomis, Bvt. Brig.-Gen. C. O., C.5169.
Loomis, Lieut.-Col. H. C., 154th N. Y. Infantry, S.3734.
Lord, Col. N., 6th Vt. Infantry, S.1731.
Lord, Col. W. B., 35th N. Y. Infantry, S.3782.
Love, Bvt. Brig.-Gen. G. M., S.2043.

Lovell, Bvt. Brig.-Gen. C. S., **S.3234.**
Ludlow, Bvt. Brig.-Gen. B. C. (in group), L.7098, **L.7350.**
Lyle, Bvt. Brig.-Gen. P., S.2018.
Lyman, Lieut.-Col. G. H., Medical Inspector, **S.1344.**
Lynch, Bvt. Brig.-Gen. W. P., C.4676.
Lyon, Col. G., 8th N. Y. S. M., S.2107, S.2111.
Lyon, Brig.-Gen. N., C.4677.
Lytle, Brig.-Gen. W. H., C.4737.
McAllister, Bvt. Maj.-Gen. R., S.3057.
McArthur, Bvt. Maj.-Gen. J., S.3071, S.3223.
McArthur, Bvt. Maj.-Gen. W. M., S.2627.
McCabe, Capt. F., 13th Pa. Cavalry, S.1617.
McCall, Brig.-Gen. G. A., S.1643.
McCallum, Bvt. Brig.-Gen. D. C., S.1489, S.1926, **S.3751.**
McCalmont, Bvt. Brig.-Gen. A. B., S.1356.
McCalmont, Col. J. S., 39th Pa. Infantry, S.1899.
McCandless, Brig.-Gen. W., S.2648.
McCarter, Col. J. M., 93d N. Y. Infantry, S.2137.
McCarty, Col., S.1916.
McChesney, Col. W. W., 10th N. Y. Infantry, S.1737.
McClellan, Maj.-Gen. G. B., S.1642.
McClellan, Maj.-Gen. G. B. and staff, S.1640, C.4530, C.5051, C.4400.
McClellan, Maj.-Gen. G. B. and wife, S.1765.
McClernand, Maj.-Gen. J. A., S.2220.
McClure, Maj. D., paymaster, S.1956.
McClure, Capt. J. W., quartermaster, S.1903.
McConihe, Bvt. Brig.-Gen. J., S.1359.
McCook, Maj.-Gen. A. McD., S.1744.
McCook, Maj.-Gen. A. McD. and staff, L.7206, L.7660, S.1022.
McCook, Maj.-Gen. E. M., S.2006, S.2086.
McDougall, Bvt. Brig.-Gen. C., S.1709.
McDougall, Bvt. Brig.-Gen. C. D., S.1340, S.1449, S.2060.
McDougall, Bvt. Brig.-Gen. C. D. and staff, C.4077.
McDowell, Maj.-Gen. I., S.1630.
McGilvery, Lieut.-Col. F., 1st Me. Light Artillery, S.3021.
McGroarty, Bvt. Brig.-Gen. S. J., S.2079.
McIntosh, Bvt. Maj.-Gen. J. B., S.2055.
McIntosh, Maj. J., 7th N. J. Infantry, S.1950, S.3777.
McIvor, Bvt. Brig.-Gen. J. P., C.5134.
Mackay, Bvt. Brig.-Gen. A. J., S.2061.
McKean, Col. J. B., 77th N. Y. Infantry, S.2178.
McKechnie, Lieut. R., 9th N. Y. Infantry, S.1495.
McKeever, Bvt. Brig.-Gen. C., S.2660.
McKibbin, Maj. T., S.3835.
McKinstry, Brig.-Gen. J., S.3075.
McLaren, Bvt. Brig.-Gen. R. N., S.3070.
McLaughlin, Bvt. Brig.-Gen. N. B., S.2052.
McLaughlin, Bvt. Brig.-Gen. N. B. and staff, L.7180, L.7201.
McLean, Brig.-Gen. N. C., S.2170.
McMahon, Col. J. P., 164th N. Y. Infantry, C.4319.
McMahon, Bvt. Brig.-Gen. M. T., S.2008.
McMillan, Surg. T., S.1583.
McMillen, Bvt. Brig.-Gen. J. W., S.2041.
McNeil, Bvt. Brig.-Gen. J., S.1653.
McPherson, Maj.-Gen. J. B., S.2612.
McQuade, Brig.-Gen. J., S.3624.
McReynolds, Col. A. T., 1st N. Y. Cavalry, S.1678, S.3806.
Madill, Surg. W. A., 23d N. Y. Infantry, S.1970.
Mahler, Col. F., 75th Pa. Infantry, S.1789, S.3743.
Mallon, Col. J. E., 42d N. Y. Infantry, S.1522.
Maluski, Capt. A., 58th N. Y. Infantry, S.3778.
Manderson, Bvt. Brig.-Gen. C. F., S.3112.
Mank, Bvt. Brig.-Gen. W. G., S.3182.
Mann, Col. W. D., 7th Mich. Cavalry, S.1644.
Manning, Bvt. Brig.-Gen. S. H., S.3008.
Mansfield, Maj. J. K. F., S.3038.
Marcy, Brig.-Gen. R. B., S.3790.
Marriner, Maj. Edward, S.1919.
Marshall, Bvt. Maj.-Gen. E. G., S.2174.
Marshall, Col. L. M., S.2167.
Marshall, Bvt. Brig.-Gen. W. R., S.3069.
Marston, Brig.-Gen. G., C.4577.
Martin, Surg. H. F., 123d Pa. Infantry, S.1392.
Martin, Maj. W. J., paymaster, S.1970.
Martindale, Bvt. Maj.-Gen. J. H., S.3767.
Martindale, Bvt. Maj.-Gen. J. H. and staff, S.2435.
Marvin, Capt., S.1575.
Mason, Bvt. Brig.-Gen. E. C., S.1861.
Mather, Bvt. Brig.-Gen. T. S., S.3742.
Matheson, Col. R., 32d N. Y. Infantry, S.3022.
Maxwell, Lieut.-Col. W. C., 103d Pa. Infantry, S.1365.
May, Maj. Isaac M., 19th Ind. Infantry, S.1819.
Meade, Maj.-Gen. G. G., S.1467.
Meade, Maj.-Gen. G. G. and staff, L.7098, L.7099, L.7330, L.7367, L.7518, L.7957.
Meagher, Brig.-Gen. T. F., S.1638.
Meigs, Bvt. Maj.-Gen. M. C., Quartermaster-General, S.1333.
Meredith, Bvt. Maj.-Gen. S., S.2182.
Meredith, Brig.-Gen. S. A., C.4679.
Merrill, Lieut.-Col. C. B., 17th Me. Infantry, S.1360.
Merritt, Maj.-Gen. Wesley, S.1830, S.1865.
Merritt, Maj.-Gen. Wesley, and staff, C.4064.
Merrow, Maj. J. M., S.3346.
Miles, Col. D. S., 2d U. S. Infantry, S.2241.
Miles, Maj.-Gen. N. A., S.1879, S.2044.
Milhau, Bvt. Brig.-Gen. J. J., C.4790.
Miller, Bvt. Maj.-Gen. J. F., C.5155.
Miller, Brig.-Gen. S., C.4736.
Milroy, Maj.-Gen. R. H., S.2225.
Minty, Bvt. Maj.-Gen. R. H. G., C.5173.
Mintzer, Bvt. Brig.-Gen. W. M., S.3229.
Mitchell, Bvt. Brig.-Gen. J., S.1680.
Mitchell, Maj.-Gen. O. M., S.2207.
Mitchell, Bvt. Maj.-Gen. J. G., S.2634.

Mitchell, Brig.-Gen. R. B., S.1680.
Mitchell, Bvt. Brig.-Gen. W. G., S.2653.
Mix, Col. S. H., 3d N. Y. Cavalry, S.2120.
Mizner, Bvt. Brig.-Gen. J. K., S.2668.
Molineux, Bvt. Maj.-Gen. E. L., C.4586.
Moor, Bvt. Brig.-Gen. A., S.2651.
Moore, Lieut.-Col. S., 11th N. J. Infantry, S.1358.
Morehead, Bvt. Brig.-Gen. T. G., S.586.
Morrell, Maj.-Gen. G. W., S.1516.
Morrell, Maj. J. A., paymaster, S.3839.
Morford, Capt. W. E., quartermaster, S.1433, **S.1821.**
Morgan, Brig.-Gen. C. H., S.2633.
Morgan, Bvt. Brig.-Gen. G. N., S.3834.
Morgan, Maj.-Gen. E. D., S.3876.
Morgan, Brig.-Gen. G. W., S.3061.
Morgan, Bvt. Maj.-Gen. J. D., S.3203.
Morris, Col. L. O., 7th N. Y. Heavy Artillery, S.2602.
Morris, Lieut.-Col. T., 4th U. S. Infantry, S.3769.
Morris, Bvt. Maj.-Gen. W. H., S.1596, S.2212.
Morrison, Col. A. J., 3d N. J. Cavalry, S.1896.
Morrison, Bvt. Brig.-Gen. D., S.3105.
Morrison, Sergt. J. J., 7th N. Y. S. M., S.1486.
Morrow, Bvt. Maj.-Gen. H. A., S.1505, S.1853.
Morse, Maj. E. C., paymaster, S.2157.
Morton, Brig.-Gen. J. St. C., C.5171.
Morton, Lieut.-Col. L., S.1357.
Moses, Lieut.-Col. I., 72d N. Y. Infantry, S.1798.
Mott, Maj.-Gen. G., S.2172.
Mott, Capt. T. P., 3d N. Y. Battery, S.1726, S.2100.
Mower, Maj.-Gen. J. E., S.2110, S.3374.
Mower, Maj.-Gen. J. A. and staff, L.4047.
Mulford, Bvt. Brig.-Gen. J. E., S.2110, S.3374.
Mulick, Lieut.-Col., S.1840.
Mulligan, Col. J. A., S.2087.
Munday, Maj. C. H., S.1946.
Mundee, Maj. C., Ass't Adjt.-Gen., S.1524.
Munesly, Maj. C. H., S.1946.
Murphy, Col. J. McL., 15th N. Y. Engineers, **S.1614.**
Murphy, Col. M., 182d N. Y. Infantry, S.1679.
Mussey, Bvt. Brig.-Gen. R. D., S.2606.
Myer, Bvt. Brig.-Gen. A. J., C.4580.
Nagle, Brig.-Gen. J., S.2623.
Naglee, Brig.-Gen. H. M., S.2223.
Nazer, Lieut.-Col. F., 4th N. Y. Cavalry, S.1805.
Neill, Capt. E. M., Ass't Adjt.-Gen., S.1771.
Neill, Bvt. Maj.-Gen. T. H., S.2629.
Nelson, Maj.-Gen. W., S.2063.
Newby, Maj. W., 6th Vt. Infantry, S.1531.
Newton, Maj.-Gen. John, S.1557.
Nichols, Bvt. Brig.-Gen. G. F., S.1397.
Nichols, Bvt. Brig.-Gen. G. S., S.1942.
Nichols, Maj. H. S., S.1618.
Norton, Bvt. Brig.-Gen. C. B., L.7200, S.1352.
Nugent, Bvt. Brig.-Gen. R., S.3856.
Nye, Bvt. Maj.-Gen. G. H., S.2618.
O'Burne, Bvt. Brig.-Gen. J. R., S.3269.
O'Connell, Capt. J. D., 14th U. S. Infantry, **S.3270.**
O'Connor, Col. E., 2d Wisc. Infantry, S.3863.
O'Dowd, Bvt. Brig.-Gen. J., S.3208.
Oglesby, Maj.-Gen. R. J., S.1755.
Olcott, Maj. E., 121st N. Y. Infantry, S.1410.
Oliphant, Bvt. Brig.-Gen. S. D., S.3796.
Oliver, Bvt. Maj.-Gen. J. M., S.2630.
Olmstead, Bvt. Brig.-Gen. W. A., S.3088.
O'Mahoney, Col. J., 40th N. Y. Infantry, S.2104.
Opdyke, Bvt. Maj.-Gen. E., S.1965.
Opdyke, Bvt. Maj.-Gen. E. and staff, C.4333.
Ord, Maj.-Gen. E. O. C., S.2081, S.2084, S.3384.
Ord, Maj.-Gen. E. O. C. and staff, C.4266.
Ordway, Bvt. Brig.-Gen. A., S.3080.
Osterhaus, Maj.-Gen. P. J., S.1871.
Owen, Brig.-Gen. J. T., C.4483.
Owen, Lieut.-Col. S. W. (caught napping), 3d Pa. Cavalry, **S.625.**
Packard, Bvt. Brig.-Gen. J., C.4735.
Page, Capt. H., quartermaster, L.7090, L.7274.
Palfrey, Brig.-Gen. F. W., C.4657.
Palmer, Bvt. Brig.-Gen. I. N., S.1823.
Palmer, Maj.-Gen. J. M., C.5168.
Palmer, Capt., S.2198.
Pangborn, Maj. Z. K., paymaster, S.1697.
Parham, Lieut.-Col. C., 29th Pa. Infantry, S.1342.
Parke, Maj.-Gen. J. G., S.1403.
Parmalee, Adjt. L. C., 2d U. S. Sharpshooters, S.1825.
Parsons, Bvt. Maj.-Gen. L. B., S.2654.
Parsons, Lieut.-Col. J. B., 10th Mass. Infantry, S.1341.
Patrick, Bvt. Maj.-Gen. R. A., S.7001, S.1693.
Patrick, Bvt. Maj.-Gen. M. R. and staff, L.7075, L.7238, L.7588.
Patten, Commissary W., 7th N. Y. S. M., S.1668.
Patterson, Bvt. Brig.-Gen. J. N., S.2666.
Patterson, Maj.-Gen. R., C.4711.
Patterson, Bvt. Brig.-Gen. R. E., C.4963.
Patton, Lieut.-Col. A. G., 1st N. Y. Mounted Rifles, S.1750.
Paul, Brig.-Gen. G. R., C.4489.
Peard, Lieut.-Col. R., 9th Mass. Infantry, S.1717.
Pearson, Brig.-Gen. A. L., S.3210.
Pease, Ass't Surg. P. C., 6th N. Y. Infantry, S.2205.
Peck, Maj.-Gen. J. J., S.1954.
Peck, Maj.-Gen. J. J. and staff, S.1907.
Peisener, Col. E., 119th N. Y. Infantry, S.3179.
Pelouze, Bvt. Brig.-Gen. L. H., C.4486.
Pennington, Bvt. Brig.-Gen. A. C. M., S.3089.
Pennypacker, Bvt. Maj.-Gen. G., C.4709.
Penrose, Brig.-Gen. W. H., S.2050.
Perkins, Lieut.-Col. S. H., 14th Conn. Infantry, S.1436.

Perley, Col. T. F., Medical Inspector, S.2163.
Perry, Bvt. Maj.-Gen. A. J., S.3721.
Perry, Col. J. H., 48th N. Y. Infantry, S.1778.
Pettes, Col. W. H., 50th N. Y. Engineers, S.2145.
Phelps, Bvt. Brig.-Gen. C. E., C.4734.
Piatt, Brig.-Gen. A. S., S.3087.
Pickett, Bvt. Brig.-Gen. J., C.5179.
Pile, Bvt. Maj.-Gen. W. A., C.4733.
Pineo, Surg. P., Medical Inspector, S.3840.
Plaisted, Bvt. Maj.-Gen. H. M., S.3722.
Pleasants, Bvt. Brig.-Gen. H., S.2622.
Pleasonton, Maj.-Gen. A., L.7317, S.342, S.2215.
Pleasonton, Maj.-Gen. A. and staff, L.7069, L.7369, L.7603.
Plummer, Brig.-Gen. J. B., S.3215.
Poe, Brig.-Gen. O. M., S.1953.
Pollock, Lieut. E., 9th U. S. Infantry, S.2200.
Poore, Maj. Ben: Perley, 8th Mass. Volunteer Militia, S.1426.
Pope, Maj.-Gen. John, S.2136.
Porter, Brig.-Gen. A. S., S.3825.
Porter, Col. B., 40th Mass. Infantry, S.3754.
Porter, Maj.-Gen. Fitz John, S.2062.
Porter, Maj.-Gen. Fitz John and staff, C.4560.
Porter, Bvt. Brig.-Gen. H., C.4490.
Post, Col. H. A. V., 2d U. S. Sharpshooters, S.3731.
Post, Bvt. Brig.-Gen. P. S., S.3230.
Potter, Maj., S.2193.
Potter, Bvt. Maj.-Gen. E. E., S.2656.
Potter, Surg. H. A., 50th N. Y. Engineers, S.3852.
Potter, Bvt. Brig.-Gen. J. H., C.4491.
Potter, Maj.-Gen. R. B., S.1729.
Potter, Maj.-Gen. R. B. and staff, C.4034.
Powell, Lieut.-Col. J. H., 9th R. I. Infantry, S.1343.
Pratt, Brig.-Gen. C. E., S.1719.
Pratt, Col. G., 80th N. Y. Infantry, S.1843.
Prendergast, Capt. R. G., 1st N. Y. Cavalry, S.1492.
Prentice, Maj.-Gen. B. M., S.2173.
Preston, Surg. A. W., 6th Wisc. Infantry, S.3854.
Preston, Col. A. W., 1st Vt. Cavalry, S.1751.
Price, Col. E. L., 145th N. Y. Infantry, S.1388.
Price, Bvt. Brig.-Gen. F., S.1752.
Price, Capt. J., 7th N. Y. S. M., S.1533.
Pride, Col. G. G., aide-de-camp, S.2260.
Prince, Brig.-Gen. H., S.2222.
Prine, Lieut. N., 17th U. S. Infantry, S.2199.
Puleston, Lieut.-Col. J. H., Military Agent of Pennsylvania, S.1957.
Pulford, Bvt. Brig.-Gen. J., S.3209.
Putnam, Capt. Lee W., S.1705.
Quick, Surg. L., S.3838.
Quinn, Chaplain T., 1st R. I. Light Artillery, S.1780.
Ramsay, Bvt. Maj.-Gen. G. D., S.1331.
Ramsay, Bvt. Maj.-Gen. J., C.4598.
Randall, Col. F. V., 13th and 17th Vt. Infantry, S.1445.
Randall, Bvt. Maj.-Gen. G. W., S.2626.
Randol, Bvt. Brig.-Gen. A. M., S.1660.
Ransom, Bvt. Maj.-Gen. T. E. G., S.1581.
Rathbon, Sergt.-Maj. R. C., 7th N. Y. S. M., S.1472.
Rawlins, Bvt. Maj.-Gen. J. A., Chief of Grant's staff, S.1758.
Rawlins, Bvt. Maj.-Gen. J. A., wife and child, S.3616.
Razenski, Maj. A., 31st N. Y. Infantry, S.2123.
Reid, Brig.-Gen. H. T., S.2659.
Reno, Maj.-Gen. J. L., C.4680.
Revere, Brig.-Gen. J. W., S.1718.
Reynolds, Maj.-Gen. J. F., S.3044, S.3045.
Reynolds, Maj.-Gen. J. J., C.4681.
Rice, Bvt. Maj.-Gen. E. W., C.4650.
Rice, Brig.-Gen. J. C., S.3025.
Rice, Brig.-Gen. S. A., C.4659.
Richardson, Maj.-Gen. I. B., S.815, S.3766.
Richardson, Col. R. H., 26th N. Y. Infantry, S.3724.
Richardson, Bvt. Maj.-Gen. W. P., S.1510.
Richmond, Bvt. Brig.-Gen. L., S.1351, S.1485, S.1549.
Ricketts, Bvt. Maj.-Gen. J. B., S.3714.
Rikell, Col. J., S.1971.
Runyon, Brig.-Gen. T., S.1887.
Riker, Col. J. L., 62d N. Y. Infantry, S.2129.
Riley, Capt., S.2197.
Riley, Col. E., 40th N. Y. Infantry, S.1898.
Ringold, Col. B., 103d N. Y. Infantry, S.3016.
Ripetti, Lieut.-Col. A., 39th N. Y. Infantry, S.1544.
Ripley, Bvt. Brig.-Gen. E. H., S.3113, S.3114.
Ripley, Bvt. Maj.-Gen. J. W., S.3213.
Roberts, Maj.-Gen. B. S., S.2083.
Roberts, Bvt. Brig.-Gen. C. W., S.3758, S.3791.
Roberts, Bvt. Brig.-Gen. C., C.4721.
Roberts, Col. T. A., 17th Me. Infantry, S.3761.
Robertson, Bvt. Brig.-Gen. J. M., C.5142.
Robinson, Adjt. H. F., 76th N. Y. Infantry, S.1832.
Robinson, Bvt. Brig.-Gen. H. L., S.2082.
Robinson, Bvt. Brig.-Gen. J. C., S.1465.
Robinson, Bvt. Brig.-Gen. J. S., S.1529, S.3756.
Robinson, Surg. J. W., 141st and 179th N. Y. Infantry, S.1434.
Rodman, Brig.-Gen. T. J., S.3093.
Rogers, Bvt. Brig.-Gen. H., C.4682.
Rogers, Surg. J. K., S.3784.
Rogers, Lieut.-Col. L. D., 16th Pa. Cavalry, S.1441.
Root, Bvt. Maj.-Gen. A. R., S.3214.
Rose, Bvt. Brig.-Gen. T. E., C.4717.
Rosecrans, Maj.-Gen. W. S., S.2001.
Ross, Bvt. Brig.-Gen. S., S.3802.
Rough, Surg., S.3855.
Rousseau, Maj.-Gen. L. H., S.2025, S.2695.
Rowley, Brig.-Gen. T., S.3792.
Rucker, Bvt. Maj.-Gen. D. H., C.4804.

Ruger, Bvt. Maj.-Gen. T. H., S.1673, S.3100.
Ruggles, Bvt. Brig.-Gen. G. D. (in group), L.7957.
Runkle, Bvt. Maj.-Gen. B. P., S.1762.
Runyon, Maj. N. M., 11th Pa. Cavalry, S.1984.
Rush, Surg. D. G., 101st Pa. Infantry, S.2244.
Rusk, Bvt. Brig.-Gen. J. M., C.4732.
Rushing, Bvt. Brig.-Gen. J. F., S.2610.
Russell, Bvt. Maj.-Gen. C. S., S.3211.
Russell, Bvt. Maj.-Gen. D. A., S.1746.
Rutherford, Brig.-Gen. F. S., S.3218.
Ryder, Sergt. S. O., 7th N. Y. S. M., S.1488.
Ryerson, Lieut.-Col. H. O., 10th N. J. Infantry, S.2238.
Sabine, Maj. J. A., S.1435.
Sackett, Bvt. Maj.-Gen. D. B., S.1387, S.1670.
Sackett, Bvt. Brig.-Gen. W. H., S.1363.
Salm Salm, Bvt. Brig.-Gen. F., S.3785.
Sanderson, Maj. J. M., aide-de-camp, S.1515.
Sanford, Maj.-Gen. C. W., N. Y. S. M., S.1319.
Sanford, Maj.-Gen. C. W. and staff, S.1503.
Satterlee, Bvt. Brig.-Gen. R. S., S.1925, S.3864.
Savage, Lieut.-Col. H. F., 25th N. Y. Infantry, S.2007.
Sawtelle, Bvt. Brig.-Gen. C. G., C.4470.
Saxton, Bvt. Maj.-Gen. R., S.3715.
Sayers, Surg. L. A., S.1532.
Schenck, Maj.-Gen. R. C., S.1399, S.2000.
Scheffer, Lieut.-Col., S.2085.
Schimmelfennig, Brig.-Gen. A., S.3042.
Schoepf, Brig.-Gen. A., S.3231.
Schoff, Maj. J. M., S.1473.
Schofield, Bvt. Brig.-Gen. G. W., S.2655.
Schofield, Maj.-Gen. J. M., S.1944.
Schurz, Maj.-Gen. Carl, S.2608, S.3007.
Schwartz, Capt., the sharpshooter, S.2423.
Schwenk, Bvt. Brig.-Gen. S. K., L.7668.
Scott, Bvt. Lieut.-Gen. Winfield, S.1313.
Scott, Bvt. Maj.-Gen. R. K., S.2032.
Scott, Bvt. Lieut.-Gen. Winfield and staff, S.3163, C.4552.
Scribner, Bvt. Brig.-Gen. B. F., S.3063.
Scully, Chaplain T., 9th Mass. Infantry, S.1990, S.2192.
Seawell, Bvt. Brig.-Gen. W., S.1474.
Sedgwick, Maj.-Gen. J., S.2177.
Sedgwick, Maj.-Gen. J. and staff, C.4619.
Selfridge, Bvt. Brig.-Gen. J. L., S.1461.
Senger, Lieut.-Col. A., 15th N. Y. Heavy Artillery, S.2168.
Serrell, Bvt. Brig.-Gen. E. A., S.1772.
Sewall, Bvt. Brig.-Gen. F. D., S.3753.
Seymour, Bvt. Maj.-Gen. T., S.3094.
Schackelford, Bvt. Brig.-Gen. J. M., S.3055.
Shafter, Bvt. Maj.-Gen. W. R., S.2604.
Shaler, Bvt. Maj.-Gen. A., S.1667.
Shanks, Bvt. Maj.-Gen. J. P. C., C.4731.
Sharpe, Bvt. Maj.-Gen. G. H., C.4588.
Sharpe, Bvt. Brig.-Gen. J., S.3730.
Shaw, Bvt. Brig.-Gen. J., C.4730.
Shaw, Maj. W. M., S.2188.
Shepley, Brig.-Gen. G. F., S.2236.
Sheridan, Maj.-Gen. P. H., C.4016, C.4039.
Sheridan, Maj.-Gen. P. H. and generals, L.4048.
Sherley, Capt. Z. M., S.1574.
Sherman, Bvt. Maj.-Gen. T. W., S.1626.
Sherman, Lieut.-Gen. W. T., S.2002, S.2017.
Sherman, Lieut.-Gen. W. T. and generals, S.1990, L.4057.
Sherman, Lieut.-Gen. W. T. and staff, L.7963.
Shields, Brig.-Gen. J., S.2069.
Shiras, Bvt. Maj.-Gen. A., S.3059.
Shreve, Maj. J. E., 132d Pa. Infantry, S.1440.
Shriver, Lieut.-Col. R. O., S.1346.
Shumway, Capt. H. C., 7th N. Y. S. M., S.1590.
Sibley, Bvt. Maj.-Gen. H. H., C.4683.
Sickel, Bvt. Maj.-Gen. H. G., C.4706.
Sickles, Maj.-Gen. D. E., S.1702.
Sickles, Maj.-Gen. D. E. and staff, S.1754.
Sidell, Bvt. Brig.-Gen. W. H., S.2621.
Sigel, Maj.-Gen. Franz, S.1512.
Sigfried, Bvt. Brig.-Gen. J. K., S.2621.
Simmons, Surg. M. E., 22d Mass. Infantry, S.1442.
Simpson, Bvt. Brig.-Gen. J. H., S.1993.
Simpson, Surg. G. B. F., 62d N. Y. Infantry, S.3805.
Sinclair, Col. W., 35th Pa. Infantry, S.1540.
Sleeper, Capt. J. H., 10th Mass. Battery, L.7085, L.7086, L.7583.
Slemmer, Brig.-Gen. A. J., S.1536.
Slocum, Maj.-Gen. H. W., S.1876.
Slocum, Maj.-Gen. H. W. and staff, L.4046.
Slough, Brig.-Gen. J. P., S.2226.
Smalley, Col. H. A., 5th Vt. Infantry, S.3729.
Smith, Lieut., L.7606.
Smith, Maj.-Gen. A. J., C.4805.
Smith, Bvt. Brig.-Gen. B. F., S.1711.
Smith, Maj.-Gen. C. F., S.1783.
Smith, Bvt. Brig.-Gen. C. H., S.3065.
Smith, Col. G. F., 61st Pa. Infantry, S.1369.
Smith, Bvt. Maj.-Gen. J. E., S.3050.
Smith, Maj. M. W., S.2190.
Smith, Brig.-Gen. T. C. H., S.1347.
Smith, Bvt. Maj.-Gen. T. K., S.1870.
Smith, Maj.-Gen. W. F., S.2160, S.2243.
Smith, Maj.-Gen. W. F. and staff, C.4038.
Smyth, Bvt. Maj.-Gen. T. A., S.3048.
Snider, Lieut.-Col. W., 4th W. Va. Cavalry, S.1455.
Snodgrass, Maj., S.3800.
Spaight, Capt. W. A., 7th N. Y. S. M., S.1572.
Spaulding, Maj. C. F., 15th Vt. Infantry, S.1396.

Spear, Bvt. Brig.-Gen. S. P., S.3072.
Sprague, Bvt. Brig.-Gen. A. B. R., C.5181.
Sprague, Bvt. Maj.-Gen. J. W., S.1934.
Sprague, Bvt. Maj.-Gen. J. W. and staff, L.4049.
Sprague, Brig.-Gen. W., S.3873.
Spofford, Bvt. Brig.-Gen. J. P., S.1348.
Stafford, Lieut.-Col. S. H., 11th N. Y. Infantry, S.2144.
Stager, Bvt. Brig.-Gen. Anson, S.1443.
Stahel, Maj.-Gen. J., S.1564.
Stanley, Maj.-Gen. D. S., C.4503.
Stannard, Bvt. Maj.-Gen. G. J., S.3047.
Starkweather, Brig.-Gen. J. C., S.1682.
Starr, Col. S. H., 5th N. J. Infantry, S.2140.
Starring, Bvt. Brig.-Gen. F. O., S.1577.
Steadman, Bvt. Brig.-Gen. G. A., S.3115.
Stebbins, E. N., storekeeper, S.3822.
Steedman, Maj.-Gen. J. B., S.2024.
Steedman, Maj.-Gen. J. B. and staff, C.4059.
Sterling, Lieut. C. R., S.1803.
Stevens, Bvt. Brig.-Gen. A. F., C.4729.
Stevens, Col. W. O., 72d N. Y. Infantry, S.1506, S.1845.
Stiles, Col. J. W., 83d N. Y. Infantry, S.1499.
Stokes, Bvt. Brig.-Gen. W. B., C.4728.
Stone, Brig.-Gen. C. P., S.1380.
Stone, Bvt. Brig.-Gen. G. A., S.2657.
Stone, Brig.-Gen. R., S.3103.
Stone, Bvt. Brig.-Gen. W. M., C.4651.
Stoneman, Maj.-Gen. G., S.437, S.1562, S.3815.
Stoneman, Maj.-Gen. G. and staff, S.436, S.438, S.445, S.696.
Storm, Gen., S.1322.
Stough, Bvt. Brig.-Gen. W., C.4594.
Stoughton, Brig.-Gen. E. H., S.2139.
Stoughton, Lieut.-Col. H. R., 2d U. S. Sharpshooters, S.1620.
Stoughton, Bvt. Maj.-Gen. W. L., C.4727.
Stratton, Bvt. Brig.-Gen. F. A., C.4719.
Streight, Bvt. Brig.-Gen. A. D., S.1760.
Strong, Maj.-Gen. G. C., S.1480, S.2210.
Strong, Bvt. Maj.-Gen. W. E., C.4595.
Strong, Brig.-Gen. W. K., C.4987.
Strother, Bvt. Brig.-Gen. D. H., S.3723.
Stryker, Maj. W. S., paymaster, S.1631.
Stuart, Col. C. B., 50th N. Y. Engineers, S.1846, S.2143.
Sturgis, Maj.-Gen. S. D., S.3842.
Sullivan, Col. T., 24th N. Y. Infantry, S.1810, S.3744.
Sully, Bvt. Maj.-Gen. A., C.4947.
Sumner, Maj.-Gen. E. V., S.2227.
Sutton, Chaplain J. F., 102d N. Y. Infantry, S.2189.
Swain, Col. J. B., 11th N. Y. Cavalry, S.1401, S.3752.
Swayne, Bvt. Maj.-Gen. W., S.3207.
Sweeney, Brig.-Gen. T. W., S.2427.
Sweet, Bvt. Brig.-Gen. B. J., S.1733.
Sweitzer, Bvt. Brig.-Gen. J. B., S.1721.
Sweitzer, Bvt. Brig.-Gen. N. B., C.4964.
Sykes, Maj.-Gen. G., S.1417.
Talley, Bvt. Brig.-Gen. W. C., S.1539.
Tapley, Col. R. P., 27th Me. Infantry, S.1422.
Tappan, Lieut.-Col. S. F., 1st Col. Cavalry, S.1858.
Taylor, Brig.-Gen. G. W., S.1828.
Taylor, Brig.-Gen. N., S.1806.
Telford, Col. W. H., 50th Pa. Infantry, L.7281.
Tenner, Lieut. L., 39th N. Y. Infantry, S.1528.
Terry, Bvt. Brig.-Gen. A. F., C.4578.
Terry, Maj.-Gen. A. H., C.4051.
Terry, Maj.-Gen. A. H. and staff, C.4051.
Terry, Maj. C. L., 13th N. Y. Infantry, S.1981.
Tevis, Bvt. Brig.-Gen. C. C., S.1420.
Thayer, Bvt. Maj.-Gen. J. M., C.4700.
Thomas, Maj.-Gen. G. C., S.1563.
Thomas, Brig.-Gen. Geo. H., S.2022, S.2607.
Thomas, Bvt. Maj.-Gen. L., S.1330.
Thomas, Brig.-Gen. M. T., S.3232.
Thourot, Lieut.-Col. L., 55th N. Y. Infantry, S.2147.
Tibbitts, Bvt. Maj.-Gen. W. B., S.2667.
Tidball, Bvt. Maj.-Gen. J. C., C.4585.
Tilton, Bvt. Brig.-Gen. W. S., S.1785.
Titus, Bvt. Brig.-Gen. H. B., S.1345.
Todd, Capt. J. B. S., 6th U. S. Infantry, S.1336.
Todd, Col. J. G., 35th N. Y. Infantry, S.1941.
Tompkins, Bvt. Brig.-Gen. C. H., C.4685.
Tompkins, Col. G. W., 82d N. Y. Infantry, S.1402.
Torbert, Bvt. Maj.-Gen. A. T. A., S.1424, S.1904.
Totten, Bvt. Brig.-Gen. J., S.2664.
Totten, Bvt. Maj.-Gen. J. G., S.1554.
Tourtelotte, Bvt. Brig.-Gen. J. E., C.4502.
Townsend, Gen., S.2213.
Townsend, Lieut.-Col. C., 106th N. Y. Infantry, S.1659.
Townsend, Bvt. Maj.-Gen. E. D., S.1860, S.3765.
Tracy, Bvt. Brig.-Gen. B. F., S.1507.
Trowbridge, Bvt. Maj.-Gen. L. S., S.1394.
Truex, Bvt. Brig.-Gen. W. S., S.3222.
Tucker, Lieut.-Col. I. M., 2d N. J. Infantry, S.2131.
Turner, Bvt. Maj.-Gen. J. W., C.4589.
Tuthill, Ass't Surg., 7th N. Y. S. M., S.1584.
Tuttle, Brig.-Gen. J. M., C.4652.
Tuttle, Col. O. L., 6th Vt. Infantry, S.1802.
Tyler, Brig.-Gen. Daniel, 1629.
Tyler, Bvt. Maj.-Gen. E. B., S.1437.
Tyler, Brig.-Gen. R. O., S.1383.
Tyler, Bvt. Maj.-Gen. R. O. and staff, L.7377, L.7504.
Tyndale, Bvt. Maj.-Gen. H., C.4704.
Ullman, Bvt. Maj.-Gen. D., S.1530.
Underwood, Bvt. Maj.-Gen. A. B., S.2045.
Upham, Maj. C. L., 8th Conn. Infantry, S.1411.
Upton, Bvt. Maj.-Gen. E., S.1835.

Vallee, Lieut.-Col. F., 82d Pa. Infantry, S.2146.
Van Allen, Brig.-Gen. J. H., S.2122.
Van Cleve, Bvt. Maj.-Gen., C.5170.
Vanderbilt, Lieut. G. W., 10th U. S. Infantry, S.2250.
Vandever, Bvt. Maj.-Gen. W., C.4686.
Van Etten, Surg. S., 56th N. Y. Infantry, S.3831.
Van Ness, Lieut., S.2251.
Van Ness, Capt. W., quartermaster, S.1924.
Van Steinhausen, Lieut.-Col. A., 68th N. Y. Infantry, S.1786.
Van Vliet, Bvt. Maj.-Gen. S., S.2206.
Van Wedell, Maj. C., 68th N. Y. Infantry, S.1836.
Varney, Bvt. Brig.-Gen. G., S.3802.
Viele, Brig.-Gen. E. L., S.1675.
Vincent, Col. S., 83d Pa. Infantry, S.3188.
Vincent, Bvt. Brig.-Gen. T. M., C.4509.
Virgin, Col. W. W., 23d Me. Infantry, S.1850.
Von Amsberg, Col. G., 45th N. Y. Infantry, S.3243.
Von Forstner, Maj. S., 3d N. J. Cavalry, S.1935.
Von Gilsa, Col. L., 41st N. Y. Infantry, S.2629.
Von Penchelstein, Maj., 4th N. Y. Cavalry, S.1882.
Von Schrader, Bvt. Brig.-Gen. A., C.5165.
Von Shack, Col. G., C.4981.
Von Steinwehr, Brig.-Gen. A., S.1415, S.2128.
Voris, Bvt. Maj.-Gen. A. C., S.1829.
Wadsworth, Brig.-Gen. J. S., S.2064.
Wadsworth, Brig.-Gen. J. S. and staff, L.7972.
Waite, Bvt. Brig.-Gen. C. A., S.2670.
Walcutt, Bvt. Maj.-Gen. C. C., S.1928.
Walcutt, Bvt. Maj.-Gen. C. C. and staff, L.7002.
Walker, Bvt. Brig.-Gen. M. B., S.3238.
Wallace, Maj.-Gen. Lew, S.2211.
Wallace, Bvt. Brig.-Gen. W. H. L., C.4687.
Ward, Bvt. Brig.-Gen. G. H., C.5183.
Ward, Brig.-Gen. J. H. H., S.1593, S.1878.
Ward, Lieut.-Col. W. G., 12th N. Y. S. M., S.1661.
Ward, Bvt. Maj.-Gen. W. T., L.4056.
Ward, Bvt. Brig.-Gen. W. T. and staff, L.4063.
Warner, Bvt. Brig.-Gen. A. J., C.4708.
Warner, Brig.-Gen. J. M., S.3086.
Warren, Bvt. Maj.-Gen. F. H., C.4653, C.4688.
Warren, Maj.-Gen. G. K., S.1757.
Washburn, Col. C., S.1849.
Washburn, Bvt. Brig.-Gen. C. C., C.4726.
Washburn, Bvt. Brig.-Gen. F., C.5156.
Washburn, Bvt. Maj.-Gen. H. D., C.4725.
Washington, Col. P. G., S.1739.
Watkins, Brig.-Gen. L. D., S.1722.
Watson, Maj. A. B., 8th Mich. Infantry, S.1931.
Way, Lieut.-Col. W. B., 9th Mich. Cavalry, S.1339.
Webb, Bvt. Maj.-Gen. A. S., S.1933.
Webb, Maj. M. F., paymaster, S.2191.
Weber, Brig.-Gen. M., C.4689.
Webster, Col. F., 12th Mass. Infantry, S.2185.
Webster, Bvt. Maj.-Gen. J. D., S.2611.
Weiss, Capt. A., 41st N. Y. Infantry, S.2261.
Weiss, Lieut.-Col. F., 20th N. Y. Infantry, S.1537.
Weitzel, Maj.-Gen. Godfrey, S.2030.
Weitzel, Maj.-Gen. Godfrey and staff, L.4066, L.4079.
Wellman, Lieut.-Col. A. J., 85th N. Y. Infantry, S.1804.
Wells, Bvt. Brig.-Gen. G. D., S.1364.
Wells, Bvt. Maj.-Gen. W., S.2635.
Welsh, Brig.-Gen. T., S.3171.
Wessells, Brig.-Gen. H. W., C.4494.
West, Bvt. Brig.-Gen. J., S.3036.
West, Bvt. Brig.-Gen. R. M., S.2152.
Westbrook, Lieut.-Col. C. D., 120th N. Y. Infantry, S.1354.
Weston, Chaplain S. H., 7th N. Y. S. M., S.1674.
Wheaton, Bvt. Maj.-Gen. F., S.2619.
Wherry, Bvt. Brig.-Gen. W. M., S.3083.
Whipple, Maj.-Gen. A. W., S.2632.
Whipple, Bvt. Brig.-Gen. W. D., C.4574.
White, Lieut., S.2248.
White, Lieut.-Col. Nelson, 1st Conn. Artillery, S.2214.
White, Lieut.-Col. A. H., 5th N. Y. Cavalry, S.1338.
White, Bvt. Brig.-Gen. S., S.3227.
White, Bvt. Maj.-Gen. J., S.2221.
White, Bvt. Brig.-Gen. J. and staff, L.7562, L.7845.
Whiting, Maj. C. J., 2d U. S. Cavalry, S.1416.
Whittaker, Bvt. Brig.-Gen. E. W., S.2040.
Whittlesey, Col. F. W., 1st Mich. Infantry, S.1945.
Wickstead, Lieut. J., 7th N. Y. S. M., S.1666.
Wilcox, Col. V. M., 132d Pa. Infantry, S.1409.
Wild, Brig.-Gen. E. A., C.5159.
Wilder, Bvt. Brig.-Gen. J. T., C.5175.
Wiley, Maj. W. M., paymaster, S.3837.
Wilkeson, Lieut.-Col. S. H., 11th N. Y. Cavalry, S.1742.
Willard, Col. G. L., 125th N. Y. Infantry, S.1525.
Willard, Maj. J. C., aide-de-camp, S.1452.
Willcox, Bvt. Maj.-Gen. O. B. and staff, L.7067, L.7526, L.7527, S.2440.
Willett, Col. J. H., 12th N. J. Infantry, S.1833.
Williams, Bvt. Maj.-Gen. A. S., S.2179.
Williams, Lieut.-Col. D. A., 136th Ohio Infantry, S.1795.
Williams, Bvt. Brig.-Gen. J. M., C.4596.
Williams, Bvt. Brig.-Gen. R., S.3067.
Williams, Col. S. J., 19th Indiana Infantry, S.1478.
Williams, Brig.-Gen. T., S.3191.
Williamson, Bvt. Maj.-Gen. J. A., C.4654.
Williamson, Capt. R. S., U. S. Engineers, S.2252.
Willich, Bvt. Maj.-Gen. A., C.4669.
Wilson, Brig.-Gen. J., S.1966.
Wilson, Bvt. Maj.-Gen. J. G., S.1815, S.1868.
Wilson, Maj.-Gen. J. H., S.2074.

Wilson, Maj.-Gen. J. H. and staff, C.4181.
Wilson, Bvt. Brig.-Gen. T. (in group), L.7957.
Wilson, Bvt. Brig.-Gen. W., S.1382.
Winchester, Quartermaster L. W., 7th N. Y. S. M., S.1594.
Winslow, Maj., S.2257.
Winslow, Chaplain G., 5th N. Y. Infantry, S.1592.
Winthrop, Bvt. Maj.-Gen. F., S.1927.
Wisewall, Bvt. Brig.-Gen. M. N., S.3747.
Wistar, Brig.-Gen. I. J., C.4705.
Wood, Col. A. M., 84th N. Y. Infantry, S.2133.
Wood, Maj.-Gen. T. J., S.1695.
Wood, Maj. W. H., 17th U. S. Infantry, S.3830.
Woodbury, Chaplain A., 1st R. I. Infantry, S.1639.
Woodbury, Col. D. A., 4th Mich. Infantry, S.3786.
Woodford, Bvt. Brig.-Gen. S. L., C.5098.
Woodruff, Col. W. E., 2d Ky. Infantry, S.2249.
Woods, Bvt. Maj.-Gen C. R., S.2636.
Woodward, Lieut.-Col. A., 31st Pa. Infantry, S.1405.
Wool, Maj.-Gen. J. E., S.1318.
Woolsey, Lieut. C. W., S.7103.
Worth, Bvt. Maj.-Gen. W. J., S.1316.
Worthington, Surg. W. H., 63d Pa. Infantry, S.3841.
Wright, Col. D. R., 15th Conn. Infantry, S.3750.
Wright, Col. E. H., aide-de-camp, S.3799.
Wright, Maj.-Gen. H. G., S.1781.
Wright, Maj.-Gen. H. G. and staff, C.4570.
Wyndham, Col. Percy, 1st N. J. Cavalry, S.1905, S.3762.
Wynkoop, Col. J. E., 20th Pa. Cavalry, S.1818.
Yeoman, Bvt. Brig.-Gen. S. B., S.2669.
York, Lieut. J. S., 5th N. Y. Infantry, S.1699.
Young, Bvt. Brig.-Gen. S. B. M., S.1615.
Young, Bvt. Brig.-Gen. S. B. M., C.4716.
Zagony, Col. C., aide-de-camp, S.3858.
Zook, Maj. P. J., S.1622.
Zook, Bvt. Maj.-Gen. S. K., S.1500.
Zulick, Bvt. Brig.-Gen. S. M., C.4496.

REGIMENTS AND BATTERIES.

Colorado Cavalry.

1st. Lieut.-Col. S. F. Tappan, S.1858.

Connecticut Cavalry.

1st. Col. E. W. Whittaker, S.2040.

Connecticut Heavy Artillery.

1st. *At Fort Richardson, Va.:*
—Officers of regiment, C.4534.
—Interior of Fort Richardson, C.4547.
—Camp at Fort Richardson, C.4552.
At Fort Darling, James River, Va., April, 1865:
—Officers of regiment, S.6, S.11.
—Officers' quarters, S.1134, S.1136, S.1139, S.1141.
—Band, S.1129.
—Lieut.-Col. Nelson White, S.2214.

Connecticut Infantry.

3d. Company —, C.4129.
11th. Col. G. A. Steadman, S.3115.
14th. Lieut.-Col. S. H. Perkins, S.1436.
15th. Col. D. R. Wright, S.3750.
 Maj. C. L. Upham, S.1411.
20th. Col. S. Ross, S.3082.
22d. Col. G. S. Burnham, S.1477, S.3736.

District of Columbia Cavalry.

1st. Officers of regiment, C.4558.
 Col. L. C. Baker, C.4965.

District of Columbia Infantry.

2d. Col. C. N. Alexander, S.2155, S.3755.
 Lieut.-Col. W. O. Drew, S.1362.

Illinois Cavalry.

9th. Col. A. G. Brackett, S.1649.
12th. Col. H. Davis, S.1425.

Illinois Light Artillery.

2d. Col. T. S. Mather, S.3742.

Illinois Infantry.

23d. Col. J. A. Mulligan, S.2087.
36th. Officers of regiment, C.4331.
58th. Col. W. P. Lynch, C.4676.
59th. Col. P. S. Post, S.3230.
72d. Col. F. A. Starring, S.1577.
105th. Col. D. Dustin, S.3847.

Indiana Cavalry.

3d. Detachment at headquarters Army of Potomac, November, 1864, L.7023.
 Ass't Surg. L. Brusie, S.1889.

Indiana Infantry.

7th. Col. I. G. Grover, S.1677.
 Col. J. P. C. Shanks, C.4731.
 Lieut.-Col. W. C. Banta, S.1794.
9th. Company C., C.4096, C.4728.
18th. Col. H. D. Washburn, C.4725.
19th. Col. S. J. Williams, S.1478.
 Lieut.-Col. W. W. Dudley, S.2625.
 Maj. I. M. May, S.1819.
22d. Lieut.-Col. A. I. Harrison, S.3776.
32d. Maj. W. G. Mank, S.3182.
33d. Col. John Colburn, C.4738.
38th. Col. B. F. Scribner, S.3063.
44th. Company H, C.4338.
 Company —, C.4335, C.4342.
 Company —, C.4337, C.4340.
51st. Col. A. D. Streight, S.1760.
70th. Col. B. Harrison, S.3039.
128th. Col. Jasper Packard, C.4735.

Iowa Infantry.

8th. Col. J. L. Geddes, S.3064.
13th. Col. J. Wilson, S.1966.
15th. Col. J. M. Hedrick, S.2049.
19th. Exchanged prisoners, after release from Camp Ford, Texas, L.3010, L.3028, L.3029, L.3030.
22d. Col. W. M. Stone, C.4651.
23d. Col. S. L. Glasgow, C.4648.
25th. Col. G. A. Stone, S.2657.
29th. Col. T. H. Benton, C.4644.
34th. Col. G. W. Clark, C.4645.

Kentucky Infantry.

2d. Col. W. E. Woodruff, S.2249.
19th. Col. W. J. Landran, S.3081.

Maine Cavalry.

1st. Col. C. H. Smith, S.3065.
 Lieut.-Col. J. P. Cilley, C.5160.

Battalion Maine Light Artillery.

1st. Lieut.-Col. J. A. Hall, S.2637.
 Lieut.-Col. F. McGilvery, S.3021.

Maine Infantry.

2d. Camp Jamison, near Washington, D. C., C.4547, C.4548, C.4130.
 Col. C. W. Roberts, S.3758, S.3791.
 Col. G. Varney, S.3802.
3d. Lieut.-Col. E. Burt, S.3779.
5th. Col. C. S. Edwards, S.1509.
 Surg. B. F. Buxton, S.1389.
7th. Col. E. C. Mason, S.1861.
8th. Col. W. M. McArthur, S.2627.
10th. Group of officers, Cedar Mountain, Va., August, 1862, S.509.
11th. Col. H. M. Plaisted, S.3722.
12th. Col. W. K. Kimball, S.2658.
17th. Col. T. A. Roberts, S.3761.
 Col. G. W. West, S.3036.
 Lieut.-Col. C. B. Merrill, S.1360.
19th. Col. F. E. Heath, S.1361.
23d. Col. W. W. Virgin, S.1853.
27th. Col. R. P. Tapley, S.1422.
29th. Col. G. H. Nye, S.2618.
30th. Col. T. H. Hubbard, C.5136.
 Lieut.-Col. G. W. Randall, S.2626.

Maryland Cavalry.

3d. Col. C. C. Tevis, S.1420.

Maryland Infantry.

4th. Col. R. N. Bowerman, S.2652.
6th. Col. J. W. Horn, C.4663.
7th. Col. Charles E. Phelps, C.4734.
8th. Col. A. W. Dennison.

Massachusetts Cavalry.

1st. *At headquarters Army of Potomac, August,* 1864:
—Officers of Companies C and D, L.7390, L.7490.
—Officers and non-commissioned officers of Companies C and D, L.7354, L.7391.
—Company C, L.7295.
—Company D, L.7392, L.7476.
—Capt. E. A. Flint, L.7403.
3d. Col. T. E. Chickering, S.3092.
4th. Col. F. Washburn, C.5156.

Massachusetts Artillery.

3d. Officers in Fort Totten, Va., S.1115.
—Officers and men, S.1156, S.1157, S.1190, S.1227.
—Col. W. S. Abert, S.3178.
Fort Totten, near Washington, D. C.:
—Officers of Companies A and B, L.7261, L.7678, L.7681.
—Sergeants of Company A, L.7253.
—Sergeants of Company B, L.7687.
Fort Stevens, near Washington, D. C.:
—Officers of Companies F and K, L.7282, L.7696.
—Company F, L.7744, L.7803, L.7917.
—Company K, L.7692, L.7746, L.7897.
Fort Lincoln, near Washington, D. C.:
—Company H, L.7874.

Massachusetts Heavy Artillery.

4th. Col. W. S. King, S.3273.

Massachusetts Battery.

10th. Officers, L.7085, L.7086, L.7089, L.7583.

Massachusetts Militia.

8th. Maj. Ben: Perley Poore, S.1426.

Massachusetts Infantry.

2d. Col. W. Cogswell, S.2029.
Maj. W. Dwight, S.1811, S.1814.
9th. Groups of officers, C.4101, C.4102.
Father Scully holding mass in camp, C.4131.
Col. T. Cass, S.3774.
Col. P. R. Guiney, S.3096.
Lieut.-Col. R. Peard, S.1717.
Chaplain T. Scully, S.1990, S.2192.
10th. Camp near Washington, D. C., S.2421.
Lieut.-Col. J. B. Parsons, S.1341.
11th. Col. W. Blaisdell, S.3111.
12th. Col. F. Webster, S.2185.
Surg. J. H. Baxter, S.3833.
15th. Col. G. H. Ward, C.5183.
Lieut.-Col. G. C. Joslin, C.5190.
Surg. S. F. Haven, C.5193.
Lieut. J. W. Grout, C.5191.
Lieut. T. J. Spurr, C.5192.
19th. Col. A. F. Devereaux, S.3066.
22d. Col. H. Wilson, C.4593.
Col. W. S. Tilton, S.1785.
Surg. M. E. Simmons, S.1442.
24th. Col. A. Ordway, S.3080.
25th. Col. Josiah Pickett, C.5179.
28th. Officers of regiment, L.7750.
34th. Col. W. S. Lincoln, C.5180.
Col. G. D. Wells, S.1364.
Maj. H. W. Pratt, C.5185.
36th. Lieut.-Col. A. A. Goodell, C.5182.
40th. Camp near Miners' Hill, Va., C.4278, C.4357.
Col. G. V. Henry, S.3220.
Col. B. Porter, S.3754.
51st. Col. A. B. R. Sprague, C.5181.
54th. Col. E. N. Hallowell, S.2665.
57th. Col. N. B. McLaughlin, S.2052.
Col. J. M. Tucker, C.5184.

Michigan Cavalry.

1st. Col. T. F. Broadhead, S.1958.
3d. Col. J. K. Mizner, S.2668.
5th. Lieut.-Col. E. Gould, S.1439.
7th. Col. W. D. Mann, S.1644.
9th. Lieut.-Col. W. B. Way, S.1339.
10th. Col. L. S. Trowbridge, S.1394.

Michigan Infantry.

1st. Col. I. C. Abbott, S.1469.
Col. F. W. Whittlesey, S.1945.
4th. Col. D. A. Woodbury, S.3786.
Capt. S. De Golyer, S.1992.
5th. Col. J. Pulford, S.3209.
8th. Maj. A. B. Watson, S.1931.
11th. Col. W. L. Stoughton, C.4727.
12th. Headquarters, C.4603, C.4611.
15th. Col. F. S. Hutchinson, S.3225.
21st. Officers of regiment, C.4103.
Company B, C.4101.
Company D, C.4099.
Company E, C.4100.
Company —, C.4092.
Company —, C.4750.
24th. Col. H. A. Morrow, S.1505, S.1853.

Minnesota Cavalry.

2d. Col. R. N. McLaren, S.3070.

Minnesota Infantry.

1st. Col. George N. Morgan, S.3834.
Lieut.-Col. C. P. Adams, S.1749.
5th. Col. L. F. Hubbard, S.3110.
7th. Col. W. R. Marshall, S.3069.
8th. Col. M. T. Thomas, S.3232.

Missouri Light Artillery.

2d. Lieut.-Col. G. W. Schofield, S.2655.

Missouri Infantry.

15th. Col. J. Conrad, S.2661.

New Hampshire Infantry.

2d. Col. J. N. Patterson, S.2666.
Maj. F. S. Fisk, S.3849.
5th. Col. E. E. Cross, S.1983.
Maj. W. W. Cook, S.1929.
Adjt. C. O. Dodd, S.1838.
9th. Col. H. B. Titus, S.1345.
13th. Col. A. F. Stevens, C.4729.

New Jersey Cavalry.

1st. Col. M. H. Beaumont, S.1943.
Col. H. Janeway, S.1658.
Col. P. Wyndham, S.1905, S.3762.
2d. Col. J. Karge, S.1616.
3d. Col. A. J. Morrison, S.1896.
Col. A. C. M. Pennington, S.3089.
Maj. S. Von Forstner, S.1935.

New Jersey Infantry.

1st. Col. M. W. Collet, S.1353.
2d. Lieut.-Col. I. M. Tucker, S.2131.
Lieut.-Col. S. L. Buck, S.1706.
4th. Col. W. B. Hatch, S.3746.
Col. J. H. Simpson, S.1993.
Lieut.-Col. C. Ewing, S.1648.
5th. Col. S. H. Starr, S.2140.
6th. Col. G. C. Burling, S.3102.
7th. Col. F. Price, S.1752.
Maj. J. D. McIntosh, S.1950, S.3777.
8th. Col. John Ramsay, C.4598.
9th. Col. A. Zabriskie, C.5135.
10th. Lieut.-Col. H. O. Ryerson, S.2238.
11th. Lieut.-Col. S. Moore, S.1358.
12th. Col. J. H. Willett, S.1833.
13th. Col. E. A. Carmen, S.1386.
14th. Col. W. S. Truex, S.3222.
24th. Lieut.-Col. F. L. Knight, S.1456.
25th. Col. A. Derrom, S.3741.
28th. Col. M. N. Wisewell, S.3747.
31st. Col. A. P. Berthond, S.3738.
Lieut.-Col. W. Holt, S.1337.

New Mexico Cavalry.

1st. Col. Kit Carson, S.2620.

New York Mounted Rifles.

1st. Lieut.-Col. A. G. Patton, S.1750.

New York Cavalry.

1st. Col. A. T. McReynolds, S.1678, S.3806.
Capt. D. Harkins, S.3870.
Capt. R. G. Prendergrast, S.1492.
Lieut. H. B. Hidden, S.2135.
2d. Col. A. M. Randol, S.1660.
Maj. A. N. Duffie, S.2154.
3d. Col. S. H. Mix, S.2120.
4th. Lieut.-Col. F. Nazer, S.1805.
Maj. A. Von Peuchelstein, S.1882.
5th. Col. John Hammond, C.4980.
Col. Amos H. White, S.1338.
7th. On parade, and camp near Washington, C.4543.
9th. Col. G. S. Nichols, S.1942.
Lieut.-Col. H. B. Hyde, S.1471.
Lieut.-Col. W. Sackett, S.1363.
11th. Col. J. B. Swain, S.1401, S.3752.
Lieut.-Col. S. H. Wilkeson, S.1742.
13th. *Prospect Hill, Va., near Washington, D. C.:*
—Regiment on inspection, L.7735.
—Field and staff officers, L.7723, L.7726, L.7738.
—Officers of regiment, L.7185, L.7734.
—Non-commissioned staff officers, L.7740.
—General view of camp, L.7218, L.7733, L.773., L.7739.
—Headquarters in camp, L.7722.
—Signal station in camp, L.7736.
16th. Col. N. B. Sweitzer, C.4964.
26th. Lieut.-Col. F. Jacobs, S.3015.

New York Artillery Battalion.

1st. Battery —, near Fair Oaks, Va., June, 1862, S.443, S.640.

New York Light Artillery.

1st. Field and staff officers, S.2417.

New York Heavy Artillery.

2d. *Fort C. F. Smith, near Washington, D. C.:*
—Officers of regiment, L.7906.
—Officers of Company F, L.7479.
—Officers of Companies K and L, L.7842.
—Company F, L.7283.
—Company K, L.7675.
—Company L, L.7672, L.7673.
4th. Officers, L.7178.
Officers in Fort Corcoran, Va., C.4103.
Col. T. D. Doubleday, S.1874.
Col. H. H. Hall, S.1921.
Col. J. C. Tidball, C.4585.
Surg. G. Bayles, S.1379.
6th. Camp at Brandy Station, Va., April, 1864, L.7265.
7th. Col. L. O. Morris, S.2602.
9th. Company M, previously 22d New York Battery, L.7818.
13th. Camp in front of Petersburg, Va., S.2495, S.2496.
14th. Col. E. G. Marshall, S.2174.
15th. Officers of Third Battalion, L.7743.
Lieut.-Col. A. Senges, S.2168.

New York Battery.

1st. Cowan's Battery, in front of Petersburg, June, 1864, S.787, S.2343.
3d. Capt. T. P. Mott, S.1726, S.2100.
17th. Officers, L.7559.
On parade, S.7008, L.7010, L.7620.

New York Engineers.

1st. Officers of Company E, S.1034.
Col. E. A. Serrell, S.1772.
15th. Col. J. McL. Murphy, S.1614.
Lieut.-Col. C. G. Colgate, S.1923.
Officers of regiment, C.4477.
50th. Col. W. H. Peters, S.2145.
Col. C. B. Stuart, S.1846, S.2143.
Maj. G. W. Ford, L.7166.
Surg. C. N. Hewitt, L.7401.
Surg. H. A. Potter, S.3852.
At Rappahannock Station, March, 1864:
—Field and staff officers, L.7600, L.7615.
—General view of camp, L.7275, L.7276, L.7461, S.138.
—Stockade entrance to camp, L.7351.
—Sutler's hut, L.7290.
—Quarters of field and staff officers, L.7293, L.7604, L.7608.
—Quarters of line officers, L.7614.
In front of Petersburg, Va.:
—Officers of regiment, L.7324.
—Officers' dinner on Fourth of July, 1864, S.790, S.791.
—Headquarters, L.7167, L.1028, S.1048.
—Colonel's quarters, L.7059, L.1047.
—Surgeon's quarters, L.7233.
—Officers' quarters, L.7210, L.7213, S.344, S.1028, S.3338.
—Church, L.7151, L.7932, S.345, S.3339, S.3340.
—Commissary department, L.7060.

New York Infantry.

1st. Col. W. H. Allen, S.1735.
Ass't Surg. A. C. Benedict, S.1458.
3d. Col. J. E. Mulford, S.2110.
5th. Col. F. Winthrop, S.1927.
Maj. C. Boyd, S.1450.
Surg. S. Van Etten, S.3831.
Chaplain G. Winslow, S.1592.
Lieut. J. S. York, S.1699.
6th. Col. W. Wilson, S.1382.
Maj. W. Newby, S.1531.
Ass't Surg. P. C. Pease, S.2205.
7th. Col. George Von Shack, C.4981.
8th. Capt. M. Kron, S.3861.
9th. Col. R. C. Hawkins, S.1511.
Lieut.-Col. G. F. Betts, S.1635.
Maj. E. A. Kimball, S.3862.
Lieut. R. McKechnie, S.1495.
10th. Col. J. E. Bendix, S.3201.
Col. W. W. McChesney, S.1737.
Lieut.-Col. A. B. Elder, S.3868.
11th. Col. E. E. Ellsworth, S.3175.
Lieut.-Col. N. L. Farnham, S.1628.
Lieut.-Col. S. H. Stafford, S.2144.
Maj. J. A. Creiger, S.1627.
Francis E. Brownell, S.1494.
13th. Maj. C. L. Terry, S.1981.
14th. Col. J. McQuade, S.3824.
16th. Surg. W. B. Crandall, S.2156.

17th. Col. H. S. Lansing, S.1595.
Maj. C. A. Johnson, S.2254.
Camp and regiment, C.4541.
20th. Col. F. Salm Salm, S.3785.
Lieut.-Col. F. Weiss, S.1537.
23d. Col. H. C. Hoffman, C.5163.
Surg. W. A. Madill, S.1419.
24th. Col. T. Sullivan, S.1810, S.3744.
25th. Col. C. A. Johnson, S.1857, S.2254.
Maj. H. F. Savage, S.2007.
26th. Col. W. H. Christian, S.2138.
Lieut.-Col. R. H. Richardson, S.3724.
On parade, C.4529, C.4545.
27th. Lieut.-Col. A. D. Adams, S.1964.
Maj. C. C. Gardiner, S.1703.
29th. Col. A. Von Steinwehr, S.2128.
31st. Maj. A. Razenski, S.2123.
32d. Col. R. Matheson, S.3022.
33d. Field and staff officers, C.4542.
35th. Col. W. B. Lord, S.3782.
Maj. J. G. Todd, S.1941.
Company —, S.2422.
37th. Col. S. B. Hayman, S.3058.
Capt. W. De Lacy, S.2253.
39th. Col. F. G. D'Utassy, S.1496, S.2184.
Lieut.-Col. A. Ripetti, S.1544.
Lieut. L. Tenner, S.1528.
40th. Col. E. Riley, S.1898.
Surg. J. E. Dexter, S.1888.
41st. Col. L. Von Gilsa, S.2649.
Capt. A. Weiss, S.2261.
Company C, Manassas, Va., July, 1862, L.7517.
42d. Col. E. C. Charles, S.2005.
Col. J. E. Mallon, S.1522.
Maj. P. J. Downing, S.2106.
44th. Officers of regiment, C.4227.
Camp of regiment, near Alexandria, C.4069, C.4172, C.4173, C.4192, C.4230, C.4231, C.4086, C.4186.
Flag of regiment, L.1504.
45th. Col. G. Von Amsberg, S.3243.
46th. Col. J. Gerhardt, S.3097.
Capt. H. Brandenstein, S.1824.
48th. Col. W. B. Barton, S.1604.
Col. J. H. Perry, S.1778.
51st. Col. C. W. Le Gendre, S.1527.
52d. Col. P. Frank, S.3001.
55th. Lieut.-Col. L. Thourot, S.2147.
Maj. F. Jehl, S.1949.
Officers of regiment, C.4550.
Camp at Fort Gaines, C.4071, C.4544.
57th. Lieut.-Col. J. W. Britt, S.1548.
Lieut.-Col. A. B. Chapman, S.1398.
58th. Capt. A. Maluski, S.3778.
59th. Col. W. A. Olmstead, S.3088.
60th. Officers of regiment at Fauquier Springs, Va., August, 1862, S.538, S.539.
61st. *At Falmouth, Va., April, 1863:*
—Officers of regiment, L.7530, L.7531.
—Drum Corps, L.7520.
—Company D, L.7313.
—Company G, L.7554.
—Company K, L.7556.
62d. Col. J. L. Riker, S.2129.
Lieut.-Col. O. V. Dayton, S.1777, S.2065.
Surg. G. B. F. Simpson, S.3805.
63d. Col. Henry Fowler, S.1906.
Officers of regiment, L.7542.
65th. Col. J. E. Hamblin, S.1476, S.2150.
Maj. H. G. Healey, S.1421.
66th. Lieut.-Col. J. S. Hammell, S.2671.
67th. Col. J. W. Adams, S.2092.
Camp near Washington, D. C., in 1861, C.4546, C.4114, C.4115, C.4116.
68th. Col. R. J. Betge, S.2132.
Col. G. Bourri, S.1519.
Lieut.-Col. A. Van Steinhauser, S.1786.
Maj. C. Van Wedell, S.1836.
69th. Col. R. Nugent, S.3856.
Lieut.-Col. James Bagley, S.1856.
Officers of regiment, L.7642.
70th. Col. J. E. Farnum, 1385.
71st. Regiment on parade at camp near Miner's Hill, Va., S.2415.
Group of Company G, S.2413.
72d. Col. W. O. Stevens, S.1506, S.1845.
Lieut.-Col. Israel Moses, S.1798.
Surg. C. K. Irwine, S.279, S.3821.
73d. Col. W. R. Brewster, S.1842.
75th. Col. J. A. Dodge, S.3869.
76th. Adjt. H. F. Robinson, S.1832.

77th. Col. J. B. McKean, S.2178.

79th. Col. J. Cameron, S.1637.
Col. D. Morrison, S.3105.
Maj. F. A. Hagadorn, S.1700.

80th. Col. J. B. Hardenburgh, S.1715.
Col. G. Pratt, S.1843.
Lieut.-Col. T. B. Gates, S.1827.
Capt. T. Alexander, L.7605.
Officers of regiment, Culpeper, Va., September, 1863, L.7071, L.7373, S.278.

82d. Col. G. W. B. Tompkins, S.1402.
Maj. J. J. Dimock, S.1393.

83d. Col. J. W. Stiles, S.1499.
Adjt. J. B. Coppinger, S.1514.

84th. Col. E. B. Fowler, S.3801.
Col. A. M. Wood, S.2133.

85th. Lieut.-Col. A. J. Wellman, S.1804.

86th. Col. B. P. Bailey, S.1866.

87th. Capt. S. F. Knight, S.1696.

93d. Col. J. S. Crocker, C.4673.
Col. J. M. McCarter, S.2137.
Maj. A. L. Cassidy, S.2187, S.3068.
At Antietam, Md., September, 1862, L.7938, L.7941.
At Bealeton, Va., August, 1863:
—Officers of regiment, L.7505.
—Field and staff officers, S.630.
—Commissioned and non-commissioned staff, L.7011, S.284.
—Company A, L.7510, L.7512.
—Company B, L.7453, L.7506.
—Company C, L.7451, L.7592.
—Officers and non-commissioned officers of Company D, L.7458, L.7539.
—Company D, L.7452, L.7591.
—Officers' "mess," Company D, S.218.
—Non-commissioned officers' "mess," Company D, S.217.
—Company E, L.7455, L.7460.
—Officers' "mess," Company E, S.225.
—Company F, L.7454, L.7594.
—Officers' "mess," Company F, S.220.
—Company G, L.7456, L.7459.
—Officers and non-commissioned officers of Company I, L.7511.
—Company I, L.7457, L.7593.
—Company K, L.7009, L.7036, L.7508.
—Drum Corps, L.7514, L.7565.
—Views of camp, S.219, S.824, S.826, S.827, S.828.

94th. Col. A. R. Root, S.3214.

95th. Col. G. H. Biddle, S.1800.

96th. Col. J. Fairman, S.2232.

97th. Col. J. P. Spofford, S.1348.

99th. Col. J. O'Mahoney, S.2104.

100th. Col. J. M. Brown, S.2603.

102d. Chaplain J. F. Sutton, S.2189.

103d. Col. B. Ringold, S.3016.

105th. Col. B. F. Tracy, S.1507.

106th. Lieut.-Col. C. Townsend, S.1659.

107th. Col. A. S. Diven, S.1852.

110th. Col. D. C. Littlejohn, C.4662.

111th. Col. C. D. McDougall, S.1340, S.1449, S.2060.

116th. Col. G. M. Love, S.2043.

118th. Col. G. F. Nichols, S.1397.

119th. Col. E. Peisener, S.3179.

120th. Col. G. H. Sharpe, C.4588.
Lieut.-Col. C. D. Westbrook, S.1354.

121st. Maj. E. Olcott, S.1410.

124th. Col. A. V. H. Ellis, S.2093.
Lieut.-Col. F. M. Cummins, S.1366, S.1621.

125th. Col. G. L. Willard, S.1525.

133d. Lieut.-Col. A. J. Allaire, S.1917.

134th. Col. C. Coster, S.3193.

141st. Col. S. G. Hathaway, S.1448.
Surg. J. W. Robinson, S.1434.

143d. Col. H. Boughton, S.2035.

144th. Col. R. S. Hughston, S.3759.

145th. Col. E. L. Price, S.1388.

146th. Col. D. Jenkins, S.1763.

153d. Col. E. P. Davis, S.3206.
Lieut. J. B. Neill, C.4310.
Officers of regiment, C.4291.
Officers of Company —, C.4320.
Company —, C.4281.

154th. Lieut.-Col. D. B. Allen, S.1444.
Lieut.-Col. H. C. Loomis, S.3734.

156th. Col. J. Sharp, S.3730.

158th. Col. J. Jourdan, S.1962.

159th. Col. E. L. Molineux, C.4586.

162d. Col. L. Benedict, 1799.

164th. Col. J. P. McMahon, C.4319.
Lieut.-Col. W. De Lacey, S.3226.
Officers of regiment, C.4312.
Company —, C.4297.
Guard mounting, C.4396.
Surgeon's quarters, C.4426.

169th. Col. A. Alden, S.3062.
Col. Clarence Buell, S.3740.
Col. J. McConihe, S.1359.

170th. Officers of regiment, C.4280, C.4282, C.3626.
Company —, C.4315.
Company —, C.4348.

175th. Lieut.-Col. J. A. Foster, S.1558, S.1605, S.1796.

179th. Surg. J. W. Robinson, S.1434.

182d. Col. M. Murphy, S.1679.

New York Militia.

7th. Col. M. Lefferts, S.1669.
Adjt. J. H. Liebenau, S.1664.
Surg. T. M. Cheeseman, S.1491.
Ass't Surg. Tuthill, S.1584.
Commissary W Patten, S.1668.
Paymaster M. Howland, S.1589.
Quartermaster L. W. Winchester, S.1594.
Chaplain S. H. Weston, S.1674.
Capt. W. P. Bensel, S.1671.
Capt. E. Clark, S.1684.
Capt. J. Price, S.1533.
Capt. H. C. Shumway, S.1590.
Capt. W. A. Spaight, S.1572.
Lieut. C. B. Babcock, S.1586.
Lieut. J. A. Baker, S.1665.
Lieut. J. W. Bogert, S.1588.
Lieut. C. B. Bostwick, S.1662.
Lieut. T. B. Bunting, S.1663.
Lieut. C. Corley, S.1570.
Lieut. W. Gurney, S.1585.
Lieut. G. T. Haws, S.1493.
Lieut. J. Wickstead, S.1666.
Lieut. J. B. Young, S.1615.
Sergt.-Maj. R. C. Rathbon, S.1472.
Sergt. J. J. Morrison, S.1486.
Sergt. S. O. Ryder, S.1488.

8th. Col. G. Lyon, S.2107.
Group of officers, Camp McDowell, Va., C.4104.
Officers and non-commissioned officers of Company —, C.4112.
Engineer company, C.4137.
Company A, C.4541.
Drum Corps, C.4540.

12th. Lieut.-Col. W. G. Ward, S.1661.
Maj. Bostwick, S.1767.
Engineer company, C.4138.

22d. Lieut.-Col. L. Aspinwall, S.3733.
Officers of regiment, C.4010.
Adjutant and First Sergeants, C.4135.
Company —, C.4194.
Company —, C.4134.
Groups, C.4155, C.4163, C.4186.

23d. Col. Wm. Everdell, S.1404.

69th. Lieut. E. K. Butler, S.2255.
Sunday services in camp, S.3713.

71st. Group of officers, Washington Navy-yard, C.4105.
Col. Bostwick, S.1578.

Ohio Cavalry.

9th. Lieut.-Col. W. Stough, C.4594.

Battery I, Ohio Light Artillery.

Capt. H. Dilger, S.3177.

Ohio Infantry.

6th. Col. N. L. Anderson, C.3004.

12th. Col. C. B. White, C.3227.

19th. Col. C. F. Manderson, S.3112.

25th. Col. W. P. Richardson, S.1510.

28th. Col. A. Moor, S.2651.

31st. Col. M. B. Walker, S.3238.

41st. Col. W. B. Hazen, S.2126.

44th. Col. S. A. Gilbert, C.5048.

46th. Maj. H. H. Gilsy, S.3190.

61st. Col. S. J. McGroarty, S.2079.

66th. Col. C. Candy, S.2181.

73d. Lieut.-Col. S. H. Hurst, S.1438.

114th. Col. J. Cradlebough, S.1775.

125th. Group of officers, C.4325.
Company B, C.4324.
Company C, C.4329.
Company H, C.4330.
Band, C.4328.

126th. Col. B. F. Smith, S.1711.

136th. Lieut.-Col. D. A. Williams, S.1795.

176th. Col. E. C. Mason, S.1861.

181st. Col. J. O'Dowd, S.3208.

Pennsylvania Cavalry.

1st. Col. O. Jones, S.1938.
Lieut.-Col. J. Higgins, S.1368.

3d. Group of officers at Westover Landing, Va., C.4532.
Group of officers, C.4106.
Camp at headquarters Army of Potomac, February, 1865, L.7298.
Company D, Brandy Station, March, 1864, L.7389.
Lieut. J. W. Ford and Lieut. A. M. Wright, August, 1862, S.622.
Field and staff officers, L.7576, S.635.
Lieut.-Col. S. W. Owen, caught napping, S.625.

4th. Col. D. Campbell, S.1724.
Col. G. H. Covode, S.1848.
Col. S. B. M. Young, C.4716.
Lieut.-Col. J. H. Childs, S.1869.
Field and staff officers at Westover Landing, August, 1862, L.7474, S.629.

5th. Camp in front of Richmond, Va., S.2499.
Col. R. M. West, S.2152.

6th. Company I, Falmouth, Va., June, 1863, L.7140.

8th. Maj. A. G. Enos, S.2158.

9th. Col. T. J. Jordan, C.4712.

11th. Col. F. A. Stratton, C.4719.
Col. S. P. Spear, S.3072.
Maj. N. M. Runyon, S.1984.

13th. Maj. G. F. McCabe, S.1617.

14th. Maj. T. Gibson, S.1543.

16th. Lieut.-Col. L. D. Rogers, S.1441.

18th. Regimental camp, February, 1864, L.7650.

20th. Col. J. E. Wynkoop, S.1818.

21st. Col. O. B. Knowles, C.4707.

Pennsylvania Light Artillery.

1st. Battery B, C.4114, C.4139.

Pennsylvania Heavy Artillery.

2d. Company I in Fort Slemmer, C.4532.

3d. Col. Joseph Roberts, C.4721.
Field and staff officers, L.7486.
On parade, L.7058, L.7423.

Pennsylvania Battery E (Knapp's).

At Antietam, Md., September, 1862, S.577.
Capt. J. M. Knapp, S.1790.

Pennsylvania Infantry.

11th. Col. Richard Coulter, C.4724.

29th. Lieut.-Col. C. Parham, S.1342.

30th. Col. W. C. Talley, S.1539.
View of camp, C.4150.
Company A, C.4485.
Company B, C.4459.
Company —, C.4466.
Company —, C.4484.
Company —, C.4493.
Drum Corps, C.4491.

31st. Camp on Queen's farm, near Fort Slocum, Va., S.2409, S.2410, S.2411, S.2412.
Camp scenes, S.2404, S.2405, S.2406.
Group of officers, S.2407.
Captain and First Sergeant of Company —, S.2408.
Lieut.-Col. G. A. Woodward, S.1405.

32d. Adjt. A. H. Jameson, S.1837.

33d. Company B, S.2418.

34th. Maj. G. Dare, S.2159.

35th. Col. W. H. Ent, S.3266.
Col. W. Sinclair, S.1540.

36th. Company H, C.4534.
Camp, C.4549.

37th. Col. S. M. Bailey, S.1854.
Flag of regiment, C.4436.

39th. Col. J. S. McCalmont, S.1899.

40th. Col. S. M. Jackson, S.3728.

45th. Col. J. J. Curtin, S.2038.

46th. Col. J. L. Selfridge, S.1461.

48th. Col. G. W. Gowan, S.2624.
Col. J. K. Sigfried, S.2621.
Lieut.-Col. H. Pleasants, S.2622.

50th. Lieut.-Col. S. K. Schwenk, L.7668.
Maj. G. W. Brumm, L.7271.
Lieut. L. Carter, L.7410.
Lieut. J. I. Eckel, L.7359.
Regiment on parade, at Beaufort, S. C., 1862, S.156.
Regiment on parade, at Gettysburg, Pa., July, 1865, L.7025, L.7027.
Officers of regiment, at Gettysburg, Pa., July, 1865, L.7225, L.7230.

51st. Lieut.-Col. T. S. Bell, S.3737.

52d. Col. Henry M. Hoyt, C.4722.

53d. Col. W. M. Mintzer, S.3229.

56th. Col. J. W. Hoffman, C.5154.

58th. Lieut.-Col. C. Clay, S.3000.

61st. Col. G. F. Smith, S.1369.

62d. Lieut.-Col. J. B. Sweitzer, S.1721.

63d. Surg. W. H. Worthington, S.3841.

69th. Field and staff officers, L.7267.
Maj. James O'Reilly, S.2197.

71st. Col. E. D. Baker, S.1459.

72d. Col. D. C. Baxter, S.3014.

73d. Col. J. A. Koltes, S.1734.

75th. Col. F. Mahler, S.1789, S.3743.
Col. John S. Littell, C.4718.

79th. Col. H. A. Hambright, S.3204.

82d. Lieut.-Col. Frank Vallee, S.2146.

83d. Col. S. Vincent, S.3188.

84th. Col. S. M. Bowman, S.1513.

85th. Surg. J. B. Laidley, S.3844.

90th. Col. P. Lyle, S.3018.

93d. Lieut.-Col. J. W. Johnston, S.2183.

96th. Col. H. L. Cake, S.1817.
Group of officers, C.4533.

97th. Col. Henry R. Guss, C.4703.

98th. Col. J. F. Ballier, S.2027.

100th. Col. David Leasure, C.4714.

101st. Surg. D. G. Rush, S.2244.

103d. Col. T. F. Lehmann, S.3814.
Lieut.-Col. W. C. Maxwell, S.1365.

104th. Col. W. W. H. Davis, C.4723.

105th. Maj. M. M. Dick, S.1725.

106th. Col. T. G. Morehead, S.586.

110th. Company C, after the battle of Fredericksburg, C.4195.

114th. *At Brandy Station, March, 1864:*
—View of camp, L.7308, L.7612.
—Guard mounting, L.7613, L.7944, S.134.
—Officers of regiment, L.7137, L.7138, L.7316, S.7602.
—Officers of Company —, L.7144, L.7145, L.7173.
—Band, L.7346, L.7611.
—Company F, L.7003, L.7038, L.7143, L.7175, L.7447.
—Company G, L.7198, L.7348.
—Company H, L.7077, L.7262, L.7263.
At Headquarters Army of Potomac, August, 1864:
—Officers, L.7137, L.7138, L.7316, L.7602.
—Officers of Company —, L.7144, L.7145.
—Capt. J. S. Crawford, L.7037, L.7145.

119th. Lieut.-Col. Gideon Clark, C.4720.
Officers of regiment, C.4290.
Officers and non-commissioned officers, C.4428.
Company —, C.4334.
Company —, C.4375.

123d. Surg. H. F. Martin, S.1392.

132d. Col. V. M. Wilcox, S.1409.
Major J. E. Shreve, S.1440.

139th. Officers of regiment, C.4288, C.4346.
Field and staff officers, C.4328.
Regiment on parade, C.4306.
Company —, C.4302.
Company —, C.4339.
Company —, C.4341.
Company —, C.4367.
Company —, C.4368.
Company —, C.4173.

143d. Col. E. L. Dana, S.3748.

145th. Col. H. L. Brown, S.3107.

148th. Col. J. A. Beaver, C.4715.

149th. Col. Roy Stone, S.3103.
Company D, in front of Petersburg, November, 1864, L.7047, L.7388.

150th. Camp, March, 1863, S.297.

155th. Col. A. L. Pearson, S.3210.

195th. Col. J. W. Fisher, S.3040.

198th. Col. H. G. Sickel, C.4706.

207th. Col. Robert C. Cox, C.4713.

208th. Col. A. B. McCalmont, S.1356.

Rhode Island Cavalry.

1st. Col. R. B. Lawton, S.3727.

Rhode Island Light Artillery.

1st. Officers of regiment, July, 1862, S.649.
Chaplain T. Quinn, S.1780.

Rhode Island Heavy Artillery.

3d. Col. W. Ames, C.4666.

Rhode Island Infantry.

1st. Col. A. E. Burnside and officers, C.4100.
 Chaplain A. Woodbury, S.1639.
 Group of Company D, C.4128.
2d. Col. Horatio Rogers, C.4682.
 Officers of regiment, C.4537.
 Capt. C. G. Dyer, S.1686.
 Camp near Washington, D. C., in 1861, C.4113.
3d. Col. N. W. Brown, C.4669.
9th. Lieut.-Col. J. H. Powell, S.1343.
11th. Headquarters of Company F, Miner's Hill, Va., C.4349.

Tennessee Cavalry.

1st. Col. J. P. Brownlow, S.3077.

United States Engineer Battalion.

At Brandy Station, Va., March, 1864:
—View of camp, L.7310, L.7433, L.7560.
—Officers' quarters, L.7109.
—Quarters of Company D, L.7005.
In front of Petersburg, Va., August, 1864:
—Headquarters, L.7065.
—Company A, L.7062, L.7384, L.7386.
—Company B, L.7066, L.7219, L.7513, L.7547, L.7566, L.7570.
—Company C, L.7568, L.7647.
—Company D, L.7054, L.7387, L.7548.
—Essayon's Dramatic Club, L.7336, L.7439.
—Detachment in city of Petersburg, April, 1865, L.7188, L.7434.

United States Cavalry.

1st. Company K, Brandy Station, February, 1864, L.7129, L.7279.
2d. Maj. C. J. Whiting, S.1416.
 Capt. G. A. Gordon, S.1482.
6th. Capt. H. B. Hays, S.2067.

United States Artillery.

2d. Capt. J. M. Robertson, C.5142.
 Officers of Battery A (Tidball's), near Fair Oaks, Va., June, 1862, S.435.
 Officers of Battery B (Robertson's), near Fair Oaks, Va., June, 1862, S.440.
 Battery B (Robertson's), near Fair Oaks, Va., June, 1862, S.439.
 Battery B (Robertson's), at Gettysburg, Pa., L.7192.
 Battery D, C.4212.
 Flag of Battery D, C.4510.
 Battery M (Benson's), near Fair Oaks, Va., June, 1862, S.433, S.641.
 Battery M (Benson's), Culpeper, Va., September, 1863, L.7245.
3d. Officers of Battery C (Gibson's), near Fair Oaks, Va., June, 1862, S.432.
 Battery C (Gibson's), near Fair Oaks, Va., June, 1862, S.431.
4th. Battery A, Culpeper, Va., September, 1863, L.7334.
5th. Lieut.-Col. B. H. Kill, S.2046.
 Capt. Charles Griffin, S.1373.

United States Infantry.

1st. Col. C. A. Waite, S.2670.
 Lieut. J. D. De Russy, S.1698.
2d. Col. S. Burbank, S.3101.
3d. Officers of regiment, June, 1865, L.7366, L.7398.
 Col. B. L. E. Bonneville, S.1968.
4th. Lieut.-Col. T. Morris, S.3769.
5th. Lieut.-Col. T. L. Alexander, S.1381.
6th. Col. H. Day, S.3793.
 Col. W. Seawell, S.1474.
 Capt. J. B. S. Todd, S.1336.
8th. Provost guard, at headquarters Army of Potomac, Fairfax Court House, June, 1863, L.7503.
 Col. J. Garland, S.1329.
 Col. W. J. Worth, S.1316.
9th. Lieut. E. Pollock, S.2200.
10th. Col. H. B. Clitz, S.1521.
 Lieut.-Col. W. H. Sidell, S.2615.
 Lieut. G. W. Vanderbilt, S.2250.
14th. Officers of regiment, March, 1862, L.7973.
 Col. C. S. Lovell, S.3234.
 Capt. J. D. O'Connell, S.3270.
15th. Maj. J. H. King, S.2609.
16th. Capt. F. M. Bache, S.2439.
 Capt. R. P. Barry, S.3871.
17th. Maj. W. H. Wood, S.3830.
 Lieut. N. Prine, S.2199.

United States Sharpshooters.

1st. Col. H. Berdan, S.3771.
2d. Col. H. A. V. Post, S.3731.
 Lieut.-Col. H. R. Stoughton, S.1620.
 Adjt. L. C. Parmelee, S.1825.

United States Veteran Reserve Corps.

3d. Col. F. D. Sewall, S.3753.
7th. Lieut.-Col. J. B. Callis, C.4740.
9th. *In Washington, D. C., May, 1865:*
—On parade, L.7686, L.7881.
—Band, L.7807, L.7808.
—Band quarters, L.7854, L.7868.
—Company A, L.7670.
10th. *In Washington, D. C., May, 1865:*
—Band, L.7865, L.7879.
—Drum Corps, L.7688.
—Company A, L.7742.
—Company B, L.7677, L.7892.
—Company C, L.7896, L.7898.
—Company D, L.7905.
—Company E, L.7810.
—Company F, L.7910.
—Company H, L.7809, L.7911.
—Company I, L.7804, L.7806.
—Company K, L.7805.
—Non-commissioned officers of Company H, L.7802.
14th. Col. S. D. Oliphant, S.3796.
19th. Col. O. V. Dayton, S.1777, S.2065.
22d. Maj. J. R. O'Beirne, S.3269.
26th. Lieut.-Col. B. P. Runkle, S.1762.

United States Veteran Volunteers.

8th. Parade of regiment, Washington, D. C., March, 1864, L.7813.

United States Colored Cavalry.

4th. Col. J. G. Wilson, S.1815, S.1868.

United States Colored Infantry.

1st. Camp and regiment, L.7013.
4th. Officers of regiment, Fort Slocum, near Washington, D. C., L.7689, L.7851.
 Company E, Fort Lincoln, near Washington, D. C., in 1865, L.7890.
7th. Col. James Shaw, C.4730.
8th. Col. S. C. Armstrong, S.1920.
14th. Col. H. C. Corbin, S.2617.
17th. Col. W. R. Shafter, S.2604.
24th. Col. O. Brown, C.4984.
27th. Col. A. M. Blackman, S.2042.
28th. Col. C. S. Russell, S.3211.
35th. Col. J. C. Beecher, S.1466.
37th. Col. N. Goff, S.3035.
39th. Field and staff officers, in front of Petersburg, Va., September, 1864, L.7051, L.7052.
43d. Col. S. B. Yeoman, S.2669.
45th. Col. U. Doubleday, S.3213.
79th. Col. J. M. Williams, C.4596.
83d. Col. S. J. Crawford, C.4784.
100th. Col. R. D. Mussey, S.2606.
103d. Col. S. L. Woodford, C.5098.
107th. *At Fort Corcoran, near Washington, D. C., November, 1865:*
—Officers of regiment, L.7684.
—Guard and guard-house, L.7841.
—Band, L.7861.
109th. Col. O. A. Bartholemew, S.2614.
119th. Col. C. G. Bartlett, S.3091.

United States Treasury Battalion.

Officers of battalion, Washington, D. C., April, 1865, L.7850.

Vermont Cavalry.

1st. Lieut.-Col. A. W. Preston, S.1751.

Vermont Heavy Artillery.

1st. Lieut.-Col. R. C. Benton, S.1355.
 Lieut.-Col. G. E. Chamberlain, S.3735.

Vermont Infantry.

3d. Col. B. N. Hyde, S.3770.
5th. Col. H. A. Smalley, S.3729.
6th. Col. E. L. Barney, S.1683.
 Col. N. Lord, S.1731.
 Col. O. L. Tuttle, S.1802.
 Lieut.-Col. A. P. Blunt, S.1813.
 Surg. C. M. Chandler, S.2148.
 Views of Camp Griffin, near Washington, D. C., in 1861, C.4787, C.4117, C.4118.
 Company A, C.4119.
 Company D, C.4120.
 Company E, C.4121.
 Company F, C.4122.
 Company G, C.4123.
 Company H, C.4124.
 Company I, C.4125.
 Company K, C.4126.
9th. Col. E. H. Ripley, S.3113, S.3114.
10th. Col. A. B. Jewett, S.2165.

Vermont Infantry.— Continued.

12th. Col. A. P. Blunt, S.1813.
13th. Col. F. V. Randall, S.1445.
 Lieut.-Col. A. C. Brown, S.1463.
15th. Lieut.-Col. R. Farnham, S.1479.
 Maj. C. F. Spaulding, S.1596.
 Surg. C. P. Frost, S.1447.
17th. Col. F. V. Randall, S.1445.
 Lieut.-Col. C. Cummings, S.1468.

West Virginia Cavalry.

1st. Lieut.-Col. C. E. Capehart, S.1623.
3d. Col. D. H. Strother, S.3723.
4th. Lieut.-Col. S. W. Snider, S.1455.

West Virginia Infantry.

12th. Col. W. B. Curtis, S.3224.

Wisconsin Infantry.

2d. Col. E. O'Connor, S.3863.
 Camp in front of Petersburg, Va., February, 1865, L.7543.
5th. Col. Amasa Cobb, C.4739.
 Maj. C. H. Larrabee, S.2186.
6th. Lieut.-Col. F. S. Bragg, S.1367.
 Surg. A. W. Preston, S.3854.
16th. Col. C. Fairchild, S.3202.
18th. Surg. E. J. Buck, S.3798.
21st. Col. H. C. Hobart, S.3205.
24th. Col. C. H. Larrabee, S.2186.
25th. Lieut.-Col. J. M. Rusk, C.4732.

PORTRAITS OF NAVY OFFICERS.

Ammen, Commander D, C.4635.
Bailey, Commodore T., S.2231.
Bankhead, Commander J. P., S.2118.
Barrett, Lieut.-Commander E., S.1987, S.3415.
Beil, Commodore C. H., S.2121.
Bennett, —, S.2256.
Blodgett, Lieut. G. M., S.2201.
Boggs, Capt. C. S., S.3764.
Breese, Commodore S. L., S.1610.
Bullus, Capt. O., S.1632.
Campbell, Acting Ass't Surg., S.2204.
Collins, Commander N., S.1930.
Conroy, Acting Lieut.-Commander E., S.1657.
Cushing, Lieut.-Commander W. B., S.1864.
Dahlgren, Rear Admiral J. A., S.1862, S.3416, S.3417, S.3418.
Dahlgren, Rear Admiral J. A. and staff, S.3413.
Davis, Rear Admiral C. H., C.4743.
De Krafft, Lieut.-Commander J. C. P., C.5143.
Drayton, Capt. P., C.5112.
Dupont, Rear Admiral S. F., C.4636.
Erben, Lieut.-Commander H., C.4637.
Farragut, Rear Admiral D. G., S.1561.
Faunce, Capt. J. (Revenue Marine), S.2134.
Foote, Rear Admiral A. H., S.1600.
Freeman, Acting Master, S.2202.
Gibson, Purser J. D., C.4803.
Gilliss, Capt. J. P., C.4809.
Glisson, Capt. O. S., C.4808.
Goldsborough, Capt. J. R., S.2119.
Goldsborough, Rear Admiral L. M., C.4744.
Gregory, Rear Admiral F. H., S.1812.
Gregory, Ass't Engineer H. P., S.1690.
Gregory, Acting Master S. B., S.2053.

Gwin, Lieut.-Commander W., S.1408.
Harwood, Commodore A. A., C.4801.
Haxtun, Lieut.-Commander M., S.2235.
Hoff, Commodore H. K., C.5113.
Howard, —, S.1603.
Hughes, Commander A. K., S.2247.
Hughes, Acting Ensign J. F., S.2166.
Hull, Commodore J. B., S.1636.
Isherwood, Engineer-in-chief B. F., S.1890.
Jenkins, Capt. T. A., C.4633.
Jeffers, Lieut.-Commander W. N., S.492.
Jones, Surg. S. J., S.3860.
Kershner, Ass't Surg. E., S.3810.
King, Chief Engineer J. W., C.4811.
Lanman, Commodore J., C.5186.
Lardner, Commodore J. L., C.4807.
Law, Lieut.-Commander R. L., C.4582.
Levy, Capt. U. P., C.4745.
Livingstone, Commodore J. W., S.2068.
Luce, Lieut.-Commander S. B., C.5075.
Meade, Capt. R. W., S.1656.
Meade, Lieut.-Commander R. W., S.1579.
Montgomery, Commodore J. B., S.2078.
Morris, Lieut.-Commander G. U., S.1826.
Morris, Commodore H. W., S.1328.
Nichols, Capt. Sylvester, S.1701.
Nichols, Lieut. S. W., S.3857.
Nones, Capt. H. B. (Revenue Marine), S.1545.
Palmer, Commodore J. S., S.1571.
Parker, S.2240.
Parker, Lieut.-Commander James, C.5203.
Pattison, Lieut.-Commander T., S.3184.
Paulding, Rear Admiral H., S.1324.
Perry, Capt. M. C., S.1317.
Porter, Lieut. B. H., S.1893.
Porter, Rear Admiral D. D., L.7945, S.1334.
Porter, Rear Admiral D. D. and staff, L.7227, L.7244, L.7541.
Porter, Acting Master W., S.1940.
Porter, Commodore W. D., S.2242.
Powell, Commodore L. M., C.4631.
Preston, Lieut. S. W., S.3836.
Ransom, Commander G. M., C.4802.
Ridgely, Capt. D. B., C.4806.
Riell, Lieut. R. B., S.1689.
Ringgold, Commodore C. H., S.1407.
Rodgers, Commander C. R. P., S.1875, S.3803.
Rodgers, Commodore J., S.1936.
Rowan, Commodore S. C., S.1766.
Salstonstall, Acting Lieut.-Commander W. G., S.2259.
Schoonmaker, Lieut. C. M., S.3415.
Shubrick, Rear Admiral W. B., S.1598.
Shufeldt, Commander R. W., C.4632.
Skerrett, Lieut.-Commander J. S., C.4583.
Smith, Commander A. N., S.1822.
Smith, Rear Admiral J., S.2176.
Stewart, Rear Admiral C., S.1332.
Stockwell, Midshipman N. P., S.1370.
Storer, Rear Admiral G. W., S.1774.
Stringham, Rear Admiral S. H., S.1768.
Thatcher, Commodore H. K., C.5187.
Trenchard, Commander S. D., S.3865.
Van Brunt, Commodore G., S.3085.
Walke, Capt. H., S.1576.
Ward, Commander J. H., S.2004.
Wheelwright, Surg. C. W., S.2258.
Whelan, Surg. W., S.5205.
Wilkes, Commodore C., C.4656.
Winslow, Commodore J. A., S.1788.
Wise, Commander H. A., S.1844.
Worden, Capt. J. L., C.4634.
Wright, S.1587.
Wyatt, 1st Ass't Engineer S. C., S.1550.
Wyman, Commander R. H., S.1994.

THERE are several thousand negatives in the vaults that have not yet been catalogued. No negative is registered until its authenticity is proved beyond a doubt. The testimony of hundreds of veterans is secured in many instances before the locality of the negative is established. The warriors who participated in these scenes are fast passing away and the work of identification is progressing as rapidly as absolute accuracy will allow. At the National Encampment at Saratoga hundreds of "unknown" negatives were identified by soldiers who saw them taken and offered their affidavits. Requests have been received from Grand Army Posts for enlargements of the rare photographs of Lincoln in the tent with McClellan at Antietam, of the Armies in Camp, and other views, the existence of which has been hitherto unknown. Mr. Eaton authorizes the enlargement of any negative for this purpose, providing that it is to be treasured in the hall of a Grand Army Post. All requests must be sent direct, accompanied by references, and no enlargement will be allowed until it bears the written signature of Edward B. Eaton, Hartford, Connecticut.